Oil Paintings in Public Ownership in
Cambridgeshire: The Fitzwilliam Museum

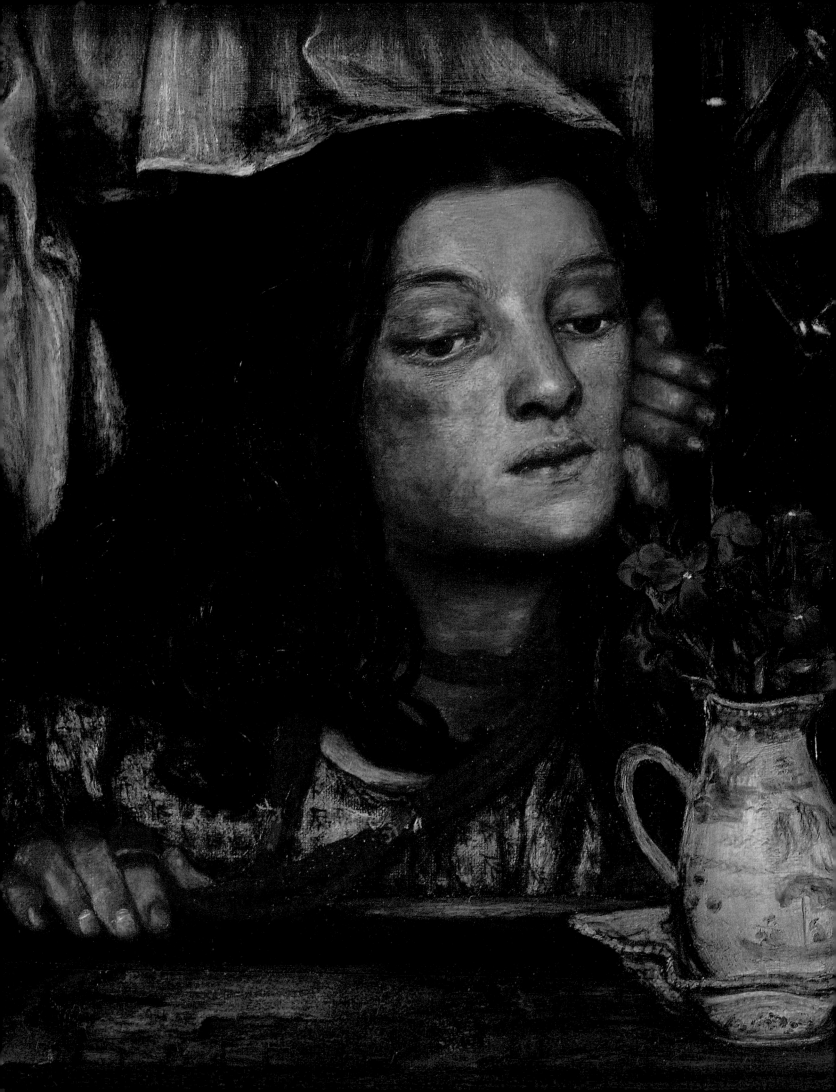

Oil Paintings in Public Ownership in Cambridgeshire: The Fitzwilliam Museum

The Public Catalogue Foundation

Andrew Ellis, Director
Sonia Roe, Editor

The Fitzwilliam Museum photography:
Andrew Morris, Andrew Norman (The Fitzwilliam
Museum); Douglas Atfield (The PCF), Christopher
Titmus (Hamilton Kerr Institute)

Designed by Jeffery Design, London

Distributed by the Public Catalogue Foundation,
St Vincent House, 30 Orange Street,
London, WC2H 7HH
Telephone 020 7747 5936

**Printed and bound in the UK by Butler & Tanner
Ltd, Frome, Somerset**

Cover image:

Sassoferrato 1609–1685
The Holy Family (detail) (see p. 159)

Image opposite title page:

Rossetti, Dante Gabriel 1828–1882
Girl at a Lattice (detail), 1862 (see p. 153)

Back cover images (from top to bottom):

Millais, John Everett 1829–1896
The Bridesmaid 1851 (see p. 123)

Palma, Jacopo il vecchio c.1479–1528
Venus and Cupid c.1523–1524 (see p. 136)

Berckheyde, Gerrit Adriaensz. 1638–1698
The Groote Kerk at Haarlem 1674 (see p. 16)

Contents

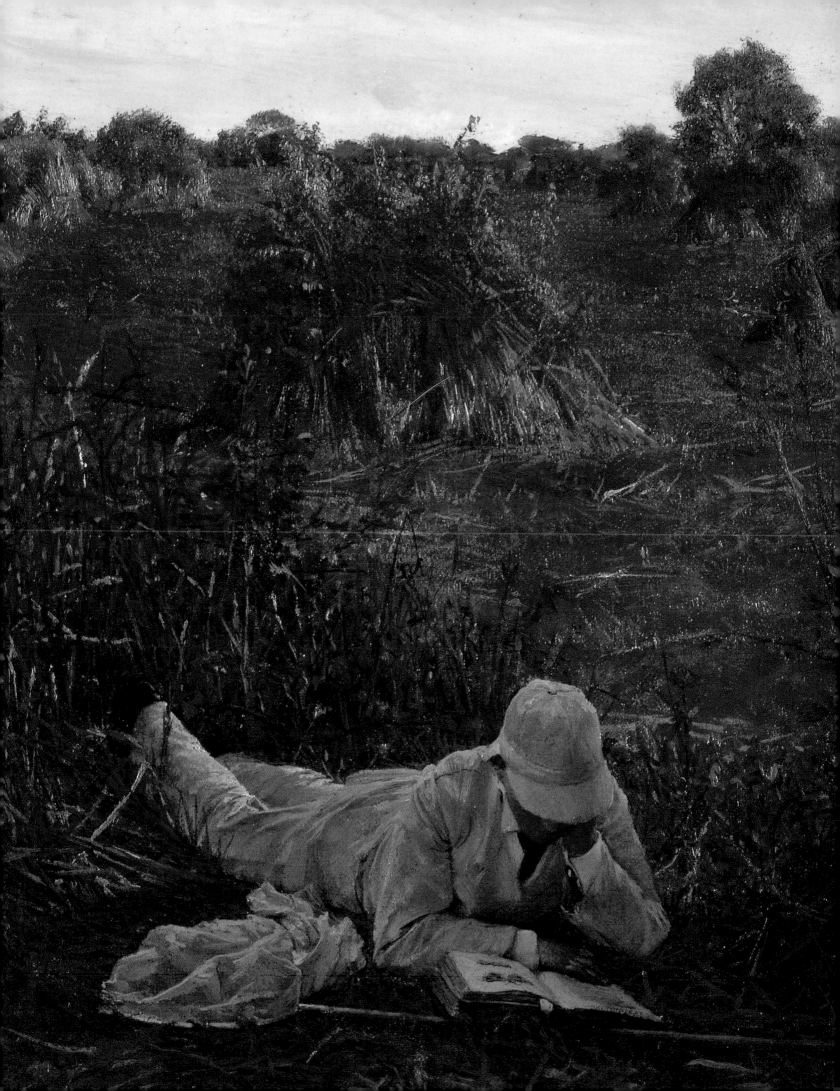

Foreword

This whole project started at the Fitzwilliam. An Oxford man, Cambridge to me was barely more than an (occasionally embarrassing) shell on the Tideway and the home of a few (occasionally dubious) luminaries of various disciplines. So the Fitzwilliam's collection of paintings – all I had time for as I waited to retrieve my daughter from her college interview – left me dazzled, breathless and more than a little ashamed of myself. Twelve months or so of visiting public art collections throughout the UK had led me to appreciate that the Nation owned an extraordinary wealth of paintings. I was, nonetheless, unprepared for the sheer range, depth and quality of this collection.

It was my astonishment at not being able to buy a catalogue of the paintings in the museum shop and my insistence on being taken immediately to the curator that led me to hear David Scrase's description of the lamentable situation regarding such catalogues throughout the nation and inspired the creation of the PCF. The rest is not yet history – but soon will be when the Foundation completes its task.

Duncan Robinson's elegant introduction to this catalogue will allow the reader to understand why the Fitzwilliam's collection of paintings is so formidable in quality and range. But, unless you are a very regular visitor and spend time in the painting stacks, you will not appreciate that what is on show – whilst sublime – is not fully representative of the breadth and depth of this magnificent collection.

Moreover, this national gem (for such it certainly is) is but one jewel in a National Collection without peer anywhere in the world. However, its fragmentary ownership, in the hands of a gallimaufry of town and city councils, local authorities, county councils, trusts, educational authorities and so on, prevents our seeing it as a National Collection, offers it no protection as part of our national heritage, and promotes its accelerating decline and decay. More absurdly, what is the point of the current political obsession with public access to our heritage if no one has more than the faintest idea of what that access is to?

Without leadership from the public sector on the need for improved catalogue records and the provision of funds to achieve this, the guardians of our National Collection will continue to be overwhelmed by the task of caring for their collections and making them accessible to the public that deserves to know what it owns. This series of catalogues of publicly owned oil paintings – ironically funded principally by the private sector and charitable trusts – is starting to address the issue and make us aware of what we all own. And as the Fitzwilliam shows, we own some staggeringly beautiful assets.

Enormous thanks to the staff at the Fitzwilliam, particularly Duncan Robinson, David Scrase and Andrew Morris for their tireless help in ensuring this catalogue is in such fine shape. And, as usual, we are indebted to a number of individuals and organisations who have so generously helped fund the production of the catalogue. In particular, I would like to thank Hiscox plc, the Manifold Trust, the Marlay Group, the Monument Trust, the Stavros S. Niarchos Foundation and the Garfield Weston Foundation.

Fred Hohler, Chairman

Facing page: Alma-Tadema, Lawrence, 1836–1912, *94 Degrees in the Shade* (detail), 1876, (p. 7)

The Public Catalogue Foundation

The United Kingdom holds in its galleries and civic buildings arguably the greatest publicly owned collection of oil paintings in the world. However, an alarming four in five of these paintings are not on view. Whilst many galleries make strenuous efforts to display their collections, too many paintings across the country are held in storage, usually because there are insufficient funds and space to show them. Furthermore, very few galleries have created a complete photographic record of their paintings, let alone a comprehensive illustrated catalogue of their collections. In short, what is publicly owned is not publicly accessible.

The Public Catalogue Foundation, a registered charity, has three aims. First, it intends to create a complete record of the nation's collection of oil, tempera and acrylic paintings in public ownership. Second, it intends to make this accessible to the public through a series of affordable catalogues and, after a suitable delay, through a free Internet website. Finally, it aims to raise funds through the sale of catalogues in gallery shops for the conservation and restoration of oil paintings in these collections and for gallery education.

The initial focus of the project is on collections outside London. Highlighting the richness and diversity of collections outside the capital should bring major benefits to regional collections around the country. The benefits also include a revenue stream for conservation, restoration, gallery education and the digitisation of collections' paintings, thereby allowing them to put the images on the Internet if they so desire. These substantial benefits to galleries around the country come at no financial cost to the collections themselves.

The project should be of enormous benefit and inspiration to students of art and to members of the general public with an interest in art. It will also provide a major source of material for scholarly research into art history.

Financial Supporters

The Public Catalogue Foundation would like to express its profound appreciation to the following organisations and individuals who have made the publication of this catalogue possible.

Donations of £5,000 or more

Hiscox plc
The Manifold Trust
The Marlay Group

The Monument Trust
Stavros S. Niarchos Foundation
Garfield Weston Foundation

Donations of £1,000 or more

ACE Study Tours
Harry and Alice Bott
Sir John & Lady Elliott
Andrew & Lucy Ellis
G. Laurence Harbottle
Neil Honebon

The Keatley Trust
Mark & Sophie Lewisohn
Michael Renshall, CBE MA FCA
Scarfe Charitable Trust
Stuart M. Southall

Other Donations

Charles & Julia Abel Smith
Lord & Lady Archer
Nicholas and Diana Baring
Edward & Sally Benthall
Dick Chapman & Ben Duncan

Daniel Fearn
Richard & Susan Goldstein
Garrett Kirk, Jr
Simon Piggott
Caroline Streets

National Supporters

The Bulldog Trust
The John S. Cohen Foundation
Hiscox plc
The Manifold Trust

The Monument Trust
Stavros S. Niarchos Foundation
Garfield Weston Foundation

National Sponsor

Christie's

Acknowledgements

The Public Catalogue Foundation would like to thank the individual artists and copyright holders for their permission to reproduce for free the paintings in this catalogue. Exhaustive efforts have been made to locate the copyright owners of all the images included within this catalogue and to meet their requirements. Copyright credit lines for copyright owners who have been traced, are listed in the Further Information section.

The Public Catalogue Foundation would like to express its great appreciation to the following organisations for their great assistance in the preparation of this catalogue:

Bridgeman Art Library
Flowers East
Marlborough Fine Art
National Association of Decorative and Fine Art Societies (NADFAS)
National Gallery, London
National Portrait Gallery, London
Royal Academy of Arts, London
Tate

The Fitzwilliam Museum and the Public Catalogue Foundation would like to thank the following individuals for their help and support in producing this catalogue:

Andrew Bowker
Sean Fall
Margaret Greaves
Sir Denis Mahon
Polly Miller
Andrew Morris
Andrew Norman
The Provost and Fellows of King's College, Cambridge
Jane Sargent
David Scrase
David Scruton
Christopher Titmus

Catalogue Scope and Organisation

Medium and Support

The principal focus of this series is oil paintings. However, tempera and acrylic are also included as well as mixed media, where oil is the predominant constituent. Paintings on all forms of support (e.g. canvas, panel etc) are included as long as the support is portable. The principal exclusions are miniatures, hatchments or other purely heraldic paintings and wall paintings *in situ*.

Public Ownership

Public ownership has been taken to mean any paintings that are directly owned by the public purse, made accessible to the public by means of public subsidy or generally perceived to be in public ownership. The term 'public' refers to both central government and local government. Paintings held by national museums, local authority museums, English Heritage and independent museums, where there is at least some form of public subsidy, are included. Paintings held in civic buildings such as local government offices, town halls, guildhalls, public libraries, universities, hospitals, crematoria, fire stations and police stations are also included. Paintings held in central government buildings as part of the Government Art Collection and MoD collections are not included in the county-by-county series but should be included later in the series on a national basis.

Geographical Boundaries of Catalogues

The geographical boundary of each county is the 'ceremonial county' boundary. This county definition includes all unitary authorities. Counties that have a particularly large number of paintings are divided between two or more catalogues on a geographical basis.

Criteria for Inclusion

As long as paintings meet the requirements above, all paintings are included irrespective of their condition and perceived quality. However, painting reproductions can only be included with the agreement of the participating collections and, where appropriate, the relevant copyright owner. It is rare that a collection forbids the inclusion of its paintings. Where this is the case and it is possible to obtain a list of paintings, this list is given in the Paintings Without Reproductions section. Where copyright consent is refused, the paintings are also listed in the Paintings Without Reproductions section. All paintings

in collections' stacks and stores are included, as well as those on display. Paintings which have been lent to other institutions, whether for short-term exhibition or long-term loan, are listed under the owner collection. In addition, paintings on long-term loan are also included under the borrowing institution when they are likely to remain there for at least another five years from the date of publication of this catalogue. Information relating to owners and borrowers is listed in the Further Information section.

Layout

Collections are grouped together under their home town. These locations are listed in alphabetical order. In some cases collections that are spread over a number of locations are included under a single owner collection. A number of collections, principally the larger ones, are preceded by curatorial forewords. Within each collection paintings are listed in order of artist surname. Where there is more than one painting by the same artist, the paintings are listed chronologically, according to their execution date.

There is additional reference material in the Further Information section at the back of the catalogue. This gives the full names of artists, titles and media if it has not been possible to include these in full in the main section. It also provides acquisition credit lines and information about loans in and out, as well as copyright and photographic credits for each painting. Finally, there is an index of artists' surnames.

Key to Painting Information

Almost all paintings are reproduced in the catalogue. Where this is not the case they are listed in the Paintings Without Reproductions section. Where paintings are missing or have been stolen, the best possible photograph on record has been reproduced. In some cases this may be black and white. Paintings that have been stolen are highlighted with a red border. Some paintings are shown with conservation tissue attached to parts of the painting surface.

Adam, Patrick William 1854–1929
Interior, Rutland Lodge: Vista through Open Doors 1920
oil on canvas 67.3 × 45.7
LEEAG.PA.1925.0671.LACF 🐝

Artist name This is shown as surname first. Where the artist is listed on the Getty Union List of Artist Names (ULAN), ULAN's preferred presentation of the name is always given. In a number of cases the name may not be a firm attribution and this is made clear. Where the artist name is not known, a school may be given instead. Where the school is not known, the painter name is listed as *unknown artist*. If the artist name is too long for the space, as much of the name is given as possible followed by (…). This indicates the full name is given at the rear of the catalogue in the Further Information section.

Painting title A painting followed by *(?)* indicates that the title is in doubt. Where the alternative title to the painting is considered to be better known than the original, the alternative title is given in parentheses. Where the collection has not given a painting a title, the publisher does so instead and marks this with an asterisk. If the title is too long for the space, as much of the title is given as possible followed by *(…)* and the full title is given in the Further Information section.

Medium and support Where the precise material used in the support is known, this is given.

Artist dates Where known, the years of birth and death of the artist are given. In some cases one or both dates may not be known with certainty, and this is marked. No date indicates that even an approximate date is not known. Where only the period in which the artist was active is known, these dates are given and preceded with the word *active*.

Execution date In some cases the precise year of execution may not be known for certain. Instead an approximate date will be given or no date at all.

Dimensions All measurements refer to the unframed painting and are given in cm with up to one decimal point. In all cases the height is shown before the width. Where the painting has been measured in its frame, the dimensions are estimates and are marked with (E). If the painting is circular, the single dimension is the diameter. If the painting is oval, the dimensions are height and width.

Collection inventory number In the case of paintings owned by museums, this number will always be the accession number. In all other cases it will be a unique inventory number of the owner institution. (P) indicates that a painting is a private loan. Details can be found in the Further Information section. The 🐝 symbol indicates that the Bridgeman administers the copyright for that artist (www.bridgeman.co.uk).

Facing page: Orpen, William, 1878–1931, *Self Portrait* (detail), 1924?, (p. 134)

THE PAINTINGS

The Fitzwilliam Museum

The Fitzwilliam Museum is named after its founder, Richard, seventh Viscount Fitzwilliam of Merrion who in 1816 bequeathed his art collection and library to the University of Cambridge 'for the increase of learning and other objects of that noble foundation.' His bequest included 144 paintings, some of which he inherited, principally from his maternal grandfather the Anglo-Dutch merchant Sir Matthew Decker, and others which he bought, most famously from the sales of the Orléans collection held in London in 1798–1799. From that source he was able to add to a collection of mostly seventeenth century Dutch cabinet pictures masterpieces of the Italian Renaissance, including Titian's *Venus and Cupid with a Lute Player* and Veronese's *Hermes, Herse and Aglauros.*

Fitzwilliam also left the University the princely sum of £100,000, invested in South Sea Annuities, the income from which was to 'cause to be erected and built a good substantial Museum Repository.' That wish was not fulfilled until 1848 when the Museum opened on Trumpington Street and the collection of paintings already augmented by further gifts and bequests, was installed throughout the five galleries on its upper floor. From the review which appeared in the *Cambridge Chronicle and Huntingdonshire Gazette* on 1st July 1848, it is clear that the floor to ceiling hang was typical of the period: 'the first *coup d'oeil* must convince the beholder how cleverly the pictures have been marshalled according to their *sizes*... Companionship in subject or style, having been made a secondary point, there must occur some few violations, perhaps rather harsh, of other harmonies... One group embraces a piece of fish, flesh, and fowl, with landscape delineations of almost all the elements. Another group contains a portrait of Hone, a Holy Family and a cattle-market.'

Other collectors were not slow to follow where Fitzwilliam had led. In 1834 Daniel Mesman bequeathed 243 paintings, drawings and prints including oils by Dou, Dujardin, van Everdingen, Hondius and Savery. Works by Hobbema and Ruysdael were added to the collection by A. A. Van Sittart between 1864 and 1876 and in 1873 the Reverend R. E. Kerrich, the son of Thomas Kerrich, a former University Librarian and one of Cambridge's leading antiquarians, bequeathed paintings he had inherited from his father including Joos van Cleve's exquisite *Virgin and Child* and van Heemskerk's *Self Portrait with the Colosseum* painted in Rome in 1553.

By the end of the nineteenth century the Founder's Building was bursting at the seams. Help arrived in the form of another major bequest, second in importance only to that of the founder. Charles Brinsley Marlay (1831–1912) was an eclectic collector who shared with a good many Victorians a taste for Medieval and early Renaissance art. In 1893 the Museum bought well at the Charles Butler sale, including the three panels by Simone Martini of Saints Geminianus, Michael and Augustine. Marlay's bequest of 1912 not only added another 84 paintings with the option to sell works to create a purchase fund for acquisitions but also provided the Museum with the capital to buy additional land for the series of extensions which followed the outlines of Smith and Brewer's master plan of 1915.

To mark the Museum's centenary in 1916, Charles Fairfax Murray capped his innumerable gifts with Titian's great, late masterpiece of *Tarquin and*

Lucretia. He belonged to a generation of artists and connoisseurs who carried the principles of the aesthetic movement into the twentieth century. With their wide-ranging interests, and passion for collecting, it included Charles Ricketts (1866–1931) and Charles Shannon (1863–1937) whom the painter Jacques-Emile Blanche described as 'living all for art', and the painter Sir Frank Brangwyn (1867–1956). On the other hand, some of the gifts and bequests received between the two wars signalled a change in the tastes of collectors who preferred the French Impressionists to the Pre-Raphaelites. *At the Café* by Degas and Renoir's *Gust of Wind* joined the collection in 1939, bequeathed by Frank Hindley Smith. By then John Maynard Keynes had emerged as one of the more adventurous collectors of the period, encouraged by another significant Cambridge figure, Roger Fry. At a time when very few individuals and no museums in this country were remotely interested in their work, he acquired important paintings by Braque and Picasso, Matisse and Derain, as well as works by his contemporaries and friends among the members of the Bloomsbury Group. Following his death and that of his widow, the ballerina Lydia Lopokova, the entire collection passed to King's College Cambridge and the Museum remains permanently indebted to the Provost and Fellows for the long-term loan of many of the most important paintings and drawings in the Keynes Collection.

Acquisitions in the second half of the twentieth century were made possible by a growing number of restricted purchase funds. In 1948 the first Lord Fairhaven endowed a fund to support the purchase of landscape paintings by British artists thanks to which the Museum has been able to obtain works by virtually every major British artist including Bonington, Constable, Cotman, Danby, Stannard, Stark and Turner. Like his elder brother, Major Henry Broughton, the second Lord Fairhaven, was an avid collector, in his case of flower paintings and botanical drawings. With his gifts of 1966 and his bequest of 1973, he transformed the Fitzwilliam into a leading centre for the study of that attractive and important genre. In 1984, John Tillotson's bequest of his collection of works by artists of the Barbizon school which he had collected lovingly over several decades, added a significant group of paintings, mostly small in scale, to the growing body of nineteenth century French art in the Museum. Meanwhile, further twentieth century acquisitions gained momentum, especially after 1974 when Alistair Hunter gave Picasso's *Cubist Head*, the first of a succession of gifts which reflected his taste as it evolved from the school of Paris, through St Ives to New York.

Happily the Museum continues to attract both gifts and bequests on a regular basis. In 1992, Dr D. M. McDonald bequeathed 36 important pictures by French, Dutch, British and Italian artists, including Canaletto's *View of the Grand Canal, Venice*, identical as it happens to the one painted by his nephew Bellotto, which belonged to the Founder. More recently, in 2003, we owe Liberale's singular *Lamentation* to the late Mrs Myril Pouncey and *Two Sisters* by Millais to a daughter of one of them, Mrs Jean Wynne. Both of these were allocated to the Museum by HM Treasury following their acceptance in lieu of estate tax, a route for acquisitions which has become increasingly important for museums throughout the country. To it we also owe the two late Monets, *Lion Rock at Port-Coton* and *The Rock Needles and the Porte d'Aval*, both received in 1998. Thanks to the extension of the scheme to allow works to remain *in situ*, this catalogue includes Guido Reni's magnificent painting

of *Joseph and Potiphar's Wife* which hangs at Holkham Hall. It is to be hoped that the success of the acceptance-in-lieu provision will encourage government to introduce further tax incentives to encourage lifetime gifts to museums, in addition to the current relief, welcome but nonetheless morbid, from estate duty. For despite the generosity of the National Art Collections Fund and occasional interventions and rescue operations by the Heritage Lottery and Memorial Funds, the combination of spiralling prices and unrelieved personal taxation threaten to deprive our museums and galleries as never before of opportunities to acquire works of national importance. Today there is a tendency to justify 'heritage' in terms of its contemporary relevance. By so doing, we diminish the importance of the past surviving into the present, and deny our own responsibility for the future.

To date, the Fitzwilliam Museum enjoys title to 1,540 oil paintings. We welcome the publication of this catalogue not least because the collections have grown significantly since the appearance, between 1960 and 1970 of the complete Catalogue of Paintings in three volumes. Work is currently under way to launch a new generation of publications devoted to the permanent collection, but in the meantime we are grateful to the Public Catalogue Foundation for including the Museum in its first wave of publishing.

Duncan Robinson, Director of the Fitzwilliam Museum

It should be noted that the paintings on long-term loan from Sir Denis Mahon and from King's College, Cambridge are included amongst the Fitzwilliam Museum's collection. These are identified in the Further Information section.

Abadía, Juan de la the elder
active c.1470–1500
St Anthony Abbot
oil, tempera & gold on panel 152.7 x 79.7
M.15

Adriaenssen, Alexander (attributed to)
1587–1661
Flowers in a Glass Vase
oil on panel 34.3 x 24.7
308

Aelst, Willem van 1627–after 1687
Group of Flowers 1675
oil on canvas 31.1 x 25.4
300

Agasse, Jacques Laurent 1767–1849
The Mail Guard 1818
oil on canvas 35.6 x 30.5
PD.21-2000

Agricola, Luigi b.c.1750
Cadmus and the Dragon
oil on canvas 46 x 25.7
PD.35-1992

Agricola, Luigi b.c.1750
Venus Giving Arms to Aeneas
oil on canvas 46 x 25.7
PD.36-1992

Albani, Francesco 1578–1660
*The Trinity with the Virgin Mary and
Musician Angels*
oil on copper 41.9 x 31.4
(P)

Albani, Francesco (school of) 1578–1660
Venus and Cupid in a Landscape
oil on panel 37.8 x 46.3
168

Albertinelli, Mariotto (studio of)
1474–1515
The Virgin and Child with the Infant Baptist
1509
oil on panel 67.3 x 50.1
162

Aligny, Théodore Caruelle d' 1798–1871
Young Man Reclining on the Downs
1833–1835
oil on paper laid down on canvas 21.6 x 45.2
PD.119-1985

Allegrini, Francesco c.1615–after 1679
The Fall of Icarus
oil on paper laid down on panel 38.4 x 28.4
PD.38-1969

Allori, Alessandro 1535–1607
The Temptation of St Benedict 1587?
oil on canvas 40.8 x 59.3
PD.19-1996

Alma-Tadema, Lawrence 1836–1912
A Floral Bank 1870s
oil on canvas 18 x 26.5
PD.10-1979

Alma-Tadema, Lawrence 1836–1912
94 Degrees in the Shade 1876
oil on canvas laid down on panel 35.3 x 21.6
1014

Alma-Tadema, Lawrence 1836–1912
Sir Herbert Thompson, Bt 1877
oil on panel 28.3 x 22.6
1013

Alma-Tadema, Lawrence 1836–1912
Sir Henry Thompson, Bt 1878
oil on panel 28.1 x 20.9
1012

Alma-Tadema, Lawrence 1836–1912
The Boating Pool
oil on canvas 17.4 x 25.7
PD.11-1979

Amidano, Giulio Cesare (attributed to)
1566–1630
*The Virgin with an Angel, the Child Christ and
St John the Baptist*
oil on canvas 60.7 x 49.9
122

Andrea di Niccolò c.1444–c.1525
Virgin and Child between St Jerome and St Peter c.1500
tempera & gold on panel 53 x 41
561

Andrews, Michael 1928–1995
Study for 'The Estuary' c.1990
oil on canvas 25.4 x 30.5
PD.3-2002

Anthonissen, Hendrick van 1606–after 1660
View of Scheveningen Sands
oil on panel 56.8 x 102.8
43

Antonissen, Henricus Josephus 1737–1794
Landscape with Flocks 1787
oil on panel 29.2 x 38.7
424

Apollonio di Giovanni di Tommaso c.1415/1417–1465
The Triumph of Scipio Africanus
tempera with gold & silver on panel
40 x 135.9 (...)
M.29

Ashford, William 1746–1824
View in Mount Merrion Park 1806
oil on canvas 64.1 x 111.1
445

Ashford, William 1746–1824
View in Mount Merrion Park 1806
oil on canvas 61.9 x 111.1
447

Ashford, William 1746–1824
View in Mount Merrion Park 1806
oil on canvas 95.9 x 131.5
462

Ashford, William 1746–1824
View in Mount Merrion Park 1806
oil on canvas 64.8 x 76.2
464

Ashford, William 1746–1824
View in Mount Merrion Park 1806
oil on canvas 62.2 x 76.2
467

Ashford, William 1746–1824
View in Mount Merrion Park
oil on canvas 64.8 x 76.6
466

Aspertini, Amico (attributed to) 1475–1552
The Beheading of St John the Baptist
oil on panel 20.7 x 29
107

Asselin, Maurice 1882–1947
Boats 1911
oil on canvas 38.2 x 54.9
PD.68-1974

Asselyn, Jan after 1610–1652
Italian Coast Scene
oil on copper 12.7 x 25.1
400

Asselyn, Jan after 1610–1652
Italian Landscape
oil on canvas laid down on wood 30.8 x 39.7
401

Ast, Balthasar van der 1593/1594–1657
Still Life with Fruit and Macaws 1622
oil on copper 20.5 x 26.8
295

Ast, Balthasar van der 1593/1594–1657
A Basket of Flowers with Shells on a Ledge
oil on panel 20 x 28.4
PD.15-1975

Ast, Balthasar van der 1593/1594–1657
A Vase of Flowers with Shells on a Ledge
oil on panel 69 x 76.2
PD.14-1975

Ast, Balthasar van der 1593/1594–1657
Wicker Basket with Fruit, Medlars and Shells
oil on panel 45.5 x 86.5
PD.189-1975

Auerbach, Frank Helmuth b.1931
Primrose Hill, Winter Fog 1960
oil on canvas 86.4 x 121.9
PD.38-1993

Austrian (Tyrolean) School
The Decollation of St John the Baptist c.1520
oil on panel 61 x 69.8
PD.28-1988

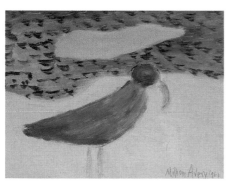

Avery, Milton 1893–1965
Bird and Sandspit 1961
oil on card 22.9 x 30.5
PD.37-1992

Backhuysen, Ludolf I 1630–1708
A Shipwreck c.1653–1660
oil on panel 29.4 x 37.7
PD.4-2003

Backhuysen, Ludolf I (attributed to)
1630–1708
Bust Portrait of a Man
oil on copper 14 x 10.2
509

Baen, Jan de 1633–1702
Gentleman with Helmet
oil on canvas 87.6 x 69
PD.17-2005

Balducci, Giovanni 1560–after 1631
The Passover
oil on panel 18.6 x 41.9
PD.38-1992

Balen, Hendrik van I 1575–1632
Adoration of the Shepherds c.1595
oil on copper 34.6 x 27.3
412

Balen, Hendrik van I 1575–1632 **& Brueghel, Jan the elder** 1568–1625
The Judgement of Paris
oil on copper 24.8 x 36.5
416

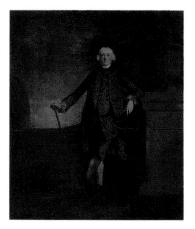

Barron, Hugh (attributed to) 1745–1791
Francis Page of Newbury 1760s
oil on canvas 75.6 x 63.5
1113

Bartolomeo di Giovanni
active c.1475–c.1505 **& Biagio d'Antonio**
1446–1516
The Story of Joseph, I 1487
tempera on panel 43.2 x 164.8
M.3

Bartolomeo di Giovanni
active c.1475–c.1505 **& Biagio d'Antonio**
1446–1516
The Story of Joseph, II 1487
tempera on panel 43.2 x 164.4
M.4

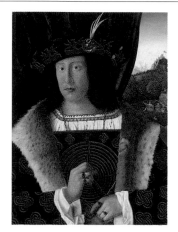

Bartolomeo Veneto d.1531
Portrait of a Man
oil on panel 72.8 x 54.3
133

Basaiti, Marco active 1496–1530
Virgin and Child with Saints 1508
tempera with oil glazes on panel 97.2 x 129.2
M.5

Bassano, Francesco II 1549–1592
Landscape with Shepherds 1570–1585
oil on canvas 65.7 x 93.7
114

Bassano, Jacopo il vecchio c.1510–1592
The Journey to Calvary c.1543
oil on canvas 81.9 x 118.7
M.6

Bassano, Jacopo il vecchio (and workshop)
c.1510–1592
St Jerome in the Wilderness 1562
oil on canvas 64.2 x 81.6
112

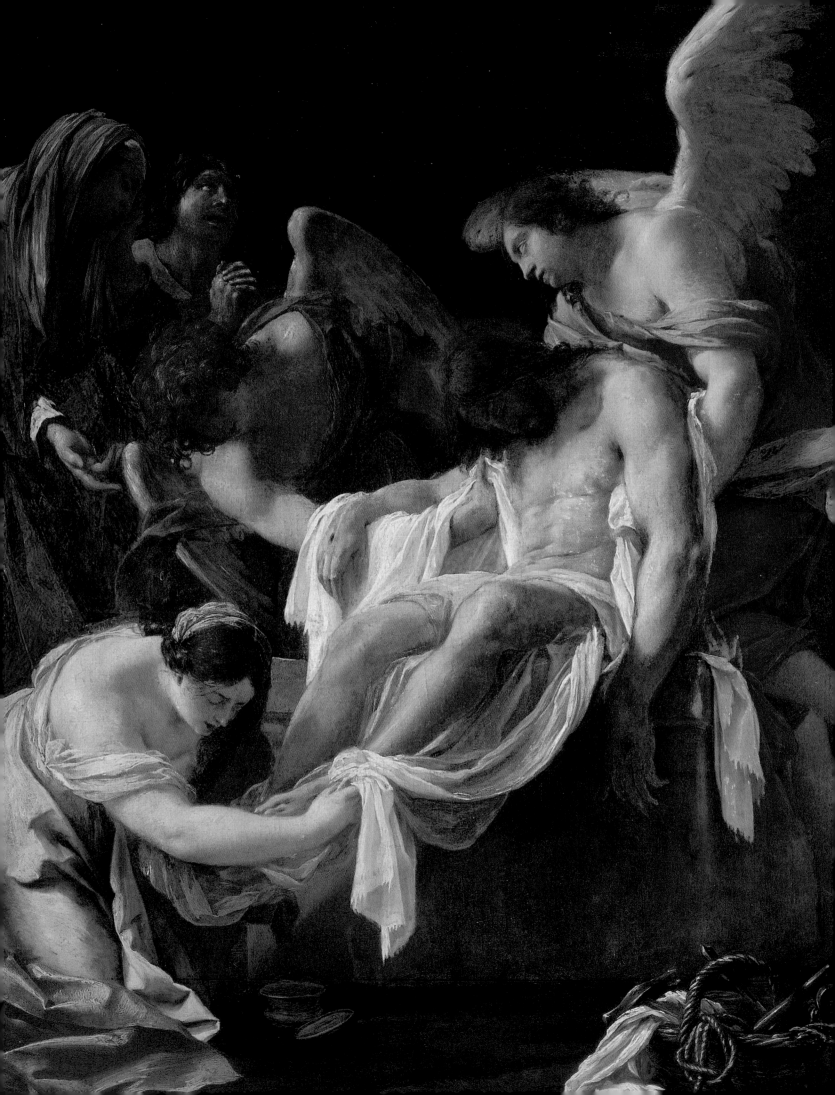

Bastien-Lepage, Jules 1848–1884
Girl with a Sunshade 1879
oil on canvas 39.1 x 28.2
M.7

Batoni, Pompeo 1708–1787
The Seventh Earl of Northampton
oil on canvas 237.7 x 149.2
PD.4-1950

Baugin, Lubin c.1612–1663
*The Holy Family with the Infant St John the
Baptist and Angels*
oil on panel 30 x 21.5
PD.14-1992

Baynes, Keith 1887–1977
St Jean-de-Luz 1911
oil on canvas board 19 x 25.7
PD.107-1975

Baynes, Keith 1887–1977
Self Portrait 1923
oil on canvas 41.3 x 33.3
PD.106-1975

Baynes, Keith 1887–1977
Chambolle-Musigny 1950
oil on canvas 51.1 x 61.2
PD.113-1975

Baynes, Keith 1887–1977
Libourne 1950
oil on canvas 50.8 x 60.9
PD.112-1975

Baynes, Keith 1887–1977
Antoine Gili at Vernet-Les-Bains 1955
oil on canvas board 34.3 x 29.2
PD.111-1975

Baynes, Keith 1887–1977
Dahlias 1955
oil on canvas 60.9 x 50.8
PD.114-1975

Facing page: Vouet, Simon, 1590–1649, *The Entombment* (detail), c.1635–1638, (p. 189)

Baynes, Keith 1887–1977
The Alfama, Lisbon 1966
oil on canvas board 50.8 x 61.3
PD.109-1975

Baynes, Keith 1887–1977
Lisbon 1971
oil on canvas 45.7 x 35.5
PD.110-1975

Beale, Charles 1660–c.1714
Unknown Man 1693
oil on canvas 75.5 x 62.8
643

Beaumont, George Howland 1753–1827
Landscape c.1825
oil on canvas 44.5 x 37.5
PD.23-1952

Beccafumi, Domenico 1484–1551
San Bernardino Preaching in the Campo, Siena
1528
oil on panel 31.7 x 42
PD.40-1993

Beechey, William 1753–1839
Hebe Feeding Jupiter's Eagle
oil on canvas 68.2 x 47.2
628

Beeton, Alan 1880–1942
Posing c.1929
oil on canvas 28.9 x 31.2
2338

Beeton, Alan 1880–1942
Reposing c.1929
oil on canvas 30.8 x 33
2339

Beeton, Alan 1880–1942
The Gipsy
oil on canvas 92.7 x 57.1
1202

Belin de Fontenay, Jean-Baptiste 1653–1715
Vase of Flowers
oil on canvas laid down on panel 34.3 x 28
PD.16-1966

Bell, Trevor b.1930
Crossover 1962
oil on canvas 121.7 x 122.2
PD.129-1992

Bell, Vanessa 1879–1961
Portrait of Mrs M. 1919
oil on canvas 68.2 x 56.8
2376

Bell, Vanessa 1879–1961
On the Seine 1921
oil on canvas 27 x 46
2375

Bellany, John b.1942
Sarah with Aga 1990
oil on canvas 122.5 x 152.8
PD.10-1991 ✻

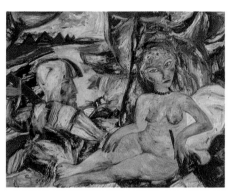

Bellany, John b.1942
Love Song: Homage to Titian
oil on canvas 122 x 152.5
PD.7-2005 ✻

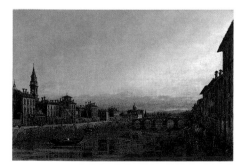

Bellotto, Bernardo 1722–1780
The Arno in Florence with the Ponte alla Carraia c.1745
oil on canvas 74.5 x 106.5
195

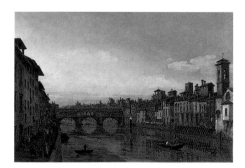

Bellotto, Bernardo 1722–1780
The Arno in Florence with the Ponte Vecchio c.1745
oil on canvas 74.2 x 106.8
192

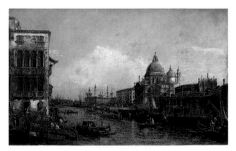

Bellotto, Bernardo 1722–1780
Entrance to the Grand Canal, Venice
oil on canvas 59.3 x 94.9
186

Bencovich, Federico (attributed to)
1677–1753
A Hermit
oil on canvas 72.7 x 61.2
PD.19-1948

Bendz, Wilhelm Ferdinand 1804–1832
Portrait of a Man
oil on canvas 22.7 x 19.5
PD.49-1997

Bendz, Wilhelm Ferdinand 1804–1832
Portrait of a Woman
oil on canvas 23 x 19.3
PD.50-1997

Berchem, Nicolaes 1620–1683
Landscape with Nymphs and Satyrs 1645
oil on canvas 59 x 51
PD.8-1960

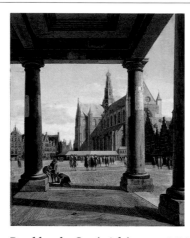

Berckheyde, Gerrit Adriaensz. 1638–1698
The Groote Kerk at Haarlem 1674
oil on panel 40.2 x 32.7
47

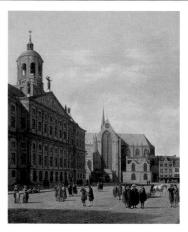

Berckheyde, Gerrit Adriaensz. 1638–1698
The Town Hall of Amsterdam
oil on panel 40.3 x 32.3
44

Bertin, Jean Victor 1767–1842
Landscape with Sheep and a Woman Sewing
c.1805
oil on canvas 40.5 x 30.5
PD.50-1973

Bevan, Robert Polhill 1865–1925
The Polish Tavern 1901–1903
oil on canvas 38.3 x 56.2
PD.10-1969

Biagio d'Antonio 1446–1516
The Siege of Troy, the Death of Hector
c.1490–1495
tempera on panel 47 x 161
M.44

Biagio d'Antonio 1446–1516
The Siege of Troy, the Wooden Horse
tempera on panel 47 x 161
M.45

Blake, Catherine c.1762–1831
Agnes 1800
tempera on canvas 14 x 18.3
PD.152-1985

Blake, William 1757–1827
The Circumcision 1799–1800
tempera on canvas 25.7 x 36.4
PD.153-1985

Blake, William 1757–1827
An Allegory of the Spiritual Condition of Man
1811?
tempera (probably carpenter's glue) on
canvas 151.8 x 120.9
PD.27-1949

Blake, William 1757–1827
The Judgement of Solomon
tempera on copper 26.7 x 38.1
PD.28-1949

Blake, William 1757–1827
Ugolino and His Sons in Prison
tempera & gold on panel 33 x 44
PD.5-1978

Bloemen, Jan Frans van 1662–1749
Roman Buildings
oil on canvas 34 x 43.2
632

Bloemen, Pieter van 1657–1720
Horses Drinking at a Fountain
oil on canvas 34.9 x 43.8
263

Bloemen, Pieter van 1657–1720
Mules Halting by the Wayside
oil on canvas 35.2 x 44.1
257

Bloemers, Arnoldus 1792–1844
Pot of Flowers and Fruit
oil on panel 46.4 x 40.7
PD.17-1966

Blondeel, Lancelot (attributed to)
1496–1581
Virgin and Child with St Anne
oil on panel 47 x 34.3
M.41

Bloot, Pieter de c.1602–1658
Outside an Almshouse
oil on panel 25.7 x 34.3
2771

Bloot, Pieter de c.1602–1658
Village Scene with Figures
oil on panel 19.3 x 24.5
48

Board, Ernest 1877–1934
Blue and Gold 1918
oil on canvas 25.9 x 35.5
2485

Boeckhorst, Jan 1605–1668
Esther before Ahasuerus
oil on canvas 153 x 236.5
PD.23-1983

Bogdany, Jakob c.1660–1724
A Stone Vase of Flowers
oil on canvas 139.7 x 144.8
PD.16-1975

Bogdany, Jakob c.1660–1724
Birds in a Landscape
oil on canvas 91.4 x 88.9
361

Bogdany, Jakob c.1660–1724
Exotic Fowl in an Ornamental Garden beside a Stone Vase, a Fountain beyond
oil on canvas 98.5 x 148
PD.111-1992

Boilly, Louis Léopold 1761–1845
A Vase of Flowers
oil on paper on canvas 46 x 33.8
PD.17-1975

Bomberg, David 1890–1957
*The Virgin of Peace in Procession through the
Streets of Ronda, Holy Week* 1935
oil on canvas 62.8 x 57
PD.13-1987

Bonechi, Matteo 1669–1756
The Adoration of the Shepherds
oil on paper laid down on panel 30.6 x 21
PD.15-1992

Bonechi, Matteo 1669–1756
The Flight into Egypt
oil on canvas 38.6 x 30.5
PD.39-1992

Bonington, Richard Parkes 1802–1828
Landscape with a Pond c.1825–1826
oil on canvas 26 x 34.9
PD.11-1955

Bonington, Richard Parkes 1802–1828
*Boccadasse, Genoa with Monte Fasce in the
Background* 1826
oil on millboard 25.6 x 33
PD.2-1983

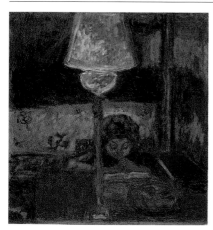

Bonnard, Pierre 1867–1947
The Oil Lamp 1898–1900
oil on panel 55.3 x 51.8
PD.28-1998

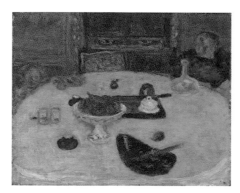

Bonnard, Pierre 1867–1947
The Meal or at Table 1899
oil on board 32 x 40
PD.14-2002

Bonnard, Pierre 1867–1947
Landscape 1902
oil on millboard 56.2 x 78.1
2377

Bonnard, Pierre 1867–1947
House among Trees 1918
oil on canvas 48.6 x 42.2
2378

Bonnard, Pierre 1867–1947
Still Life 1922
oil on canvas 43.5 x 47
2379

Bonvin, François 1817–1887
Interior
oil on canvas 30.8 x 25.4
1591

Boonen, Arnold (attributed to) 1669–1729
Portrait of a Lady c.1700
oil on canvas 42.9 x 34.9
377

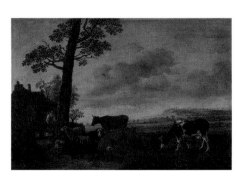

Borssom, Anthonie van c.1630–1677
Landscape with Cattle
oil on panel 51.4 x 76.8
344

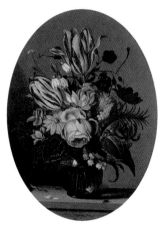

Bosschaert, Ambrosius the younger
1609–1645
A Vase of Flowers 1633
oil on copper 38 x 28.5
PD.18-1975

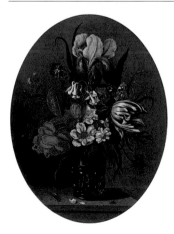

Bosschaert, Ambrosius the younger
1609–1645
A Vase of Flowers
oil on copper 38.3 x 28.5
PD.19-1975

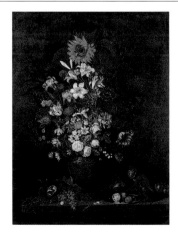

Bosschaert, Ambrosius the younger
1609–1645
A Vase of Flowers with a Monkey
oil on canvas 144.2 x 105
PD.59-1974

Bosschaert, Ambrosius the younger
1609–1645
Metal Vase of Flowers
oil on panel 52.6 x 40
PD.18-1966

Facing page: Vernet, Claude-Joseph, 1714–1789, *Sunrise* (detail), 1760, (p. 187)

Both, Jan c.1618–1652
Italian Landscape with Monte Socrate c.1635–1641
oil on canvas 146.8 x 206
56

Botticelli, Sandro (studio of)
1444/1445–1510
Virgin and Child
oil on panel 80.7
M.9

Botticini, Francesco 1446–1497
Virgin Adoring the Child
tempera with gold on panel 71.5 x 47.5
M.10

Boucher, François (after) 1703–1770
The Loves of the Gods: Mars and Venus
oil on canvas 58 x 66
PD.14-1980

Boudin, Eugène Louis 1824–1898
Portrieux 1873
oil on canvas 32.6 x 46.2
PD.12-1968

Boudin, Eugène Louis 1824–1898
The Beach at Trouville 1873
oil on canvas 19.2 x 33.2
1774

Boudin, Eugène Louis 1824–1898
Cows in a Field under a Stormy Sky 1877
oil on canvas 41 x 55
PD.57-1996

Boudin, Eugène Louis 1824–1898
The Fish Cart, Berck 1880
oil on panel 31.7 x 46.6
PD.13-1968

Boudin, Eugène Louis 1824–1898
Ships at Dock, Deauville 1881
oil on canvas 40 x 55.4
PD.8-1967

Boudin, Eugène Louis 1824–1898
The Dock at Le Havre 1887
oil on panel 32 x 41
PD.7-1967

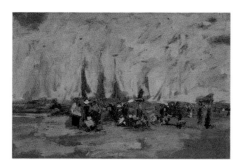

Boudin, Eugène Louis 1824–1898
Beach Scene (possibly Harfleur) c.1888–1895
oil on paper laid down on board 15 x 22.3
PD.16-1959

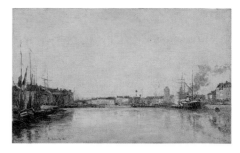

Boudin, Eugène Louis 1824–1898
The Dutch Dock, Dunkirk 1889
oil on canvas 36 x 58
PD.14-1968

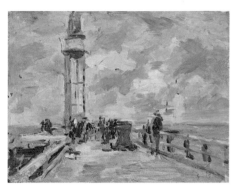

Boudin, Eugène Louis 1824–1898
The Jetty and Lighthouse at Honfleur
late 1880s
oil on panel 18.7 x 24
PD.6-1967

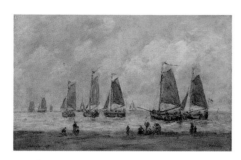

Boudin, Eugène Louis 1824–1898
Scheveningen
oil on canvas 40.3 x 65.2
PD.9-1967

Boughton, George Henry 1833–1905
Winter Scene in Holland
oil on canvas 41 x 60.6
637

Bourdon, Sébastien 1616–1671
Classical Landscape
oil on copper 20.3 x 31.8
PD.15-1979

Bourdon, Sébastien (attributed to)
1616–1671
A Bandits' Cave c.1634–1637
oil on canvas 49.2 x 64.1
429

Bourdon, Sébastien (attributed to)
1616–1671
Classical Ruins with Figures c.1634–1637
oil on canvas 49.2 x 64.1
421

Bouts, Albert c.1452/1455–1549
The Transfiguration
oil on panel 73.5 x 45.5
99

Brabant School
*The Chevalier Philip Hinckaert and St Philip
the Apostle, before the Virgin and Child*
c.1494–1505
oil on panel 66.2 x 73
PD.19-1961

Brakenburg, Richard 1650–1702
Family Scene c.1680
oil on panel 34 x 28.3
403

Brakenburg, Richard 1650–1702
Interior of a Farmhouse 1699
oil on panel 40.3 x 49.2
434

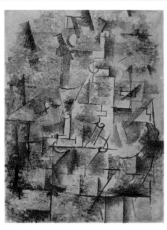

Braque, Georges 1882–1963
Cubist Design c.1911
oil on canvas 72.5 x 54

Braque, Georges 1882–1963
Reclining Nude 1925
oil on canvas 49.5 x 59.7

Bray, Jan de c.1627–1697
Portrait of a Woman 1660
oil on canvas 97.4 x 76.8
PD.14-1959

Breenbergh, Bartholomeus 1598–1657
Classical Landscape with Rocks c.1627–1629
oil on copper 21.3
431

Breenbergh, Bartholomeus 1598–1657
Classical Landscape with Ruins c.1627–1629
oil on copper 21.3
432

Brekelenkam, Quiringh van
after 1622–1669 or after
Cottage Interior 1657
oil on panel 49 x 38
404

Brett, John 1830–1902
Landscape 1852
oil on millboard 17.8 x 25.4
PD.19-1968

Brett, John 1830–1902
Rocky Coast Scene 1872
oil on millboard 25 x 35.6
PD.55-1973

Breydel, Karel 1678–1733
Battle Piece c.1710–1720
oil on panel 18.7 x 20.9
237

Bridge, Joseph 1845–1894
Edward, Third Earl of Powis 1891–1892
oil on canvas 69.2 x 57.1
609*

Bril, Paul 1554–1626
View on the Rhine
oil on copper 21.5 x 29.5
227

Bril, Paul (after) 1554–1626
Landscape with Roman Ruins after 1600
oil on copper 21.6 x 29.5
249

Bril, Paul (attributed to) 1554–1626
Landscape with Sportsmen
oil on panel 18.7 x 24.7
233

British School
St Dorothy? c.1300
distemper on stone 36.2 x 21.6
736

British School
Christ before Pilate c.1400–1425
oil & gold on panel 29.8 x 33
706

British School
Christ Bearing the Cross c.1400–1425
oil & gold on panel 33.1 x 29.9
707

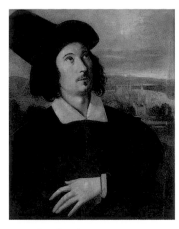

British School
Sir Henry Slingsby c.1595–1600
oil on panel 76.8 x 62.2
2051

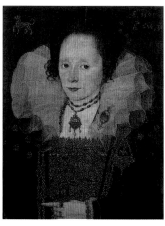

British School
Unknown Lady 1598
oil on panel 51.4 x 40
1773

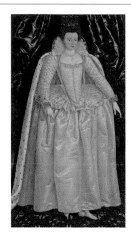

British School
Elizabeth Vernon, Countess of Southampton
1603
oil on canvas 188 x 109
PD.6-1984

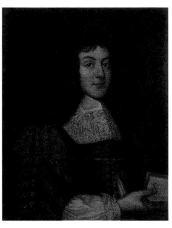

British School
The Young Student c.1660–1665
oil on canvas 73 x 62.2
2548

British School
Eleanor, Countess of Tyrconnel c.1670–1680
oil on canvas 76.5 x 64.1
161

British School
A Musician c.1700–1750
oil on canvas 102.2 x 87.7
9

British School
Richard, Fifth Viscount Fitzwilliam of Merrion
1710–1715
oil on canvas 76.8 x 64.2
440

British School
Lady Decker c.1715
oil on canvas 76 x 63
444

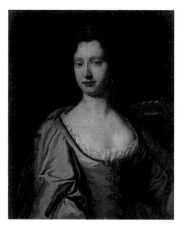

British School
Frances, Viscountess Fitzwilliam 1723
oil on canvas 69.2 x 54.6
446

British School
Memorial to Thomas and John Fitzwilliam
by 1730
oil on canvas 84.4 x 114.9
465

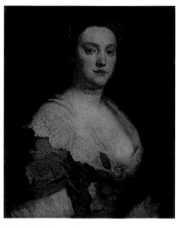

British School
A Lady 1745–1750
oil on canvas 61.1 x 50
M.53

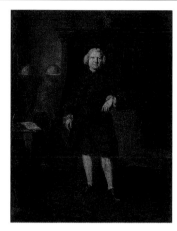

British School
Portrait of a Librarian c.1760–1769
oil on canvas 91.4 x 70.8
652

British School
A Young Draughtsman 1767
oil on canvas 58 x 44.8
PD.22-1951

British School early 18th C
Unknown Man
oil on canvas 60.3 x 50.2
926

British School 18th C
Mary, Viscountess Fitzwilliam
oil on canvas 60.7 x 46.4
438

British School 18th C
*Thomas, Fourth Viscount Fitzwilliam of
Merrion*
oil on canvas 60.7 x 46.4
439

British School
J. M. W. Turner, RA c.1852
oil on canvas 34.4 x 29.2
2729

British School
Joan and Olive Kingsford and Malcolm Burgess c.1890–1900
oil on card 19.3 x 21.6
PD.143-1975

British School early 19th C
Holy Family with St John the Baptist
oil on canvas 75.5 x 62.5
1100

Broeck, Crispin van den 1523–1589/1591
Two Young Men
oil on panel 44.5 x 60
PD.20-1961

Broeck, Elias van den 1657–1708
Stone Niche with Thistle, Lizard and Insects
1690
oil on canvas 61.4 x 52.8
PD.45-1966

Broeck, Elias van den 1657–1708
Vase of Flowers
oil on canvas 56 x 43.5
PD.19-1966

Broeck, Elias van den (attributed to)
1657–1708
Still Life with a Thistle, Boletus, Snail, Lizard, Butterflies and a Bee in a Landscape
oil on canvas 29.8 x 22.8
PD.39-1975

Broers, Jasper 1682–1716
Battle Piece 1715
oil on panel 23.2 x 29.8
353

Broers, Jasper 1682–1716
Battle Piece
oil on panel 23.2 x 29.8
352

Brown, Ford Madox 1821–1893
The Last of England 1860
oil on canvas 46.4 x 42.3
M.Add.3

Brown, Ford Madox 1821–1893
Cordelia's Portion 1867–1875
oil on canvas 55.9 x 77.2
PD.9-1950

Brown, John Alfred Arnesby 1866–1955
The Yacht Race
oil on canvas 41.9 x 52.1
1073

Bruegel, Pieter the elder (copy after)
c.1525–1569
The Bird-Trap
oil on copper 18.5 x 24.6
248

Brueghel, Jan the elder 1568–1625
A Stoneware Vase of Flowers c.1607/1608
oil on panel 60.3 x 42.2
PD.20-1975

Brueghel, Jan the elder 1568–1625
Landscape with Mill and Carts c.1611
oil on copper 17 x 22.3
PD.186-1975

Brueghel, Jan the elder 1568–1625 &
Rottenhamer, Jan the Elder 1564–1625
The Contest of Apollo and Pan 1599
oil on copper 25.4 x 35
PD.23-1981

Brueghel, Jan the elder (after) 1568–1625
A Basket of Flowers
oil on panel 54.4 x 75.7
PD.22-1975

Brueghel, Jan the younger (attributed to)
1601–1678
A Vase of Flowers
oil on panel 64.3 x 40.6
PD.21-1975

Brueghel, Jan the younger (attributed to)
1601–1678
River Scene
oil on copper 11.1 x 13
2461

Brueghel, Pieter the younger
1564/1565–1637/1638
Village Festival in Honour of St Hubert and St Anthony 1632
oil on panel 118.1 x 158.4
1192

Brussel, Paul Theodor van 1754–1795
Vase of Flowers 1783
oil on panel 73 x 57
PD.58-1973

Brussel, Paul Theodor van 1754–1795
Fruit and Flowers 1792
oil on panel 80 x 53.3
PD.59-1973

Brussel, Paul Theodor van 1754–1795
Vase with Flowers (after Jan van Huysum)
oil on panel 87.9 x 81.9
M.12

Burch, Hendrick van der 1627–after 1666
The Village School
oil on panel 37.4 x 27.6
395

Byss, Johann Rudolf 1660–1738
A Vase of Flowers
oil on copper 23.5 x 17.8
PD.60-1973

Byss, Johann Rudolf 1660–1738
A Vase of Flowers
oil on copper 23.5 x 17.8
PD.61-1973

Calame, Alexandre 1810–1864
Storm at Handeck 1838
oil on canvas 22.5 x 31
PD.38-2004

Calandrucci, Giacinto 1646–1707
The Transfiguration
oil on canvas 98.4 x 73
130

Calliyannis, Manolis b.1923
Greek Landscape I 1963
oil on canvas 96.5 x 146
PD.26-1999

Calraet, Abraham Pietersz. van 1642–1722
A Glass Vase of Flowers
oil on panel 48.2 x 38
PD.62-1973

Calraet, Abraham Pietersz. van 1642–1722
Landscape with Figures and Horses
oil on panel 35.8 x 53.3
68

Calraet, Abraham Pietersz. van 1642–1722
Landscape with Figures and Horses
oil on panel 35.8 x 53.3
77

Cals, Adolphe Félix 1810–1880
Still Life c.1860
oil on board 13.3 x 14.6
PD.123-1985

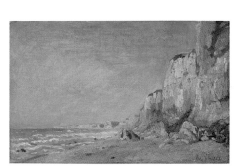

Cals, Adolphe Félix 1810–1880
Cliffs near Dieppe 1862
oil on canvas 20.7 x 31.7
PD.122-1985

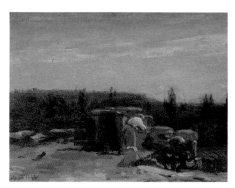

Cals, Adolphe Félix 1810–1880
*The Well in the Rue Montlaville, Orrouy
(viewed from the east)* 1866
oil on canvas 14 x 18.6
PD.120-1985

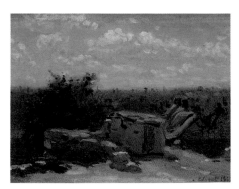

Cals, Adolphe Félix 1810–1880
*The Well in the Rue Montlaville, Orrouy
(viewed from the west)* 1866
oil on canvas 14 x 18.5
PD.121-1985

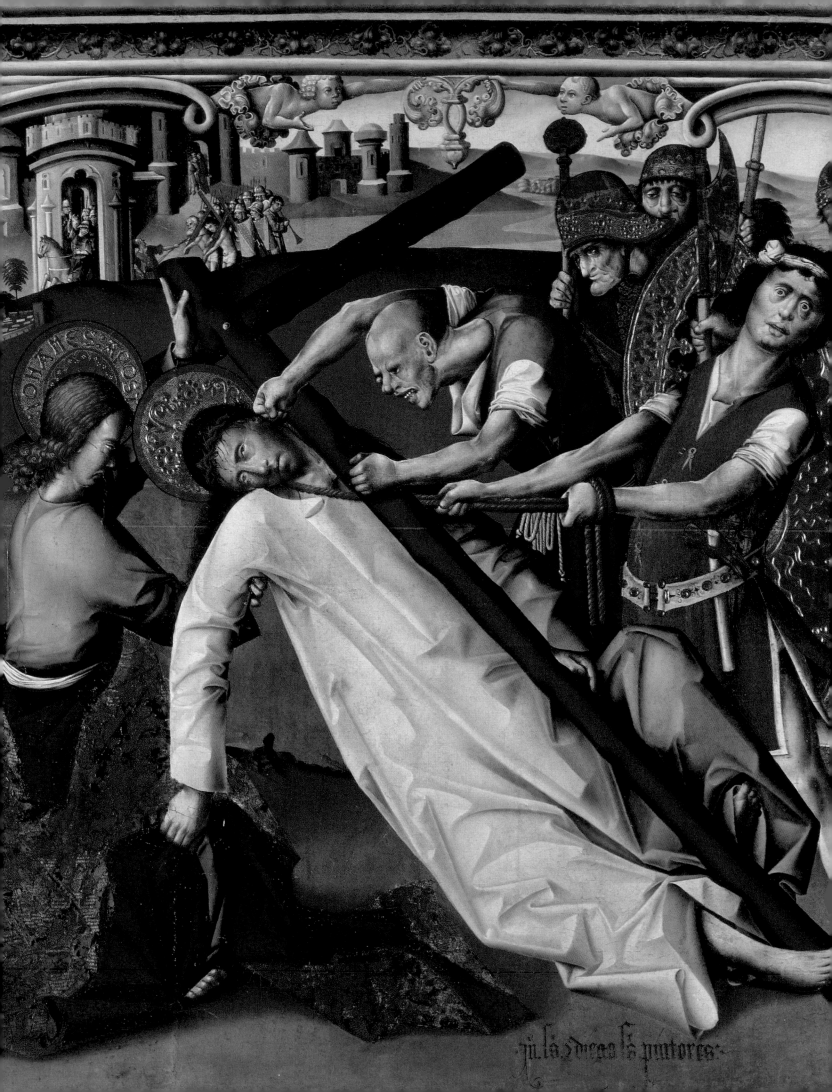

Calvert, Edward 1799–1883
A Pastoral Idyll, 'The Other Shore'
oil on paper 23.2 x 37.9
PD.188-1985

Calvert, Edward 1799–1883
Hesperides, 'Dance around the Golden Tree'
oil on card 24.4 x 38
PD.155-1995

Calvert, Edward 1799–1883
The Return Home
tempera on mahogany panel 8.5 x 14.8
PD.154-1985

Cameron, David Young 1865–1945
A Little Town of Provence 1922
oil on canvas 66.4 x 66.1
1078

Campi, Galeazzo c.1477–1536
Virgin and Child after 1494
tempera with oil glazes on panel 60.5 x 41
908

Canaletto 1697–1768
View of the Grand Canal: Santa Maria della Salute and the Dogana from Campo Santa Maria Zobenigo early 1730s
oil on canvas 54.6 x 100.3
PD.106-1992

Canaletto 1697–1768
Interior Court of the Doge's Palace, Venice c.1756
oil on canvas 46.6 x 37.5
194

Canaletto 1697–1768
St Mark's, Venice c.1756
oil on canvas 46.6 x 38.1
193

Canaletto (imitator of) 1697–1768
The Doge's Palace, Venice
oil on canvas 61 x 92.5
M.13

Facing page: Sánchez, Juan, active c.1500 and Sánchez, Diego, active late 15th C, *The Road to Calvary* (detail), (p. 158)

Canaletto (school of) 1697–1768
Ruins with Figures
oil on canvas 63.5 x 75.5
197

Canaletto (school of) 1697–1768
Ruins with Figures
oil on canvas 63.2 x 74.9
201

Canti, Giovanni 1653–1716
Allegory of Fortitude and Wisdom
oil on canvas marouflé to wood 30.4 x 40.6
PD.41-1992

Carline, George F. 1855–1920
A Harvest Landscape
oil on wood 21 x 29.5
PD.26-1979

Carlone, Carlo Innocenzo 1686–1775
St Mark 1715–1723
oil on canvas 37 x 26.8
PD.44-1992

Carlone, Carlo Innocenzo 1686–1775
St Augustine
oil on panel 24.7 x 15.8
PD.45-1992

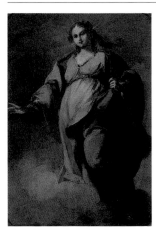

Carlone, Carlo Innocenzo 1686–1775
The Assumption of St Lucy
oil on panel 32.5 x 23.3
PD.42-1992

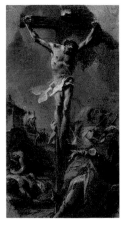

Carlone, Carlo Innocenzo 1686–1775
The Crucifixion with St Roch and St Sebastian
oil on canvas 44.2 x 24.3
PD.16-1992

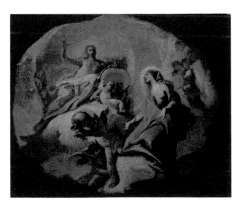

Carlone, Carlo Innocenzo 1686–1775
The Triumph of the Virgin
oil on canvas 39.8 x 49
PD.43-1992

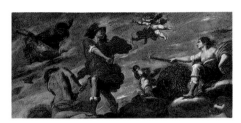

Carlone, Giovanni Battista 1603–1684
Juno and Mars c.1650
oil on canvas 47.5 x 96.2
PD.13-1992

Carracci, Annibale 1560–1609
St Roch and the Angel c.1585–1589
oil on canvas 62.2 x 81.3
134

Carracci, Annibale 1560–1609
Head of an Old Woman c.1590
oil on paper laid down on board 42 x 29
PD.17-1992

Carracci, Annibale 1560–1609
Mary Magdalene in a Landscape c.1599
oil on copper 32.4 x 43
PD.12-1976

Carrière, Eugène 1849–1906
Portrait of His Daughter, Lisbeth 1888
oil on canvas 46.2 x 38.5
PD.9-1978

Cast, Jesse Dale 1900–1976
Miss June Miell 1956
oil on canvas 53.2 x 39
PD.32-1986

Casteels, Pieter 1684–1749
Pheasant and Ducks c.1720
oil on canvas 60.3 x 90.5
359

Castiglione, Giovanni Benedetto 1609–1664
Abraham Journeying to the Land of Canaan
oil on canvas 85.1 x 99.1
148

Cavalletto, Giovanni Battista (attributed to)
active 1486–1523
Adoration of the Shepherds
tempera with gold on canvas transferred
from panel 37.1 x 40.4
1652

Ceccarelli, Naddo (school of) active c.1347
The Crucifixion
tempera with gold on panel 47.6 x 19.7
558

Ceresa, Carlo (attributed to) 1609–1679
Portrait of a Man not before 1660–1670
oil on canvas 140 x 117.2
1768

Cesare da Sesto (copy after) 1477–1523
Holy Family with the Infant St John the Baptist
oil on copper 42.1 x 30.5
175

Cézanne, Paul 1839–1906
Uncle Dominique c.1866
oil on canvas 39 x 30.5

Cézanne, Paul 1839–1906
The Abduction 1867
oil on canvas 88 x 107

Cézanne, Paul 1839–1906
Still Life with Apples c.1878
oil on canvas 19 x 27

Cézanne, Paul 1839–1906
Undergrowth c.1880
oil on canvas 55 x 46

Cézanne, Paul 1839–1906
Landscape c.1900
oil on canvas 62.2 x 51.5
2381

Chazal, Antoine 1793–1854
Roses in a Vase 1845
oil on canvas 32.4 x 24.1
PD.57-1975

Chinnery, George 1774–1852
John Reeves (1774–1856)
oil on canvas 24.7 x 21.3
PD.3-1976

Chinnery, George (attributed to)
1774–1852
Head and Shoulders of a Man
oil on canvas 10.8 x 7.8
PD.72-1991

Chinnery, George (attributed to)
1774–1852
Head and Shoulders of an Elderly Man
oil on canvas 13.6 x 10.1
PD.73-1991

Chintreuil, Antoine 1814–1873
Landscape with an Ash Tree 1850–1857
oil on canvas 26.7 x 34
2382

Chintreuil, Antoine 1814–1873
Apple Trees in Blossom
oil on canvas 19.7 x 31.7
PD.124-1985

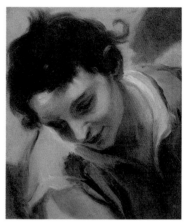

Cigoli 1559–1613
*Study of Head and Bust of Youth, Looking to
Lower Left* 1594
oil on paper laid down on canvas 44.3 x 36.4
PD.10-1983

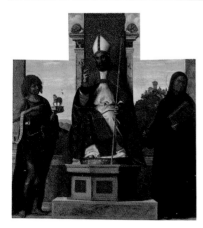

**Cima da Conegliano, Giovanni
Battista** c.1459–1517
*St Lanfranc Enthroned between St John the
Baptist and St Liberius* c.1515–1516
oil on panel 144 x 128.5
M.16

Cina, Colin b.1943
A Young Person's Guide to Suprematism
1976–1977
acrylic on cotton duck 167.5 x 183
PD.20-2002

Civerchio, Vincenzo (attributed to)
c.1470–c.1544
St Roch with the Angel of the Annunciation (...)
tempera with gold & oil glazes on panel
36.2 x 12.3; 36.2 x 11.6
M.51

Claesz., Anthony the younger
c.1607/1608–1649
A Vase of Flowers
oil on panel 28.5 x 22.8
PD.63-1973

Claesz., Pieter 1597/1598–1660
Still Life 1630
oil on panel 25.1 x 32.7
294

Clausen, George 1852–1944
Self Portrait 1918
oil on canvas 62.9 x 51.1
923

Clausen, George 1852–1944
Henry Festing Jones 1923
oil on canvas 46.4 x 38.7
1118

Cleve, Cornelis van (attributed to)
1520–1567
Virgin and Child
oil on panel 27.5 x 21.6
M.17

Cleve, Joos van c.1464–c.1540
Virgin and Child c.1525–1530
oil on panel 61 x 45.1
104

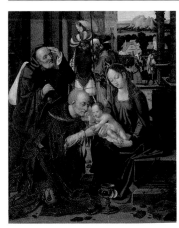

Cleve, Joos van (school of) c.1464–c.1540
Adoration of the Kings
oil on panel 87.3 x 70.2
1784

Clough, Prunella 1919–1999
Bolted Fence 1973–1977
oil on canvas 116.5 x 132
PD.28-1984

Clough, Prunella 1919–1999
In the Yard 1975
131.8 x 121.9
PD.26-2003

Coghill, Egerton Bush 1851–1921
The Mall from Malmaison, Castletownshend
c.1900
oil on canvas 46.5 x 61.8
PD.14-1981

Cohen, Harold b.1928
Random
oil on canvas 91.5 x 111.4
PD.30-1998

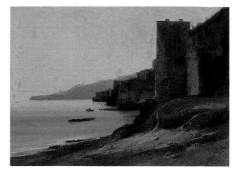

Coignet, Jules 1798–1860
The Coast of the Bay of Naples near Posillipo
c.1823–1828
oil on paper marouflé on canvas 21.5 x 29
PD.30-1979

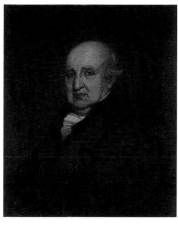

Coleman, James William active c.1830–1882
Thomas, Ninth Viscount Fitzwilliam of Merrion c.1830
oil on canvas 75.6 x 62.6
503**

Collier, John 1708–1786
Trompe l'Oeil Painting 1729
oil on canvas 61.5 x 74.8
4156

Collins, Cecil 1908–1989
Night 1932
oil on canvas 76.2 x 51
PD.8-2001

Collins, Charles Allston 1828–1873
Wilkie Collins 1853
oil on panel 29.9 x 24.1
676

Colquhoun, Robert 1914–1962
Dancers Rehearsing 1958
oil on canvas 152 x 121
PD.18-1982 🐝

Comolera, Melanie de active 1816–1854
Vase of Flowers
oil on canvas 89.5 x 71
PD.20-1966

Conca, Sebastiano (attributed to)
1680–1764
*The Virgin and Child in Glory and the Four
Latin Fathers of the Church*
oil on panel 37.5 x 18
PD.60-1992

Conder, Charles 1868–1909
Mrs Amy Halford
oil on canvas 76.3 x 63.7
PD.32-1984

Constable, John 1776–1837
East Bergholt 1808
oil on millboard 25.3 x 61.5
PD.15-1968

Constable, John 1776–1837
Archdeacon John Fisher 1816
oil on canvas 35.9 x 30.3
PD.44-1972

Constable, John 1776–1837
Mrs Mary Fisher 1816
oil on canvas 36 x 30.6
PD.45-1972

Constable, John 1776–1837
Hampstead Heath c.1820
oil on canvas 54 x 76.9
PD.207-1948

Constable, John 1776–1837
Sky Study with a Shaft of Sunlight 1822?
oil on paper 13.3 x 14.9
PD.222-1961

Constable, John 1776–1837
Parham's Mill, Gillingham, Dorset 1824
oil on canvas 24.8 x 30.2
2291

Constable, John 1776–1837
Shoreham Bay, near Brighton 1824
oil on paper laid down on canvas 14.9 x 24.7
PD.21-1969

Facing page: Cézanne, Paul, 1839–1906, *Landscape* (detail), c.1900, (p. 36)

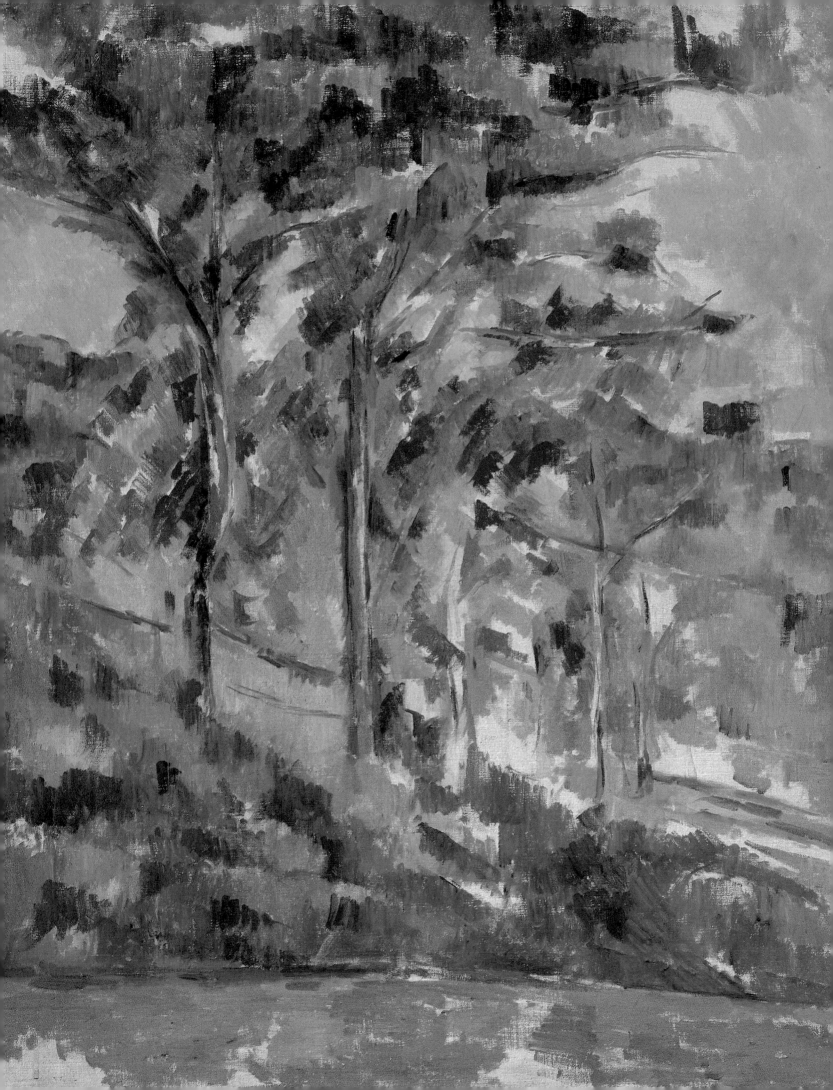

Constable, John 1776–1837
Salisbury 1829?
oil on canvas 61 x 51.8
2383

Constable, John 1776–1837
Hove Beach
oil on canvas 33 x 50.8
PD.16-1968

Constable, John (attributed to) 1776–1837
Sky Study, Sunset 1821–1822
oil on paper 14.6 x 23.2
PD.7-1951

Constable, John (attributed to) 1776–1837
Sky Study with Mauve Clouds 1821–1822
oil on paper 14.2 x 22.2
PD.8-1951

Constable, John (attributed to) 1776–1837
At Hampstead, Looking towards Harrow
oil on paper 17.5 x 23.4
PD.79-1959

Conte, Jacopino del (attributed to)
1510–1598
F. De Pisia, a Papal Notary
oil on canvas 84.7 x 71.1
1653

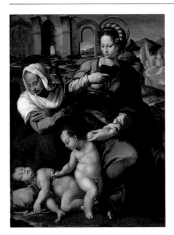

Conte, Jacopino del (attributed to)
1510–1598
The Virgin and Child with St Elizabeth and the Infant Baptist
oil on panel 100.3 x 76.7
651

Cooper, Thomas Sidney 1803–1902
Cattle by a River 1835
oil on panel 15.2 x 26.4
469

Cooper, Thomas Sidney 1803–1902
Cattle Reposing 1846
oil on canvas 111.7 x 158.1
492

Coorte, Adriaen c.1660–after 1707
A Bundle of Asparagus 1703
oil on canvas 30 x 23
2575

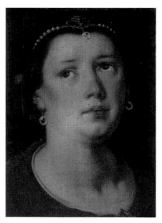

Cornelisz. van Haarlem, Cornelis
1562–1638
Female Head
oil on panel 23.8 x 17.5
251

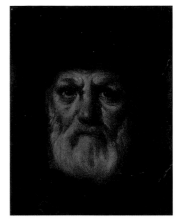

Cornelisz. van Haarlem, Cornelis
(studio of) 1562–1638
Dirck Volckertsz. Coornhert
oil on panel 43.5 x 34
872

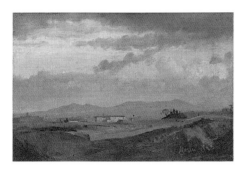

Corot, Jean-Baptiste-Camille 1796–1875
*View of the Convent of Sant'Onofrio on the
Janiculum, Rome* 1826
oil on paper marouflé to canvas 22 x 33
PD.1-1960

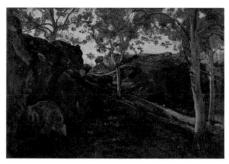

Corot, Jean-Baptiste-Camille 1796–1875
The Chestnut Grove 1830–1840
oil on canvas 34 x 48.9
2384

Corot, Jean-Baptiste-Camille 1796–1875
Landscape in Holland 1854
oil on canvas 18.4 x 31.8
2385

Corot, Jean-Baptiste-Camille 1796–1875
Auvers-sur-Oise, Daubigny's Pond 1855–1860
oil on paper marouflé to canvas 17.2 x 26
PD.125-1985

Corot, Jean-Baptiste-Camille 1796–1875
The Dyke c.1865
oil on canvas 22.2 x 35.8
830

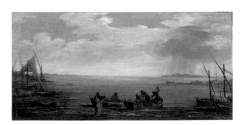

Cortona, Pietro da 1596–1669
The Calling of St Peter and St Andrew
1626–1630
oil on canvas 28.7 x 57.4
PD.3-1965

Cotman, John Sell 1782–1842
Boats at Anchor on Breydon Water c.1810
oil on canvas 51 x 73.5
PD.9-1988

Courbet, Gustave 1819–1877
The Rock at Bayard, Dinant 1856 or after
oil on canvas 56 x 47
2386

Courbet, Gustave 1819–1877
The Charente at Port-Berteau 1862
oil on canvas 54 x 65
PD.14-1999

Courbet, Gustave 1819–1877
Beneath the Trees at Port-Berteau: Children Dancing c.1862
oil on paper laid down on canvas 66.5 x 52.1
PD.28-1951

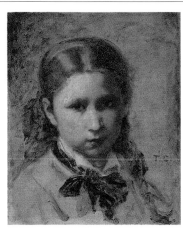

Couture, Thomas 1815–1879
A Girl's Head
oil on canvas 39.7 x 32.4
2512

Couture, Thomas 1815–1879
Still Life with a Cornemuse
oil on canvas 46 x 38.2

Cox, David the elder 1783–1859
Coast Scene near Hastings 1812
oil on paper laid down on millboard
13.4 x 21.6
1339*

Cox, David the elder 1783–1859
The Vale of Clwyd 1849
oil on canvas 90.5 x 142.3
1788

Cox, David the elder 1783–1859
Landscape with Cattle by a Pool 1850
oil on panel 22.2 x 26.7
PD.10-1950

Cox, David the elder 1783–1859
Fisherman Riding on the Sands
oil on cardboard 16 x 20.7
PD.11-2004

Coypel, Antoine (copy after) 1661–1722
Zephyr and Flora
oil on canvas 30.8 x 23.5
333

Crayer, Gaspar de (attributed to)
1584–1669
Portrait of a Young Man
oil on canvas 78.5 x 61.5
57

Crespi, Giuseppe Maria 1665–1747
Girl with a Cat c.1700
oil on canvas 44.4 x 34.9
221

Creswick, Thomas 1811–1869
Crossing the Stream 1849
oil on canvas 81.3 x 113.6
480

Creti, Donato 1671–1749
*The Mystic Marriage of St Catherine of
Alexandria* c.1695
grisaille oils on canvas 64.2 x 50.8
PD.34-2005

Crivelli, Vittore c.1444–1501 or later
Virgin and Child Enthroned (…) c.1489
tempera with gold & oil glazes on panel
140.3 x 43.3; 153 x 66.3; 140 x 42.8 (…)
1060

Crome, John 1768–1821
High Tor, Matlock 1811
oil on canvas 39.8 x 61.1
PD.49-1949

Crome, John 1768–1821
A Sandy Hollow 1812–1815?
oil on canvas 38.4 x 51.1
PD.1-1966

Croos, Anthonie Jansz. van der
c.1606–1662/1663
Landscape with Figures 1646
oil on panel 24.1
625

Croos, Anthonie Jansz. van der
c.1606–1662/1663
Landscape with Figures 1646
oil on panel 24.7
626

Crowe, Eyre 1824–1910
Capo le case, Rome 1844
oil on paper 22.1 x 26.2
PD.32-2004

Crowe, Eyre 1824–1910
Horses in a Field with Gypsies and a Caravan
oil on canvas 17.4 x 29.3
PD.37-2004

Cruz-Diez, Carlos b.1923
Physichromie No.1.288 1993
mixed media 61 x 91
PD.89-1993

Cuylenborch, Abraham van c.1610–1658
Grotto with Figures c.1645–1650
oil on panel 32.6 x 40.3
433

Cuyp, Aelbert 1620–1691
Sunset after Rain 1648–1652
oil on panel 83.9 x 69.9
PD.115-1975

Cuyp, Jacob Gerritsz. 1594–1651/1652
Portrait of a Woman 1636
oil on panel 70.5 x 59.7
M.18

Cuyp, Jacob Gerritsz. 1594–1651/1652
Portrait of a Young Girl 1645
oil on panel 69.5 x 59.7
638

Dael, Jan Frans van 1764–1840
A Vase of Flowers on a Ledge 1817
oil on canvas 55.3 x 46.4
PD.19-1987

Dahl, Johan Christian Clausen 1788–1857
*The Neapolitan Coast with Vesuvius in
Eruption* 1820
oil on paper marouflé to canvas 22.9 x 33.6
PD.43-1986

Dalby, John 1810–1865
Jumping the Brook 1849
oil on canvas 35 x 43.2
PD.20-2000

Dalby, John 1810–1865
The End of the Day 1849
oil on canvas 35 x 43.2
PD.19-2000

Dall, Nicholas Thomas d.1776/1777
Ashby Lodge, Northamptonshire c.1760–1765
oil on canvas 81.3 x 122.2
26

Danby, Francis 1793–1861
*View of a Norwegian Lake before the Sun Has
Dissipated the Early Morning Mist* 1833
oil on canvas 43.1 x 61.3
PD.10-1990

Dandridge, Bartholomew 1691–c.1754
Portrait of a Painter
oil on canvas 128.3 x 102.5
658

Dandridge, Bartholomew (after)
1691–c.1754
George Frederick Handel
oil on canvas 118.4 x 94
693

Daniell, William 1769–1837
Coast Scene, Madeira? c.1810
oil on canvas 15.2 x 20.3
948

Daubigny, Charles-François 1817–1878
Village on a River, Sunset 1864
oil on panel 36 x 55.2
1799

Daubigny, Charles-François 1817–1878
Villerville, Normandy 1864?
oil on panel 24.8 x 41
715

Daubigny, Charles-François 1817–1878
Beach at Villerville, Normandy 1875
oil on panel 39 x 67
PD.126-1985

Daubigny, Charles-François 1817–1878
On the River Oise
oil on panel 24.3 x 46.4
701

Daubigny, Charles-François 1817–1878
The Painter's Family in the Country
oil on panel 22.9 x 35.1
PD.127-1985

Daubigny, Charles-François 1817–1878
The Wood
oil on panel 23.5 x 35.2
702

Davie, Alan b.1920
Entry of the Fetish 1955
oil on hardboard 122.2 x 152.4
PD.46-1973

Davie, Alan b.1920
Prophet in a Tree, 1963
oil on canvas 213.4 x 173
PD.21-1981

De Karlowska, Stanislawa 1876–1952
Lock on the Canal 1913
oil on canvas 56.2 x 45.7
PD.17-1968

de Longpré, Paul 1855–1911
Iris, Fuchsia and Other Flowering Plants
oil on canvas 51.7 x 39.8
PD.765-1973

de Longpré, Paul 1855–1911
Lily of the Valley, Camellia, Pansy and Laburnum
oil on canvas 52 x 39.8
PD.766-1973

de Longpré, Paul 1855–1911
Three Flower and Shrub Plants
oil on canvas 40 x 52
PD.764-1973

de Longpré, Paul 1855–1911
Wild Roses and Various Other Flowers and Shrubs
oil on canvas 40 x 52
PD.763-1973

De Wint, Peter 1784–1849
Dunster, Somerset? c.1848
oil on canvas 59 x 94.8
PD.5-1977a

De Wint, Peter 1784–1849
Landscape Study
oil on paper-faced cardboard 30.7 x 47.6
PD.12-1975

Decamps, Alexandre-Gabriel 1803–1860
Scene in the Near East
oil on panel 30 x 47
1004

Decan, Eugène 1829–after 1894
Corot at His Easel, Crécy-en-Brie
oil on canvas 30.7 x 40
PD.132-1985

Degas, Edgar 1834–1917
Ceremony of Ordination in the Cathedral of Lyons 1855
oil on paper marouflé on canvas 31.4 x 23.3
PD.11-1978

Degas, Edgar 1834–1917
*The Finding of Moses (copy after Paolo
Veronese)* 1855
oil on canvas 31.2 x 17.3
PD.10-1978

Degas, Edgar 1834–1917
*The Castel Sant Elmo from the Capodimonte,
Naples* 1856
oil on paper laid down on canvas 20 x 27
PD.18-2000

Degas, Edgar 1834–1917
David and Goliath c.1857
oil on canvas 80 x 63.8
PD.7-1966

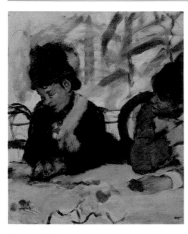

Degas, Edgar 1834–1917
At the Café c.1875–1877
oil on canvas 65.7 x 54.6
2387

Delacroix, Eugène 1798–1863
Odalisque Reclining on a Divan c.1825
oil on canvas 38 x 46.7
PD.3-1957

Delacroix, Eugène 1798–1863
*Study for Part of the 'Justice' Frieze, Palais
Bourbon, Paris* 1833–1836
oil on canvas 38.7 x 61
2033

Delacroix, Eugène 1798–1863
The Muse of Orpheus 1845–1847
pen & ink heightened with oil on paper laid
down on canvas 21.2 x 25.4
2035

Delacroix, Eugène 1798–1863
The Lion and the Snake 1847
oil on canvas 33 x 25

Delacroix, Eugène 1798–1863
Ceres 1849–1853
oil on canvas 19.7 x 37.5
2034

Delacroix, Eugène 1798–1863
Horse in a Landscape
oil on canvas 16.2 x 22.6

Delacroix, Eugène 1798–1863
The Bride of Abydos
oil on canvas 32.5 x 41

Delen, Dirck van 1604/1605–1671
Interior of a Church 1628
oil on panel 36.8 x 58.1
30

Denies, Isaac (attributed to) 1647–1690
Glass Vase of Flowers
oil on canvas 87.5 x 68.5
PD.21-1966

Derain, André 1880–1954
Madame Van Leer c.1929
oil on panel 50.1 x 35.9
2388

Derain, André 1880–1954
Still Life
oil on canvas 16.5 x 34.3

Desgoffe, Alexandre 1805–1882
Château de la Bâtiaz, Sion, Martigny 1827
oil on paper laid down on canvas 22 x 29.3
PD.25-1998

Desportes, Alexandre-François 1661–1743
Sketches of a Kitten
oil on buff paper 27 x 51.1
PD.1-1951

Deverell, Walter Howell 1827–1854
Self Portrait c.1849
oil on canvas 25.7 x 20.3
774

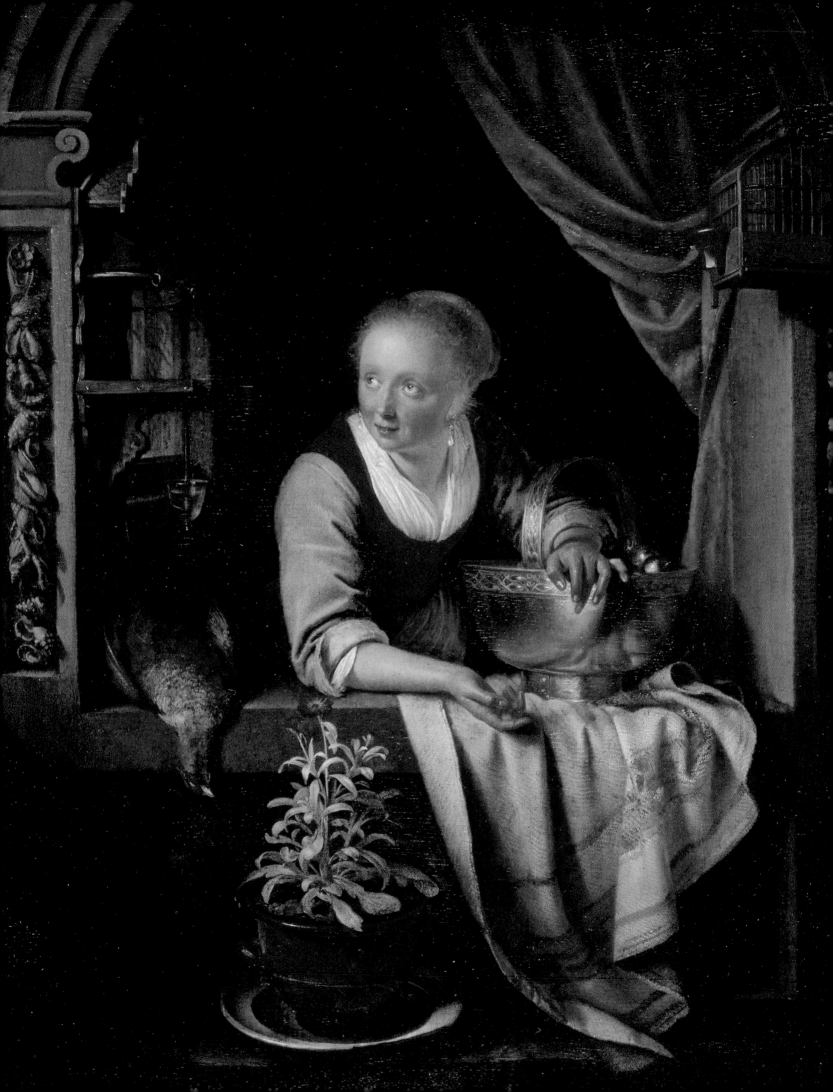

Devis, Arthur 1712–1787
Sir John van Hatten 1753
oil on canvas 76.2 x 64
PD.114-1992

Devis, Arthur 1712–1787
Lady Milner (née Miss Mordaunt) 1760
oil on canvas 50.8 x 35.5
PD.25-1997

Diaz de la Peña, Narcisse Virgile 1808–1876
Wooded Landscape 1870
oil on canvas 43.8 x 60.9
PD.133-1985

Diaz de la Peña, Narcisse Virgile 1808–1876
Storm in the Forest of Fontainbleau 1871
oil on panel 43.5 x 55.2
1776

Diaz de la Peña, Narcisse Virgile 1808–1876
Landscape
oil on canvas 97.8 x 130.5
PD.30-1953

Diaz de la Peña, Narcisse Virgile 1808–1876
Nymphs and Satyrs
oil on panel 30.2 x 40.6
PD.134-1985

Diepenbeeck, Abraham Jansz. van
1596–1675
The Crucifixion
grisaille oils on panel 45 x 32.8
PD.77-1972

Diepenbeeck, Abraham Jansz. van
(attributed to) 1596–1675
The Last Communion of St Francis of Assisi
(after Peter Paul Rubens)
oil on panel 104 x 74.5
PD.17-1984

Dolci, Carlo 1616–1686
The Penitent Magdalene 1650–1651
oil on canvas 64.4 x 52.7
PD.4-1966

Facing page: Dou, Gerrit, 1613–1675, *Woman at a Window with a Copper Bowl of Apples and a Cock Pheasant* (detail), 1663, (p. 54)

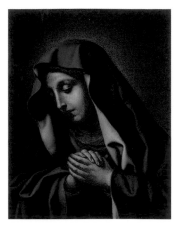

Dolci, Carlo 1616–1686
Sir John Finch FRS, FRCP (1626–1682)
1665–1670
oil on canvas 87.2 x 70.8
PD.12-1972

Dolci, Carlo 1616–1686
Sir Thomas Baines FRS, FRCP (1622–1681) 1665–1670
oil on canvas 86.2 x 72.4
PD.13-1972

Dolci, Carlo (copy after) 1616–1686
Mater Dolorosa
oil on copper 50.8 x 40.3
215

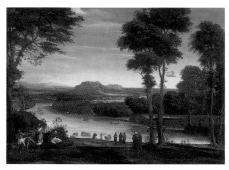

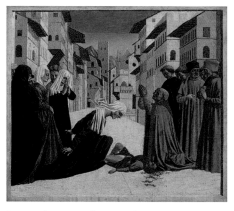

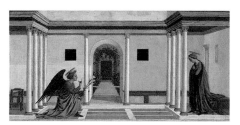

Domenichino 1581–1641
Landscape with St John Baptising 1610–1620
oil on canvas 112.3 x 156.2
2774

Domenico Veneziano active 1438–1461
A Miracle of St Zenobius 1442–1448
tempera on panel 28.6 x 32.5
1107

Domenico Veneziano active 1438–1461
The Annunciation c.1442–1448
tempera on panel 27.3 x 54
1106

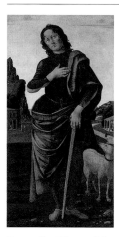

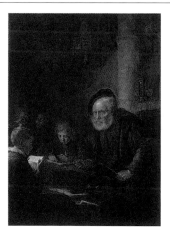

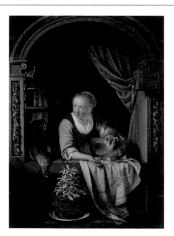

Donzello, Pietro del 1452–1509
St Julian the Hospitaller
oil on canvas 125.4 x 68
M.72

Dou, Gerrit 1613–1675
The Schoolmaster 1645
oil on panel 27 x 19.3
33

Dou, Gerrit 1613–1675
Woman at a Window with a Copper Bowl of Apples and a Cock Pheasant 1663
oil on panel 38.5 x 27.7
34

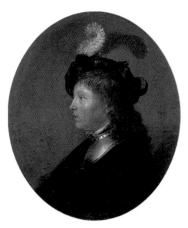

Dou, Gerrit 1613–1675
Portrait of a Young Man
oil on panel 15.1 x 12.2
35

Dou, Gerrit (copy after) 1613–1675
Self Portrait
oil on panel 30.2 x 27.1
417

Drechsler, Johann Baptist 1756–1811
A Basket of Flowers with Fruit 1805
oil on canvas 71.5 x 55.5
PD.24-1975

Drouais, François Hubert 1727–1775
Child with a Tambourine 1772
oil on canvas 43.2
PD.12-1997

Duck, Jacob c.1600–1667
Soldier with a Girl c.1650–1660
oil on copper 15.5 x 13.3
338

Dufy, Raoul 1877–1953
The Basket of Bread 1914
oil on canvas 22.2 x 27
PD.78-1974

Dufy, Raoul 1877–1953
The Painter's Studio
oil on canvas squared in graphite 38 x 46
PD.79-1974

Dughet, Gaspard 1615–1675
Landscape near Rome
oil on canvas 73.7 x 110.5
M.73

Dughet, Gaspard 1615–1675
Landscape with Figures
oil on canvas 47.6 x 65.1
335

Dughet, Gaspard 1615–1675 **& Miel, Jan**
1599–1663
Landscape with Figures
oil on canvas 126.4 x 174.6
PD.27-1969

Dujardin, Karel 1626–1678
Italians with a Dog c.1650
oil on copper 22.4 x 16.8
362*

Dujardin, Karel 1626–1678
Italian Landscape
oil on panel 20.6 x 27
1099

Dujardin, Karel 1626–1678
Travellers Resting
oil on canvas 44.5 x 54.3
636

Dulac, Edmund 1882–1953
*Charles Ricketts and Charles Shannon as
Medieval Saints* 1920
tempera on linen 38.7 x 30.5
PD.51-1966

Dunoyer de Segonzac, André 1884–1974
Landscape with Red Roofs 1919–1920
oil on canvas 60.3 x 92.7
2405

Dunoyer de Segonzac, André 1884–1974
Still Life 1920–1921
oil on paper on canvas 48.3 x 62.9
2406

Dunthorne, John IV 1798–1832
Salisbury Cathedral
oil on canvas 54.8 x 78.1
PD.24-1997

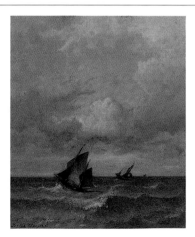

Dupré, Jules 1811–1889
Shipping in a Breeze
oil on canvas 46.3 x 38.7
PD.19-2005

Dutch School late 15th C
Deposition from the Cross
oil on panel 72 x 50.5
1523

Dutch School
Adoration of the Kings c.1520
oil on panel 61.6 x 47.5
M.19

Dutch School
A Man and His Wife 1549
oil on panel 55.8 x 72
871

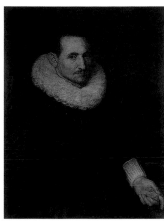

Dutch School
A Young Man c.1620–1625
oil on panel 80 x 61.5
M.58

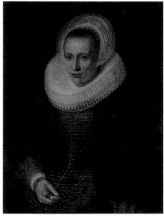

Dutch School
A Young Woman c.1620–1625
oil on panel 80.3 x 61.5
M.59

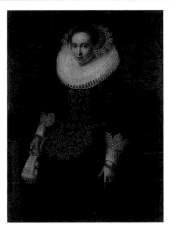

Dutch School
A Lady 1625
oil on panel 121.9 x 91.1
M.21

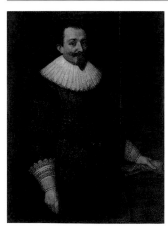

Dutch School
A Gentleman 1629
oil on panel 113.3 x 85.7
M.22

Dutch School
A Young Gentleman c.1635–1640
oil on panel 23.1 x 18.4
328

Dutch School
Portrait of a Child with a Toy Goat 1646
oil on panel 111 x 79.7
147

Dutch School 17th C
Portrait of a Female Artist
oil on canvas 91.4 x 75.9
93

Dutch School 17th C
Portrait of a Woman in a White Cap and Ruff
oil on copper 13.8 x 11.3
543

Dutch School 17th C
Sea Piece
oil on panel 40.3 x 60.3
623

Dutch School 17th C
St Peter Healing St Agatha (after Alessandro Turchi)
oil on panel 26.7 x 35.3
102

Dutch School 17th C
Vase of Flowers
oil on canvas 36.8 x 29.8
PD.15-1966

Dutch School 17th C
Winter Scene
oil on panel 41.5 x 53.7
1109

Dutch School 19th C
Assorted Flowers in an Urn on a Brown Ledge
oil on sheet glass 62.4 x 48.5
PD.45-1975

Dyck, Anthony van 1599–1641
An Old Woman c.1620
oil on wood 74.6 x 55.3
PD.12-1961

Dyck, Anthony van 1599–1641
The Virgin and Child 1628
oil on panel 146.8 x 109
PD.48-1976

Dyck, Anthony van 1599–1641
Portrait of a Man 1630
oil on panel 64.8 x 59.6
PD.79-1972

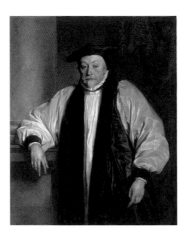

Dyck, Anthony van 1599–1641
Archbishop Laud c.1635–1637
oil on canvas 121.6 x 97
2043

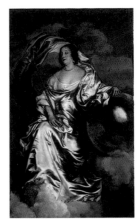

Dyck, Anthony van 1599–1641
*Rachel de Ruvigny, Countess of Southampton,
as Fortune* c.1638
oil on canvas 219.5 x 132.5
PD.73-1978

Eastlake, Charles Lock 1793–1865
A Panoramic View near Rome c.1818
oil on paper laid down on canvas 35 x 171.5
PD.17-1998

Edwards, Edwin 1823–1879
High Street, Whitechapel c.1869
oil on millboard 25.1 x 33.3
2465

Edwards, John Uzzell b.1937
Green Spread 1975
acrylic on paper 61.6 x 47.8
PD.253-1985

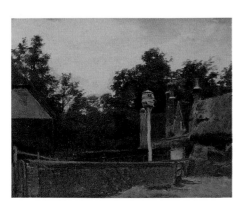

Egg, Augustus Leopold 1816–c.1863
The Farmyard
oil on board over traces of graphite
outline 20 x 24.7
PD.38-1980

Elmore, Alfred 1815–1881
On the Brink 1865
oil on canvas on panel 113.7 x 82.7
PD.108-1975

Elsheimer, Adam 1578–1610
*Minerva as Patroness of Arts and
Sciences* 1600–1605
oil on copper 8.6 x 14.6
539

Elsheimer, Adam 1578–1610
Venus and Cupid 1600–1605
oil on copper 8.7 x 14.6
532

Ensor, James 1860–1949
Porcelaines et masques 1929
oil on canvas 59.1 x 73.7
PD.244-1989

Etchells, Frederick 1886–1973
The Dead Mole 1912
oil on canvas 167 x 106

Etty, William 1787–1849
Two Male Nude Studies c.1818–1820
oil on paper laid onto canvas 53.6 x 62.2
2052

Etty, William 1787–1849
Dr John Camidge c.1825
oil on millboard 30.8 x 24.5
641

Etty, William (attributed to) 1787–1849
Taking of Christ (copy of Guercino)
oil on panel 34.8 x 44.9
PD.105-1990

Evans, Merlyn Oliver 1910–1973
Discrimination
acrylic on canvas 71.5 x 91
PD.1-1986

Everdingen, Allart van 1621–1675
Norwegian Landscape 1656
oil on panel 43.8 x 55.9
66

Everdingen, Allart van (attributed to)
1621–1675
Rocky Landscape
oil on canvas 45.4 x 73.1
PD.18-2005

Facing page: Batoni, Pompeo, 1708–1787, *The Seventh Earl of Northampton* (detail), (p. 13)

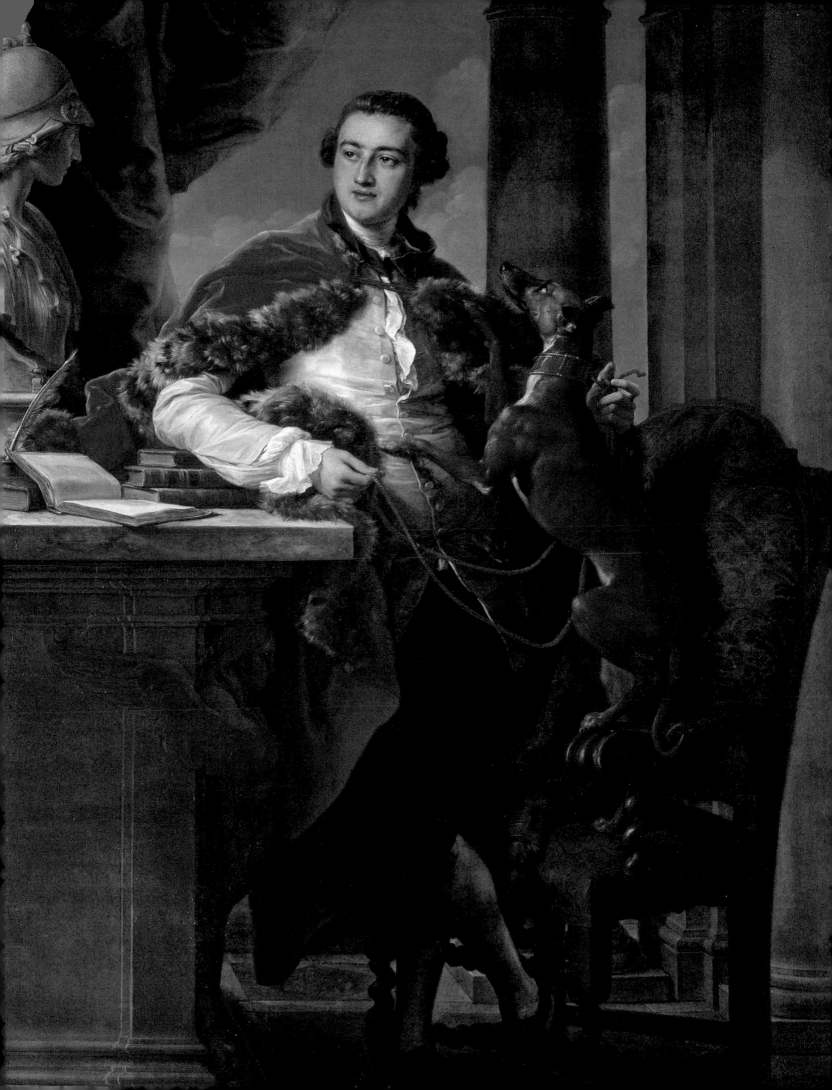

Eworth, Hans c.1525–after 1578
Female Portrait (possibly Queen Mary I)
c.1550–1555
oil on panel 109.9 x 80
PD.1-1963

Fabre, François-Xavier 1766–1837
Allen Smith Contemplating across the Arno, Florence 1797
oil on canvas 70.9 x 90.5
PD.16-1984

Fabris, Pietro active 1768–1801
Ferry over the Volturno, near Caiazzo 1801
oil on canvas 35.2 x 58.1
140

Fabritius, Barent 1624–1673
Portrait of a Child c.1650
oil on canvas 91.6 x 86
455

Faes, Peter 1750–1814
A Vase of Flowers 1790
oil on panel 53.9 x 40.6
PD.64-1973

Fantin-Latour, Henri 1836–1904
White Cup and Saucer 1864
oil on canvas 19.4 x 28.9
1016

Fantin-Latour, Henri 1836–1904
Head of a Young Girl 1870
oil on canvas 31.7 x 21.6
1519

Fantin-Latour, Henri 1836–1904
White Candlestick 1870
oil on canvas 17.1 x 25.1
1019

Fantin-Latour, Henri 1836–1904
The Entombment (after Titian)
oil on canvas stuck down on millboard
44 x 57.3
M.37

Fantin-Latour, Henri (attributed to)
1836–1904
Venus and Cupid
oil on canvas 45.7 x 76.2
PD.27-2003

Fearnley, Thomas 1802–1842
Sunrise in the Wengeralp c.1835
oil on paper laid on canvas 24.5 x 30
PD.53-1998

Ferneley, John E. 1782–1860
Longford Lass and the Jew 1853
oil on canvas 101 x 132
PD.119-1992

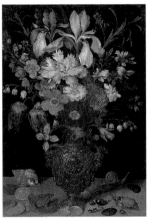

Ferri, Ciro 1634–1689
The Adoration of the Shepherds 1670
oil on copper 52.5 x 38.8
(P)

Fielding, Anthony V. C. 1787–1855
A Heath near the Coast
oil on canvas 32.1 x 47
1797

Flegel, Georg 1566–1638
Still Life with Flowers c.1604
oil on panel 22.5 x 15
PD.12-1996

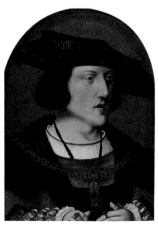

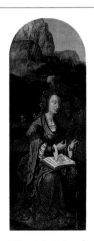

Flemish School
The Emperor Charles V c.1515
oil on panel 44.5 x 33.4
2309

Flemish School early 16th C
St Catherine of Alexandria (left wing of triptych)
oil on panel 86.5 x 31.8
2308

Flemish School early 16th C
St Barbara (right wing of triptych)
oil on panel 87 x 32
2307

Flemish School
Portrait of a Man c.1625
oil on canvas 112.4 x 82.6
83

Flemish School
Portrait of a Woman c.1625
oil on canvas 113 x 81.9
59

Flemish School early 17th C
Dives and Lazarus (after Heinrich Aldegrever)
oil on panel 17.8 x 23.2
274

Flemish School early 17th C
Nonsuch Palace
oil on canvas 151.8 x 302.5
95

Flemish School early 17th C
The Thames at Richmond with the Old Royal Palace
oil on canvas 152.1 x 304.2
61

Flemish School 17th C
Girl Gathering Flowers
oil on copper 15.2 x 10.5
524

Flemish School late 17th C
Virgin and Child with a Female Saint
oil on panel 45.4 x 32
PD.1-1969

Flemish School 18th C
Portraits of a Man and His Wife
oil on canvas 50.5 x 82.5
261

Floris, Frans the elder c.1517–1570
Couple Embracing 1569
oil on panel 48.9 x 41.3
459

Forain, Jean Louis 1852–1931
Bust of a Small Boy in a Red Coat
oil on canvas 45.5 x 40
PD.12-1978

Fouquier, Jacques 1590/1591–1659
Winter Scene 1617
oil on panel 57.8 x 76.8
M.32

Fragonard, Jean-Honoré 1732–1806 &
Gérard, Marguerite 1761–1837
The Reader
oil on canvas 64.8 x 53.8
M.8

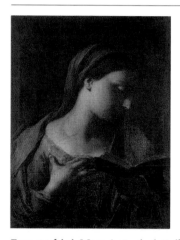

Franceschini, Marc Antonio (attributed to)
1648–1729
The Virgin Reading
oil on canvas 68.6 x 52.4
136

Francesco di Antonio di Bartolomeo
active 1393–1433
The Virgin and Child Enthroned (...) 1415–1418
tempera & gold on panel 91.7 x 34.3; 103.2 x
50.2; 89.8 x 34.6
M.33

Franchi, Rossello di Jacopo c.1376–1456
Virgin and Child (...)
tempera & gold on panel 109 x 58
1129

Francken, Ambrosius I 1544–1618
The Judgement of Zaleucus 1606
oil on panel 179.5 x 216.5
781

Francken, Frans II 1581–1642
The Worship of the Golden Calf c.1630–1635
oil on panel 56.8 x 86.3
262

Fredricks, Jan Hendrick
Basket of Fruit
oil on panel 68.6 x 52.1
PD.22-1966

Freedman, Barnett 1901–1958
The Barn at Fingest, Buckinghamshire 1933
oil on canvas 48.3 x 67.5
PD.4-1953

Frélaut, Jean 1879–1954
The Brigantine 1919
oil on canvas 50.2 x 65.1
2390

French School late 15th C–early 16th C
The Deposition (centre), the Presentation of the Virgin (left), the Marriage of the Virgin (right)
oil on panel
100.3 x 37.2; 99.5 x 70.8; 100.3 x 36.8
M.25

French School late 17th C
River Scene by Moonlight
oil on panel 11.5 x 15.6
533

French School late 17th C–early 18th C
River Scene
oil on canvas 24.1 x 31.7
327

French School
Study of a Mulatto Woman 1820–1825
oil on canvas 55.9 x 24.5
PD.3-1954

French School
Charles Brinsley Marlay c.1850
oil on canvas 67.3 x 55.9
M.84

French School
Provencal Landscape 1869
oil on canvas 23.7 x 40.6
PD.138-1985

French School mid-19th C
A French Revolutionary
oil on millboard 72.8 x 56.2
1536

Frith, William Powell 1819–1909
Othello and Desdemona 1840–1856
oil on canvas 55.9 x 48.3
498

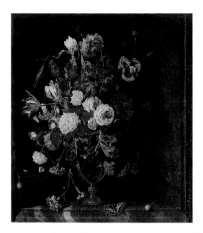

Fromantiou, Hendrik de c.1633–c.1700
Vase of Flowers
oil on canvas 91.2 x 79
PD.37-1966

Frost, Terry 1915–2003
Orange and Yellow Verticals 1959
oil on canvas 270.7 x 102.3
PD.23-1979

Frost, Terry 1915–2003
Red, White and Blue 1963
oil on canvas 25.3 x 20.4
PD.46-1992

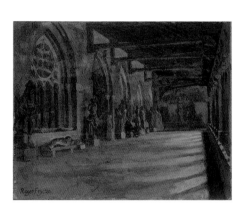

Fry, Roger Eliot 1866–1934
The Cloister 1924
oil on millboard 33 x 40.9
2392

Fry, Roger Eliot 1866–1934
The Port of Cassis 1925
oil on panel 32.1 x 40.9
PD.73-1972

Fry, Roger Eliot 1866–1934
Still Life of Fish 1928
oil on canvas 46.7 x 55.3
1754

Fry, Roger Eliot 1866–1934
The Church of St Etienne, Toulouse 1929
oil on millboard 33.1 x 40.9
PD.74-1972

Fry, Roger Eliot 1866–1934
A Study of Ilexes
oil on millboard 28.5 x 33.7
PD.47-1992

Fussell, Michael 1927–1974
Instant, 1 1960
moulded & painted paper on canvas
30.8 x 30.7
PD.48-1992

Fussell, Michael 1927–1974
Storm Centre c.1961
oil & paper collage on canvas 30 x 30
PD.21-1979

Fyt, Jan 1611–1661
Flowers and Game c.1660
oil on canvas 82 x 66.5
M.38

Fyt, Jan (copy after) 1611–1661
Dead Birds late 17th C
oil on canvas 42.2 x 42.2
305

Gainsborough, Thomas 1727–1788
Landscape with a Pool c.1746–1747
oil on canvas 34.9 x 29.8
PD.3-1966

Gainsborough, Thomas 1727–1788
John Kirby after 1748
oil on canvas 76.2 x 63.7
644

Gainsborough, Thomas 1727–1788
Mrs John Kirby after 1748
oil on canvas 76.2 x 63.7
645

Gainsborough, Thomas 1727–1788
A Forest Road 1750
oil on canvas 62.8 x 75.5
1654

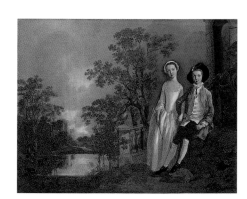

Gainsborough, Thomas 1727–1788
Heneage Lloyd and His Sister, Lucy c.1750
oil on canvas 64.1 x 81
710

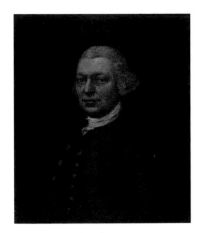

Gainsborough, Thomas 1727–1788
Joshua Kirby c.1764
oil on canvas 75.6 x 63.2
709

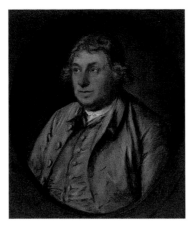

Gainsborough, Thomas 1727–1788
Philip Dupont c.1770
oil on canvas 76.2 x 62.5
915

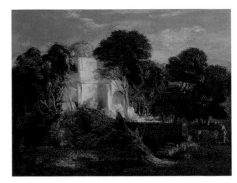

Gainsborough, Thomas 1727–1788
Landscape with Herdsman and Cows Crossing a Bridge c.1772
oil on paper laid down on canvas 41.5 x 54
PD.25-2000

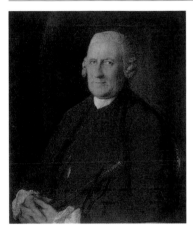

Gainsborough, Thomas 1727–1788
The Hon. William Fitzwilliam 1775
oil on canvas 76.2 x 63.5
18

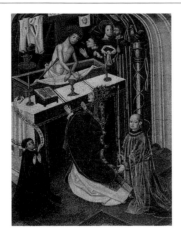

Gallego, Fernando (school of)
active 1468–1507
The Mass of St Gregory
oil? on panel 55.9 x 38.7
708

Gauguin, Paul 1848–1903
Landscape 1873
oil on canvas 50.5 x 81.6
PD.20-1952

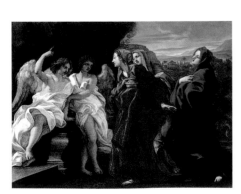

Gaulli, Giovanni Battista 1639–1709
The Three Marys at the Sepulchre c.1684/1685
oil on canvas 87 x 112.5
PD.7-1987

Gelder, Aert de 1645–1727
Baptism of Christ c.1710
oil on canvas 48.3 x 37.1
633

Gelton, Toussaint c.1630–1680
Boors Playing Cards
oil on panel 29.5 x 23.2
341

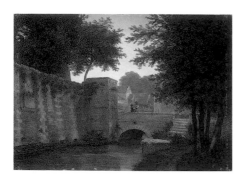

Gérard, Louis-Auguste 1782–1862
Landscape with a Bridge c.1820
oil on canvas 24.5 x 34
PD.49-1973

Géricault, Théodore 1791–1824
Wounded Soldiers in a Cart 1814–1817
oil on paper laid down on canvas 33.2 x 31
PD.10-1964

Gerini, Niccolò di Pietro active 1368–1415
Virgin and Child
tempera with gold on panel 112.7 x 55.3
2078

German (Saxon) School late 15th C
Albert the Bold, Duke of Saxony
oil on panel 39.7 x 29.8
286

German (Saxon) School
An Historical Scene c.1530
oil on panel 66 x 81
2310

German School late 15th C
The Mass of St Gregory
tempera with gold on linen 20.7 x 20.3
4004

German School
Johannes Theodorus Streuffius 1582
oil on panel 39.7 x 32.4
M.42

German School early 18th C
Stream in a Dell, with Flowers and Reptiles
oil on canvas 48.2 x 59.3
PD.44-1966

Gerrard, Kaff 1894–1970
Chalk Pit
oil on canvas 30.6 x 40.8
PD.7-1992

Gerrard, Kaff 1894–1970
Fungi and Woodland
oil on canvas 50.8 x 61.5
PD.5-1992

Gerrard, Kaff 1894–1970
Small Fungus Painting
oil on canvas 30.8 x 33.5
PD.4-1992

Gerrard, Kaff 1894–1970
Twisted Metal in Crater
oil on canvas 45.4 x 56.2
PD.6-1992

Gertler, Mark 1892–1939
Seashells 1907
oil on canvas 27.9 x 38.1
2728

Gertler, Mark 1892–1939
The Pigeon House 1920
oil on canvas 60.9 x 45.4
PD.7-1968

Gertler, Mark 1892–1939
Violin and Bust 1934
oil on millboard 36.8 x 46.3
PD.6-1968

Ghezzi, Pier Leone (attributed to)
1674–1755
*St Dominic Receiving the Rosary from the
Virgin Mary* c.1700
oil on copper 37.5 x 26.6
171

Ghirlandaio, Davide 1452–1525
*Virgin and Child Enthroned between St Ursula
and St Catherine* 1480–1500
tempera with oil glazes on panel 66.4 x 41.6
M.2

Ghirlandaio, Domenico 1449–1494
The Nativity
tempera on panel 85.4 x 62.5
M.54

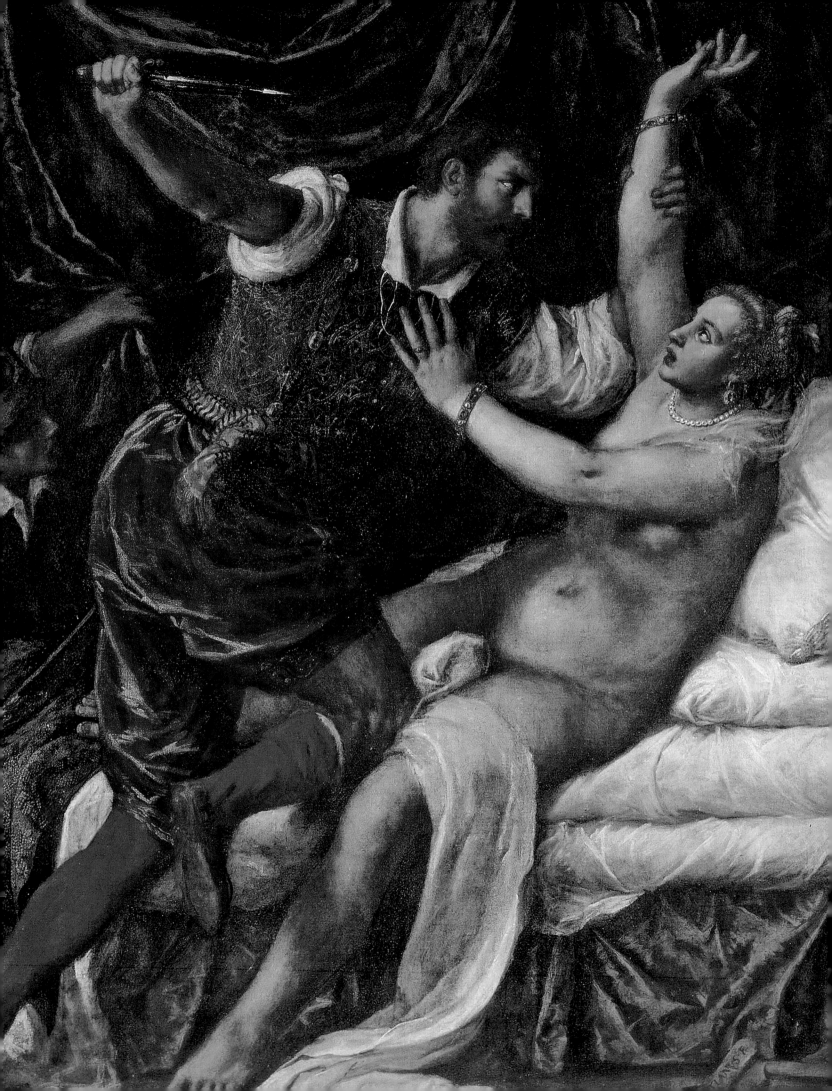

Ghirlandaio, Ridolfo (attributed to)
1483–1561
Portrait of a Young Man c.1505
oil on panel 52.1 x 36.2
1112

Ghislandi, Giuseppe 1655–1743
Boy in Red
oil on canvas 51.5 x 40.4
1593

Gill, William active 1826–1869
Leap Frog c.1852
oil on panel 46 x 63.7
499

Gilman, Harold 1876–1919
Still Life 1909–1910
oil on canvas 31.4 x 41.6
PD.29-1948

Gilman, Harold 1876–1919
Nude on a Bed c.1914
oil on canvas 61.4 x 46.7
PD.3-1967

Gilpin, Sawrey 1733–1807
A Grey Arab
oil on canvas 71.1 x 91.2
2751

Ginner, Charles 1878–1952
The Church of All Souls, Langham Place, London 1924
oil on canvas 76.2 x 55.6
PD.75-1972

Ginner, Charles 1878–1952
Dahlias and Cornflowers 1929
oil on canvas 50.8 x 61.7
PD.9-1968

Ginner, Charles 1878–1952
The Punt in the Mill Stream
oil on canvas 60.9 x 45.7
PD.209-1948

Facing page: Titian, c.1488–1576, *Tarquin and Lucretia* (detail), 1571, (p. 178)

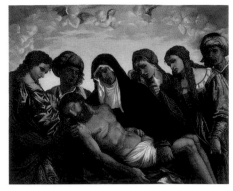

Giolfino, Niccolò the younger 1476–1555
Atalanta's Race
tempera on panel 24.5 x 28.7
210

Giolfino, Niccolò the younger 1476–1555
Classical Subject
tempera on panel 27.2 x 32.2
208

Giovanni da Asola d.1531
Lamentation over the Dead Christ
tempera on canvas 126.1 x 152.4
566

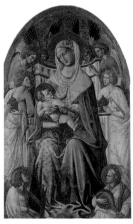

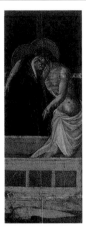

Giovanni dal Ponte 1385–c.1437
Virgin and Child with Angels 1425
tempera with gold on panel 139.1 x 85.7
551

Giovanni dal Ponte 1385–c.1437
St Jerome and St Francis (recto, panel 1)
tempera with gold on panel 88.9 x 35.2
565B

Giovanni dal Ponte 1385–c.1437
Pietà (verso, panel 1)
tempera with gold on panel 88.7 x 35.2
565B

Giovanni dal Ponte 1385–c.1437
*St John the Baptist and St Anthony Abbot
(recto, panel 2)*
tempera with gold on panel 88.7 x 35.2
565A

Giovanni dal Ponte 1385–c.1437
*Mary Magdalene Embracing the Cross (verso,
panel 2)*
tempera with gold on panel 88.9 x 35.2
565A

Giovanni di Paolo 1403–1482
St Bartholomew 1430–1435
tempera with gold on panel 27.6 x 12.4
1758

Giovanni di Paolo 1403–1482
The Entombment of the Virgin with St Bartholomew (left) and a Female Saint (right) c.1450–1460
tempera with gold on panel 18.4 x 46.7
2323

Giroux, André 1801–1879
A View of Rome before 1831
oil over graphite on paper marouflé to canvas
21 x 29.7
PD.101-1978

Glimes, P. de active 1750–1800
Portrait of a Young Man 1793
oil on panel 14 x 10.8
322

Goetze, Sigismund Christian Hubert
1866–1939
Tamarisk Tree, Lake Como 1934
oil on canvas, on plywood 65.4 x 38.7
2543

Goetze, Sigismund Christian Hubert
1866–1939
Old Bridge, Glen Moriston
oil on canvas, on plywood 46.7 x 65.8
2544

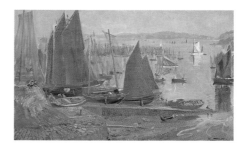

Goetze, Sigismund Christian Hubert
1866–1939
Return of the Sardine Boats, Dournenez, Brittany
oil on canvas, on plywood 39 x 65.4
2541

Goetze, Sigismund Christian Hubert
1866–1939
The Feast Day of St George, Portofino
oil on canvas, on plywood 38.7 x 64.8
2542

Goetze, Sigismund Christian Hubert
1866–1939
Vannes, Brittany
oil on canvas, on plywood 38.7 x 64.5
2545

Gogh, Vincent van 1853–1890
The Alley of Trees in Autumn 1885
oil on canvas laid down on panel 64.5 x 86.5
PD.33-1980

Golding, John b.1929
DII 1974
acrylic on cotton duck 165.1 x 198.2
PD.116-1975

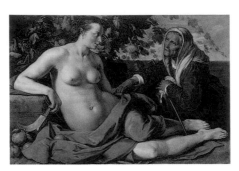

Goltzius, Hendrick 1558–1617
Vertumnus and Pomona 1615
oil on canvas 90.4 x 104.2
PD.33-1991

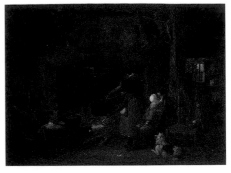

Goodall, Frederick 1822–1904
Cottage Interior 1844
oil on millboard 33 x 42.8
470

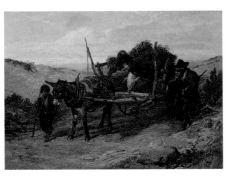

Goodall, Frederick 1822–1904
The Heath Cart 1850
oil on panel 30.2 x 40.6
482

Gore, Spencer 1878–1914
The Green Dress 1908–1909
oil on canvas 45.7 x 35.5
PD.3-1955

Gore, Spencer 1878–1914
*A View from the Window at 6 Cambrian Road,
Richmond*
oil on canvas 50.8 x 40
PD.6-1983

Gore, Spencer 1878–1914
Nearing Euston Station
oil on canvas 49.8 x 60

Gore, Spencer 1878–1914
The Toilet
oil on canvas 44.8 x 34.6

Gosse, Laura Sylvia 1881–1968
Still Life with Eggs and Carrots
oil on canvas 35.5 x 46
PD.35-1991

Gower, George (follower of) c.1540–1596
Unknown Lady c.1595
oil on panel 55.6 x 44.2
M.43

Gowing, Lawrence 1918–1991
Hester Chapman 1944
oil on canvas 40.8 x 45
PD.45-1976

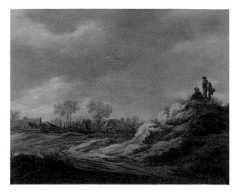

Goyen, Jan van 1596–1656
Landscape with Figures 1628
oil on panel 28.9 x 37.7
52

Goyen, Jan van 1596–1656
An Estuary 1643
oil on panel 35.6 x 33.1
42

Goyen, Jan van 1596–1656
A Watergate by an Estuary 1644
oil on panel 37.4 x 56.4
PD.5-1970

Goyen, Jan van 1596–1656
Near Dordrecht 1654
oil on panel 20.9 x 29.5
415

Goyen, Jan van 1596–1656
River Landscape with Boats
oil on panel 35.4 x 71
PD.187-1975

Granet, François-Marius 1775–1849
Hermit Reading 1831
oil on canvas 24.5 x 32.5
PD.65-1997

Grant, Duncan 1885–1978
Miss Mary Coss 1931
oil on canvas-covered board 44.2 x 35.3
2395

Grant, Duncan 1885–1978
The Chinese Plate 1943
oil on canvas 35.5 x 46
PD.49-1992

Grant, Duncan 1885–1978
Design for Needlework
oil on card 22.7
PD.81-1974

Grant, Keith b.1930
Volcano and White Bird, Iceland (4 panels)
1974–1975
oil on canvas 106.5 x 106.5; 106.5 x 106.5;
106.5 x 106.5; 106.5 x 106.5
PD.384-1995

Grant, Keith b.1930
*Eruption Column at 20,000 Feet, Heimæy,
Iceland* 1976
oil on board 149.3 x 94
PD.42-2001

Grassi, Nicola (attributed to) 1682–1748
Christ Falling under the Cross c.1731
oil on canvas 27.3 x 22
PD.51-1992

Grassi, Nicola (attributed to) 1682–1748
The Woman Taken in Adultery
oil on canvas 28 x 41
PD.50-1992

Gray, Maurice 1889–1918
Langdale Pikes from near Crinkle Crags
oil on canvas 61.3 x 91.4
2721

Greuze, Jean-Baptiste 1725–1805
*George Augustus Herbert, Eleventh Earl of
Pembroke (1759–1827)* 1780
oil on canvas 54.5 x 43.5
PD.33-2000

Griffier, Jan I c.1645–1718
View on the Rhine c.1700–1710
oil on copper 25.2 x 34.3
379

Gryef, Adriaen de 1670–1715
Spaniel and Dead Game in a Landscape
oil on canvas backed onto wood 29.2 x 37.2
293

Guardi, Antonio 1699–1760
The Sala Grande of the Ridotto, Palazzo Dandolo, San Moise 1755–1760
oil on canvas 50 x 85
PD.1-1980

Guardi, Antonio 1699–1760
Pharaoh's Daughter (after Jacopo Palma il giovane)
oil on canvas 58.8 x 47
PD.22-1952

Guardi, Francesco 1712–1793
Forte San Andrea del Lido, Venice 1760–1770
oil on canvas 31.7 x 52.7
185

Guardi, Francesco 1712–1793
The Island of Anconetta, Venice
oil on canvas 15.8 x 22.9
184

Guardi, Francesco 1712–1793
View near Venice
oil on canvas, on panel 13.5 x 18.8
183

Guardi, Francesco 1712–1793
View towards Murano from the Fondamente Nuove, Venice
oil on canvas 31.7 x 52.7
189

Guardi, Giacomo 1764–1835
Punta di San Giobbe, Venice
oil on canvas 16.8 x 23.8
187

Guardi, Giacomo 1764–1835
The Island of San Cristoforo di Murano, Venice
oil on canvas 16.5 x 23.8
188

Guercino 1591–1666
St Sebastian Succoured by Two Angels 1617
oil on copper 43 x 32.5
PD.216-1994

Guercino 1591–1666
The Betrayal of Christ 1621 or before
oil on canvas 115.3 x 142.2
1131

Guercino (attributed to) 1591–1666
*The Holy Family on the Return from the Flight
Meets the Infant St John*
tempera on canvas 52.7 x 66
PD.4-1983

Gunn, Herbert James 1893–1964
Louis Colville Gray Clarke 1959
oil on canvas, on millboard 30.7 x 28.6
PD.120-1975

Gyselaer, Nicolaes de 1590/1595–1654
Interior of a Hall 1621
oil on panel 51.3 x 64.1
422

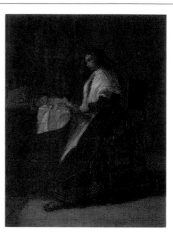

Hals, Dirck (after) 1591–1656
Woman at Her Work
oil on panel 36.8 x 28.9
423

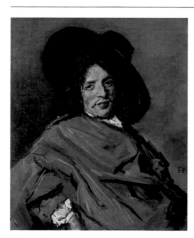

Hals, Frans c.1581–1666
Portrait of an Unknown Man 1660–1663
oil on canvas 80 x 67
150

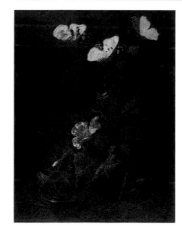

Hamilton, Karl Wilhelm de 1668–1754
A Thistle with Snakes and Butterflies
oil on wood 29.2 x 22.2
296

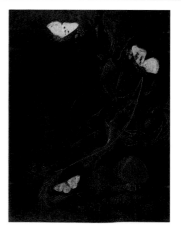

Hamilton, Karl Wilhelm de 1668–1754
Ivy with Bird's Nest, Snakes and Moths
oil on wood 29.2 x 22.2
297

Facing page: Léger, Fernand, 1881–1955, *Young Girl Holding a Flower* (detail), 1954, (p. 108)

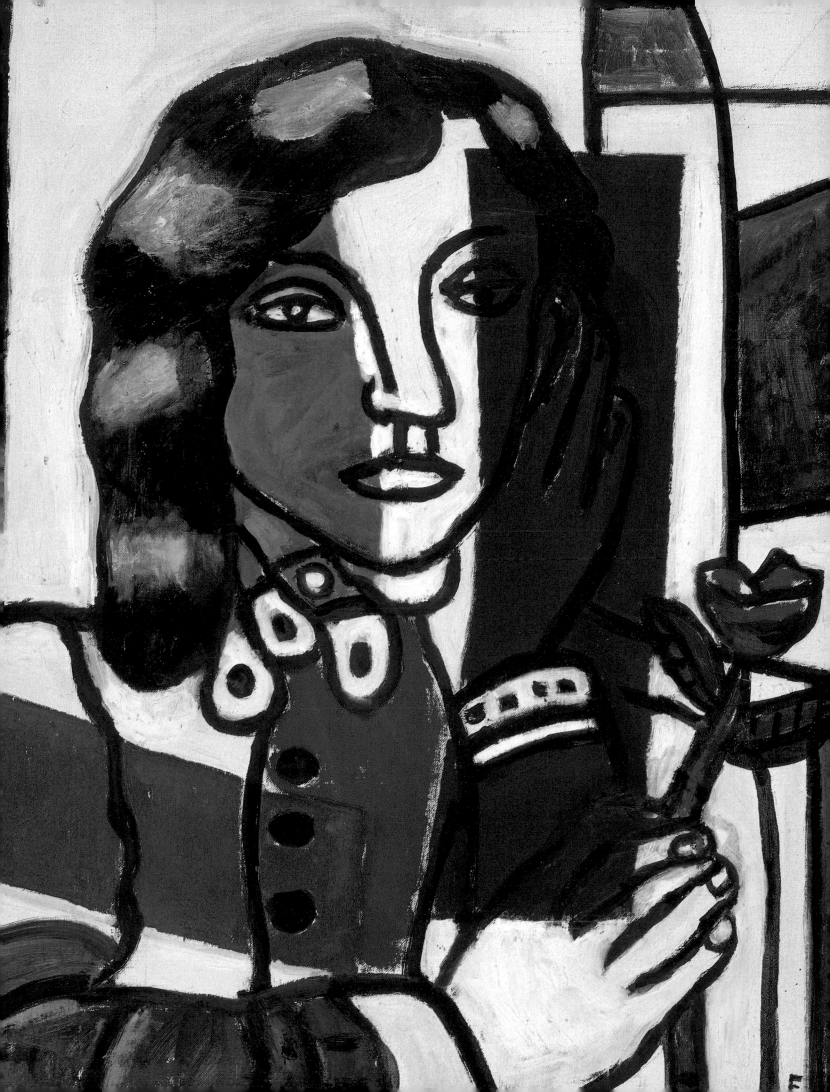

Hardimé, Simon 1664/1672–1737
Vase of Flowers
oil on canvas 76.2 x 63.5
PD.23-1966

Harlow, George Henry 1787–1819
Professor Charles Hague c.1813
oil on canvas 76.2 x 63.6
630

Harpignies, Henri-Joseph 1819–1916
Crémieu 1847
oil on canvas 38 x 46
PD.140-1985

Harpignies, Henri-Joseph 1819–1916
On the Banks of the Oise 1883
oil on canvas 59.7 x 82.3
PD.139-1985

Harpignies, Henri-Joseph 1819–1916
The Open Road 1883/1885?
oil on canvas 51 x 86.5
PD.15-1999

Harpignies, Henri-Joseph 1819–1916
The Lake 1897
oil on canvas 27 x 40.9
PD.13-1950

Harris, Frederick Leverton 1864–1926
George Moore 1920
oil on canvas 25.4 x 20.6
PD.1-1972

Harris, Frederick Leverton 1864–1926
Souillac 1923
oil on panel 36.8 x 44.5
1120

Hayman, Francis c.1708–1776
The Masters Martin Atkin c.1740–1742
oil on canvas 76.5 x 63.8
PD.13-1997

Hayman, Francis c.1708–1776
George Dance c.1750
oil on canvas 53.4 x 43.1
PD.20-1951

Hayter, Stanley William 1901–1988
L'Escoutay 1957
oil on canvas 100.2 x 80.6
PD.29-1984

Haytley, Edward active 1740–1764
Sir William Milner, Second Bt 1764
oil on canvas 50.8 x 38
PD.26-1997

Hecken, Maddalena van den
active early–mid-17th C
Flowers in a Glass Vase
oil on panel 26.5 x 15.2
PD.638-1973

Hecken, Maddalena van den
active early–mid-17th C
Flowers in a Glass Vase
oil on panel 22 x 12.5
PD.639-1973

Hecken, Maddalena van den
active early–mid-17th C
Flowers in a Glass Vase
oil on panel 31.1 x 18.3
PD.640a-1973

Hecken, Maddalena van den
active early–mid-17th C
Flowers in a Glass Vase
oil on panel 30.6 x 18
PD.640b-1973

Heem, Cornelis de 1631–1695
Flowers and Still Life
oil on canvas 53.3 x 73.8
PD.24-1966

Heem, David-Cornelisz. de
before 1663–1718
A Festoon of Flowers and Fruit
oil on canvas 67.3 x 55.8
PD.25-1975

Heem, Jan Davidsz. de 1606–1683/1684
Still Life with Fruit late 1650s
oil on canvas on panel 67 x 77
M.47

Heem, Jan Davidsz. de 1606–1683/1684
Flower Piece
oil on panel 93.2 x 69.6
1487

Heemskerck, Egbert van the elder
1634/1635–1704
Monks Singing
oil on panel 25.4 x 22.9
430

Heemskerck, Egbert van the elder
1634/1635–1704
Singing Peasants
oil on panel 16.3 x 23
1990

Heemskerck, Maerten van 1498–1574
Self Portrait with the Colosseum, Rome 1553
oil on panel 42.2 x 54.2
103

Helst, Bartholomeus van der 1613–1670
Portrait of a Man 1662
oil on canvas 83.2 x 71.1
149

Hemessen, Catharina van 1528–after 1587
Portrait of a Woman
oil on panel 33 x 25
269

Hendriks, Wybrand 1744–1831
Basket of Flowers and Fruit
oil on panel 63.5 x 54.6
PD.26-1966

Hendriks, Wybrand 1744–1831
Vase of Flowers
oil on panel 63.5 x 54.6
PD.25-1966

Hering, George Edwards 1805–1879
A View in Genoa
oil on panel 30.5 x 25
PD.59-1996

Hering, George Edwards 1805–1879
A View in the Italian Lakes
oil on panel 30.4 x 25
PD.58-1996

Herkomer, Hubert von 1849–1914
Professor Henry Fawcett 1886
oil on canvas 142.5 x 112
503*

Highmore, Joseph 1692–1780
Mrs Elizabeth Birch and Her Daughter 1741
oil on canvas 119.1 x 97.2
646

Highmore, Joseph 1692–1780
Pamela and Mr B. in the Summer House
c.1744
oil on canvas 62.9 x 75.6
M.Add.6

Highmore, Joseph 1692–1780
Pamela Leaves Mr B.'s House in Bedfordshire
c.1744
oil on canvas 62.6 x 75.6
M.Add.7

Highmore, Joseph 1692–1780
*Pamela Shows Mr Williams a Hiding Place for
Their Letters* c.1744
oil on canvas 62.9 x 74.7
M.Add.8

Highmore, Joseph 1692–1780
Pamela Tells a Nursery Tale c.1744
oil on canvas 62.9 x 74.7
M.Add.9

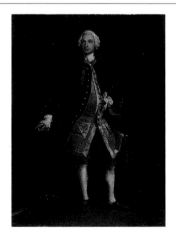

Highmore, Joseph 1692–1780
Unknown Man 1745
oil on canvas 48.3 x 35.6
PD.19-1951

Hilton, Roger 1911–1975
Large Orange (Newlyn) 1959
oil on canvas 152.4 x 137.2
PD.35-1972

Hirschley, Kaspar 1698–1743
Bowl of Flowers 1737
oil on panel 58.9 x 45.3
PD.27-1966

Hitchens, Ivon 1893–1979
Chestnut Forest 1950
oil on canvas 51.4 x 105.1
PD.8-1962

Hitchens, Ivon 1893–1979
The Boat House 1956
oil on canvas 50.8 x 84.2
PD.3-1968

Hitchens, Ivon 1893–1979
The Brown Boat 1961
oil on canvas 47.7 x 144.2
PD.2-1968

Hitchens, Ivon 1893–1979
Blue Door, House and Outside 1972
oil on canvas 53.3 x 131.7
PD.17-1974

Hitchens, Ivon 1893–1979
Flower Piece, Stonor 1974
oil on canvas 108.9 x 58.5
PD.25-1984

Hitchens, Ivon 1893–1979
Landscape: Water to Boat House beyond 1976
oil on canvas 43.2 x 105.4
PD.251-1985

Hitchens, Ivon 1893–1979
Flowers, Red against Blue
oil on canvas 47 x 110.8
PD.8-2000

Hobbema, Meindert 1638–1709
A Wooded Landscape with Cottages 1665
oil on canvas 96.3 x 122.9
PD.1-1970

Hobbema, Meindert 1638–1709
Wooded Landscape 1667
oil on canvas 80.3 x 106
49

Hoecke, Kaspar van den d. after 1648
Tub of Flowers 1614
oil on panel 84.4 x 52
PD.28-1966

Hogarth, William 1697–1764
*A Prisoner of the Fleet Being Examined before
a Committee of the House of Commons*
1728–1729
oil on paper 470 x 596
675

Hogarth, William 1697–1764
Before 1730–1731
oil on canvas 37.2 x 44.7
PD.11-1964

Hogarth, William 1697–1764
After 1731
oil on canvas 37.2 x 45.1
PD.12-1964

Hogarth, William 1697–1764
A Musical Party 1730s
oil on canvas 63.3 x 76.4
647

Hogarth, William 1697–1764
Frances Arnold 1738–1740
oil on canvas 90.5 x 70.5
24

Hogarth, William 1697–1764
George Arnold 1738–1740
oil on canvas 90.5 x 70.8
21

Hogarth, William 1697–1764
Dr Benjamin Hoadly late 1730s
oil on canvas 60.7 x 47.9
648

Hogarth, William 1697–1764
Richard James of the Middle Temple c.1744
oil on canvas 75 x 62.2
PD.116-1992

Hogarth, William 1697–1764
Unknown Man 1740s
oil on canvas 75.6 x 62.6
1642

Hogarth, William 1697–1764
The Bench 1753–1754
oil on canvas marouflé to panel 14.8 x 18.2
727

Holbein, Hans the younger (after)
1497/1498–1543
William Fitzwilliam, Earl of Southampton
after 1539
oil on panel 187.1 x 100
164

Holbein, Hans the younger (copy after)
1497/1498–1543
Unknown Man in the Service of Henry VIII
oil on copper 13.5
537

Holl, Frank 1845–1888
Study of a Girl
oil on canvas 52.5 x 29.5
PD.20-2005

Holland, Harry b.1941
Skull on a Ledge 1978
oil on wood 24.9 x 25.9
PD.397-1995

Holman, Francis 1729–1790
*Shipping Passing the Eddystone
Lighthouse* 1773?
oil on canvas 98.8 x 128
PD.14-1997

Holman, Francis 1729–1790
Shore Scene with Shipping 1778
oil on canvas 96.5 x 127
PD.94-1992

Holmes, Charles John 1868–1936
Farmyard at Soberton, Surrey 1923
oil on canvas 68.6 x 76.5
1139

Hondius, Abraham c.1625–1691
Hawking Party 1665
oil on canvas 50.7 x 63.8
356

Hondius, Abraham c.1625–1691
Arctic Adventure c.1677
oil on canvas 55.4 x 84.7
355

Hone, Nathaniel I 1718–1784
General Lloyd 1773
oil on canvas 76.2 x 63.8
457

Hone, Nathaniel I 1718–1784
The Honourable Mrs Nathaniel Curzon 1778
oil on canvas 127.5 x 110
916

Honthorst, Gerrit van 1590–1656
William, Earl of Craven 1642
oil on canvas 209.6 x 144.8
PD.117-1992

Hoppner, John 1758–1810
Boy with a Bird's Nest
oil on canvas 77.5 x 64.7
1102

Howard, Charles Houghton 1899–1978
The Matement
oil on canvas 60.9 x 86.3
PD.28-2003

Howard, Henry (copy after) 1769–1847
Richard, Seventh Viscount Fitzwilliam of Merrion
oil on panel 38.4 x 30.5
2

Howson, Peter b.1958
Three Men in Moonlight
oil on canvas 91.7 x 61.3
PD.8-2005

Hoyland, John b.1934
Untitled c.1965
acrylic on canvas 213.5 x 182.8
PD.29-2003 ✲

Hoyland, John b.1934
29.3.69 1969
acrylic on linen 198.6 x 365.5
PD.13-1976 ✲

Hoyland, John b.1934
Untitled c.1970
acrylic on canvas 182.9 x 182.9
PD.30-2003 ✲

Hoyland, John b.1934
Untitled c.1975
acrylic on canvas 228 x 228.6
PD.31-2003 ✲

Hoyland, John b.1934
Memory Mirror 1981
acrylic on canvas 91.4 x 74.1
PD.56-2001 ✲

Hubbard, John b.1931
Coastal Landscape 1967
oil on paper 15.5 x 22
PD.52-1992

Hubbard, John b.1931
River Landscape 1968
oil on paper 77.5 x 57.2
PD.53-1992

Hubbard, John b.1931
Quarry Painting c.1976
oil on canvas 182.9 x 182.9
PD.32-2003

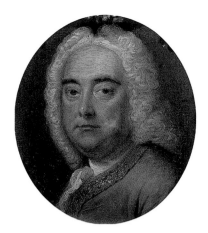

Hudson, Thomas (copy after) 1701–1779
George Frederick Handel
oil on canvas backed onto panel 20.3 x 17.8
17

Hudson, Thomas (school of) 1701–1779
Mrs Susannah Hope c.1760
oil on canvas 74.6 x 65.1
PD.25-1952

Huet, Jean-Baptiste I 1745–1811
A Pastoral
oil on canvas 21 x 41.9
319

Huet, Jean-Baptiste I 1745–1811
A Pastoral
oil on canvas 21 x 41.9
324

Hughes, Arthur 1832–1915
Edward Robert Hughes as a Child
c.1853–1854
oil on canvas 56.8 x 29.2
1145

Hughes, Arthur 1832–1915
The King's Orchard 1858/1859
oil on paper, on panel 28.6 x 29.2
1509

Hulsman, Johann d. before 1652
Latona Transforming the Peasants into Frogs
oil on copper 23.8 x 30.5
101

Hunt, William Holman 1827–1910
The Thames at Chelsea, Evening 1853
oil on panel 15.2 x 20.3
868

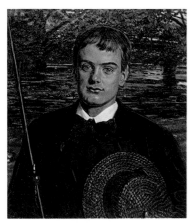

Hunt, William Holman 1827–1910
Cyril Benoni Holman Hunt 1880
oil on canvas 60.9 x 50.8
1760

Huxley, Paul b.1938
Untitled 1960–1965
oil on canvas 188 x 188
PD.33-2003

Huxley, Paul b.1938
Untitled No.17 1962–1964
oil on canvas 172.5 x 172.5
PD.37-1984

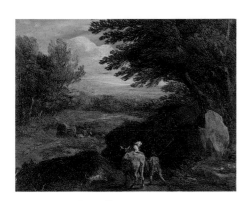

Huysmans, Cornelis 1648–1727
Landscape with Figures
oil on copper 13 x 17
247

Huysum, Jacob van 1686–1740
A Vase of Flowers with Fruit
oil on canvas 89 x 71.1
PD.65-1973

Huysum, Jacob van 1686–1740
Twelve Months of Flowers: January
oil on canvas 76.5 x 64
PD.66-1973

Huysum, Jacob van 1686–1740
Twelve Months of Flowers: February
oil on canvas 76.2 x 63.4
PD.67-1973

Huysum, Jacob van 1686–1740
Twelve Months of Flowers: March
oil on canvas 76.2 x 63.5
PD.68-1973

Huysum, Jacob van 1686–1740
Twelve Months of Flowers: April
oil on canvas 76.2 x 63.5
PD.69-1973

Facing page: Constable, John, 1776–1837, *Parham's Mill, Gillingham, Dorset* (detail), 1824, (p. 40)

Huysum, Jacob van 1686–1740
Twelve Months of Flowers: May
oil on canvas 76.2 x 63.4
PD.70-1973

Huysum, Jacob van 1686–1740
Twelve Months of Flowers: June
oil on canvas 76.2 x 63.4
PD.71-1973

Huysum, Jacob van 1686–1740
Twelve Months of Flowers: July
oil on canvas 76.2 x 63.4
PD.72-1973

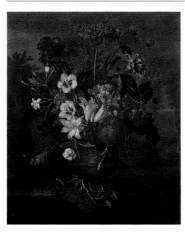

Huysum, Jacob van 1686–1740
Twelve Months of Flowers: August
oil on canvas 76.2 x 63.4
PD.73-1973

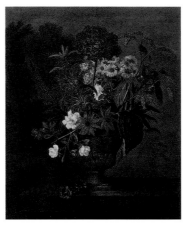

Huysum, Jacob van 1686–1740
Twelve Months of Flowers: September
oil on canvas 76.2 x 63.4
PD.74-1973

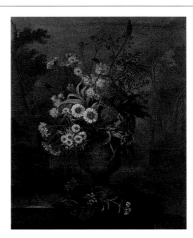

Huysum, Jacob van 1686–1740
Twelve Months of Flowers: October
oil on canvas 76.2 x 63.4
PD.75-1973

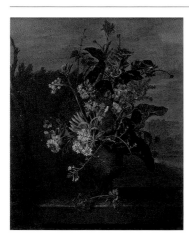

Huysum, Jacob van 1686–1740
Twelve Months of Flowers: November
oil on canvas 76.2 x 63.4
PD.76-1973

Huysum, Jacob van 1686–1740
Twelve Months of Flowers: December
oil on canvas 76.2 x 63.4
PD.77-1973

Huysum, Jan van 1682–1749
A Vase of Flowers
oil on canvas 52.9 x 53.5
PD.26-1975

Huysum, Jan van (after) 1682–1749
Fruit and Flowers
oil on canvas 74.6 x 60
M.66

Huysum, Jan van (attributed to) 1682–1749
A Vase of Flowers
oil on panel 71.1 x 54.5
PD.78-1973

Huysum, Justus van 1659–1716
A Vase of Flowers
oil on canvas 118.1 x 91.5
PD.28-1975

Huysum, Justus van 1659–1716
A Vase of Flowers
oil on canvas 118.1 x 91.5
PD.29-1975

Huysum, Justus van 1659–1716
Group of Flowers
oil on canvas 93 x 117
635

Huysum, Michiel van 1703–1777
A Dish of Fruit
oil on canvas 39.9 x 32.2
PD.31-1975

Huysum, Michiel van 1703–1777
A Vase of Flowers
oil on canvas 39.9 x 32.3
PD.30-1975

Ibbetson, Julius Caesar 1759–1817
Ullswater from the Foot of Gowbarrow Fell 1808
oil on canvas 58.6 x 88.2
M.50

Inchbold, John William 1830–1888
Anstey's Cove, Devon 1854
oil on canvas 50.5 x 68.3
PD.2-1951

Inlander, Henry 1925–1983
Mirror Landscape, Self Portrait
oil on canvas 40.8 x 35.3
PD.54-1992

Innes, James Dickson 1887–1914
Arenig Fawr, North Wales c.1911
oil on panel 30.5 x 40.9
2457

Isabey, Eugène 1803–1886
Washerwomen on the Shore
oil on canvas 28.5 x 45.5
PD.13-1978

Isenbrandt, Adriaen c.1500–before 1551
A Male Donor
oil on panel 25.2 x 8
PD.12-1950

Isenbrandt, Adriaen c.1500–before 1551
St Jerome
oil on panel 24.9 x 8.1
PD.11-1950

Israëls, Jozef 1824–1911
A Young Girl Sewing, Seated at a Window
oil on canvas 39 x 31
PD.14-1987

Italian (Bolognese) School 17th C
A Prophet Set in a Spandrel
grisaille oils on canvas 38 x 63.5
PD.96-1992

Italian (Bolognese) School 17th C
The Triumph of Galatea
oil on canvas 48.9 x 64.8
123

Italian (Florentine) School early 15th C
Virgin and Child
tempera with gold on panel 86 x 44.5
1987

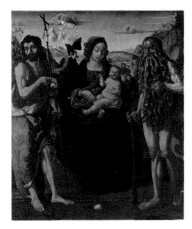

Italian (Neopolitan) School
*Virgin and Child between St John the Baptist
and St Onuphrius* 1507
tempera on panel 148.6 x 120.9
1185

Italian (Roman) School
Fight of Sea Deities and Sea Monsters
1780–1820
oil on canvas 13.2 x 22.6
PD.55-1992

Italian (Roman) School
Fight of Sea Deities and Sea Monsters
1780–1820
oil on canvas 13.2 x 22.6
PD.56-1992

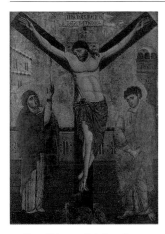

Italian (Sienese) School
Crucifixion c.1285
tempera with gold on panel 134.9 x 94
564

Italian (Sienese) School late 15th C
Joseph Sold by His Brethren
oil on panel 28.3 x 34.6
1178A

Italian (Sienese) School late 15th C
Joseph and Potiphar's Wife
oil on panel 27.9 x 36.2
1178B

Italian (Sienese) School late 15th C
Joseph before Pharaoh
oil on panel 28.6 x 34.6
1178C

Italian (Sienese) School late 15th C
*Trajan and the Widow (a desco da parto or
salver to celebrate the birth of a child)*
tempera with gold & silver on panel 57.7
M.30

Italian (Umbrian) School
Head of Christ c.1360
tempera on plaster 33.3 x 32
562

Italian (Venetian) School 14th/15th C
St Augustine, St Jerome and St Benedict
tempera with gold on panel 44.1 x 44.7
1594

Italian (Venetian) School mid-16th C
The Presentation in the Temple
oil on panel 84.7 x 120.9
3714

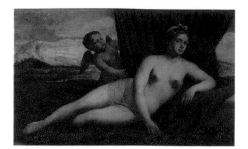

Italian (Venetian) School late 16th C
Venus and Cupid
oil on panel 41.3 x 67.6
128

Italian (Venetian) School
Rebecca and Eliezer at the Well c.1600
oil on canvas 47.3 x 34.9
620

Italian (Veronese) School
Unknown Man c.1545
oil on canvas 54.6 x 45.7
1161

Italian School late 15th C
Ecce homo
tempera on plaster 35.2 x 28.6
M.52

Italian School
*Apollo and Poseidon Come to Assist
Laomedon* c.1500
oil on canvas 62.9 x 108.3
M.69

Italian School
*Laomedon Refuses Apollo and Poseidon Their
Reward* c.1500
oil on canvas 61.9 x 108.3
M.70

Italian School late 16th C
Portrait of a Young Man
oil on copper 6.7
521

Jackson, John 1778–1831
Thomas Stothard, RA
oil on canvas 74.3 x 62.2
649

Jacque, Charles Émile 1813–1894
The Distant Storm
oil on canvas 52.3 x 43
PD.142-1985

Janson, Johannes 1729–1784
Cattle Piece 1779
oil on canvas 31.1 x 39.4
235

Janson, Johannes 1729–1784
Cattle Piece 1779
oil on canvas 32.1 x 40
244

Janson, Johannes 1729–1784
Cattle Piece
oil on panel 35 x 47
253

Janssens van Ceulen, Cornelis 1593–1661
Unknown Lady 1646
oil on canvas 83.9 x 70.5
PD.60-1958

Jeaurat, Etienne (attributed to) 1699–1789
Beggar Boy
oil on panel 21.6 x 15
318

Jeaurat, Etienne (attributed to) 1699–1789
Beggar Girl
oil on panel 21.7 x 15.1
332

Jervas, Charles (studio of) c.1675–1739
Martha and Teresa Blount
oil on canvas 111 x 113.3
650

John, Augustus Edwin 1878–1961
Dorelia with a Feathered Hat c.1906
oil on canvas 60.9 x 50.8
PD.19-1976 🐝

John, Augustus Edwin 1878–1961
David and Dorelia in Normandy 1908
oil on canvas, laid down on millboard
37.2 x 45.4
2456 🐝

John, Augustus Edwin 1878–1961
Sir William Nicholson 1909
oil on canvas 190.2 x 143.8
1641 🐝

John, Augustus Edwin 1878–1961
Caspar c.1909
oil on panel 40.6 x 32.9
PD.23-1976 🐝

John, Augustus Edwin 1878–1961
Dorelia and the Children at Martigues 1910
oil on panel 23.5 x 32.9
PD.16-1976 🐝

John, Augustus Edwin 1878–1961
Girl Leaning on a Stick 1910
oil on panel 33 x 23.5
PD.24-1961 🐝

John, Augustus Edwin 1878–1961
The Blue Pool 1910
oil on panel 30.2 x 40.6
PD.14-1976 🐝

John, Augustus Edwin 1878–1961
Woman with a Daffodil 1910
oil on panel 30.3 x 23.8
1018 🐝

John, Augustus Edwin 1878–1961
Dorelia by the Caravan 1911
oil on panel 35.5 x 26.7
PD.25-1961 🐝

Facing page: Dulac, Edmund, 1882–1953, *Charles Ricketts and Charles Shannon as Medieval Saints* (detail), 1920, (p. 56)

John, Augustus Edwin 1878–1961
David and Caspar c.1912
oil on panel 53 x 35.1
PD.17-1976 ✵

John, Augustus Edwin 1878–1961
Dorelia Seated and Holding Flowers c.1912
oil on panel 32.8 x 23.8
PD.20-1976 ✵

John, Augustus Edwin 1878–1961
Dorelia Wearing a Turban c.1912
oil on panel 33 x 23.8
PD.18-1976 ✵

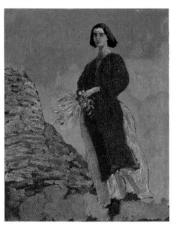

John, Augustus Edwin 1878–1961
The Yellow Dress c.1912
oil on panel 40.6 x 32.1
PD.21-1976 ✵

John, Augustus Edwin 1878–1961
The Woman of Ower 1914
oil on canvas 45.7 x 30.5
851 ✵

John, Augustus Edwin 1878–1961
The Mumper's Daughter c.1914
oil on panel 58.6 x 49.7
PD.22-1976 ✵

John, Augustus Edwin 1878–1961
George Bernard Shaw 1915
oil on canvas 76.5 x 46.3
1071 ✵

John, Augustus Edwin 1878–1961
Olives in Spain 1922
oil on canvas 33 x 40.9
PD.22-1961 ✵

John, Augustus Edwin 1878–1961
Thomas Hardy 1923
oil on canvas 61.3 x 51.1
1116 ✵

John, Augustus Edwin 1878–1961
Study in Provence c.1926
oil on canvas 38.1 x 39.1
PD.23-1961 🐝

John, Augustus Edwin 1878–1961
Edwin John c.1940
oil on canvas 53.8 x 43.8
PD.15-1976 🐝

John, Gwen 1876–1939
The Convalescent c.1923–1924
oil on canvas 41.2 x 33
PD.24-1951

Joli, Antonio c.1700–1777
*Capriccio: Elegant Figures outside and within a
Classical Palace*
oil on canvas 86.3 x 114.3
PD.15-1997

Jones, Thomas 1742–1803
Scene near Naples 1783
oil on paper 24.1 x 34.6
PD.21-1954

Jordaens, Jacob 1593–1678
Two Studies of a Male Head
oil on canvas on panel 34 x 33.7
258

Kauffmann, Angelica 1741–1807
Louisa Hammond
oil on copper 32.7 x 26.3
PD.17-1995

Kerr-Lawson, James 1864–1939
Paul Verlaine 1894
oil on canvas 42.6 x 32.4
2507

Kessel, Jan van (attributed to) 1641–1680
*Swags of Fruit and Flowers Surrounding a
Cartouche with a Sulphur-Crested Cockatoo*
oil on canvas 147 x 119
PD.122-1992

Kessel, Jan van II 1626–1679
Butterflies and Other Insects 1661
oil on copper 19.3 x 29
223

Kessel, Jan van II 1626–1679
Butterflies and Other Insects 1661
oil on copper 19.1 x 28.9
224

Kessel, Jan van II 1626–1679
A Vase of Flowers
oil on panel 29.8 x 21
PD.79-1973

Kessel, Jan van II 1626–1679
A Vase of Flowers
oil on copper 27.3 x 34.2
PD.32-1975

Kessel, Jan van II 1626–1679
Insects
oil on copper 11.7 x 15.2
298

Kessel, Jan van II 1626–1679
Insects
oil on copper 11.8 x 15.1
309

Kessel, Jan van II 1626–1679
Insects
oil on copper 11.7 x 15.2
312

Kessel, Jan van II 1626–1679
Insects
oil on copper 8.9 x 12.7
506
STOLEN

Kessel, Jan van II 1626–1679
Insects
oil on copper 8.5 x 12.6
508

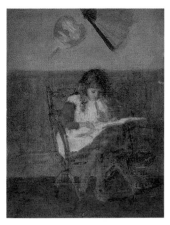

Kingsford, Florence Kate 1872–1949
Joan Kingsford Reading
oil on canvas 30.2 x 22.5
PD.144-1975

Klinghoffer, Clara 1900–1970
Mrs Jimmy H. Ede 1927
oil on canvas 40 x 30.5
PD.11-1982

Klomp, Albert Jansz. c.1618–1688/1689
Cattle in a Landscape
oil on panel 42.9 x 36.5
346

Klomp, Albert Jansz. c.1618–1688/1689
Cattle Piece
oil on panel 48 x 64.5
349

Klomp, Albert Jansz. c.1618–1688/1689
Sheep and Goats with a Shepherd
oil on panel 48.3 x 64.8
348

Knapton, George 1698–1778
Edward Morrison
oil on canvas 75.3 x 62.9
22

Knewstub, Walter John 1831–1906
O If I Were Grandma
oil & watercolour with gum on paper
mounted on panel 52.7 x 35.7
673

König, Johann 1586–1642
Adam and Eve in Paradise c.1629
oil on copper 17 x 23.3
PD.63-1974

Kustodiyev, Boris 1878–1927
Peter Kapitza 1926
oil on canvas 107.9 x 90.5
1770

Lachtropius, Nicolaes active c.1656–1700
Vase of Flowers
oil on canvas 55.8 x 49.4
PD.29-1966

Lamb, Henry 1883–1960
Lytton Strachey c.1913–1914
oil on canvas 59 x 46
2748

Lamb, Henry 1883–1960
The River Ebble, Wiltshire 1937
oil on canvas-covered millboard 50.5 x 60.3
PD.233-1961

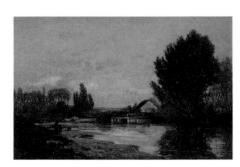

Lambinet, Emile Charles 1815–1877
The Mill
oil on canvas 37.5 x 56
PD.23-2003

Lance, George 1802–1864
Fruit Piece
oil on canvas 27.9 x 35.6
490

Lancret, Nicolas 1690–1743
'In this pleasant solitude...'
oil on panel 29.5 x 18.4
330

Lancret, Nicolas 1690–1743
Music Party in a Landscape
oil on panel 22 x 29
329

Lancret, Nicolas 1690–1743
'With a tender little song…'
oil on panel 27 x 19
317

Landseer, Edwin Henry 1802–1873
*The Pot of Gartness, Drymen,
Stirlingshire* c.1830
oil on panel 25.1 x 35.5
PD.20-1984

Lanyon, Peter 1918–1964
Shy Deep 1959
oil on canvas 152.9 x 152.8
PD.27-1984

László, Philip Alexius de 1869–1937
Sir Charles Walston
oil on canvas 92.7 x 72.4
PD.42-1986 🐝

Laurent, François Nicholas c.1775–1828
A Bowl of Flowers
oil on vellum laid down on canvas
69.8 x 53.3
PD.33-1975

Lauri, Filippo 1623–1694
The Agony in the Garden
oil on canvas 21.2 x 27.3
218

Lavery, John 1856–1941
Studies Made in the House of Lords
before 1922
oil on canvas 30.6 x 25.4
1072

Lavieille, Eugène Antoine Samuel
1820–1889
On the Banks of the Seine at Lévy, 1884 1884
oil on panel 27.8 x 49.2
PD.60-1996

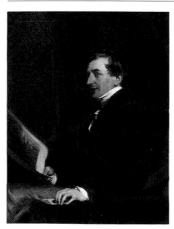

Lawrence, Thomas 1769–1830
Samuel Woodburn c.1820
oil on panel 109.2 x 83.5
27

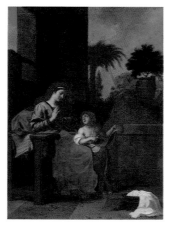

Le Brun, Charles 1619–1690
The Holy Family
oil on panel 56.8 x 43.5
339

Le Sidaner, Henri Eugène 1862–1939
The Pond Garden, Hampton Court
oil on wood 18.8 x 22.7
PD.1-1962

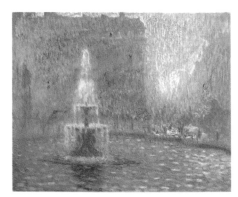

Le Sidaner, Henri Eugène 1862–1939
Trafalgar Square
pastel mixed with water on a partially primed
canvas 59.1 x 72.7
1540

Lear, Edward 1812–1888
The Temple of Apollo at Bassae 1854–1855
oil on canvas 146.4 x 229.5
460*

Leeb, Nat b.1906
The Tortoise 1940
oil, gouache & tempera on canvas 46 x 38
PD.12-1981

Leen, Willem van 1753–1825
Bowl of Flowers
oil on panel 54.6 x 44.4
PD.30-1966

Lees, Derwent 1885–1931
Lyndra in Wales 1910–1914
oil on panel 32.7 x 40.6
2450

Leeuwen, Gerrit Johan van 1756–1825
Flowers in an Urn, with Fruit 1809
oil on panel 77.9 x 58.6
PD.31-1966

Léger, Fernand 1881–1955
Young Girl Holding a Flower 1954
oil on canvas 55 x 46
PD.16-1974

Legros, Alphonse 1837–1911
The Reverend Robert Burn 1880
oil on canvas 63.5 x 45.7
94*

Legueult, Raymond Jean 1898–1971
*MOUTHIER: Abstract Landscape with
Trees* 1947
oil on canvas 74 x 93
PD.30-1970

**Leighton, Frederic, 1st Baron Leighton of
Stretton** 1830–1896
Miss Laing 1853
oil on canvas 106 x 75.5
1501

**Leighton, Frederic, 1st Baron Leighton of
Stretton** 1830–1896
On the Nile 1868
oil on canvas 26.9 x 41.5
PD.5-1979

**Leighton, Frederic, 1st Baron Leighton of
Stretton** 1830–1896
Clytie 1890–1892
oil on canvas 84.4 x 137.5
M.84

Lely, Peter 1618–1680
*Portrait of a Lady, Probably Mary Parsons,
Later Mrs Draper* c.1665
oil on canvas 126.1 x 101.6
2442

Lemonnier, Anicet Charles Gabriel 1743–
1824
Vesuvius in Eruption 1779
oil on paper 27.8 x 36
PD.11-1997

Lengele, Maerten d.1668
A Company of the Hague Arquebusiers c.1660
oil on canvas 81 x 65.4
M.27

Lépine, Stanislas 1835–1892
The Coast of Normandy
oil on canvas 15.5 x 26
711

Lewis, John Frederick 1805–1876
A Syrian Sheik, Egypt 1856
oil on panel 43.1 x 30.4
468

Lewis, Neville 1895–1972
H. S. Reitlinger
oil on canvas 76.6 x 64.2
PD.21-2005

Liberale da Verona c.1445–c.1526
Simon Magus Offering St Peter Money (…)
1470–1475
tempera on panel 30.5 x 56.2
PD.21-1961

Liberale da Verona c.1445–c.1526
*The Dead Christ Supported by Mourning
Angels* c.1489
tempera with oil glazes on panel 116.5 x 76
PD.21-2003

Licinio, Bernadino (attributed to)
c.1489–c.1565
An Unknown Youth 1540
oil on canvas 73.6 x 61.6
1785

Lievens, Jan Andrea c.1640/1644–before
1708
Dirck Decker of Amsterdam 1671
oil on canvas 137.8 x 131.4
28

Lin, Richard b.1933
Friday 1973
oil on canvas 63.5 x 63.5
PD.67-1974

Lingelbach, Johannes 1622–1674
A Port Scene
oil on canvas laid down on panel 30.7 x 36.6
PD.24-1983

Linnell, John 1792–1882
The River Kennet, near Newbury 1815
oil on canvas on wood 45.1 x 65.2
PD.55-1958

Linnell, John 1792–1882
Steep Hill, Isle of Wight 1815–1816
oil on millboard 19.7 x 35
PD.248-1985

Linnell, John 1792–1882
Sunset over a Moorland Landscape
early 1850s
oil on panel 21.3 x 25.6
PD.7-1950

Linnell, John 1792–1882
Autumn Woods
oil on panel 19.7 x 30.5
PD.963-1963

Linnell, John 1792–1882
Christ and the Woman of Samaria at Jacob's Well
oil on panel 19.5 x 42.4
PD.22-1981

Linnell, John 1792–1882
Shoreham Vale
oil on panel 16.8 x 22
PD.156-1985

Linnell, John 1792–1882 **& Palmer, Hannah Emma** 1818–1893
Job Offering a Sacrifice on His Return to Prosperity 1845
oil on panel 56 x 76
PD.11-2000

Linnell, William 1826–1906
View near Redhill
oil over graphite on paper 30.8 x 47.8
PD.47-1971

Lint, Hendrik Frans van 1684–1763
The Villa Madama, Rome 1748
oil on canvas 36.8 x 46.3
265

Lint, Hendrik Frans van 1684–1763
Coast Scene 1756
oil on canvas 21.6 x 15.2
245

Lint, Hendrik Frans van 1684–1763
Landscape with Figures and Cattle 1756
oil on canvas 21.6 x 15.2
246

Linthorst, Jacobus 1745–1815
Vase of Flowers 1799
oil on panel 71 x 55.3
PD.32-1966

Linthorst, Jacobus 1745–1815
Vase of Flowers
oil on panel 71 x 54.6
PD.33-1966

Linton, William 1791–1876
Mistra
oil on canvas 114.9 x 107
493

Liot, A. active 19th C
A Bowl of Flowers
oil on canvas 53.9 x 40.6
PD.34-1975

Liotard, Jean-Étienne 1702–1789
Louise Elizabeth, Madame Infanta
c.1750–1751
oil on canvas 59.5 x 50
PD.56-2005

Lippi, Filippo c.1406–1469
Virgin and Child (centre)(...)
tempera with gold on panel
41.9 x 11.8; 41.9 x 26.7; 42.3 x 11.4
559

Liss, Johann 1597–1631
A Bacchanalian Feast c.1617
oil on panel 34.2 x 27.3
PD.100-1978

Lisse, Dirck van der 1586–1669
Landscape with Diana and Actaeon
oil on panel 25 x 36.8
407

Lizars, William Home (attributed to)
1788–1859
John Cowper, an Edinburgh Beggar
oil on canvas 75.9 x 62.8
1756

Loir, Nicolas Pierre (attributed to)
1624–1679
Christ and the Woman of Samaria
oil over pen & ink outlines on paper,
mounted on canvas 26.7 x 37.8
337

Facing page: Hals, Frans, c.1581–1666, *Portrait of an Unknown Man* (detail), 1660–1663, (p. 80)

Loiseau, Gustave 1865–1935
The Iron Bridge, St Ouen 1908
oil on canvas 61 x 73.7
1497

Lonsdale, James 1777–1839
Dr Samuel Parr before 1823
oil on canvas 76.5 x 64.2
25

Lopez, Gasparo d.c.1732
Flowers in a Landscape
oil on copper 34.7 x 24.6
PD.47-1975

Lopez, Gasparo d.c.1732
Flowers in a Landscape with Overturned Urn
oil on copper 34.7 x 24.6
PD.48-1975

Lopez, Gasparo d.c.1732
Vase of Flowers
oil on canvas 73 x 58.4
PD.34-1966

Lorenzo Monaco c.1370–1425
Virgin and Child Enthroned with Two Attendant Angels c.1400–1403
tempera with gold on panel 32.4 x 21.2
555

Lorrain, Claude 1604–1682
Pastoral Landscape with Lake Albano and Castel Gandolfo 1639
oil on tin 30.5 x 37.5
PD.950-1963

L'Ortolano 1485–c.1527
St John the Baptist c.1525
oil on panel 73.7 x 53.3
160

Loutherbourg, Philip James de 1740–1812
The River Wye at Tintern Abbey 1805
oil on canvas 108 x 161.9
PD.46-1958

Lowry, Laurence Stephen 1887–1976
After the Wedding 1939
oil on canvas 53.3 x 43.4
PD.6-2002

Luca di Tommè active 1355–1389
Virgin and Child Enthroned 1367–1370
tempera with gold on panel 160 x 85.5
563

Luini, Bernadino (attributed to)
c.1480–c.1532
Child Angel Playing a Flute
oil on canvas 35.4 x 28
634

Lust, Antoni de (attributed to) active 1650
Flower Piece
oil on canvas 64.8 x 51.8
313

Lust, Antoni de (attributed to) active 1650
Glass Vase of Flowers
oil on canvas 55.8 x 45.1
PD.35-1966

MacColl, Dugald Sutherland 1859–1948
Blue Glass and Pippin
oil on canvas 27.8 x 21.7
PD.142-1994

Mackley, George 1900–1983
Brackie's Burn, Northumberland
oil on canvas 50 x 60
PD.5-1982

Maes, Dirk 1659–1717
A Riding School
oil on canvas 40.8 x 48.9
370

Maes, Dirk 1659–1717
A Riding School
oil on canvas 40 x 47.9
371

Maes, Dirk 1659–1717
Stag Hunt
oil on canvas 32.4 x 40
369

Magnasco, Alessandro 1667–1749
Landscape with Camaldolite Monks Praying at a Roadside Shrine 1720s
oil on canvas 115.5 x 82.2
PD.29-2000

Maineri, Gian Francesco de
active 1489–1506
The Virgin and Child Enthroned (...)
c.1500
oil on panel 28 x 21
PD.30-2000

Maitland, Paul Fordyce 1863–1909
In Kensington Gardens
oil on canvas 29 x 49.5
PD.20-1979

Manzuoli, Tommaso 1531–1571
The Visitation 1560
oil on panel 408.8 x 248.6
496

Maratti, Carlo 1625–1713
Cardinal Jacopo Rospigliosi 1667–1669
oil on canvas 100 x 75.2
PD.6-1962

Maratti, Carlo (copy after) 1625–1713
The Virgin Teaching the Infant Christ to Read
oil on canvas 97.8 x 74
131

Marchand, Jean Hippolyte 1883–1940
Still Life
oil on canvas 35.3 x 27.7
PD.87-1974

Marellus, Jacob 1614–1678
Vase of Flowers 1640
oil on panel 46.5 x 36.2
PD.36-1966

Marieschi, Michele Giovanni 1710–1743
The Grand Canal, Venice, above the Rialto Bridge
oil on canvas 62 x 96.4
190

Marieschi, Michele Giovanni (copy after)
1710–1743
The Grand Canal with San Simeone, Venice 1738–1741
oil on canvas 61.9 x 98.4
182

Marion, Antoine Fortune 1846–1900
The Village Church 1866–1870
oil on canvas 64.8 x 50
PD.4-1956

Mariotto di Nardo active 1394–1424
The Coronation of the Virgin
tempera with gold on panel 80.7 x 52.1
M.28

Marlow, William 1740–1813
View near Naples
oil on canvas 73 x 98.4
PD.1-1952

Marquet, Albert 1875–1947
River Scene
oil on canvas 54.2 x 65
PD.34-1991

Martin, John 1789–1854
Landscape: View in Richmond Park 1850
oil on paper marouflé onto Sunderland A board with cellofas 50.8 x 91.5
PD.26-1977

Martin, John 1789–1854
Twilight in the Woodlands 1850
oil on paper, laid down on canvas 38.1 x 76.3
1502

Martini, Simone c.1284–1344
St Geminianus, St Michael and St Augustine, Each with an Angel above c.1319
tempera with gold & silver on panel
109.3 x 38.3; 110.3 x 38.3; 110.5 x 38.3
552

Martino di Bartolomeo d.1434/1435
The Annunciation 1402–1404
tempera with gold on panel
35.8 x 24.8; 35.8 x 24.8
553

Mason, George Heming 1818–1872
Landscape c.1869
oil on paper, laid down on wood 25.7 x 35.3
1019-b

Master of the Castello Nativity
active second half of 15th C
Virgin Adoring the Child c.1460–1465
tempera with oil glazes & gold on panel
87 x 59
M.14

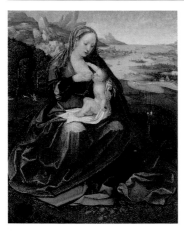

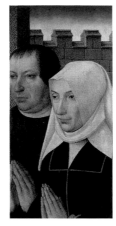

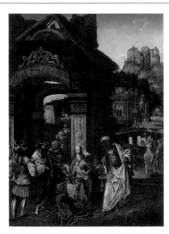

Master of the Female Half-Lengths
active c.1525–1550
Virgin and Child
oil on panel 39.7 x 32.7
M.71

Master of the Magdalen Legend
c.1483–c.1530
*Two Donors from a Wing of an
Altarpiece* c.1515
oil on panel 54 x 27
2549

Master of the Munich Adoration
active c.1520
The Adoration of the Kings
oil on panel 69.5 x 52.7
M.1

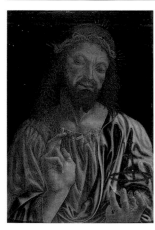

Master of the Pala Sforzesca
active c.1490–c.1500
Salvator mundi c.1490–1494
oil on panel 44.4 x 30.8
PD.4-1955

Master of the Saint Ursula Legend (circle of)
active c.1485–1515
The Entombment
grisaille oils on panel 31.7 x 12
1518a

Master of the Saint Ursula Legend (circle of)
active c.1485–1515
The Virgin of the Annunciation
grisaille oils on panel 32.7 x 13
1518b

Master of the Statthalterin Maria
active 1530–1540
Portrait of a Man c.1540
oil on panel 34.3 x 26
282

Master of Verucchio c.1320–1350
Crucifixion c.1345
tempera with gold on panel 20 x 12.7
PD.8-1955

Matisse, Henri 1869–1954
The Studio under the Eaves c.1903
oil on canvas 55.2 x 46
PD.14-1964

Matisse, Henri 1869–1954
Woman Seated in an Armchair c.1917
oil on canvas 40.5 x 32.5

Matisse, Henri 1869–1954
Boats on the Beach, Etrétat 1920
oil on canvas-covered millboard 37.5 x 45.4
PD.8-1966

Matisse, Henri 1869–1954
The Bulgarian Blouse 1920
oil on canvas 41 x 32.7
2400

Matisse, Henri 1869–1954
Women on the Beach, Etrétat 1920–1921
oil on canvas 54.3 x 65.2
PD.15-1964

Mazzolino, Lodovico c.1480–c.1530
Christ before Pilate c.1530
oil on panel 54 x 42.5
M.55

McEvoy, Ambrose 1878–1927
Professor James Ward 1913
oil on canvas 91.7 x 71.1
1144

Meulen, Adam Frans van der (studio of)
1631/1632–1690
Siege of Besançon by Condé in 1674 c.1674
oil on canvas 106.3 x 145.5
132

Meyer, Henry Hoppner 1782–1847
George Dyer with His Dog Daphne 1819
oil on canvas 90.2 x 70.5
609

Meyer, Jan van c.1681–after 1741
The Daughters of Sir Matthew Decker, Bt 1718
oil on canvas 77.5 x 66.1
437

Meyer, Jeremiah 1735–1789
Adoration of the Kings (after Theodor van Loon)
oil on panel 29 x 41.3
277

Michallon, Achille Etna 1796–1822
The Oak and the Reed 1816
oil on canvas 43.5 x 53.5
PD.180-1991

Michau, Theobald 1676–1765
Wooded Landscape with Stream and Figures
oil on panel 16.5 x 22.5
547

Michel, Georges 1763–1843
Landscape with a Windmill
oil on panel 59.2 x 80.7
2313

Michetti, Francesco Paolo 1851–1929
Study for 'The Return from the Campagna'
oil on panel 19 x 10.1
PD.32-2000

Middleton, John 1827–1856
A Path through a Wooded Landscape
oil on canvas 37 x 58.2
PD.259-1985

Facing page: Riley, Bridget, b.1931, *Shadow Play* (detail), 1990, (p. 150)

Miel, Jan 1599–1663
The Veneration of St Lambert c.1648
oil on canvas 76.8 x 50.2
PD.9-1974

Miereveld, Michiel Jansz. van 1567–1641
Portrait of a Lady c.1615
oil on panel 65.4 x 55
2311

Miereveld, Michiel Jansz. van 1567–1641
Aeltje van der Graft 1619
oil on panel 113.7 x 86.3
M.56

Miereveld, Michiel Jansz. van 1567–1641
Heyndrik Damensz. van der Graft 1620
oil on panel 113.7 x 86.3
M.57

Mieris, Frans van the elder 1635–1681
Dutch Courtship 1675
oil on panel 27 x 20
32

Mieris, Frans van the younger 1689–1763
Man with a Tankard 1739
oil on panel 21.3 x 16.8
365

Mieris, Willem van 1662–1747
*Landscape with Ruins, Nymphs
Bathing* c.1730
oil on panel 30.2 x 35.9
393

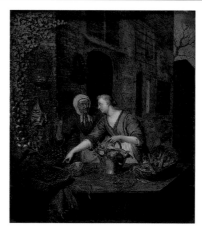

Mieris, Willem van 1662–1747
The Market Stall c.1730
oil on panel 41.9 x 35.9
36

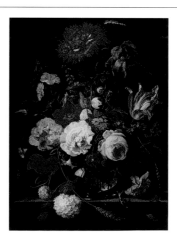

Mignon, Abraham 1640–c.1679
Flower Piece
oil on panel 50.8 x 36.8
306

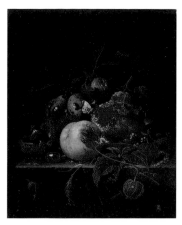

Mignon, Abraham 1640–c.1679
Still Life: Fruit and Nuts on a Stone Ledge
oil on panel 34 x 27
PD.104-1992

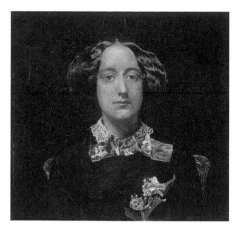

Millais, John Everett 1829–1896
Mrs Coventry Patmore 1851
oil on panel 19.7 x 20.3
1010

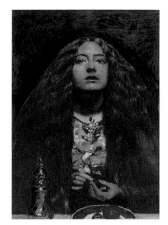

Millais, John Everett 1829–1896
The Bridesmaid 1851
oil on panel 27.9 x 20.3
499*

Millais, John Everett 1829–1896
The Twins, Kate and Grace Hoare 1876
oil on canvas 153.5 x 113.7
PD.36-2005

Millar, James active 1763–1805
Young Man in Red 1769
oil on canvas 74.3 x 62.2
PD.21-1951

Modigliani, Amedeo 1884–1920
Portrait of a Young Woman, Seated c.1915
oil on paper on board 75 x 52.4
PD.29-1998

Mola, Pier Francesco 1612–1666
Landscape with Mythological Figures
oil on canvas mounted on panel 18.4 x 24.7
323

Molenaer, Klaes d.1676
Landscape with Sportsmen
oil on panel 30.5 x 25.7
67

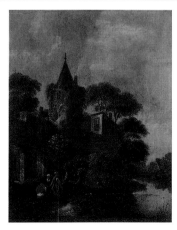

Molenaer, Klaes d.1676
Outside the Town Wall
oil on panel 51.1 x 40
639

Molyn, Pieter 1595–1661
Landscape with Figures c.1635
oil on panel 40 x 60
46

Molyn, Pieter 1595–1661
Landscape with Figures c.1655–1660
oil on panel 44.4 x 66
45

Momper, Frans de 1603–1660
A Village in Winter
oil on panel 22.9 x 34.9
M.81

Monet, Claude 1840–1926
*The Rock Needle and Porte d'Aval,
Etrétat* 1885?
oil on canvas 64.8 x 81
PD.26-1998

Monet, Claude 1840–1926
Rocks at Port Coton, the Lion Rock 1886
oil on canvas 65.4 x 81.2
PD.27-1998

Monet, Claude 1840–1926
Springtime 1886
oil on canvas 64.8 x 80.6
PD.2-1953

Monet, Claude 1840–1926
Poplars 1891
oil on canvas 89 x 92
PD.9-1966

Moni, Louis de 1698–1771
The Fishmonger
oil on panel 31.4 x 26.3
358

Moni, Louis de 1698–1771
The Fishwife
oil on panel 34 x 27.8
360

Monnoyer, Jean-Baptiste 1636–1699
An Urn with Flowers 1698
oil on canvas 198.1 x 116.9
PD.60-1974

Monnoyer, Jean-Baptiste 1636–1699
Still Life of Mixed Flowers in a Vase on a Ledge
oil on canvas 107.5 x 85
PD.120-1992

Monnoyer, Jean-Baptiste 1636–1699 &
Monnoyer, Antoine 1677–1745
A Floral Composition
oil on canvas 108.6 x 157.5
PD.23-1975

Monti, Francesco 1685–1768
The Apotheosis of St Martin 1756
oil on canvas 60 x 44
PD.61-1992

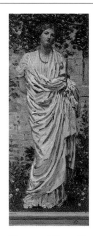

Moore, Albert Joseph 1841–1893
The Umpire 1888
oil on canvas 45.1 x 18.2
2518

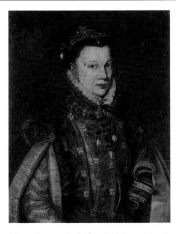

Mor, Antonis (after) 1512–1516–c.1576
Elisabeth of Valois
oil on panel 70.2 x 55.3
M.62

Mor, Antonis (after) 1512–1516–c.1576
Portrait of a Man as St Sebastian
oil on panel 89.8 x 71.1
2517

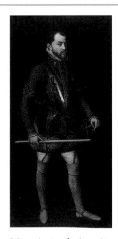

Mor, Antonis (studio of) 1512–1516–c.1576
Philip II of Spain after 1557
oil on panel 186.1 x 94
M.64

More, Jacob 1740–1793
Bonnington Linn on the River Clyde
oil on canvas 71.1 x 91.2
7

Moreelse, Paulus 1571–1638
*A Girl with a Mirror, an Allegory of Profane
Love* 1627
oil on canvas 105.5 x 83
PD.32-1968

Morland, George 1763–1804
Visit to the Child at Nurse c.1788
oil on canvas 64 x 77.7
PD.115-1992

Morland, George 1763–1804
Donkey and Pigs 1789
oil on canvas 30.5 x 38.1
14

Morland, George 1763–1804
Landscape with Figures c.1790–1793
oil on canvas 29.8 x 36.8
19

Morland, George 1763–1804
Watering Horses after 1791
oil on canvas 85.6 x 117.2
1604

Morland, George 1763–1804
Morning (The Benevolent Sportsman) 1792
oil on canvas 101.6 x 137.2
1786

Morland, George 1763–1804
The Smugglers 1792
oil on canvas 102 x 142
PD.110-1992

Morland, George 1763–1804
A Windy Day
oil on canvas 92.5 x 143.5
PD.105-1992

Morland, George 1763–1804
Buying Fish
oil on panel 31.2 x 37.2
PD.16-1997

Morland, George 1763–1804
Calf and Sheep
oil on canvas 30.5 x 38.7
13

Morland, George 1763–1804
Coast Scene
oil on canvas 25.4 x 30.2
20

Morland, George 1763–1804
Encampment of Gypsies
oil on canvas 64.1 x 76.5
6

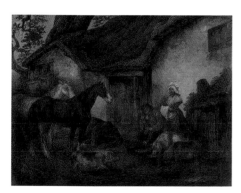

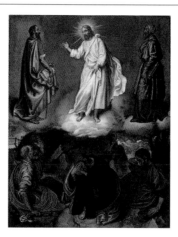

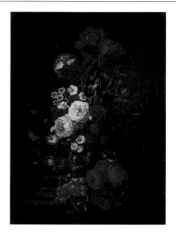

Morland, George (after) 1763–1804
The Farmyard 1797?
oil on canvas 91.2 x 121.3
1603

Moroni, Giovanni Battista c.1525–1578
The Transfiguration
oil on canvas 77.5 x 59.4
1020

Moser, Mary 1744–1819
Vase of Flowers
oil on canvas 72.1 x 53.6
PD.38-1966

Mostaert, Jan c.1475–1555/1556
Ecce homo
oil on panel 89.8 x 69
2576

Motesiczky, Marie Louise von 1906–1996
At the Dressmaker's 1930
oil on canvas 113 x 60.1
PD.55-1993

Motesiczky, Marie Louise von 1906–1996
Baron Philippe de Rothschild 1986
oil on canvas 87.3 x 72.6
PD.56-1993

Moynihan, Rodrigo 1910–1990
Self Portrait in a Mirror 1940
oil on canvas 30.3 x 40.5
PD.15-1986

Müller, William James 1812–1845
River Landscape with an Angler 1842
oil on millboard on wood 30.2 x 45.5
PD.1-1974

Müller, William James 1812–1845
Millpond with Children Fishing 1843
oil on canvas 92.5 x 71.5
1103

Müller, William James 1812–1845
Landscape with a Cottage
oil on canvas 37 x 27
PD.63-1997

Mulready, William 1786–1863
The Farrier's Shop after 1820
oil on canvas 40.9 x 52.1
952

Mundy, Henry b.1919
Composition
oil on paper 55.5 x 76
PD.58-1992

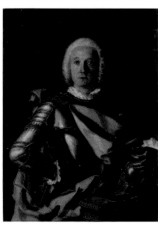

Mura, Francesco de 1696–1782
*Count James Joseph O'Mahoney, Lieutenant-
General in the Neapolitan Service, Knight of St
Januarius* c.1748
oil on canvas 99 x 73
PD.4-1984

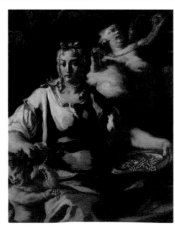

Mura, Francesco de 1696–1782
Liberality
oil on canvas 35.3 x 27.5
PD.19-1992

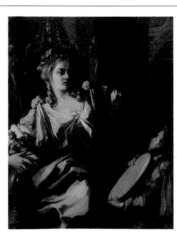

Mura, Francesco de 1696–1782
Wisdom or Nobility
oil on canvas 35.3 x 27.5
PD.18-1992

Murant, Emanuel 1622–1700
Landscape with a Bridge
oil on panel 19.1 x 26
402

Murillo, Bartolomé Esteban 1618–1682
The Vision of Fray Lauterio c.1640
oil on canvas 217.8 x 172.1
100

Murillo, Bartolomé Esteban 1618–1682
St John the Baptist with the Scribes and Pharisees c.1655
oil on canvas 261.2 x 178.8
334

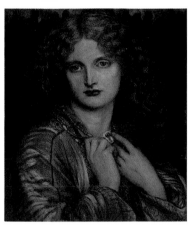

Murray, Charles Fairfax 1849–1919
The Flaming Heart (after Dante Gabriel Rossetti) 1863
oil on panel 33 x 27.9
2293

Nash, John Northcote 1893–1977
The Edge of the Plain 1926
oil on canvas 50.8 x 61
PD.36-1991 🐝

Nash, Paul 1889–1946
Coronilla (recto) 1929
oil on canvas 61.2 x 50.8
PD.59-1997

Nash, Paul 1889–1946
Landscape (verso) 1929
oil on canvas 61.2 x 50.8
PD.59a-1997

Nash, Paul 1889–1946
November Moon 1942
oil on canvas 76.2 x 50.8
PD.6-1955

Nasmyth, Alexander 1758–1840
Loch Doon, Ayrshire
oil on canvas 45.2 x 61
PD.2-1974

Nasmyth, Patrick 1787–1831
A View of the Douglas Bridge near Inverary, Argyllshire 1818
oil on canvas 35.7 x 58.1
PD.17-1997

Nasmyth, Patrick 1787–1831
View near Norwood 1821–1822
oil on panel 28.8 x 38.7
1787

Nasmyth, Patrick 1787–1831
View in Leigh Woods 1830
oil on canvas 71.4 x 101.9
PD.8-1956

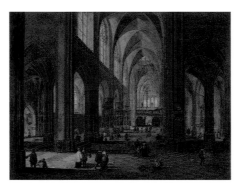

Nason, Pieter c.1612–c.1690
Man in Armour with Yellow, Flowing Hair
oil on canvas 113.2 x 90.4
PD.16-2005

Neeffs, Peeter the younger 1620–1675
Interior of a Gothic Church c.1650–1660
oil on canvas 57.2 x 76.8
91

Neer, Aert van der 1603–1677
An Estuary by Moonlight c.1645–1658
oil on panel 19 x 27.2
PD.250-1985

Neroccio de' Landi (studio of) 1447–1500
Virgin and Child with St Bernardino and St Catherine of Siena c.1495
tempera with gold on panel 47.3 x 31.7
554

Netscher, Theodorus 1661–1732
Pineapple Grown in Sir Matthew Decker's Garden at Richmond, Surrey 1720
oil on canvas 84.3 x 95.2
357

Netscher, Theodorus 1661–1732
Sir Matthew Decker, Bt
oil on canvas 92.1 x 74
443

Newton, Herbert H. 1881–1959
The Valley of the Palud, towards Sunset 1928
oil on canvas 50.8 x 76.2
1522

Neyn, Pieter de 1597–1639
Halt at an Inn c.1628
oil on panel 33.5 x 63.2
M.46

Nicholson, Ben 1894–1982
White Relief, 1936, Second Version 1957
oil on carved board 64.4 x 87.6
PD.28-1977

Nicholson, Ben 1894–1982
Ivory 1979
ink & oil on millboard 53 x 70
PD.38-1986

Nicholson, Kate b.1929
Jug Leaf 1958
oil on canvas 50.8 x 40.5
PD.59-1992

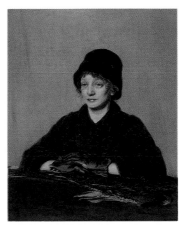

Nicholson, William 1872–1949
The Girl with a Tattered Glove 1909
oil on canvas 89.8 x 71.1
892

Nicholson, William 1872–1949
Armistice Night 1918
oil on canvas 54 x 59.1
1498

Nicholson, William 1872–1949
Field Marshall J. C. Smuts 1923
oil on canvas 60 x 54.9
907

Nicholson, William 1872–1949
A. C. Benson 1924
oil on panel 56.9 x 66.7
1138

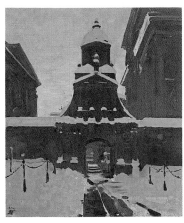

Nicholson, William 1872–1949
The Gate of Honour under Snow 1924
oil on canvas 61.2 x 51.4
1125

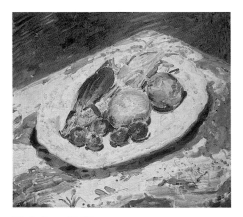

Nicholson, William 1872–1949
Still Life, Fruit on a Dish 1929?
oil on panel 54.3 x 59.4
1524

Nicholson, William 1872–1949
Matadero, Segovia 1935
oil on panel 37.7 x 45.7
PD.10-1967

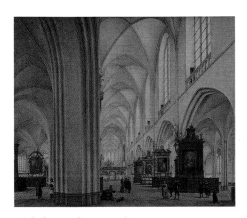

Nickele, Isaak van active 1660–1703
St Bavo, Haarlem 1668
oil on canvas 58.4 x 68
82

Nickele, Jan van (attributed to) 1656–1721
Architecture with Figures c.1710–1720
oil on panel 58.1 x 73.3
354

Noland, Kenneth b.1924
Saturday Morning 1965
acrylic resin on canvas 218 x 218
PD.30-1984

Nomé, François de c.1593–after 1644
King Asa of Judah Destroying the Idols
oil on canvas 73.9 x 100.9
PD.12-1962

Northcote, James 1746–1831
Joseph Nollekens
oil on canvas 60 x 48.6
23

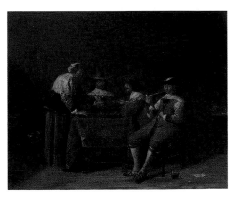

Olis, Jan c.1610–1676
Gentlemen Playing Backgammon
c.1635–1640
oil on panel 32.1 x 41
405

Facing page: Panini, Giovanni Paolo, c.1692–1765, *Capriccio of Roman Ruins with the Colosseum* (detail), 1737, (p. 136)

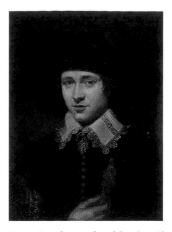

Olivuccio di Cicarello da Camerino
c.1365–1439
St Peter and St Paul with Angels c.1400
tempera with gold on panel 164.4 x 37.1
1061A

Olivuccio di Cicarello da Camerino
c.1365–1439
*St James and Possibly St Andrew with
Angels* c.1400
tempera with gold on panel 164.4 x 36.8
1061B

Oost, Jacob van the elder (attributed to)
1603–1671
Portrait of a Man Holding a Statuette 1629
oil on panel 64.5 x 49.8
89

Oosterwyck, Maria van 1630–1693
A Vase of Flowers
oil on canvas 62.8 x 53.3
PD.27-1975

Orioli, Pietro di Francesco degli 1458–1496
The Baptism of Christ
tempera with oil glazes & gold on panel
38 x 26.9
PD.980-1963

Orioli, Pietro di Francesco degli 1458–1496
The Resurrection
tempera with oil glazes & gold on panel
38 x 26.9
PD.981-1963

Orley, Bernaert van (attributed to)
c.1492–1541
The Annunciation
oil on panel 68 x 54
98

Orpen, William 1878–1931
The Right Honourable Sir Clifford Allbutt
by 1920
oil on canvas 127 x 102.2
1143

Orpen, William 1878–1931
Self Portrait 1924?
oil on panel 79.1 x 64.8
1486

Os, Georgius Jacobus Johannes van
1782–1861
A Vase of Flowers
oil on panel 59.6 x 44.5
PD.80-1973

Os, Jan van 1744–1808
A Vase of Flowers
oil on panel 51 x 40.4
PD.81-1973

Os, Jan van 1744–1808
Flowers and Fruit
oil on panel 78.7 x 58.7
PD.82-1973

Os, Jan van 1744–1808
Fruit Piece
oil on panel 44.8 x 34.6
302

Os, Jan van 1744–1808
Fruits and Flowers
oil on panel 81.3 x 59.9
PD.83-1973

Os, Jan van 1744–1808
Still Life with Fruit, Flowers and Fish
oil on canvas 47.3 x 36.4
PD.35-1975

Os, Jan van 1744–1808
Vase of Flowers and Fruit
oil on panel 80.1 x 58.6
M.67

Ostade, Adriaen van 1610–1685
Fiddler at the Door of a House 1639
oil on panel 31.3 x 26.4
70

Ostade, Adriaen van 1610–1685
Peasants Smoking
oil on panel 23.5 x 20.3
64

Oudry, Jean-Baptiste 1686–1755
Huntsman with a Tufter on a Leash
oil on canvas 99.5 x 79
PD.20-1988

Ouless, Walter William 1848–1933
Professor Sir George Murray Humphrey 1886
oil on canvas 65.4 x 54.6
495

Palma, Jacopo il giovane 1544/1548–1628
Christ Calling Zacchaeus 1575?
oil on canvas 100.8 x 41.9
108

Palma, Jacopo il giovane 1544/1548–1628
Elijah and the Angel 1575?
oil on canvas 100.8 x 41.9
111

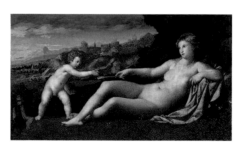

Palma, Jacopo il vecchio c.1479–1528
Venus and Cupid c.1523–1524
oil on canvas 118.1 x 208.9
109

Palmer, Samuel 1805–1881
View of Lee, North Devon 1834
oil on canvas 26.7 x 38.1
PD.8-2003

Panini, Giovanni Paolo c.1692–1765
Ruins with Figures c.1720
oil on canvas 40.6 x 31.7
199

Panini, Giovanni Paolo c.1692–1765
Ruins with Figures c.1720
oil on canvas 40.6 x 31.7
204

Panini, Giovanni Paolo c.1692–1765
Capriccio of Roman Ruins with the Colosseum
1737
oil on canvas 36.8 x 69.2
PD.107-1992

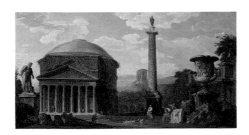

Panini, Giovanni Paolo c.1692–1765
Capriccio of Roman Ruins with the Pantheon 1737
oil on canvas 36.8 x 69.2
PD.108-1992

Panini, Giovanni Paolo c.1692–1765
Marcus Curtius Leaping into the Gulf
oil on canvas 73.7 x 98.1
207

Paolo Schiavo 1397–1478
Tabernacle: The Virgin of Humility, with a Complete Cycle of Sin and Redemption (made for a flagellant company) c.1440/1445
tempera with gold on panel 44.5 x 17.1
557

Pasinelli, Lorenzo 1629–1700
A Sibyl c.1650–1657
oil on canvas 66 x 49.2
137

Passeri, Giuseppe 1654–1714
Vision of St Philip Neri c.1700
oil on canvas 89.5 x 58.7
155

Patch, Thomas 1725–1782
Interior of an Italian Coffee House 1747–1755
oil on canvas 38.7 x 50.5
87

Patel, Pierre I c.1605–1676
Landscape with Classical Ruins 1640–1645
oil on canvas 64.8 x 85.7
331

Pater, Jean-Baptiste 1695–1736
Elegant Company in a Park
oil on canvas 72.4 x 88.8
PD.121-1992

Pater, Jean-Baptiste 1695–1736
The Fortune Teller
oil on canvas 34 x 45.5
PD.113-1992

Pater, Jean-Baptiste 1695–1736
The Swing
oil on canvas 46.3 x 56.5
PD.22-1997a

Peeters, Bonaventura I 1614–1652
River Scene
oil on panel 20.9 x 27.3
413

Peeters, Bonaventura I 1614–1652
Sea Coast with a Storm
oil on panel 12.4 x 20.9
399

Peeters, Bonaventura I 1614–1652
Sea Piece with Figures
oil on panel 32.1 x 45.1
347

Pellegrini, Giovanni Antonio (attributed to)
1675–1741
St Catherine of Siena before Pope Gregory XI
oil on canvas 28 x 38.7
PD.57-1992

Peploe, Samuel John 1871–1935
Still Life c.1906–1907
oil on panel 24.4 x 34.9
700 🐝

Pérez, Bartolomé 1634–1693
Flowers in a Sculpted Vase 1666
oil on canvas 84 x 62.8
PD.43-1954

Perryman, Margot b.1938
Untitled c.1963
oil on canvas 182.8 x 152.4
PD.34-2003

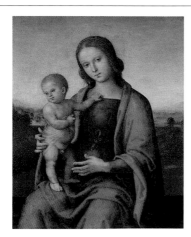

Perugino (studio of) c.1450–1523
Virgin and Child c.1515
tempera on panel 54 x 45.5
120

Petersen, Vilhelm 1812–1880
View towards Hesbjerg from the Hornbaek Estate 1857
oil on paper on board 21 x 30
PD.30-2002

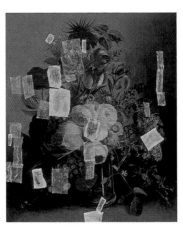

Petter, Franz Xaver 1791–1866
Jug of Flowers
oil on panel 83.8 x 67.2
PD.39-1966

Pettie, John 1839–1893
Mrs Bossom, the Artist's Mother 1870
oil on canvas 34.3 x 29.2
2132

Phillip, John 1817–1867
Spanish Carnival
oil on millboard 60.7 x 50.8
1021

Phillips, Thomas 1770–1845
Hugh Percy, Third Duke of Northumberland 1803
oil on canvas 76 x 63.6
10

Philpot, Glyn Warren 1884–1937
The Dog-Rose (La zarzarosa) 1910–1911
oil on canvas 265 x 184
2472

Philpot, Glyn Warren 1884–1937
Siegfried Sassoon 1917
oil on canvas 61 x 50.8
1121

Piazzetta, Giovanni Battista 1682–1754
The Death of Darius before 1745
oil on canvas 40.8 x 78.7
1117

Picart, Jean Michel 1600–1682
A Vase of Flowers
oil on panel 50.1 x 38.5
PD.36-1975

Picart, Jean Michel 1600–1682
A Vase of Flowers
oil on panel 50.1 x 38.5
PD.37-1975

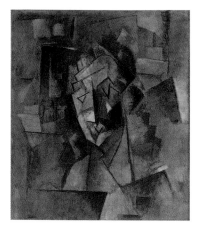

Picasso, Pablo 1881–1973
Cubist Head (Portrait of Fernande)
c.1909/1910
oil on canvas 66 x 53
PD.13-1974

Picasso, Pablo 1881–1973
Still Life: Green Apple and Glass 1923
oil, sand & body colour on canvas 23.5 x 32.5

Picasso, Pablo 1881–1973
Still Life: Bowl and Apples 1924
oil on canvas 32 x 38

Picolet, Cornelis 1626–1679
Boy Drinking
oil on panel 15.5 x 12.3
406

Picot, François Eduard 1786–1868
Adélaïde-Sophie Cléret, Mme Tiolier
c.1817
oil on canvas 46.3 x 35.6
PD.98-1978

Picot, François Eduard 1786–1868
Nicolas-Pierre Tiolier c.1817
oil on canvas 46.4 x 35.7
PD.97-1978

Pietersz., Gertrude active c.1718
Still Life of Flowers
oil on canvas 79 x 67
58

Pietro di Niccolò da Orvieto 1430–1484
Virgin and Child c.1450
tempera with gold on panel 31.4 x 20.3
1757

Facing page: Domenico Veneziano, active 1438–1461, *A Miracle of St Zenobius* (detail), 1442–1448, (p. 54)

Pignoni, Simone 1611–1698
A Poet, Presented to Jupiter by Hercules is
Crowned by Glory, below Venus, Cupid and
the Poet
oil on canvas 45 x 25
PD.20-1992

Pils, Isidore Alexandre
Augustin 1813/1815–1875
Study for the Head of a Young Arab
c.1860–1862
oil on canvas 33 x 24
PD.54-1998

Pino, Paolo (attributed to) active 1534–1565
Man in a Fur Coat c.1540
oil on canvas 83.2 x 76.2
M.11

Pinturicchio, Bernardino c.1454–1513
Virgin and Child with St John the Baptist
1490–1495
tempera with oil glazes & gold on panel
56.7 x 40.7
119

Pissarro, Camille 1830–1903
Road to Port-Marly 1860–1867
oil on panel 22.9 x 33.7
PD.58-1958

Pissarro, Camille 1830–1903
Study for 'The Banks of the Marne' 1864
oil on canvas 24.4 x 32.4
PD.23-1964

Pissarro, Camille 1830–1903
Haymaking 1874
oil on canvas 45.5 x 54.8
PD.16-1964

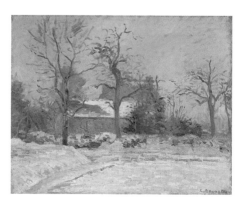

Pissarro, Camille 1830–1903
Piette's House at Montfoucault: Snow Effect
1874
oil on canvas 60 x 73.5
PD.10-1966

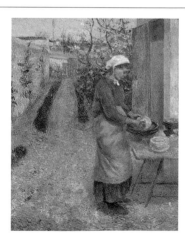

Pissarro, Camille 1830–1903
In the Garden at Pontoise: A Young Woman
Washing Dishes 1882
oil on canvas 81.9 x 65.3
PD.53-1947

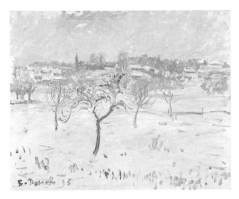

Pissarro, Camille 1830–1903
Snowy Landscape at Eragny with an Apple Tree 1895
oil on canvas 38.2 x 46.2
PD.974-1963

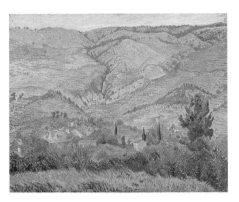

Pissarro, Lucien 1863–1944
Le Ragas, near Toulon 1930
oil on canvas 54.3 x 65.1
PD.18-1948

Pitati, Bonifazio de' 1487–1553
The Trial of Moses
oil on panel 16.9 x 24
PD.40-1992

Pittoni, Giovanni Battista the younger 1687–1767, **Valeriani, Domenico** d.1771 (...)
An Allegorical Monument to Sir Isaac Newton 1727–1729
oil on canvas 220 x 139
PD.52-1973

Poelenburgh, Cornelis van 1594/1595–1667
Adoration of the Kings
oil on copper 32.4 x 43.5
397

Poelenburgh, Cornelis van 1594/1595–1667
Jan Both
oil on copper 14 x 12.4
545

Poelenburgh, Cornelis van 1594/1595–1667
Landscape with Abraham and Isaac
oil on copper 19 x 23.8
388

Poelenburgh, Cornelis van 1594/1595–1667
Landscape with the Finding of Moses
oil on panel 19 x 25.4
389

Poelenburgh, Cornelis van (style of)
1594/1595–1667
Landscape with Herdsman and Flocks
oil on copper 17.5 x 23.2
390

Polidoro da Lanciano c.1515–1565
*Holy Family with the Infant St John Baptist
and St Catherine*
oil on canvas 119.4 x 171.5
145

Polidoro da Lanciano c.1515–1565
*Virgin and Child with St Catherine, Mary
Magdalene and St Barbara*
oil on canvas 133.7 x 176.5
156

Pond, Arthur c.1705–1758
Richard Snow 1738
oil on canvas 75.2 x 62.9
1752

Pond, Arthur (attributed to) c.1705–1758
Thomas Gray probably 1731
oil on canvas 126.3 x 101.3
8

Porter, Frederick James 1883–1944
Tulips
oil on millboard 65.4 x 47.3
2402

Pot, Hendrik Gerritsz. c.1585–1657
Portrait of a Man
oil on panel 17.5 x 15.2
505

Poussin, Nicolas 1594–1665
Rebecca and Eliezer at the well 1660–1665
oil on canvas 96.5 x 138
PD.38-1984

Poussin, Nicolas (after) 1594–1665
Rebecca and Eliezer at the Well after 1648
oil on canvas 50.2 x 79.4
316

Procktor, Patrick 1936–2003
Two Figures and a Head Hand 1962–1963
oil on canvas 36 x 36
PD.9-2002

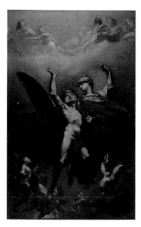

Prud'hon, Pierre-Paul (after) 1758–1823
Study for 'Minerva Leading the Genius of the Arts into Immortality' c.1813
oil on canvas 51 x 32.5
PD.4-1982

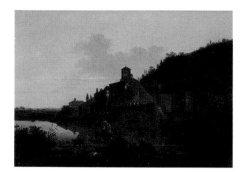

Pynacker, Adam c.1620–1673
Italian Landscape with a Monastery
oil on panel 36.1 x 50.9
PD.64-1958

Pynas, Jacob Symonsz. c.1590–c.1648
Jupiter and Io
oil on panel 13.5 x 18.3
PD.9-1977

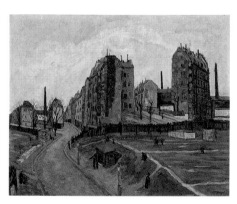

Quizet, Alphonse 1885–1955
The Boulevard Sérurier c.1910
oil on canvas 59.7 x 73
PD.21-1953

Raeburn, Henry 1756–1823
William Glendonwyn c.1795–1800
oil on canvas 124.8 x 101.6
220

Ramenghi, Bartolomeo (attributed to)
1484–1542
The Virgin and Child with St Catherine
oil on panel 51.7 x 36.6
631

Ramsay, Allan 1713–1784
James Haughton Langston 1750
oil on canvas 76.2 x 63.5
PD.25-1979

Raphael, Sarah 1960–2001
Desert Painting I
oil & sand on paper, laid down on board
39 x 52.9
PD.407-1995

Raphael, Sarah 1960–2001
Desert Painting II
oil & sand on paper, laid down on board
39 x 53
PD.408-1995

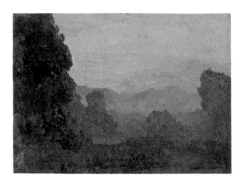

Raverat, Gwendolen 1885–1957
Mountain Scenery
oil on panel 24.6 x 33.9
PD.9-1994

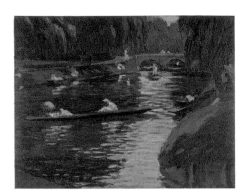

Raverat, Gwendolen 1885–1957
Punting
oil on panel 30.9 x 39.1
PD.8-1994

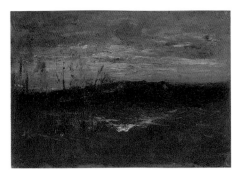

Ravier, Auguste François 1814–1895
Landscape at Sunset
oil on newspaper, marouflé to canvas
25 x 33.9
PD.146-1985

Redon, Odilon 1840–1916
The Chariot of Apollo 1907–1910
oil on panel 47.6 x 29.9
PD.28-1964

Reichelt, Augusta Wilhelmine 1840–1907
Flowers under a Lion Mask Fountain
oil on canvas 73.7 x 61.4
PD.40-1966

Reinagle, Philip 1749–1833
Cupid Inspiring the Plants with Love
oil on linen 43.5 x 34.5
PD.65-1974

Reinagle, Philip 1749–1833
Lilium Superbum
oil on canvas 44.5 x 34.5
PD.892-1973

Reinagle, Philip (attributed to) 1749–1833
Landscape with Figures
oil on paper, on wood 13 x 23.2
453

Reinagle, Ramsay Richard 1775–1862
*Landscape near Tivoli, with Part of the
Claudian Aqueduct*
oil on canvas 52.1 x 73.3
448

Rembrandt van Rijn (attributed to)
1606–1669
Portrait of a Man in Military Costume 1650
oil on panel 128 x 103.8
152

Rémond, Jean Charles Joseph 1795–1875
Italian Landscape with a View of a Harbour
oil on paper, laid on canvas 23.3 x 31.5
PD.6-1976

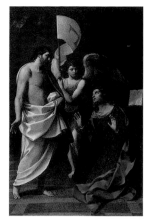

Reni, Guido 1575–1642
Christ Appearing to the Virgin c.1608
oil on canvas 223.5 x 141.6
163

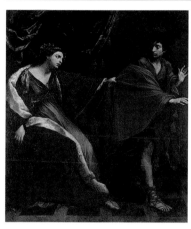

Reni, Guido 1575–1642
Joseph and Potiphar's Wife 1625–1626
oil on canvas 220 x 188
PD.53-1993

Reni, Guido 1575–1642
The Man of Sorrows c.1639
oil on canvas 113 x 95.2
2546

Renoir, Pierre-Auguste 1841–1919
Apples and Walnuts c.1865–1870
oil on panel 13.3 x 20.3
PD.18-1964

Renoir, Pierre-Auguste 1841–1919
The Gust of Wind c.1872
oil on canvas 52 x 82.5
2403

Renoir, Pierre-Auguste 1841–1919
Place Clichy c.1880
oil on canvas 65 x 54
PD.44-1986

Renoir, Pierre-Auguste 1841–1919
Léon Goujon in Sailor-Suit 1885
oil on canvas 39.8 x 30

Renoir, Pierre-Auguste 1841–1919
The Return from the Fields 1886
oil on canvas 54 x 65.1
PD.29-1964

Renoir, Pierre-Auguste 1841–1919
Dance 1895
oil on canvas 40 x 16.5
PD.20-1964

Renoir, Pierre-Auguste 1841–1919
Music 1895
oil on canvas 40 x 16.5
PD.19-1964

Renoir, Pierre-Auguste 1841–1919
Apples and Teacup probably 1890s
oil on canvas 16 x 29
PD.17-1964

Renoir, Pierre-Auguste 1841–1919
Landscape probably 1890s
oil on canvas laid down & inset into
panel 10.6 x 6.5
PD.15-1977

Renoir, Pierre-Auguste 1841–1919
Study of Flowers probably 1890s
oil on canvas laid down & inset into panel
66 x 13.7
PD.14-1977

Renoir, Pierre-Auguste 1841–1919
Olive Trees, Cagnes 1913–1914
24.5 x 45.2

Renoir, Pierre-Auguste 1841–1919
Study of a Girl c.1918–1919
oil on canvas 23 x 21
2404

Renoir, Pierre-Auguste 1841–1919
Landscape with Figures
oil on canvas 27.3 x 39.4
PD.15-2005

Reynolds, Alan b.1926
Dusk, the Outbuildings 1957
oil on hardboard 43.5 x 60.9
PD.48-1958

Reynolds, Joshua 1723–1792
Henry Vansittart c.1753/1754
oil on canvas 73.7 x 60.3
1179

Reynolds, Joshua 1723–1792
Mrs Angelo 1760
oil on canvas 55.6 x 45.4
1775

Reynolds, Joshua 1723–1792
Lord Rockingham and Edmund Burke c.1766
oil on canvas 145.4 x 159.1
653

Reynolds, Joshua 1723–1792
The Braddyll Family 1789
oil on canvas 238.1 x 147.3
PD.10-1955

Ribot, Augustin Théodule 1823–1891
Jules Luquet
oil on panel 35.4 x 26.3
PD.1-1964

Ribot, Augustin Théodule 1823–1891
The Cooks
oil on canvas 46.4 x 38.4
1496

Ricci, Sebastiano 1659–1734
Bacchus and Ceres before 1720
oil on canvas 86.4 x 109.5
180

Richards, Ceri Geraldus 1903–1971
Pastorale 1967
oil on canvas 127 x 127
PD.55-2001

Richardson, Jonathan the younger
1694–1771
Alexander Pope 1742
oil on canvas 33.9 x 28.6
16

Richardson, Jonathan the younger
(follower of) 1694–1771
Henry, Lord Herbert, Later Tenth Earl of
Pembroke 1748
oil on canvas 83.8 x 68.9
456

Richmond, George 1809–1896
Self Portrait 1840
oil & wax on canvas 40.9 x 40.6
PD.179-1975

Richmond, George 1809–1896
Mrs William Fothergill Robinson 1870
oil on panel 94 x 70.5
1204

Richmond, George 1809–1896
Ploughing: Study for 'The Mantle of Elijah'
oil on panel 21.7 x 58.7
PD.157-1985

Rigden, Geoff b.1943
Riposte 1977
acrylic on canvas 103.5 x 113.5
PD.21-2002

Riley, Bridget b.1931
Shadow Play 1990
oil on canvas 96.5 x 68.6
PD.56-1996

Rivers, Larry 1923–2002
Camels c.1961
oil with collage on canvas 162.5 x 129.5
PD.12-1979

Robert, Hubert 1733–1808
Wooded River Landscape with a Traveller,
a Barking Dog, a Horseman, and Women
Washing at an Islet c.1798
oil on canvas 246.5 x 255
PD.118-1992

Roberts, David 1796–1864
The Doge's Palace, Venice, from the Bacino di San Marco 1853
oil on canvas 122 x 183
PD.18-1997

Roedig, Johannes Christianus 1751–1802
Still Life with Fruit and Flowers 1796
oil on panel 38.1 x 30.5
PD.43-1966

Roedig, Johannes Christianus 1751–1802
Vase of Flowers 1796
oil on panel 38.1 x 30.5
PD.42-1966

Roedig, Johannes Christianus 1751–1802
Basket of Flowers with Fruit
oil on panel 69.9 x 59.8
PD.41-1966

Rogers, Claude 1907–1979
Big Red Still Life 1959
oil on canvas 50 x 127
PD.17-1987

Rogers, Claude 1907–1979
Clover Field, Somerton, Suffolk 1959
oil on canvas 76.2 x 101.9
PD.4-1960

Rogers, Claude 1907–1979
Athens
oil on millboard 25.1 x 20.6
PD.90-1974

Romanelli, Giovanni Francesco 1610–1662
St John and St Peter at the Empty Tomb of Christ before 1641
oil on silvered copper 46.8 x 38.4
PD.260-1985

Romney, George 1734–1802
Mrs Beal Bonnell 1779–1780
oil on canvas 127 x 101.5
PD.131-1992

Romney, George 1734–1802
Possibly William Thomas Meyer
oil on canvas 54 x 40.6
654

Rosa, Salvator 1615–1673
Human Frailty c.1656
oil on canvas 197.4 x 131.5
PD.53-1958

Rosselli, Cosimo 1439–1507
Virgin and Child with St John the Baptist,
St Andrew, St Bartholomew and St Zenobius
tempera with gold on panel 190.5 x 175.2
556

Rossetti, Dante Gabriel 1828–1882
Girl at a Lattice 1862
oil on canvas 30.5 x 27
728

Rossetti, Dante Gabriel 1828–1882
Joan of Arc 1882
oil on panel 52.7 x 45.7
685

Rossi, Mariano (attributed to) 1731–1807
The Dove of the Holy Ghost Surrounded by
Cherubim
oil on canvas marouflé on panel 23.4 x 28.6
PD.97-1992

Rouault, Georges 1871–1958
Landscape with St George and the Dragon
oil on paper laid down on canvas 36 x 26
PD.14-1974

Rousseau, Théodore 1812–1867
Panoramic Landscape 1830–1840
oil on canvas 26.7 x 56.1
PD.49-1956

Rousseau, Théodore 1812–1867
The Plain of Chailly 1833
oil on prepared panel 29 x 37
PD.147-1985

Facing page: Courbet, Gustave, 1819–1877, *Beneath the Trees at Port-Berteau: Children Dancing* (detail), c.1862, (p. 44)

Rousseau, Théodore 1812–1867
The Marsh in the Souterraine 1842
oil on paper marouflé to canvas 22.5 x 29.5
PD.148-1985

Royen, Wilhelm Frederik van 1645–1723
A Vase of Flowers
oil on canvas 44.7 x 35.5
PD.84-1973

Rubens, Peter Paul 1577–1640
Death of Hippolytus c.1611–1613
oil on copper 50.2 x 70.8
PD.8-1979

Rubens, Peter Paul 1577–1640
Teresa of Avila's Vision of the Dove c.1614
oil on panel 97 x 63
PD.43-1999

Rubens, Peter Paul 1577–1640
Head Study of a Bearded Man c.1617
oil on panel 68.6 x 53.3
PD.13-1980

Rubens, Peter Paul 1577–1640
*The Discovery of Achilles among the Daughters
of Lykomedes* c.1618
oil on panel 28.5 x 26
PD.22-1964

Rubens, Peter Paul 1577–1640
The Union of Earth and Water 1620
oil on panel 35 x 30.5
267

Rubens, Peter Paul 1577–1640
Christ as Redeemer of the World before c.1624
oil on panel 68.3 x 48.6
PD.181-1975

Rubens, Peter Paul 1577–1640
The Four Evangelists (panel 1 of 7)
c.1625–1626
oil on panel 16.2 x 16.5
242

Rubens, Peter Paul 1577–1640
The Victory of the Eucharist over Heresy
(panel 2 of 7) c.1625–1626
oil on panel 16.2 x 21.3
229

Rubens, Peter Paul 1577–1640
The Triumph of Divine Love (panel 3 of 7)
c.1625–1626
oil on panel 15.9 x 16.2
230

Rubens, Peter Paul 1577–1640
The Triumph of the Eucharist over Ignorance
and Blindness (panel 4 of 7) c.1625–1626
oil on panel 16.2 x 24.4
228

Rubens, Peter Paul 1577–1640
The Defenders of the Eucharist (panel 5 of 7)
c.1625–1626
oil on panel 15.8 x 16.5
241

Rubens, Peter Paul 1577–1640
The Triumph of the Eucharist over Philosophy
and Science (panel 6 of 7) c.1625–1626
oil on panel 16.5 x 21.9
243

Rubens, Peter Paul 1577–1640
The Meeting of Abraham and Melchisedek
(panel 7 of 7) c.1625–1626
oil on panel 15.6 x 15.6
231

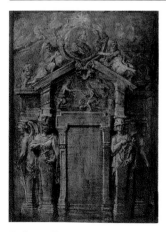

Rubens, Peter Paul 1577–1640
Design for the Title Page of the Pompa Introitus
... Ferdinandi c.1638
oil on panel 52.4 x 37.5
240

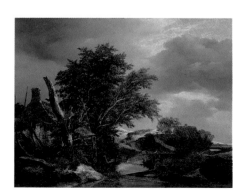

Ruisdael, Jacob van 1628/1629–1682
Landscape with a Blasted Tree near a
House c.1645
oil on panel 52.7 x 67.6
84

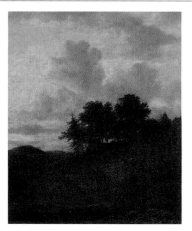

Ruisdael, Jacob van 1628/1629–1682
Landscape with River and Pines
oil on canvas 66.3 x 53.7
75

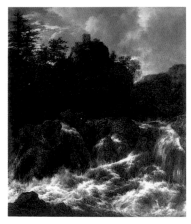

Ruisdael, Jacob van 1628/1629–1682
Landscape with Waterfall
oil on canvas 100 x 86.5
63

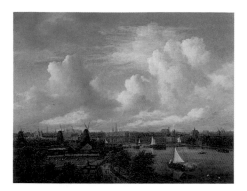

Ruisdael, Jacob van 1628/1629–1682
View on the Amstel Looking towards Amsterdam
oil on canvas 52.1 x 66.1
74

Ruisdael, Jacob van (imitator of) 1628/1629–1682
Landscape with a Brook and Farmhouse among Trees
oil on panel 25.5 x 35.9
65

Russell, John 1745–1806
Captain and Mrs Hardcastle 1785
oil on canvas 101.6 x 126.7
PD.19-1997

Rustin, Jean b.1928
Portrait of a Young Man 1991
oil on canvas 41.1 x 27
PD.128-1992

Ruysch, Anna Elisabeth d.1741
Vase of Flowers
oil on canvas 57.5 x 44
PD.50-1966

Ruysch, Rachel 1664–1750
A Vase of Flowers 1701
oil on canvas 77 x 63.5
PD.85-1973

Ruysch, Rachel 1664–1750
A Vase of Flowers 1701
oil on canvas 76.9 x 63.5
PD.86-1973

Ruysch, Rachel 1664–1750
A Spray of Flowers
oil on canvas 36.6 x 30.4
PD.38-1975

Ruysch, Rachel 1664–1750
A Still Life with Flowers, Butterflies and a Lizard in a Dell
oil on canvas 59.6 x 48.2
PD.87-1973

Ruysch, Rachel 1664–1750
Still Life with Fruit and a Vase of Flowers
oil on canvas 99 x 83.5
PD.88-1973

Ruysdael, Salomon van c.1602–1670
Farm Buildings in a Landscape 1625–1628?
oil on panel 30 x 46.7
1049

Ryckaert, Marten 1587–1631
Landscape with Pan and Syrinx (after Paul Bril)
oil on copper 40 x 63
81

Sacchi, Andrea 1599–1661
The Baptism of Christ
oil on panel 29.7 x 40.3
(P)

Saftleven, Cornelis 1607–1681
Boy with Goats c.1640
oil on panel 42.9 x 59.1
383

Saftleven, Cornelis 1607–1681
Interior of a Stable
oil on panel 41.3 x 49.5
380

Saftleven, Herman the younger 1609–1685
View on the Rhine
oil on panel 22.5 x 28.9
378

Sagrestani, Giovanni Camillo 1660–1731
The Virgin with St John
oil on canvas 25.3 x 19
PD.62-1992

Salazar, Francisco b.1937
Immaterial Space, No.783 1993
mixed media 150 x 150
PD.40-2001

Salviati, Francesco (attributed to)
1510–1563
Portraits of Five Artists: Giotto, Donatello, Michelangelo, Raphael and Brunelleschi
oil on canvas 23.5 x 70.1
1162

Sánchez, Juan active c.1500 **& Sánchez, Diego** active late 15th C
The Road to Calvary
oil with gold & silver on panel 100 x 128.5
M.Add.16

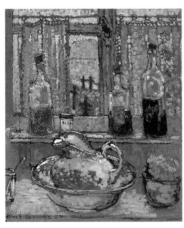

Sands, Ethel 1873–1962
Still Life with a View over a Cemetery
oil on board 45 x 37.5
PD.37-1991

Sandys, Frederick 1829–1904
Mrs Sandys, the Artist's Mother late 1840s
oil on canvas 46.5 x 36.2
881

Sandys, Frederick 1829–1904
Mrs Sandys, the Artist's Mother late 1840s
oil on panel 40.9 x 30.5
887

Sandys, Frederick 1829–1904
Portrait of a Young Man (copy after Rogier van der Weyden) before 1850
oil on panel 20.9 x 16.5
886

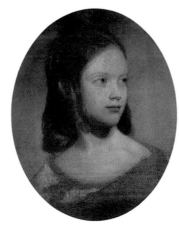

Sandys, Frederick 1829–1904
Emma Sandys, the Artist's Sister c.1853–1855
oil on canvas laid down on panel 23.8 x 18.7
724

Santvoort, Dirck Dircksz. 1610/1611–1680
Portrait of a Man
oil on panel 69.8 x 57.5
PD.13-1959

Sargent, John Singer 1856–1925
Dorothy Barnard 1889
oil on canvas 70.5 x 39.4
PD.34-1949

Sargent, John Singer 1856–1925
Santa Maria della Salute, Venice c.1904/1908
oil on canvas 64 x 92
1169

Sargent, John Singer 1856–1925
Near the Mount of Olives, Jerusalem
c.1905–1906
oil on canvas 66.5 x 97.7
1506

Sargent, John Singer 1856–1925
Study of a Sicilian Peasant 1907
oil on canvas 60 x 46
753

Sargent, John Singer 1856–1925
Olives in Corfu 1909
oil on canvas 56.5 x 71.7
1067

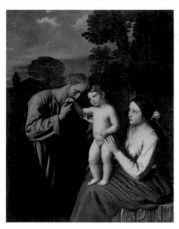

Sassoferrato 1609–1685
The Holy Family
oil on canvas 134 x 104.8
M.74

Savery, Roelandt 1576–1639
The Creation of Birds 1619
oil on panel 20.6 x 25.4
343

Savery, Roelandt 1576–1639
Orpheus with Beasts and Birds 1622
oil on copper 22.6 x 26.4
342

Savery, Roelandt 1576–1639
*Still Life with Flowers in a Glass Berkemeyer
with a Lizard, Frog and Dragonfly on a
Ledge* 1637
oil on copper 36 x 29.2
PD.19-2002

Say, Frederick Richard c.1827–1860
*Albert Francis Charles Augustus Emmanuel
of Saxe-Coburg-Gotha, Prince Consort of
England* 1849
oil on canvas 268 x 175.3
605

Scarsellino 1551–1620
Landscape with Abraham and Isaac
oil on canvas 58 x 75
113

Scarsellino (school of) 1551–1620
The Annunciation
oil on canvas 51.1 x 72.6
2550

Schalcken, Godfried 1643–1706
A Lady Holding a Plate c.1680–1690
oil on panel 23.5 x 20.5
365

Schalcken, Godfried 1643–1706
Self Portrait
oil on canvas 61 x 50
368

Schedoni, Bartolomeo 1578–1615
The Coronation of the Virgin c.1608–1610
oil on panel 47 x 38
(P)

Schoevaerdts, Mathys active 1682–1694
Landscape with a Hunting Party
oil on copper 54.9 x 68.9
256

Schoevaerdts, Mathys active 1682–1694
Landscape with a Pleasure Party
oil on copper 54.5 x 68.5
264

Schooten, Floris Gerritsz. van
c.1585–after 1655
Kitchen Utensils, Meat and Vegetables
c.1600–1610
oil on canvas 102.2 x 158.1
96

Facing page: Veronese, Paolo, 1528–1588, *Hermes, Herse and Aglauros* (detail), 1576–1584, (p. 187)

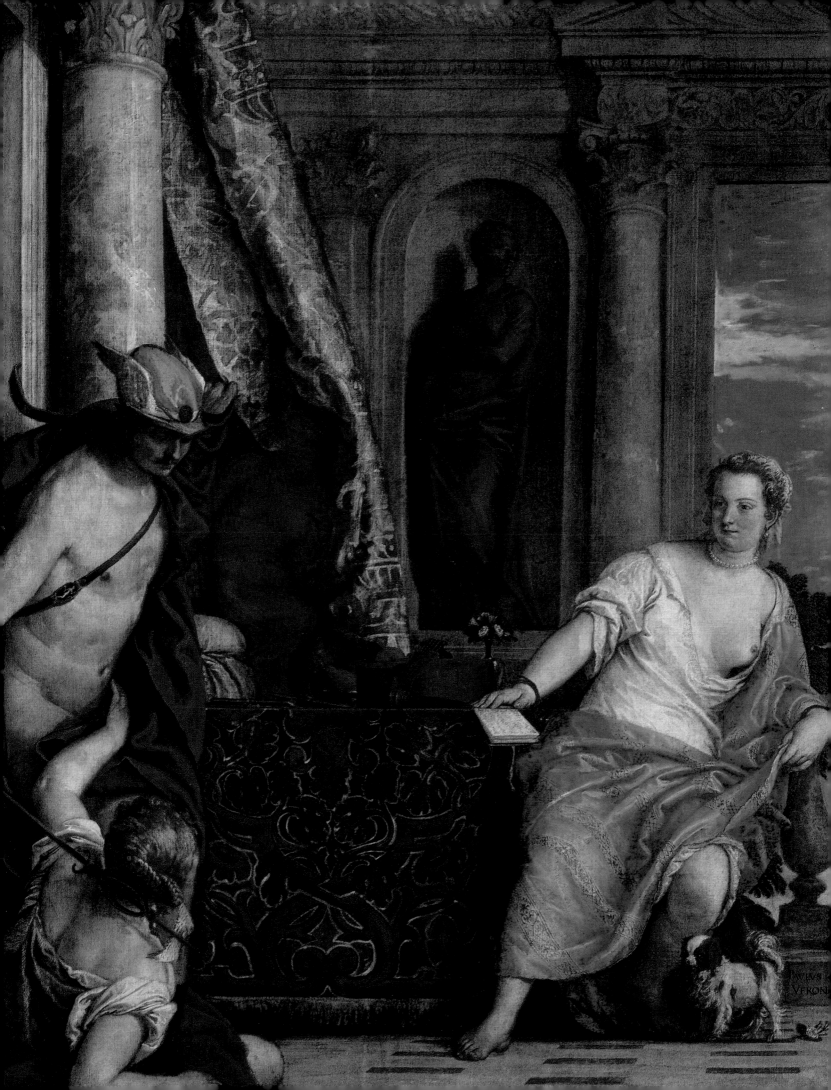

Schrieck, Otto Marseus van
1619/1620–1678
Flowers, Insects and Reptiles 1673
oil on canvas 69.5 x 52.7
303

Schrieck, Otto Marseus van
1619/1620–1678
Still Life with Flowers
oil on canvas 69.8 x 53.3
PD.41-1975

Schrieck, Otto Marseus van (attributed to)
1619/1620–1678
*Silver Birch Trunk and Branch with Rose,
Lizards, a Snake, Toadstools, (...)*
oil on canvas 61.7 x 52.3
PD.40-1975

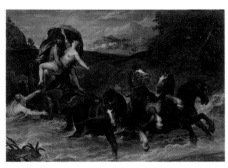

Schwarz, Christoph c.1548–1592
The Rape of Proserpine c.1573
oil on canvas 66 x 95.9
1778

Scott, William George 1913–1989
Full House 1963
oil on canvas 86.8 x 112.2
PD.65-1992

Scott, William George 1913–1989
Message obscure II 1965
oil on canvas 40.6 x 50.8
PD.66-1992

Scott, William George 1913–1989
Kippers on a Blue Plate
oil on canvas 23 x 33.3
PD.63-1992

Scott, William George 1913–1989
Pears and Grapes
oil on canvas 41 x 51
PD.64-1992

Scully, Sean b.1945
Painting 20/7/74, No.3/3 1974
acrylic on canvas 121.9 x 121.9
PD.105-1975

Sebastiano del Piombo c.1485–1547
Adoration of the Shepherds 1511–1512
oil on canvas 124.2 x 161.3
138

Sebastiano del Piombo c.1485–1547
Madonna and Child c.1513
oil on panel 68.5
PD.55-1997

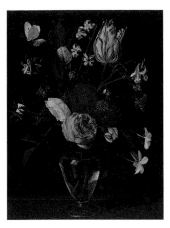

Seghers, Daniel 1590–1661
A Vase of Flowers
oil on copper 48 x 35
PD.42-1975

Seghers, Daniel (attributed to) 1590–1661
Festoon of Flowers
oil on canvas 35.2 x 39
301

Seghers, Daniel (attributed to) 1590–1661
Festoon of Flowers
oil on canvas 35.2 x 39.4
307

Seghers, Gerard (attributed to) 1591–1651
Faith, Hope and Charity
oil on panel 100.9 x 88.5
1098

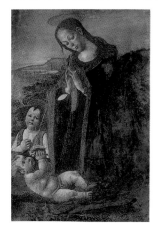

Sellaio, Jacopo del c.1441–1493
Virgin Adoring the Child after 1473
tempera with gold on panel 73.9 x 49.5
2186

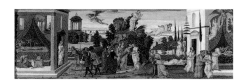

Sellaio, Jacopo del c.1441–1493
The Story of Cupid and Psyche
tempera with gold on panel 59 x 178.8
M.75

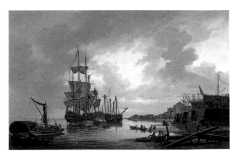

Serres, Dominic 1722–1793
British Men-of-War at Anchor in Blackwell Reach
oil on canvas 107.5 x 168
PD.109-1992

Seurat, Georges 1859–1891
The Rue St Vincent, Paris in Spring c.1884
oil on panel 24.7 x 15.5
PD.1-1948

Seurat, Georges 1859–1891
Study for 'A Sunday on the Island of La Grand Jatte': Couple Walking
oil on canvas 81 x 65

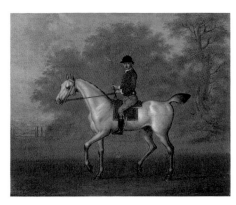

Seymour, James 1702–1752
Horse and Groom 1740s
oil on canvas 30.2 x 35.6
450

Shannon, Charles Haslewood 1863–1937
Self Portrait 1917
oil on canvas 68.6 x 68
2294

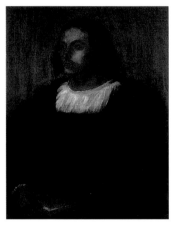

Shannon, Charles Haslewood 1863–1937
Jacopo Nazzaro (copy of Titian)
oil on canvas 89 x 75
PD.183-1991

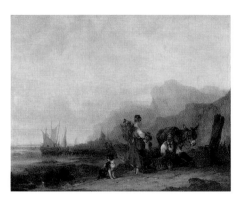

Shayer, William 1788–1879
The Prawn Fishers before 1835
oil on canvas 60.9 x 75.9
1104

Sickert, Walter Richard 1860–1942
The Old Bedford Music Hall 1894–1895
oil on canvas 54.9 x 38.1
2458

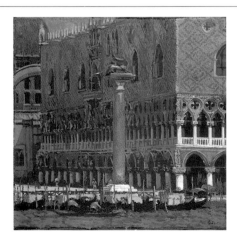

Sickert, Walter Richard 1860–1942
The Lion of St Mark c.1895–1896
oil on canvas 89.8 x 90.2
PD.17-1959

Sickert, Walter Richard 1860–1942
Church of St Jacques, Dieppe c.1899–1900
oil on panel 16.7 x 12
PD.28-1970

Sickert, Walter Richard 1860–1942
St Mark's, Venice c.1901–1902
oil on panel 20 x 24.6
PD.24-1984

Sickert, Walter Richard 1860–1942
Mrs Swinton 1905–1906
oil on canvas 76.2 x 63.5
PD.2-1955

Sickert, Walter Richard 1860–1942
The Montmartre Theatre 1906
oil on canvas 48.9 x 61

Sickert, Walter Richard 1860–1942
Girl at a Looking Glass, Little Rachel 1907
oil on canvas 51.1 x 41
PD.91-1974

Sickert, Walter Richard 1860–1942
Mornington Crescent Nude c.1907
oil on canvas 45.7 x 50.8
PD.103-1990

Sickert, Walter Richard 1860–1942
The Glance c.1911
oil on canvas 38.1 x 30.5
2727

Sickert, Walter Richard 1860–1942
Woman with Ringlets c.1911
oil on canvas 35.6 x 30.5
2411

Sickert, Walter Richard 1860–1942
Rushford Mill 1916
oil on canvas 63.8 x 76.5
PD.25-1953

Sickert, Walter Richard 1860–1942
The Trapeze 1920
oil on canvas 64.7 x 81
2410

Sickert, Walter Richard 1860–1942
The Bar Parlour c.1922
oil on canvas 104.1 x 157.5

Sickert, Walter Richard 1860–1942
Chez Vernet 1925
oil on canvas 61.3 x 50.5
PD.92-1974

Sickert, Walter Richard 1860–1942
Lainey's Garden (The Garden of Love)
c.1927–1931
oil on canvas 81.9 x 61.6
2726

Sickert, Walter Richard 1860–1942
Sir Hugh Walpole 1928
oil on canvas 41.9 x 42.9
2515

Signac, Paul 1863–1935
The Entry to the Port, Portrieux
oil on panel 15.1 x 25.1
PD.9-1959

Sims, Charles 1873–1928
The Little Faun 1905–1906
oil on canvas 51.1 x 61.3
2547

Sims, Charles 1873–1928
Study of a Dead Rail
oil on canvas laid down on millboard
30.5 x 40.6
1505

Sisley, Alfred 1839–1899
A Street, Possibly in Port-Marly 1875–1877
oil on canvas 46.4 x 36.8
2414

Sisley, Alfred 1839–1899
The Flood at Port-Marly 1876
oil on canvas 46.1 x 55.9
PD.69-1958

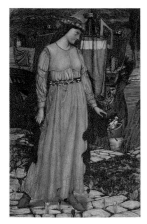

Sleigh, Bernard 1872–1954
Aslaug 1902
tempera on canvas 49.6 x 31.2
PD.68-1996

Smibert, John (attributed to) 1688–1751
Unknown Man
oil on canvas 75.9 x 63.2
642

Smith, Jack b.1928
Four Movements 'Relief' 1962
oil on panel 58.5 x 60
PD.67-1992

Smith, Jack b.1928
Above and Below 1971
oil on board 24 x 22
PD.68-1992

Smith, Jack b.1928
Abstract Painting c.1990
oil on canvas 91.4 x 91.4
PD.35-2003

Smith, Matthew Arnold Bracy 1879–1959
Still Life with Pomegranates and Pears 1935
oil on canvas 38.1 x 46.3
PD.51-1971

Smith, Matthew Arnold Bracy 1879–1959
Landscape at Aix-en-Provence c.1936
oil on canvas 46.1 x 55.2
2453

Smith, Ralph Maynard 1892–1962
Circles and Moon 1950
oil on hardboard 34.9 x 46.3
PD.5-2003

Snyders, Frans 1579–1657
The Larder c.1620
oil on canvas 149.5 x 260.3
362

Snyders, Frans (studio of) 1579–1657
The Fowl Market
oil on canvas 213.8 x 337.8
315

Snyers, Peeter 1681–1752
A Dead Hare
oil on copper 41.5 x 30.9
PD.25-1983

Soest, Gerard c.1600–1681
Unknown Man c.1670–1675
oil on canvas 75.3 x 62.6
2356

Sole, Giovan Gioseffo dal 1654–1719
Salome with the Head of St John the Baptist
oil on copper 28.3 x 20.8
255

Solimena, Francesco 1657–1747
The Virgin and Child, with a Boy Presented by His Guardian Angel, and San Francesco di Paola c.1705–1708
oil on canvas 93.7 x 116.5
PD.14-1962

Solimena, Francesco (attributed to)
1657–1747
The Rest on the Flight into Egypt
oil on copper 28.9 x 32.3
(P)

Solimena, Francesco (studio of) 1657–1747
Virgin and Child c.1725–1730
oil on canvas 49.8 x 40.6
177

Somer, Paulus van I 1576–1621
Elizabeth, Countess of Kent c.1615–1620
oil on canvas 126.5 x 104.2
2484

Somer, Paulus van I 1576–1621
Catherine Vaux, Lady Abergavenny c.1617
oil on canvas 77.5 x 63.8
442

Son, Joris van 1623–1667
Still Life with a Lobster 1660
oil on canvas 64.1 x 89.2
M.76

Sonnabend, Yolanda b.1935
Gaby 1985
oil on canvas 178.5 x 71.7
PD.41-1999

Sørensen, Carl Frederik 1818–1879
Rough Sea beside a Jetty 1849
oil on canvas 31.8 x 45.4
PD.219-1994

Sorgh, Hendrik Martensz. 1609/1611–1670
A Kitchen
oil on panel 18.7 x 25.1
381

Sorgh, Hendrik Martensz. 1609/1611–1670
Peasant in an Outhouse
oil on panel 22.5 x 27.3
382

Soulages, Pierre b.1919
Untitled 1958
oil on canvas 115 x 80
PD.26-1984

Spaendonck, Cornelis van 1756–1840
*Open wicker basket of mixed flowers, including
iris, roses, poppies, hollyhock, marigold,
larkspur (...)* 1789
oil on canvas 47 x 38
PD.90-1973

Spaendonck, Cornelis van 1756–1840
*Open wicker basket of mixed flowers, including
tulip, roses, harebell, hollyhock, poppy, larkspur
and auricula on a marble ledge* 1789
oil on canvas 47.2 x 38
PD.89-1973

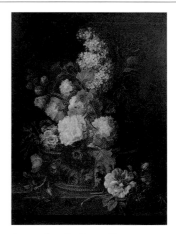

Spaendonck, Cornelis van 1756–1840
A Basket of Flowers
oil on panel 51.4 x 39
PD.44-1975

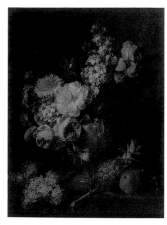

Spaendonck, Cornelis van 1756–1840
Vase of Flowers
oil on panel 68.3 x 54.4
PD.46-1966

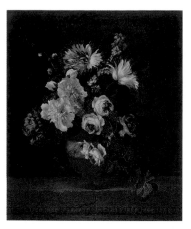

Spaendonck, Gerard van 1746–1822
A Vase of Flowers
oil on canvas 76.4 x 64.1
PD.91-1973

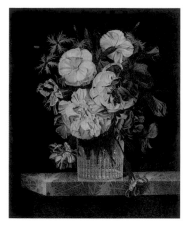

Speeckaert, Michel Joseph 1748–1838
A Glass of Flowers 1811
oil on panel 32.4 x 26.2
PD.61-1974

Spencer, Gilbert 1893–1979
Dorset Downs 1919
oil on canvas 40.9 x 55.8
PD.48-1956

Spencer, Stanley 1891–1959
Study for 'The Centurian's Servant' c.1914
oil on board 27.5 x 27.5
PD.24-2003

Spencer, Stanley 1891–1959
Sarajevo, Bosnia 1922
oil on canvas 61 x 56
1481

Spencer, Stanley 1891–1959
Cottages at Burghclere 1927–1930
oil on canvas 62.2 x 160
1533

Spencer, Stanley 1891–1959
Love among the Nations 1935–1936
oil on canvas 91.1 x 280
PD.967-1963

Spencer, Stanley 1891–1959
Self Portrait with Patricia Preece 1937
oil on canvas 61 x 91.2
PD.966-1963

Spencer, Stanley 1891–1959
Landscape in North Wales 1938
oil on canvas 55.9 x 70.8
2452

Spencer, Stanley 1891–1959
Self Portrait 1939
oil on canvas 39.7 x 55.2
2506

Spencer, Stanley 1891–1959
Love on the Moor 1949–1954
oil on canvas 79.1 x 310.2
PD.968-1963

Spinello Aretino 1350/1352–1410
Annunciation
tempera with gold on panel
80 x 50.8; 80 x 50.8
550

Stanfield, Clarkson 1793–1867
Coast Scene near Genoa 1846
oil on canvas 71.4 x 112.4
501

Stannard, Joseph 1797–1830
*Boats on the Yare near Bramerton,
Norfolk* 1828
oil on panel 46 x 64.8
PD.69-1948

Stark, James 1794–1859
Near Norwich 1819–1830
oil on panel 57.2 x 77.2
PD.6-1954

Steele, Jeffrey b.1931
Sg III 103 1988
oil on canvas 152.3 x 152.3
PD.135-1994

Steen, Jan 1626–1679
Village Festival c.1650
oil on canvas 54.3 x 81
73

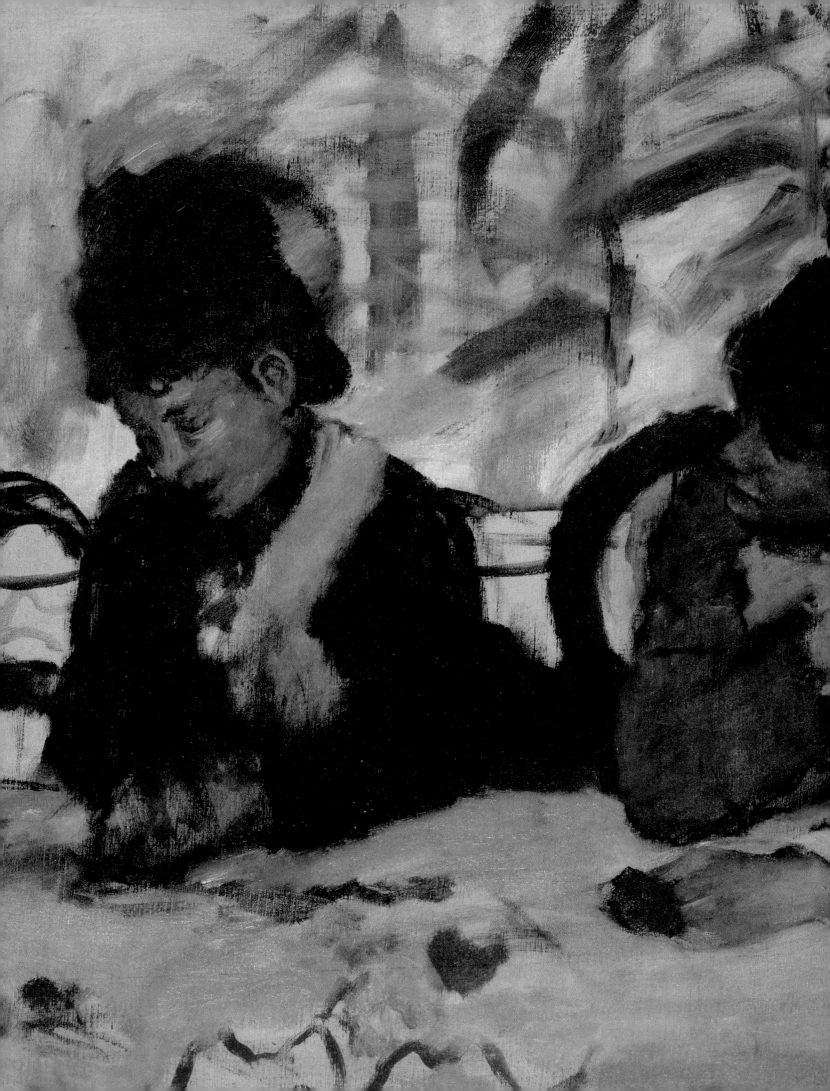

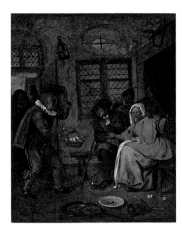

Steen, Jan 1626–1679
Interior with Figures c.1668
oil on canvas 40.6 x 31.4
76

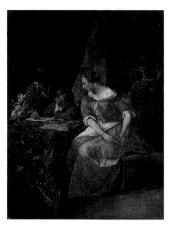

Steen, Jan 1626–1679
Interior with a Painter and His Family c.1670
oil on panel 41.6 x 31.1
78

Steenwijck, Hendrick van the younger
c.1580–1649
The Liberation of St Peter 1615
oil on panel 11.7
536

Steenwijck, Hendrick van the younger
c.1580–1649
The Liberation of St Peter 1626
oil on panel 38.1 x 52.4
31

Steer, Philip Wilson 1860–1942
Surf 1885–1886?
oil on panel 15.9 x 74
2415

Steer, Philip Wilson 1860–1942
The Blue Dress 1892
oil on canvas 91.3 x 70.5
PD.184-1975

Steer, Philip Wilson 1860–1942
The Thames from Richmond Hill 1893
oil on panel 21 x 26.4
2416

Steer, Philip Wilson 1860–1942
Walberswick, Children Paddling 1894
oil on canvas 64.3 x 92.6
PD.18-1951

Steer, Philip Wilson 1860–1942
Children Playing, Ludlow Walks 1899
oil on canvas 57.5 x 92.7
PD.183-1975

Facing page: Degas, Edgar, 1834–1917, *At the Café* (detail), c.1875–1877, (p. 50)

Steer, Philip Wilson 1860–1942
Hydrangeas 1901
oil on canvas 85.4 x 112
PD.185-1975

Steer, Philip Wilson 1860–1942
Richmond, Yorkshire 1905
oil on canvas 40.6 x 54.9
2449

Steer, Philip Wilson 1860–1942
Montreuil from the Ramparts 1907
oil on canvas 50.2 x 60.9
2455

Steer, Philip Wilson 1860–1942
Summer Evening 1912
oil on canvas 61.3 x 92.1
1513

Steer, Philip Wilson 1860–1942
Self Portrait 1920
oil on canvas 73.7 x 59
1008

Stella, Jacques 1596–1657
The Martyrdom of St Stephen c.1623
oil on copper 43.6 x 31.6
PD.387-1995

Stephenson, Ian 1934–2000
Reddi Painting
oil on canvas 101.6 x 101.6
PD.31-2000

Stevens, Alfred 1817–1875
The Ascension of Christ c.1845–1846
oil on panel 91.4 x 42.8
2204

Stevens, Alfred 1817–1875
The Return of Odysseus to His Hearth 1851
oil on wood 28.8 x 144.2
737

Stevens, Alfred 1817–1875
Leonard W. Collmann c.1854
oil on canvas 46 x 35.3
2228

Stevens, Alfred Emile Léopold Joseph Victor 1823–1906
The Reader
oil on canvas 66.1 x 55.3
1527

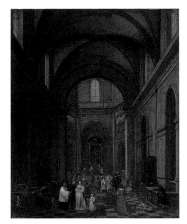

Stöcklin, Christian (attributed to)
1741–1795
Interior of a Church
oil on copper 30.5 x 25.5
414

Stone, Henry (attributed to) 1616–1653
Unknown Man
oil on canvas 76.5 x 63.8
2312

Storck, Abraham 1644–1708
A Marine Sham Fight on the Y before Amsterdam
oil on canvas 59.7 x 84.1
1108

Storck, Abraham 1644–1708
Sea Piece with a Dutch Man-of-War
oil on canvas 77.8 x 109.2
55

Storck, Abraham 1644–1708
The Four Days' Battle, 1–4 June 1666
oil on canvas 82.8 x 145.7
106

Stralen, Antoni van c.1594–1641
Winter Scene
oil on copper 14.9 x 18.1
2508

Strang, William 1859–1921
Self Portrait 1919
oil on canvas 63.5 x 50.5
981

Stuart, Gilbert 1755–1828
Unknown Man c.1775–1780
oil on canvas 60.3 x 50.3
785

Stuart, Gilbert (copy after) 1755–1828
George Washington before 1801
oil on canvas 72.7 x 60.9
1142

Stubbs, George 1724–1806
Joseph Smyth Esquire, Lieutenant of Whittlebury Forest, Northamptonshire, on a Dapple Grey Horse c.1762–1764
oil on canvas 64.2 x 76.8
PD.95-1992

Stubbs, George 1724–1806
Gimcrack with John Pratt up on Newmarket Heath c.1765
oil on canvas 100 x 124
PD.7-1982

Stubbs, George 1724–1806
Isabella Salstonstall as Una in Spenser's 'Faerie Queene' 1782
enamel on ceramic 47.9 x 63.8
PD.45-1971

Subleyras, Pierre Hubert 1699–1749
The Holy Family with Saints Elisabeth and Zaccharias and the Infant Saint John
oil on canvas 63.5 x 48.7
(P)

Susenier, Abraham (attributed to)
c.1620–1668
A Storm at Sea
oil on panel 32.6 x 52.7
PD.26-1983

Sutherland, Graham Vivian 1903–1980
The Deposition 1946
oil on millboard 152 x 121.9
PD.969-1963

Sutherland, Graham Vivian 1903–1980
Tree, Red Ground 1962
oil on canvas 127.7 x 101
PD.5-1984

Swanevelt, Herman van c.1600–1665
The Campo Vaccino, Rome 1631?
oil on copper 45.4 x 67
367

Swanevelt, Herman van c.1600–1665
Landscape with Joseph and His Brethren
c.1641
oil on canvas 49.5 x 63.5
202

Swanevelt, Herman van c.1600–1665
Landscape with the Sale of Joseph c.1641
oil on canvas 51.1 x 63.8
206

Sweerts, Michael 1618–1664
An Old Woman Spinning 1646–1648
oil on canvas 43 x 34
PD.145-1994

Taylor, Edward Ingram 1855–1923
Lambert Castle 1915
oil on prepared canvas board 26 x 35.3
PD.264-1985

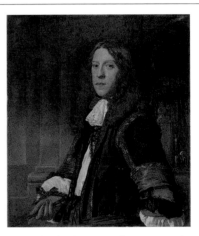

Tempel, Abraham Lambertsz. van den
1622/1623–1672
Portrait of a Man 1670
oil on canvas 87.5 x 75
PD.14-1952

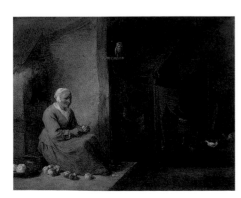

Teniers, David II 1610–1690
Interior, with an Old Woman Peeling Apples
oil on panel 35.6 x 46.4
72

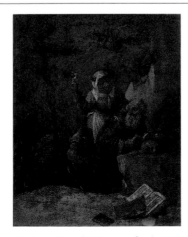

Teniers, David II (copy after) 1610–1690
The Temptation of St Anthony
oil on copper 17.5 x 14.3
250

Thielen, Jan Philip van (attributed to)
1618–1667
Flowers with a Sculptured Bust 1641
oil on panel 50.7 x 40.7
PD.176-1975

Thielen, Jan Philip van (attributed to)
1618–1667
A Vase of Flowers
oil on panel 50.7 x 40.6
PD.43-1975

Thielen, Jan Philip van (attributed to)
1618–1667
A Vase of Flowers
oil on panel 51.3 x 41.2
PD.178-1975

Thielen, Jan Philip van (attributed to)
1618–1667
A Vase of Flowers
oil on panel 51.3 x 41.2
PD.177-1975

Tillemans, Peter 1684–1734
View of a Town 1709
oil on canvas 38.7 x 52.3
226

Tintoretto, Jacopo 1519–1594
The Adoration of the Shepherds 1540s
oil on canvas 172.7 x 274.4
1610

Tintoretto, Jacopo (studio of) 1519–1594
Young Man in a Fur Cloak 1558
oil on canvas 117.5 x 92.1
M.80

Titian c.1488–1576
Venus and Cupid with a Lute Player
1555–1565
oil on canvas 150.5 x 196.8
129

Titian c.1488–1576
Tarquin and Lucretia 1571
oil on canvas 188.9 x 145.1
914

Titian (after) c.1488–1576
Sleeping Venus c.1760
oil on canvas 99.3 x 166
154

Titian (copy after) c.1488–1576
Death of St Peter Martyr 17th C
oil on canvas 123.8 x 84.2
621

Tommaso active late 15th C–early 16th C
Martyrdom of St Sebastian
oil on panel 178.4 x 115.6
125

Torbido, Francesco c.1482–c.1562
Portrait of a Man
oil on canvas 45.7 x 40.6
1111

Tott, Sophie de (copy after)
active 1801–1804
Charles X of France
oil on canvas 27.9 x 22.8
458

Toulouse-Lautrec, Henri de 1864–1901
Study of a Female Nude
oil on canvas 25 x 30
PD.6-2005

Tovey, Samuel Griffiths 1808–1873
William Beard c.1836
oil on canvas 130.2 x 103.9
3987

Towne, Charles 1739–1816
Hilly Landscape 1780
oil on canvas 38.7 x 51.1
1616

Trevisani, Francesco 1656–1746
*Study for 'The Massacre of the
Innocents'* 1700–1710
oil on canvas 53.3 x 37.5
PD.66-1996

Trevisani, Francesco (attributed to)
1656–1746
The Agony in the Garden
oil on canvas 61 x 49.2
51

Tristán de Escamilla, Luis 1585–1624
The Adoration of the Shepherds 1620
oil on canvas 233 x 115
M.78

Troy, Jean François de 1679–1752
Duck Shooting in a Wood 1730
oil on canvas 83 x 66
PD.9-1964

Troyon, Constant 1810–1865
Shepherd and His Flock 1850s
oil on panel 24.1 x 43.2
PD.149-1985

Troyon, Constant 1810–1865
Four Sketches of Cows
oil on millboard 39 x 47.2
PD.150-1985

Tucker, James Justus 1795/1796–1842
The Angel Proclaiming the End of Time
oil on canvas 86.4 x 69.9
3988

Tunnard, John 1900–1971
Untitled c.1950
mixed media on board 52 x 62
PD.181-1991

Tura, Cosmè c.1430–1495
The Crucifixion
tempera & oil on panel 48.9 x 29.5
PD.30-1947

Turchi, Alessandro 1578–1649
The Adoration of the Shepherds 1600–1610
oil on copper 47.4 x 23.4
PD.33-1986

Turner, Joseph Mallord William 1775–1851
Welsh Mountain Landscape c.1799–1800
oil on canvas 64.1 x 98.8
M.Add.17

Facing page: Ruysch, Rachel, 1664–1750, *A Still Life with Flowers, Butterflies and Lizard in a Dell* (detail), (p. 157)

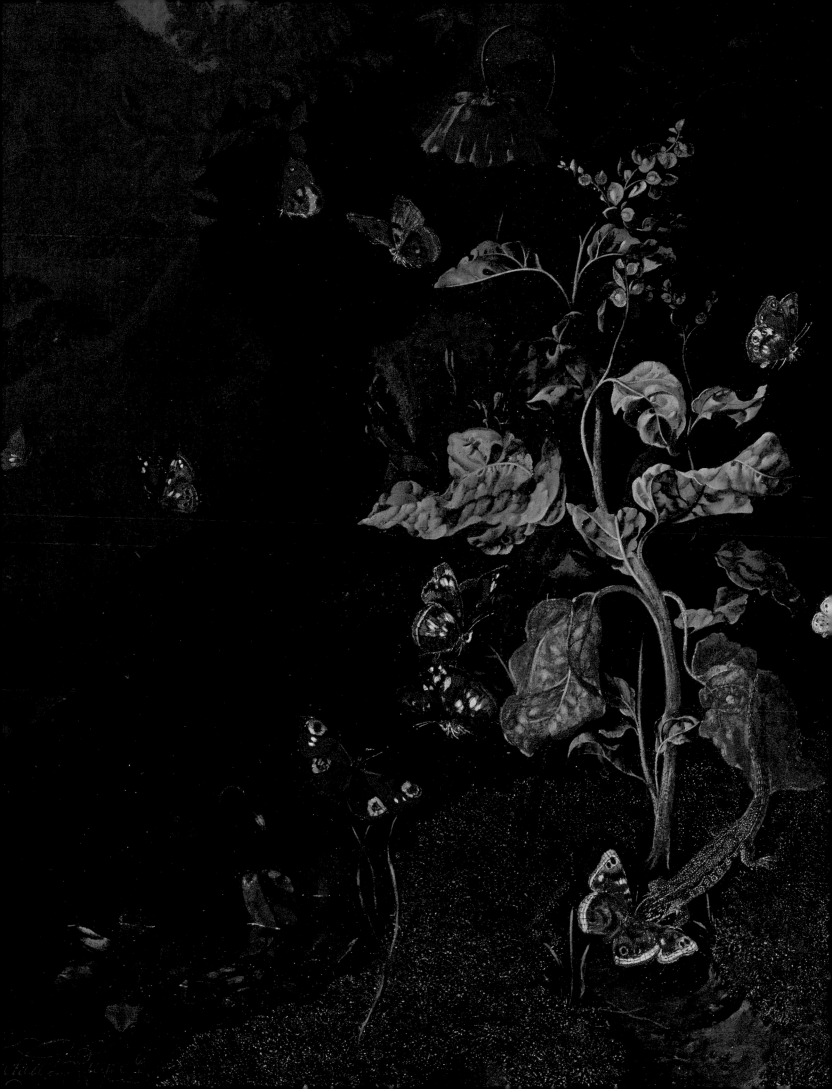

Turner, Joseph Mallord William 1775–1851
*A Beech Wood with Gypsies round a
Campfire* c.1799–1801
oil on paper, laid down on panel 27 x 19
PD.25-1981

Turner, Joseph Mallord William 1775–1851
*A Beech Wood with Gypsies Seated in the
Distance* c.1799–1801
oil on paper, laid down on panel 27 x 19
PD.24-1981

Uden, Lucas van 1595–1672
*The Escorial from a Foothill of the
Guadarrama Mountains (after Peter Paul
Rubens)*
oil on panel 48.9 x 73.3
92

unknown artist late 17th C
The Annunciation
oil on panel 17.9 x 17.3
PD.13-1949

unknown artist late 17th C
*The Elevation of the Cross with St George and
St Demetrius*
oil on panel 55.6 x 39.5
PD.12-1949

unknown artist 18th C
St Anastasius
oil on panel 18.2 x 14.5
PD.16-1949

unknown artist late 18th C
The Altmaria
oil on panel 24.3 x 21
PD.17-1949

unknown artist
Deisis
oil on panel 25.5 x 20.6
PD.15-1949

unknown artist
Head of a Virgin
oil on panel 21.8 x 16
PD.14-1949

unknown artist
Head of Christ
oil on panel 20.3 x 16
PD.10-1949

unknown artist
The Baptism in Jordan
oil on panel 33.2 x 24
PD.18-1949

unknown artist
The Entry into Jerusalem
oil on panel 38.8 x 27.6
PD.9-1949

unknown artist
The Forty Martyrs of Taki Sebaste
oil on panel 30.7 x 25.8
3716

unknown artist
Virgin and Child with St George
oil on panel 27.5 x 20.5
PD.11-1949

Vallayer-Coster, Anne 1744–1818
A Vase of Flowers 1775
oil on canvas 46 x 30.4
PD.46-1975

Van Utrecht, Jacob Claesz. (attributed to)
c.1480–1530
Marriage of the Virgin (polyptych)
oil on panel 29.8 x 15.2
M.26A

Van Utrecht, Jacob Claesz. (attributed to)
c.1480–1530
The Annunciation (polyptych)
oil on panel 29.8 x 15.2
M.26B

Van Utrecht, Jacob Claesz. (attributed to)
c.1480–1530
Adoration of the Child (polyptych)
oil on panel 29.8 x 15.2
M.26C

Van Utrecht, Jacob Claesz. (attributed to)
c.1480–1530
Adoration of the Kings (polyptych)
oil on panel 29.8 x 15.2
M.26D

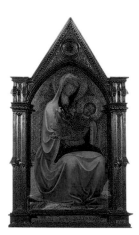

Vanni, Andrea c.1332–c.1414
Virgin and Child c.1400
tempera with gold on panel 94.9 x 52.7
560

Vasarely, Victor 1908–1997
Kontosh 1964
oil on board 84 x 80
PD.151-1985

Vaughan, John Keith 1912–1977
Road through a Village 1957
oil on board 97 x 71.5
PD.22-1979

Vaughan, John Keith 1912–1977
Standing Figure 1960
oil on canvas 76 x 63.3
PD.15-1960

Vaughan, John Keith 1912–1977
Cattle Shed 1972
oil on board 44.4 x 38.3
PD.252-1985

Veen, Otto van 1556–1629
*On the Disposal of Wealth: Illustration to
Horace, Carmina III, xxiv, 40–45*
grisaille oils over graphite on paper marouflé
on panel 18.5 x 14.7
PD.12-1980

Velde, Adriaen van de 1636–1672
Landscape with Cattle and Figures 1664
oil on canvas 125.7 x 167
88

Velde, Esaias van de I 1587–1630
Winter Landscape 1614
oil on panel 21 x 40.6
M.79

Velde, Jan van de II c.1593–1641
Landscape c.1620
oil on panel 26.8 x 37.8
85

Velde, Willem van de II (school of)
1633–1707
*Dutch Men O'War and Other Shipping in
Choppy Seas*
oil on canvas 56 x 71
PD.90-1993

Velde, Willem van de II (school of)
1633–1707
Storm at Sea
oil on canvas 109.2 x 196.8
153

Vellacott, Elisabeth 1905–2002
Garden Painting
oil on board 68.6 x 87.6
PD.36-2003

Venne, Adriaen van de 1589–1662
*Christ and the Woman of Samaria at the
Well* 1631
grissaille oils over graphite on panel
33.4 x 26.3
PD.182-1991

Verbeeck, Pieter Cornelisz. c.1610–1654
Horse Drinking
oil on panel 23.5 x 18.4
363

Verbeeck, Pieter Cornelisz. (attributed to)
c.1610–1654
Sea Piece with Shipping
oil on panel 23.8 x 37.2
398

Verbruggen, Gaspar Peeter de II 1664–1730
A Vase of Flowers with Fruit in a Landscape
oil on canvas 39.7 x 32.5
PD.92-1973

Verelst, Cornelis 1667–1734
A Vase of Flowers
oil on canvas 54.5 x 46
PD.47-1966

Verelst, Simon Pietersz.
1644–probably 1721
A Vase of Flowers 1669
oil on canvas 51 x 40.5
PD.50-1975

Verelst, Simon Pietersz.
1644–probably 1721
A Vase of Flowers
oil on canvas 106.6 x 88.8
PD.48-1966

Verelst, Simon Pietersz.
1644–probably 1721
A Vase of Flowers
oil on canvas 84.5 x 70.6
PD.93-1973

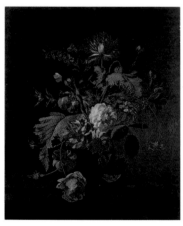

Verelst, Simon Pietersz.
1644–probably 1721
A Vase of Flowers
oil on canvas 76.4 x 63.9
PD.49-1975

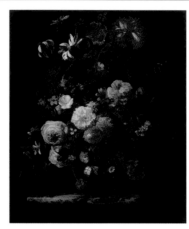

Verelst, Simon Pietersz.
1644–probably 1721
Glass Vase of Mixed Flowers on a Marble Ledge
oil on canvas 78.7 x 64.8
314

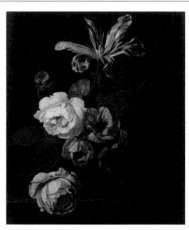

Verelst, Simon Pietersz.
1644–probably 1721
Group of Flowers
oil on canvas 42.3 x 37
304

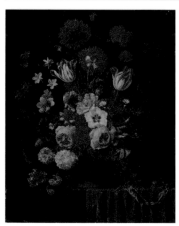

Verendael, Nicolaes van 1640–1691
A Vase of Flowers 1673
oil on canvas 76.2 x 63.4
PD.51-1975

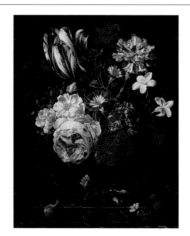

Verendael, Nicolaes van 1640–1691
A Vase of Flowers
oil on canvas 34.2 x 26.6
PD.94-1973

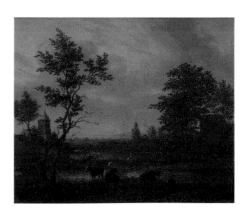

Vermeulen, Cornelis c.1732–1813
Landscape with Figures 1771
oil on panel 26 x 31.1
410

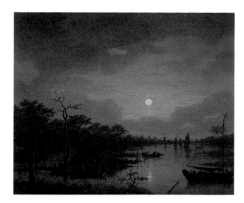

Vermeulen, Cornelis c.1732–1813
River Scene by Moonlight
oil on panel 26 x 31.1
408

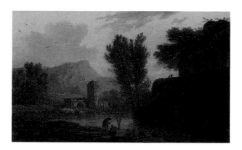

Vernet, Claude-Joseph 1714–1789
View on the Arno 1747
oil on canvas 30.7 x 48.7
336

Vernet, Claude-Joseph 1714–1789
Sunrise 1760
oil on canvas 96.4 x 133
PD.20-1997

Vernet, Claude-Joseph 1714–1789
Noon 1760
oil on canvas 95 x 131
PD.21-1997

Vernet, Claude-Joseph 1714–1789
Sunset 1760
oil on canvas 96.5 x 134
PD.22-1997

Vernet, Claude-Joseph 1714–1789
*A Coastal Mediterranean Landscape with a
Dutch Merchantman in a Bay* 1769
oil on canvas 87 x 130
PD.23-1997

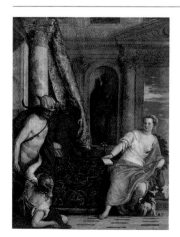

Veronese, Paolo 1528–1588
Hermes, Herse and Aglauros 1576–1584
oil on canvas 232.4 x 173
143

Veronese, Paolo (copy after) 1528–1588
The Martyrdom of St George 17th C
oil on canvas 422.9 x 298.4
181

Vidal, L. c.1754–1804
Vase of Flowers
oil on copper 51.1 x 40.6
PD.49-1966

Ville, Nick de b.1945
Still Life with Stools and Books
wire & pigment on board 122.1 x 101.5
PD.29-1979

Vincent, George 1796–1831
Loch Etive, Argyllshire 1821
oil on canvas 54 x 72.2
PD.4-1954

Vincent, George 1796–1831
View in the Highlands 1827
oil on canvas 101.6 x 127.9
PD.50-1949

Vinckeboons, David 1576–1632
Wooded Landscape c.1603–1605
oil on panel 56 x 105
90

Vleughels, Nicolas 1668–1737
Telemachus on Calypso's Island
oil on copper 25 x 34
PD.8-1995

Vlieger, Simon de 1601–1653
Storm with a Wreck c.1635
oil on panel 29.3 x 38.4
345

Vlieger, Simon de 1601–1653
Sea Piece, a Breeze near a Dutch Port c.1640
oil on panel 51.7 x 94.3
54

Vlieger, Simon de 1601–1653
Shipping before Dordrecht 1651
oil on panel 89 x 122.5
105

Vlieger, Simon de 1601–1653
Sea Piece, a Calm
oil on panel 30.2 x 28
386

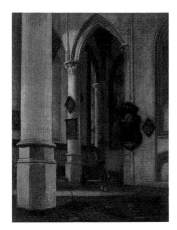

Vliet, Hendrick Cornelisz. van c.1611–1675
The Old Church at Delft
oil on panel 49.2 x 36.5
79

Vollon, Antoine 1833–1900
A River Scene 1885–1900
oil on canvas 25.1 x 32.7
831

Vonck, Jacobus active 1717–1773
*A Sculpted Stone Vase with Roses, Auricula,
Poppies, Convolvulus, with a Jay on a Ledge*
1760
oil on canvas 85.1 x 68.5
PD.52-1975

Vonck, Jacobus active 1717–1773
*A Sculpted Stone Vase with Roses, Poppies,
Convolvulus, Ivy (...)* 1760
oil on canvas 85.1 x 68.5
PD.53-1975

Vos, Paul de 1591–1592 or 1595–1678
Stag Hunt
oil on canvas 172.1 x 241.9
62

Vos, Simon de (attributed to) 1603–1676
Portrait of a Man (perhaps Jan de Wael)
oil on panel 60.6 x 51.3
159

Vouet, Simon 1590–1649
The Entombment c.1635–1638
oil on panel 56.5 x 41.5
PD.8-1959

Vries, Guilliam de 1624/1629–1675/1678
Still Life of Fruit with the Supper at Emmaus
oil on canvas 163.2 x 117.5
2290

Vries, Roelof van c.1631–after 1681
A Tower beside a River
oil on panel 23.8 x 31.1
236

Vroom, Cornelis the younger (circle of) c.1591–1661
River Scene
oil on panel 16.5 x 22.2
387

Vuillard, Jean Edouard 1868–1940
The Artist's Sister with a Cup of Coffee 1893
distemper on card 35.5 x 29.1
PD.1-1994

Vuillard, Jean Edouard 1868–1940
Seated Woman, Reading c.1905
oil on canvas 32.5 x 27.3
PD.11-1966

Vuillard, Jean Edouard 1868–1940
Woman Reading in the Reeds, Saint-Jacut-de-la-mer 1909
distemper on paper, laid down on a stretcher 44.5 x 64.6
PD.11-1967

Vuillard, Jean Edouard 1868–1940
Marguerite Chapin in Her Apartment with Her Dog 1910
oil on millboard 59 x 73.6
2454

Vuillard, Jean Edouard 1868–1940
Stoneware Vase and Flowers
oil on paper laid down on wood 77.5 x 54
2417

Walker, Ethel 1861–1951
Girl's Head late 1920s
oil on canvas 35.2 x 27.9
2317

Walker, Frederick 1840–1875
Mother with a Baby and a Nursemaid
oil on canvas 46 x 61.8
PD.22-2005

Wallis, Alfred 1855–1942
Two Masted Yawl
oil & graphite on card 17.5 x 24
PD.69-1992

Wallis, George Augustus 1761–1847
The Marble Falls, Terni 1788–1806
oil on paper 45.5 x 38.5
PD.29-1997

Wallis, George Augustus 1761–1847
Portrait of an Unknown Lady
oil on canvas 61 x 49
PD.4-2004

Wals, Goffredo c.1605–c.1638
A Country Road by a House
oil on copper 24.5
PD.19-1974

Walton, Edward Arthur 1860–1922
Self Portrait
oil on canvas 67 x 51.5
1119

Walton, Elijah 1832–1880
The Tombs of the Sultans near Cairo 1865
oil on canvas 137 x 183
456*

Ward, James 1769–1859
Pigs before 1793
oil on canvas 38.1 x 59.1
2577

Ward, James 1769–1859
Fight between a Lion and a Tiger 1797
oil on canvas 101.6 x 136.2
60

Ward, James 1769–1859
Two Studies of Children c.1812
oil on paper 61.6 x 51.4
2261

Ward, James 1769–1859
Sketch for 'The Family Compact' before 1834
oil on panel 24.1 x 29.5
PD.59-1993

Ward, James 1769–1859
Sleeping Lioness 1840–1850
oil on canvas 38.1 x 59.1
3939

Ward, James 1769–1859
The Descent of the Swan
oil on panel 34.9 x 31.1
PD.58-1993

Waterlant, Simon Claesz. van d.1556
Adoration of the Kings 1537
oil on panel 65.5 x 51.7
M.20

Watts, George Frederick 1817–1904
William Cavendish, Seventh Duke of Devonshire 1883
oil on canvas 127 x 101.6
503

Watts, George Frederick 1817–1904
Chaos
oil on canvas 19.3 x 74.3
784

Watts, George Frederick 1817–1904
Three Heads
oil on canvas 28.2 x 53.3
1761

Webber, John 1750–1793
A Native of Otaheite 1777
oil on canvas 46.3 x 36.2
454

Weenix, Jan 1642–1719
Dead Game and Fruit 1706
oil on canvas 104.9 x 94.3
50

Weenix, Maria c.1679–1720 or later
Flowers and Fruit 1720
oil on canvas 58.3 x 48.2
PD.55-1975

Facing page: British School, *Christ before Pilate* (detail), c.1400–1425, (p. 26)

Weenix, Maria c.1679–1720 or later
A Group of Flowers
oil on canvas 58.3 x 48.2
PD.54-1975

Werff, Adriaen van der 1659–1722
Tancred's Servant Presenting the
Heart of Guiscard in a Golden Cup to
Guismond c.1675
oil on panel 43.5 x 36.2
375

Werff, Pieter van der 1665–1722
Bacchus and Ariadne 1712
oil on panel 37.1 x 28.6
376

Weschke, Karl 1925–2005
Cloud Study 1963
mixed media on board 19 x 27
PD.70-1992

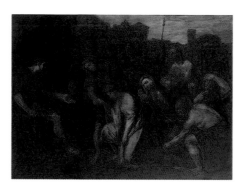

West, Benjamin 1738–1820
The Continence of Scipio c.1766
oil on panel 100.3 x 133.3
655

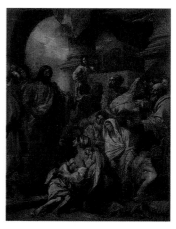

West, Benjamin 1738–1820
Christ Healing the Sick in the Temple
c.1780–1781
oil on canvas 90.5 x 69.8
656

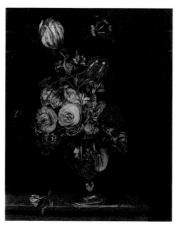

Weyerman, Jacob Campo 1677–1747
A Vase of Flowers
oil on canvas 56.8 x 48.9
PD.95-1973

Wheatley, Francis 1747–1801
Benjamin Bond Hopkins before 1791
oil on canvas 102 x 127.5
PD.6-1953

Whistler, James Abbott McNeill 1834–1903
Portrait Study of a Man 1890s
oil on panel 16.8 x 10.2
PD.29-1970

**Whistler, James Abbott McNeill
(imitator of)** 1834–1903
*Symphony in Grey and Brown: Lindsey Row,
Chelsea*
oil on canvas 30.2 x 26.4
PD.17-1948

**Whistler, James Abbott McNeill
(imitator of)** 1834–1903
Woman Sewing
oil on panel 20.2 x 12.6
PD.975-1963

Wijnants, Jan c.1635–1684
Landscape with Cattle 1670
oil on panel 23.2 x 28.6
39

Wijnants, Jan c.1635–1684
Landscape with a Man and a Dog
oil on canvas 24.1 x 27.6
37

Wijnants, Jan c.1635–1684
Landscape with a Woman and a Dog
oil on canvas 22.2 x 27.9
38

Wijnants, Jan c.1635–1684
Landscape with Coursing
oil on panel 21 x 27.6
40

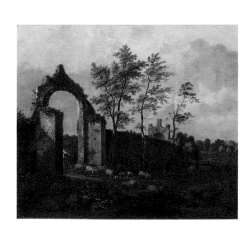

Wijnants, Jan (copy after) c.1635–1684
Landscape with Sheep
oil on panel 36.5 x 44.8
292

Wilkie, David 1785–1841
The Burial of the Scottish Regalia
c.1835–1836
oil on panel 30.5 x 21.3
PD.16-2000

Willaerts, Abraham c.1603–1669
Family Group 1660
oil on panel 18.7 x 17.5
534

Williams, Solomon 1757–1824
Daniel Mesman
oil on canvas 75.3 x 62.5
12

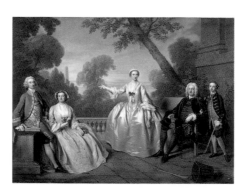

Wills, James active 1743–1777
The Andrews Family 1749
oil on canvas 110.5 x 145
657

Wilson, Frank Avray b.1914
Miniature Configuration 1960
oil on canvas board 26 x 17.8
PD.71-1992

Wilson, Richard 1713/1714–1782
Apollo and the Seasons
oil on canvas 100.1 x 125.7
PD.27-1952

Wilson, Richard 1713/1714–1782
Italian River Landscape with a Broken Bridge
oil on panel 41.3 x 53.3
PD.2-1948

Wilson, Richard (after) 1713/1714–1782
Bridge of Augustus at Rimini
oil on canvas 44.4 x 73.3
1130

Wilson, Richard (attributed to)
1713/1714–1782
Lake and Hills
oil on canvas 34.9 x 44.2
1126

Woensel, Petronella van 1785–1839
An Urn of Flowers 1827
oil on panel 41.9 x 35.5
PD.56-1975

Wood, Christopher 1901–1930
La Ville-Close, Concarneau, Brittany 1930
oil on millboard 56.8 x 81.6
2451

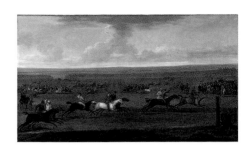

Wootton, John c.1682–1765
A Race on the Round Course at Newmarket
oil on canvas 85.7 x 143.9
PD.1-1979

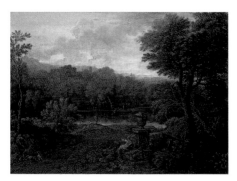

Wootton, John c.1682–1765
Classical Landscape
oil on canvas 81.2 x 107.5
5

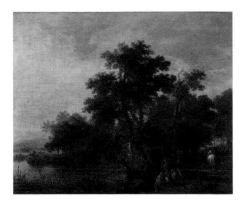

Wouwerman, Philips 1619–1668
Landscape with a Sporting Party
oil on panel 36.2 x 44.1
69

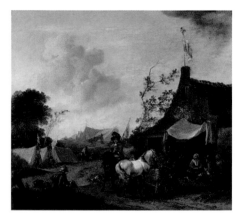

Wouwerman, Pieter 1623–1682
Encampment beside an Ale House
oil on canvas 45.2 x 50.1
71

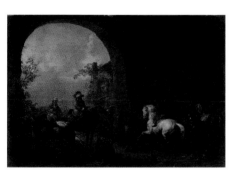

Wouwerman, Pieter 1623–1682
The Stable
oil on panel 33 x 48.3
80

Wragg, Gary b.1946
Painting No.1 C January 1974 1974
liquitex on cotton duck 175 x 223.5
PD.22-2002

Wragg, Gary b.1946
Untitled c.1980
oil on canvas 261.8 x 173.1
PD.37-2003

Wragg, Gary b.1946
Oval Works, Gaze Left 1997
oil on cotton duck 171.4 x 144
PD.31-2002

Wright, Joseph of Derby 1734–1797
*The Honourable Richard Fitzwilliam, Seventh
Viscount Fitzwilliam of Merrion* 1764
oil on canvas 74.9 x 62.2
1

Wright, Joseph of Derby 1734–1797
Mrs John Ashton c.1769–1771
oil on canvas 126.1 x 101
659

Wright, Joseph of Derby 1734–1797
Matlock Tor c.1778–1780
oil on canvas 73.1 x 100
PD.8-1948

Wtewael, Joachim Anthonisz. (after)
1566–1638
The Judgement of Paris
oil on copper 17.1 x 21.3
427

Wyck, Thomas 1616–1677
The Alchemist
oil on panel 35.2 x 30.2
351

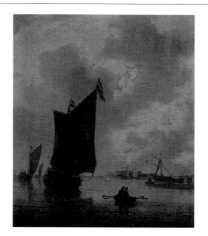

Zeeman, Reiner c.1623–c.1668
Sea Piece
oil on canvas 36.8 x 31.4
41

**Ziem, Félix François Georges
Philibert** 1821–1911
A View in Venice
oil on canvas 68.5 x 107
PD.61-1996

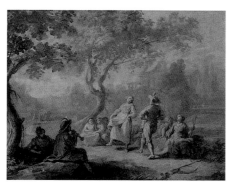

Zocchi, Giuseppe 1711/1717–1767
The Month of June 1761
oil on paper marouflé on canvas 33.6 x 43.9
PD.11-1983

Zuccarelli, Franco 1702–1788
Refreshment during the Ride c.1745
oil on canvas 72 x 105
198

Zuccarelli, Franco 1702–1788
*Italianate Wooded River Landscape with a
Piping Shepherd, Two Women and a Child*
oil on canvas 105.5 x 89.5
PD.112-1992

Zuccarelli, Franco 1702–1788
Stag Hunt
oil on canvas 73 x 106
200

Zuccari, Taddeo 1529–1566
Adoration of the Kings c.1550
oil on panel 111.5 x 86.3
M.31

Zugno, Francesco 1709–1787
The Apotheosis of St Zeno
oil on canvas 55 x 29.3
PD.72-1992

Zurbarán, Francisco de (school of)
1598–1664
St Rufina
oil on canvas 85.4 x 64.7
M.83

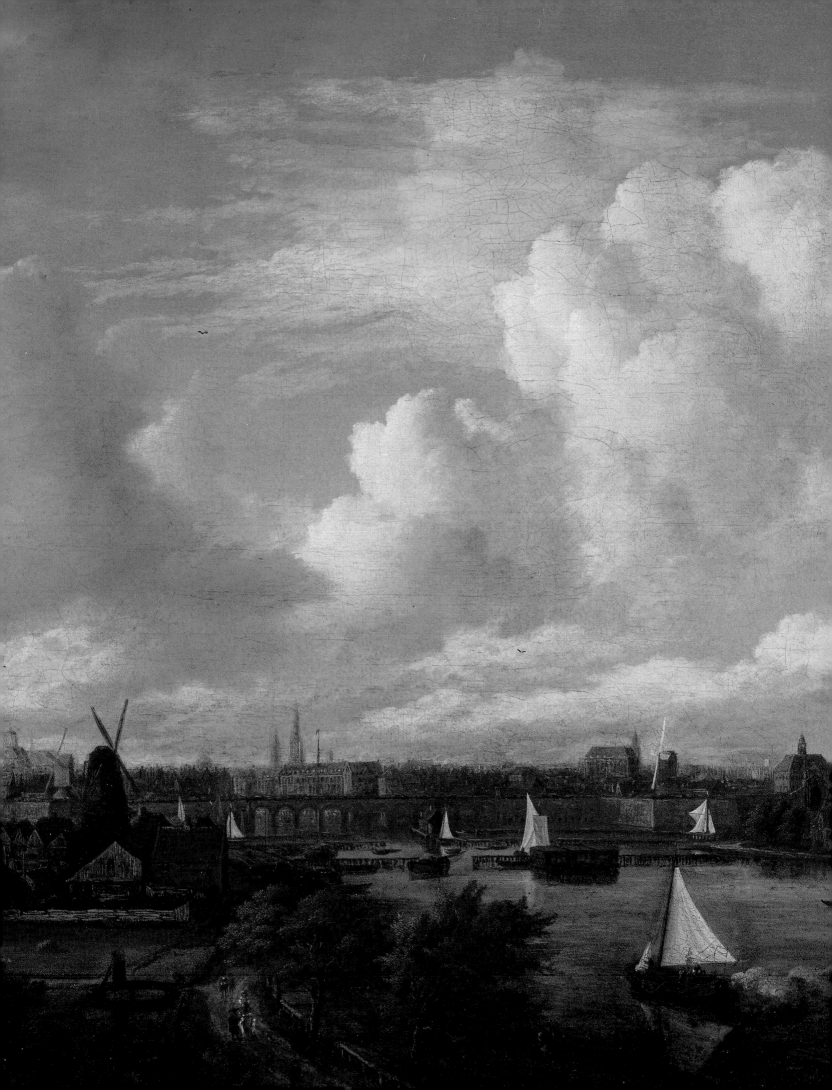

Further Information

The paintings listed in this section have additional information relating to one or more of the five categories outlined below. Paintings listed in this section follow the same order as in the illustrated pages of the catalogue.

I	The full name of the artist if this was too long to display in the illustrated pages of the catalogue. Such cases are marked in the catalogue with a (…).
II	The full title of the painting if this was too long to display in the illustrated pages of the catalogue. Such cases are marked in the catalogue with a (…).
III	Acquisition information or acquisition credit lines as well as information about loans, copied from the records of the owner collection.
IV	Artist copyright credit lines where the copyright owner has been traced. Exhaustive efforts have been made to locate the copyright owners of all the images included within this catalogue and to meet their requirements. Any omissions or mistakes brought to our attention will be duly attended to and corrected in future publications.
V	The credit line of the lender of the transparency if the transparency has been borrowed. Bridgeman images are available subject to any relevant copyright approvals from the Bridgeman Art Library at www.bridgeman.co.uk

The Fitzwilliam Museum

Abadía, Juan de la the elder active c.1470–1500, *St Anthony Abbot*, bequeathed by Charles Brinsley Marlay, 1912

Adriaenssen, Alexander (attributed to) 1587–1661, *Flowers in a Glass Vase*, bequeathed by Daniel Mesman, 1834

Aelst, Willem van 1627–after 1687, *Group of Flowers*, bequeathed by Daniel Mesman, 1834

Agasse, Jacques Laurent 1767–1849, *The Mail Guard*, given by the executors of Sir Paul Mellon's estate, 2000

Agricola, Luigi b.c.1750, *Cadmus and the Dragon*, bequeathed by Warren Pollock, 1986, received 1992

Agricola, Luigi b.c.1750, *Venus Giving Arms to Aeneas*, bequeathed by Warren Pollock, 1986, received 1992

Albani, Francesco 1578–1660, *The Trinity with the Virgin Mary and Musician Angels*, lent by Sir Denis Mahon

Albani, Francesco (school of) 1578–1660, *Venus and Cupid in a Landscape*, bequeathed by Richard, Seventh Viscount Fitzwilliam, 1816

Albertinelli, Mariotto (studio of) 1474–1515, *The Virgin and Child with the Infant Baptist*, given by Mrs J. C. Hare in accordance with the wishes of her husband the Ven. J. C. Hare, Archdeacon of Lewes, 1855

Aligny, Théodore Caruelle d' 1798–1871, *Young Man Reclining on the Downs*, bequeathed by John Tillotson, 1984, received 1985

Allegrini, Francesco c.1615–after 1679, *The Fall of Icarus*, given by the Friends of the Fitzwilliam Museum, 1969

Allori, Alessandro 1535–1607, *The Temptation of St Benedict*, bequeathed by Samuel Gorley Putt, 1996

Alma-Tadema, Lawrence 1836–1912, *A Floral Bank*, bought from the Fairhaven Fund, 1979

Alma-Tadema, Lawrence 1836–1912, *94 Degrees in the Shade*, given by Sir (Henry Francis) Herbert Thompson, Bt, 1920

Alma-Tadema, Lawrence 1836–1912, *Sir Herbert Thompson, Bt*, given by Sir (Henry Francis) Herbert Thompson, Bt, 1920

Alma-Tadema, Lawrence 1836–1912, *Sir Henry Thompson, Bt*, given by Sir (Henry Francis) Herbert Thompson, Bt, 1920

Alma-Tadema, Lawrence 1836–1912, *The Boating Pool*, bought from the Fairhaven Fund, 1979

Amidano, Giulio Cesare (attributed to) 1566–1630, *The Virgin with an Angel, the Child Christ and St John the Baptist*, bequeathed by Richard, Seventh Viscount Fitzwilliam, 1816

Andrea di Niccolò c.1444–c.1525, *Virgin and Child between St Jerome and St Peter*, bought, 1893

Andrews, Michael 1928–1995, *Study for 'The Estuary'*, bought from the Fairhaven Fund, 2002, © the artist's estate

Anthonissen, Hendrick van 1606–after 1660, *View of Scheveningen Sands*, bequeathed by the Reverend Richard Edward Kerrich, 1873

Antonissen, Henricus Josephus 1737–1794, *Landscape with Flocks*, bequeathed by Daniel Mesman, 1834

Apollonio di Giovanni di Tommaso c.1415/1417–1465, *The Triumph of Scipio Africanus*, 40 x 135.9, painted surface 36.2 x 133.6, bequeathed by Charles Brinsley Marlay, 1912

Ashford, William 1746–1824, *View in Mount Merrion Park*, bequeathed by Richard, Seventh Viscount Fitzwilliam, 1816

Ashford, William 1746–1824, *View in Mount Merrion Park*, bequeathed by Richard, Seventh Viscount Fitzwilliam, 1816

Ashford, William 1746–1824, *View in Mount Merrion Park*, bequeathed by Richard, Seventh Viscount Fitzwilliam, 1816

Ashford, William 1746–1824, *View in Mount Merrion Park*, bequeathed by Richard, Seventh Viscount Fitzwilliam, 1816

Ashford, William 1746–1824, *View in Mount Merrion Park*, bequeathed by Richard, Seventh Viscount Fitzwilliam, 1816

Ashford, William 1746–1824, *View in Mount Merrion Park*, bequeathed by Richard, Seventh Viscount Fitzwilliam, 1816

Aspertini, Amico (attributed to) 1475–1552, *The Beheading of St John the Baptist*, given by Mrs J. C. Hare in accordance with the wishes of her husband, the Ven. J. C. Hare, Archdeacon of Lewes, 1855

Asselin, Maurice 1882–1947, *Boats*, given by Keith Stuart Baynes, 1974, © ADAGP, Paris and DACS, London 2006

Asselyn, Jan after 1610–1652, *Italian Coast Scene*, bequeathed by Daniel Mesman, 1834

Asselyn, Jan after 1610–1652, *Italian Landscape*, bequeathed by Daniel Mesman, 1834

Ast, Balthasar van der 1593/1594–1657, *Still Life with Fruit and Macaws*, bequeathed by Daniel Mesman, 1834

Ast, Balthasar van der 1593/1594–1657, *A Basket of Flowers with Shells on a Ledge*, bequeathed by Major the Hon. Henry Rogers Broughton, Second Lord Fairhaven, 1973, received 1975

Ast, Balthasar van der 1593/1594–1657, *A Vase of Flowers with Shells on a Ledge*, bequeathed by Major the Hon. Henry Rogers Broughton, Second Lord Fairhaven, 1973, received 1975

Ast, Balthasar van der 1593/1594–1657, *Wicker Basket with Fruit, Medlars and Shells*, bequeathed by Major the Hon. Henry Rogers Broughton, Second Lord Fairhaven, 1973, received 1975

Auerbach, Frank Helmuth b.1931, *Primrose Hill, Winter Fog*, bought from the L. D. Cunliffe, Abbott, Marlay and Gow Funds with a contribution from the National Art Collections Fund, 1993, © the artist

Austrian (Tyrolean) School *The Decollation of St John the Baptist*, given by Michael Straight, through the American Friends of Cambridge University, 1988

Avery, Milton 1893–1965, *Bird and Sandspit*, bequeathed by Warren Pollock 1986, received 1992, © ARS, NY and DACS, London 2006

Backhuysen, Ludolf I 1630–1708, *A Shipwreck*, bequeathed by Mrs Gwendoline Amy Rooke, 2002

Backhuysen, Ludolf I (attributed to) 1630–1708, *Bust Portrait of a Man*, bequeathed by Richard, Seventh Viscount Fitzwilliam, 1816

Baen, Jan de 1633–1702, *Gentleman with Helmet*, bequeathed by Henry Scipio Reitlinger, 1950, transferred from the Reitlinger Trust, 1991, accessioned 2005

Balducci, Giovanni 1560–after 1631, *The Passover*, bequeathed by Warren Pollock, 1986, received 1992

Balen, Hendrik van I 1575–1632, *Adoration of the Shepherds*, bequeathed by Richard, Seventh Viscount Fitzwilliam, 1816

Balen, Hendrik I 1575–1632 **& Brueghel, Jan the elder** 1568–1625 *The Judgement of Paris*, bequeathed by Richard, Seventh Viscount Fitzwilliam, 1816

Barron, Hugh (attributed to) 1745–1791, *Francis Page of Newbury*, bequeathed by Professor Frederick Fuller, 1909, received 1923

Bartolomeo di Giovanni active c.1475–c.1505 **& Biagio d'Antonio** 1446–1516 *The Story of Joseph, I*, bequeathed by Charles Brinsley Marlay, 1912

Bartolomeo di Giovanni active c.1475–c.1505 **& Biagio d'Antonio** 1446–1516 *The Story of Joseph, II*, bequeathed by Charles Brinsley Marlay, 1912

Bartolomeo Veneto d.1531, *Portrait of a Man*, given by Mrs J. C. Hare in accordance with the wishes of her husband, the Ven.

Facing page: Ruisdael, Jacob van, 1628/1629–1682, *View on the Amstel Looking towards Amsterdam* (detail), (p. 156)

J. C. Hare, Archdeacon of Lewes, 1855

Basaiti, Marco active 1496–1530, *Virgin and Child with Saints*, bequeathed by Charles Brinsley Marlay, 1912

Bassano, Francesco II 1549–1592, *Landscape with Shepherds*, bequeathed by Richard, Seventh Viscount Fitzwilliam, 1816

Bassano, Jacopo il vecchio c.1510–1592, *The Journey to Calvary*, bequeathed by Charles Brinsley Marlay, 1912

Bassano, Jacopo il vecchio (and workshop) c.1510–1592, *St Jerome in the Wilderness*, bequeathed by Richard, Seventh Viscount Fitzwilliam, 1816

Bastien-Lepage, Jules 1848–1884, *Girl with a Sunshade*, bequeathed by Charles Brinsley Marlay, 1912

Batoni, Pompeo 1708–1787, *The Seventh Earl of Northampton*, bought from the S. G. Perceval Fund, 1950

Baugin, Lubin c.1612–1663, *The Holy Family with the Infant St John the Baptist and Angels*, bequeathed by Warren Pollock, 1986, received 1992

Baynes, Keith 1887–1977, *St Jean-de-Luz*, given by Keith Stuart Baynes, 1975

Baynes, Keith 1887–1977, *Self Portrait*, given by Keith Stuart Baynes, 1975

Baynes, Keith 1887–1977, *Chambolle-Musigny*, given by Keith Stuart Baynes, 1975

Baynes, Keith 1887–1977, *Libourne*, given by Keith Stuart Baynes, 1975

Baynes, Keith 1887–1977, *Antoine Gili at Vernet-Les-Bains*, given by Keith Stuart Baynes, 1975

Baynes, Keith 1887–1977, *Dahlias*, given by Keith Stuart Baynes, 1975

Baynes, Keith 1887–1977, *The Alfama, Lisbon*, given by Keith Stuart Baynes, 1975

Baynes, Keith 1887–1977, *Lisbon*, given by Keith Stuart Baynes, 1975

Beale, Charles 1660–c.1714, *Unknown Man*, given by Charles Fairfax Murray, 1908

Beaumont, George Howland 1753–1827, *Landscape*, bought from the Fairhaven Fund, 1952

Beccafumi, Domenico 1484–1551, *San Bernardino Preaching in the Campo, Siena*, accepted by HM Government in lieu of tax and allocated to the Fitzwilliam Museum in memory of Dr and Mrs Alfred Scharf, 1993

Beechey, William 1753–1839, *Hebe Feeding Jupiter's Eagle*, given by H. J. Pfungst, 1904

Beeton, Alan 1880–1942, *Posing*, given by Huttleston, First Lord Fairhaven, 1938

Beeton, Alan 1880–1942, *Reposing*, given by Huttleston, First Lord Fairhaven, 1938

Beeton, Alan 1880–1942, *The Gipsy*, given by Harold, First Viscount Rothermere, 1927

Belin de Fontenay, Jean-Baptiste 1653–1715, *Vase of Flowers*, given by Major the Hon. Henry Rogers Broughton, 1966

Bell, Trevor b.1930, *Crossover*, bequeathed by Diana A. M. Hunter, 1985, received 1992, © the artist

Bell, Vanessa 1879–1961, *Portrait of Mrs M.*, bequeathed by Frank Hindley Smith, 1939, © 1961 estate of Vanessa Bell, courtesy of Henrietta Garnett

Bell, Vanessa 1879–1961, *On the Seine*, bequeathed by Frank Hindley Smith, 1939, © 1961 estate of Vanessa Bell, courtesy of Henrietta Garnett

Bellany, John b.1942, *Sarah with Aga*, given by John Bellany, 1991, © courtesy of the artist's estate/ www.bridgeman.co.uk

Bellany, John b.1942, *Love Song: Homage to Titian*, bequeathed by Daniele and Howard Harrison, 2005, © courtesy of the artist's estate/ www.bridgeman.co.uk

Bellotto, Bernardo 1722–1780, *The Arno in Florence with the Ponte alla Carraia*, given by Augustus Arthur VanSittart, 1876

Bellotto, Bernardo 1722–1780, *The Arno in Florence with the Ponte Vecchio*, given by Augustus Arthur VanSittart, 1876

Bellotto, Bernardo 1722–1780, *Entrance to the Grand Canal, Venice*, bequeathed by Richard, Seventh Viscount Fitzwilliam, 1816

Bencovich, Federico (attributed to) 1677–1753, *A Hermit*, given by the Friends of the Fitzwilliam Museum, 1948

Bendz, Wilhelm Ferdinand 1804–1832, *Portrait of a Man*, given by Daniel Katz, 1997

Bendz, Wilhelm Ferdinand 1804–1832, *Portrait of a Woman*, given by Daniel Katz, 1997

Berchem, Nicolaes 1620–1683, *Landscape with Nymphs and Satyrs*, bought from the Leverton Harris Fund, 1960

Berckheyde, Gerrit Adriaensz. 1638–1698, *The Groote Kerk at Haarlem*, bequeathed by Richard, Seventh Viscount Fitzwilliam, 1816

Berckheyde, Gerrit Adriaensz. 1638–1698, *The Town Hall of Amsterdam*, bequeathed by Richard, Seventh Viscount Fitzwilliam, 1816

Bertin, Jean Victor 1767–1842, *Landscape with Sheep and a Woman Sewing*, given by the Friends of the Fitzwilliam Museum, 1973

Bevan, Robert Polhill 1865–1925, *The Polish Tavern*, bought from the Fairhaven Fund, 1969

Biagio d'Antonio 1446–1516, *The Siege of Troy, the Death of Hector*, bequeathed by Charles Brinsley Marlay, 1912

Biagio d'Antonio 1446–1516, *The Siege of Troy, the Wooden Horse*, bequeathed by Charles Brinsley Marlay, 1912

Blake, Catherine c.1762–1831, *Agnes*, accepted by HM Treasury from the estate of Geoffrey Keynes and allocated to the Fitzwilliam Museum through the Minister of the Arts in lieu of capital taxes, 1985

Blake, William 1757–1827, *The Circumcision*, accepted by HM Treasury from the estate of Sir Geoffrey Keynes and allocated to the Fitzwilliam Museum through the Minister of the Arts in lieu of capital taxes, 1985

Blake, William 1757–1827, *An Allegory of the Spiritual Condition of Man*, given by the executors of Walford Graham Robertson (1867–1948), through the National Art Collections Fund, 1949

Blake, William 1757–1827, *The Judgement of Solomon*, given by the executors of Walford Graham Robertson (1867–1948), through the National Art Collections Fund, 1949

Blake, William 1757–1827, *Ugolino and His Sons in Prison*, given by Sir Geoffrey Keynes, 1978

Bloemen, Jan Frans van 1662–1749, *Roman Buildings*, given by the Right Reverend Lord Alwyne Frederick Compton, Bishop of Ely, 1905

Bloemen, Pieter van 1657–1720, *Horses Drinking at a Fountain*, bequeathed by Daniel Mesman, 1834

Bloemen, Pieter van 1657–1720, *Mules Halting by the Wayside*, bequeathed by Daniel Mesman, 1834

Bloemers, Arnoldus 1792–1844, *Pot of Flowers and Fruit*, given by Major the Hon. Henry Rogers Broughton, 1966

Blondeel, Lancelot (attributed to) 1496–1581, *Virgin and Child with St Anne*, bequeathed by Charles Brinsley Marlay, 1912

Bloot, Pieter de c.1602–1658, *Outside an Almshouse*, bought from the Marlay Fund, 1946

Bloot, Pieter de c.1602–1658, *Village Scene with Figures*, bequeathed by the Reverend C. Lesingham Smith, 1878

Board, Ernest 1877–1934, *Blue and Gold*, given by Claude Dickason Rotch, 1942

Boeckhorst, Jan 1605–1668, *Esther before Ahasuerus*, given by Mrs M. Joan Wyburn-Mason in memory of her husband, Professor R. Wyburn-Mason, 1983

Bogdany, Jakob c.1660–1724, *A Stone Vase of Flowers*, bequeathed by Major the Hon. Henry Rogers Broughton, Second Lord Fairhaven, 1973, received 1975

Bogdany, Jakob c.1660–1724, *Birds in a Landscape*, bequeathed by Daniel Mesman, 1834

Bogdany, Jakob c.1660–1724, *Exotic Fowl in an Ornamental Garden beside a Stone Vase, a Fountain beyond*, bequeathed by Dr D. M. McDonald, 1991, received 1992

Boilly, Louis Léopold 1761–1845, *A Vase of Flowers*, bequeathed by Major the Hon. Henry Rogers Broughton, Second Lord Fairhaven, 1973, received 1975

Bomberg, David 1890–1957, *The Virgin of Peace in Procession through the Streets of Ronda, Holy Week*, given by Lady Alexandra Dacre of Glanton, 1987, © the artist's family

Bonechi, Matteo 1669–1756, *The Adoration of the Shepherds*, bequeathed by Warren Pollock, 1986, received 1992

Bonechi, Matteo 1669–1756, *The Flight into Egypt*, bequeathed by Warren Pollock, 1986, received 1992

Bonington, Richard Parkes 1802–1828, *Landscape with a Pond*, given by the National Art Collections Fund from the Ernest Edward Cook Collection, 1955

Bonington, Richard Parkes 1802–1828, *Boccadasse, Genoa with Monte Fasce in the Background*, bought from the Fairhaven Fund with contributions from the Victoria & Albert Museum Grant-in-Aid, and the National Art Collections Fund, 1983

Bonnard, Pierre 1867–1947, *The Oil Lamp*, accepted in lieu of inheritance tax by HM Government and allocated to the Fitzwilliam Museum, 1998, © ADAGP, Paris and DACS, London 2006

Bonnard, Pierre 1867–1947, *The Meal or at Table*, acquired from the Trustees of Mrs Rosemary Maud Peto's Settlement, (hybrid transaction part in lieu, part payment), by the Syndics of the Fitzwilliam Museum with a contribution from the National Art Collections Fund and additional support from the Resource/ Victoria & Albert Purchase Grant Fund, 2002, © ADAGP, Paris and DACS, London 2006

Bonnard, Pierre 1867–1947, *Landscape*, bequeathed by Frank Hindley Smith, 1939, © ADAGP, Paris and DACS, London 2006

Bonnard, Pierre 1867–1947, *House among Trees*, bequeathed by Frank Hindley Smith, 1939, © ADAGP, Paris and DACS, London 2006

Bonnard, Pierre 1867–1947, *Still Life*, bequeathed by Frank Hindley Smith, 1939, © ADAGP, Paris and DACS, London 2006

Bonvin, François 1817–1887, *Interior*, given by Francis Falconer Madan, 1931

Boonen, Arnold (attributed to) 1669–1729, *Portrait of a Lady*, bequeathed by Daniel Mesman, 1834

Borssom, Anthonie van c.1630–1677, *Landscape with Cattle*, given by Augustus Arthur VanSittart, 1876

Bosschaert, Ambrosius the younger 1609–1645, *A Vase of Flowers*, given by Major the Hon. Henry Rogers Broughton, Second Lord Fairhaven, 1973, received 1975

Bosschaert, Ambrosius the younger 1609–1645, *A Vase of Flowers*, bequeathed by Major the Hon. Henry Rogers Broughton, Second Lord Fairhaven, 1973, received 1975

Bosschaert, Ambrosius the younger 1609–1645, *A Vase of Flowers with a Monkey*, bequeathed by the Hon. Major Henry Rogers Broughton, Second Lord Fairhaven, 1973, received 1974

Bosschaert, Ambrosius the younger 1609–1645, *Metal Vase of Flowers*, given by Major the Hon. Henry Rogers Broughton, 1966

Both, Jan c.1618–1652, *Italian Landscape with Monte Socrate*, bequeathed by Richard, Seventh Viscount Fitzwilliam, 1816

Botticelli, Sandro (studio of) 1444/1445–1510, active 15th C, *Virgin and Child*, bequeathed by Charles Brinsley Marlay, 1912

Botticini, Francesco 1446–1497, *Virgin Adoring the Child*, bequeathed by Charles Brinsley Marlay, 1912

Boucher, François (after) 1703–1770, *The Loves of the Gods: Mars and Venus*, bought from the Gow Fund with contributions from the National Art Collections Fund and the Victoria & Albert Museum Grant-in-Aid, 1980

Boudin, Eugène Louis 1824–1898, *Portrieux*, bequeathed by Sidney Ernest Prestige, 1965, with a life-interest to his widow, who died in 1968, when the picture was received

Boudin, Eugène Louis 1824–1898, *The Beach at Trouville*, given by the Friends of the Fitzwilliam Museum, 1936

Boudin, Eugène Louis 1824–1898, *Cows in a Field under a Stormy Sky*, given by Philip McClean, 1996

Boudin, Eugène Louis 1824–1898, *The Fish Cart, Berck*, bequeathed by Sidney Ernest Prestige, 1965, with a life-interest to his widow, who died in 1968, when the picture was received

Boudin, Eugène Louis 1824–1898, *Ships at Dock, Deauville*, given by E. Vincent Harris, OBE, RA, in memory of his wife, Edith, 1967

Boudin, Eugène Louis 1824–1898, *The Dock at Le Havre*, given by E. Vincent Harris, OBE, RA, in memory of his wife, Edith, 1967

Boudin, Eugène Louis 1824–1898, *Beach Scene (possibly Harfleur)*, bequeathed by Guy John Fenton Knowles, 1959

Boudin, Eugène Louis 1824–1898, *The Dutch Dock, Dunkirk*, bequeathed by Sidney Ernest Prestige, 1965, with a life-interest to his widow, who died in 1968, when the picture was received

Boudin, Eugène Louis 1824–1898, *The Jetty and Lighthouse at*

Honfleur, given by E. Vincent Harris OBE, RA, in memory of his wife Edith, 1967

Boudin, Eugène Louis 1824–1898, *Scheveningen*, given by E. Vincent Harris, OBE, RA, in memory of his wife Edith, 1967

Boughton, George Henry 1833–1905, *Winter Scene in Holland*, given by H. J. Pfungst, 1906

Bourdon, Sébastien 1616–1671, *Classical Landscape*, bought from the Gow Fund, with 50% Grant-in-Aid from the Victoria & Albert Museum and a contribution from Mr Clyde Newhouse, 1979

Bourdon, Sébastien (attributed to) 1616–1671, *A Bandits' Cave*, bequeathed by Daniel Mesman, 1834

Bourdon, Sébastien (attributed to) 1616–1671, *Classical Ruins with Figures*, bequeathed by Daniel Mesman, 1834

Bouts, Albert c.1452/1455–1549, *The Transfiguration*, given by Richard Ellison, 1857

Brabant School *The Chevalier Philip Hinckaert and St Philip the Apostle, before the Virgin and Child*, bequeathed by Louis Colville Gray Clarke, 1960, received 1961

Brakenburg, Richard 1650–1702, *Family Scene*, bequeathed by Daniel Mesman, 1834

Brakenburg, Richard 1650–1702, *Interior of a Farmhouse*, bequeathed by Richard, Seventh Viscount Fitzwilliam, 1816

Braque, Georges 1882–1963, *Cubist Design*, lent by the Provost and Fellows of King's College, Cambridge (Keynes Collection)

Braque, Georges 1882–1963, *Reclining Nude*, lent by the Provost and Fellows of King's College, Cambridge (Keynes Collection)

Bray, Jan de c.1627–1697, *Portrait of a Woman*, bequeathed by Guy John Fenton Knowles, 1959

Breenbergh, Bartholomeus 1598–1657, *Classical Landscape with Rocks*, bequeathed by Richard, Seventh Viscount Fitzwilliam, 1816

Breenbergh, Bartholomeus 1598–1657, *Classical Landscape with Ruins*, bequeathed by Richard, Seventh Viscount Fitzwilliam, 1816

Brekelenkam, Quiringh van after 1622–1669 or after, *Cottage Interior*, bequeathed by Richard, Seventh Viscount Fitzwilliam, 1816

Brett, John 1830–1902, *Landscape*, bought from the Fairhaven Fund, 1968

Brett, John 1830–1902, *Rocky Coast Scene*, bought from the Fairhaven Fund, 1973

Breydel, Karel 1678–1733, *Battle Piece*, bequeathed by Daniel Mesman, 1834

Bridge, Joseph 1845–1894, *Edward, Third Earl of Powis*, bought from J. J. R. Bridge, 1897

Bril, Paul 1554–1626, *View on the Rhine*, bequeathed by Daniel Mesman, 1834

Bril, Paul (after) 1554–1626, *Landscape with Roman Ruins*, bequeathed by Daniel Mesman, 1834

Bril, Paul (attributed to) 1554–1626, *Landscape with Sportsmen*, bequeathed by Daniel Mesman, 1834

British School *St Dorothy?*, given by Thomas Hacke Naylor, 1882

British School *Christ before Pilate*, given by the Friends of the Fitzwilliam Museum, 1910

British School *Christ Bearing the Cross*, given by the Friends of the Fitzwilliam Museum, 1910

British School *Sir Henry Slingsby*, bequeathed by Charles Haslewood Shannon, 1937

British School *Unknown Lady*, given by the Friends of the Fitzwilliam Museum, 1936

British School *Elizabeth Vernon, Countess of Southampton*, bought from the Perceval Fund with contributions from the National Art Collections Fund and the Victoria & Albert Museum Grant-in-Aid, 1984

British School *The Young Student*, given by Mrs Sigismund Goetze, 1943

British School *Eleanor, Countess of Tyrconnel*, bequeathed by Richard, Seventh Viscount Fitzwilliam, 1816

British School *A Musician*, given by Adam Lodge, 1875

British School *Richard, Fifth Viscount Fitzwilliam of Merrion*, bequeathed by Richard, Seventh Viscount Fitzwilliam, 1816

British School *Lady Decker*, bequeathed by Richard, Seventh Viscount Fitzwilliam, 1816

British School *Frances, Viscountess Fitzwilliam*, bequeathed by Richard, Seventh Viscount Fitzwilliam, 1816

British School *Memorial to Thomas and John Fitzwilliam*, bequeathed by Richard, Seventh Viscount Fitzwilliam, 1816

British School *A Lady*, bequeathed by Charles Brinsley Marlay, 1912

British School *Portrait of a Librarian*, given by Charles Fairfax Murray, 1908

British School *A Young Draughtsman*, bequeathed by Roger Francis Lambe, 1951

British School early 18th C, *Unknown Man*, given by F. A. White, 1918

British School 18th C, *Mary, Viscountess Fitzwilliam*, bequeathed by Richard, Seventh Viscount Fitzwilliam, 1816

British School 18th C, *Thomas, Fourth Viscount Fitzwilliam of Merrion*, bequeathed by Richard, Seventh Viscount Fitzwilliam, 1816

British School *J. M. W. Turner, RA*, given by J. Howard Bliss, 1945

British School *Joan and Olive Kingsford and Malcolm Burgess*, given by Wilfred R. Wood, 1975

British School early 19th C, *Holy Family with St John the Baptist*, bequeathed by Samuel Sandars,

1923

Broeck, Crispin van den 1523–1589/1591, *Two Young Men*, bequeathed by Louis Colville Gray Clarke, 1961

Broeck, Elias van den 1657–1708, *Stone Niche with Thistle, Lizard and Insects*, given by Major the Hon. Henry Rogers Broughton, 1966

Broeck, Elias van den 1657–1708, *Vase of Flowers*, given by Major the Hon. Henry Rogers Broughton, 1966

Broeck, Elias van den (attributed to) 1657–1708, *Still Life with a Thistle, Boletus, Snail, Lizard, Butterflies and a Bee in a Landscape*, bequeathed by Major the Hon. Henry Rogers Broughton, Second Lord Fairhaven, 1973, received 1975

Broers, Jasper 1682–1716, *Battle Piece*, bequeathed by J. Heath, 1862

Broers, Jasper 1682–1716, *Battle Piece*, bequeathed by J. Heath, 1862

Brown, Ford Madox 1821–1893, *The Last of England*, bought from the Marlay Fund, 1917

Brown, Ford Madox 1821–1893, *Cordelia's Portion*, bequeathed by Thomas Henry Riches, 1935, with a life-interest to his widow, who died 1950

Brown, John Alfred Arnesby 1866–1955, *The Yacht Race*, given by John Alfred Arnesby Brown, 1922

Bruegel, Pieter the elder (copy after) c.1525–1569, *The Bird-Trap*, bequeathed by Daniel Mesman, 1834

Brueghel, Jan the elder 1568–1625, *A Stoneware Vase of Flowers*, bequeathed by Major the Hon. Henry Rogers Broughton, Second Lord Fairhaven, 1973, received 1975

Brueghel, Jan the elder 1568–1625, *Landscape with Mill and Carts*, bequeathed by Dr R. B. Meyer, 1975

Brueghel, Jan the elder 1568–1625 **& Rottenhamer, Hans I** 1564–1625, *The Contest of Apollo and Pan*, bought from the Gow Fund with contributions from the Victoria & Albert Museum and the National Art Collections Fund, 1981

Brueghel, Jan the elder (after) 1568–1625, *A Basket of Flowers*, bequeathed by Major the Hon. Henry Rogers Broughton, Second Lord Fairhaven, 1973, received 1975

Brueghel, Jan the younger (attributed to) 1601–1678, *A Vase of Flowers*, bequeathed by Major the Hon. Henry Rogers Broughton, Second Lord Fairhaven, 1973, received 1975

Brueghel, Jan the younger (attributed to) 1601–1678, *River Scene*, bequeathed by Charles Lingard Bell, 1942

Brueghel, Pieter the younger 1564/1565–1637/1638, *Village Festival in Honour of St Hubert and*

St Anthony, given by Harold First Viscount Rothermere,1927

Brussel, Paul Theodor van 1754–1795, *Vase of Flowers*, bequeathed by Major the Hon. Henry Rogers Broughton, Second Lord Fairhaven, 1973

Brussel, Paul Theodor van 1754–1795, *Fruit and Flowers*, bequeathed by Major the Hon. Henry Rogers Broughton, Second Lord Fairhaven, 1973

Brussel, Paul Theodor van 1754–1795, *Vase with Flowers (after Jan van Huysum)*, bequeathed by Charles Brinsley Marlay, 1912

Burch, Hendrick van der 1627–after 1666, *The Village School*, bequeathed by Daniel Mesman, 1834

Byss, Johann Rudolf 1660–1738, *A Vase of Flowers*, bequeathed by Major the Hon. Henry Rogers Broughton, Second Lord Fairhaven, 1973

Byss, Johann Rudolf 1660–1738, *A Vase of Flowers*, bequeathed by Major the Hon. Henry Rogers Broughton, Second Lord Fairhaven, 1973

Calame, Alexandre 1810–1864, *Storm at Handeck*, bought from the Pollock Fund, 2004

Calandrucci, Giacinto 1646–1707, *The Transfiguration*, bequeathed by the Reverend Charles Mesman, 1842

Calliyannis, Manolis b.1923, *Greek Landscape I*, bequeathed by Phyllida Sewell, 1999

Calraet, Abraham Pietersz. van 1642–1722, *A Glass Vase of Flowers*, bequeathed by Major the Hon. Henry Rogers Broughton, Second Lord Fairhaven, 1973

Calraet, Abraham Pietersz. van 1642–1722, *Landscape with Figures and Horses*, bequeathed by Richard, Seventh Viscount Fitzwilliam, 1816

Calraet, Abraham Pietersz. van 1642–1722, *Landscape with Figures and Horses*, bequeathed by Richard, Seventh Viscount Fitzwilliam, 1816

Cals, Adolphe Félix 1810–1880, *Still Life*, bequeathed by John Tillotson, 1984, received 1985

Cals, Adolphe Félix 1810–1880, *Cliffs near Dieppe*, bequeathed by John Tillotson, 1984, received 1985

Cals, Adolphe Félix 1810–1880, *The Well in the rue Montlaville, Orrouy (viewed from the east)*, bequeathed by John Tillotson, 1984, received 1985

Cals, Adolphe Félix 1810–1880, *The Well in the Rue Montlaville, Orrouy (viewed from the west)*, bequeathed by John Tillotson, 1984, received 1985

Calvert, Edward 1799–1883, *A Pastoral Idyll, 'The Other Shore'*, accepted by HM Treasury from the estate of Sir Geoffrey Keynes and allocated to the Fitzwilliam Museum through the Minister of the Arts in lieu of taxes, 1985

Calvert, Edward 1799–1883, *Hesperides, 'Dance around the Golden Tree'*, accepted by HM Treasury from the estate of Sir Geoffrey Keynes and allocated to the Fitzwilliam Museum through the Minister of the Arts in lieu of taxes, 1985

Calvert, Edward 1799–1883, *The Return Home*, accepted by HM Treasury from the estate of Sir Geoffrey Keynes and allocated to the Fitzwilliam Museum through the Minister of the Arts in lieu of taxes, 1985

Cameron, David Young 1865–1945, *A Little Town of Provence*, given by David Young Cameron, 1922

Campi, Galeazzo c.1477–1536, *Virgin and Child*, given by Sir Henry Howorth, KCIE, 1917

Canaletto 1697–1768, *View of the Grand Canal: Santa Maria della Salute and the Dogana from Campo Santa Maria Zobenigo*, bequeathed by Dr D. M. McDonald, 1991, received 1992

Canaletto 1697–1768, *Interior Court of the Doge's Palace, Venice*, bequeathed by Richard, Seventh Viscount Fitzwilliam, 1816

Canaletto 1697–1768, *St Mark's, Venice*, bequeathed by Richard, Seventh Viscount Fitzwilliam, 1816

Canaletto (imitator of) 1697–1768, *The Doge's Palace, Venice*, bequeathed by Charles Brinsley Marlay, 1912

Canaletto (school of) 1697–1768, *Ruins with Figures*, bequeathed by Daniel Mesman, 1834

Canaletto (school of) 1697–1768, *Ruins with Figures*, bequeathed by Daniel Mesman, 1834

Canti, Giovanni 1653–1716, *Allegory of Fortitude and Wisdom*, bequeathed by Warren Pollock, 1986, received 1992

Carline, George F. 1855–1920, *A Harvest Landscape*, bought from the Fairhaven Fund, 1979

Carlone, Carlo Innocenzo 1686–1775, *St Mark*, bequeathed by Warren Pollock, 1986, received 1992

Carlone, Carlo Innocenzo 1686–1775, *St Augustine*, bequeathed by Warren Pollock, 1986, received 1992

Carlone, Carlo Innocenzo 1686–1775, *The Assumption of St Lucy*, bequeathed by Warren Pollock, 1986, received 1992

Carlone, Carlo Innocenzo 1686–1775, *The Crucifixion with St Roch and St Sebastian*, bequeathed by Warren Pollock, 1986, received 1992

Carlone, Carlo Innocenzo 1686–1775, *The Triumph of the Virgin*, bequeathed by Warren Pollock, 1986, received 1992

Carlone, Giovanni Battista 1603–1684, *Juno and Mars*, bequeathed by Warren Pollock, 1986, received 1992

Carracci, Annibale 1560–1609, *St*

Roch and the Angel, bequeathed by Richard, Seventh Viscount Fitzwilliam, 1816

Carracci, Annibale 1560–1609, *Head of an Old Woman*, bequeathed by Warren Pollock in 1986, received 1992

Carracci, Annibale 1560–1609, *Mary Magdalene in a Landscape*, given by the Friends of the Fitzwilliam Museum, with a contribution from the National Art Collections Fund and the Victoria & Albert Museum through Grant-in-Aid, 1976

Carrière, Eugène 1849–1906, *Portrait of His Daughter, Lisbeth*, bequeathed by A. S. F. Gow, through the National Art Collections Fund, 1978

Cast, Jesse Dale 1900–1976, *Miss June Miell* , given by the National Art Collections Fund (The David Cast Gift), 1986, © the artist

Casteels, Pieter 1684–1749, *Pheasant and Ducks*, bequeathed by Richard, Seventh Viscount Fitzwilliam, 1816

Castiglione, Giovanni Benedetto 1609–1664, *Abraham Journeying to the Land of Canaan*, bequeathed by Richard, Seventh Viscount Fitzwilliam, 1816

Cavalletto, Giovanni Battista (attributed to) active 1486–1523, *Adoration of the Shepherds*, given by Joseph First Lord Duveen, 1933

Ceccarelli, Naddo (school of) active c.1347, *The Crucifixion*, bought, 1893

Ceresa, Carlo (attributed to) 1609–1679, *Portrait of a Man*, given by Lancelot Hugh Smith, 1935

Cesare da Sesto (copy after) 1477–1523, *Holy Family with the Infant St John the Baptist*, bequeathed by Richard, Seventh Viscount Fitzwilliam, 1816

Cézanne, Paul 1839–1906, *Uncle Dominique*, lent by the Provost and Fellows of King's College, Cambridge (Keynes Collection)

Cézanne, Paul 1839–1906, *The Abduction*, lent by the Provost and Fellows of King's College, Cambridge (Keynes Collection)

Cézanne, Paul 1839–1906, *Still Life with Apples*, lent by the Provost and Fellows of King's College, Cambridge (Keynes Collection)

Cézanne, Paul 1839–1906, *Undergrowth*, lent by the Provost and Fellows of King's College, Cambridge (Keynes Collection)

Cézanne, Paul 1839–1906, *Landscape*, bequeathed by Frank Hindley Smith, 1939

Chazal, Antoine 1793–1854, *Roses in a Vase*, bequeathed by Major the Hon. Henry Rogers Broughton, Second Lord Fairhaven, 1973, with a life-interest to his widow, Joyce, Lady Fairhaven, relinquished 1975

Chinnery, George 1774–1852, *John Reeves (1774–1856)*, given by the National Art Collections Fund, 1976

Chinnery, George (attributed to) 1774–1852, *Head and Shoulders of a Man*, bequeathed by Henry Scipio Reitlinger, 1950, transferred from the Reitlinger Trust, 1991

Chinnery, George (attributed to) 1774–1852, *Head and Shoulders of an Elderly Man*, bequeathed by Henry Scipio Reitlinger, 1950, transferred from the Reitlinger Trust, 1991

Chintreuil, Antoine 1814–1873, *Landscape with an Ash Tree*, bequeathed by Frank Hindley Smith, 1939

Chintreuil, Antoine 1814–1873, *Apple Trees in Blossom*, bequeathed by John Tillotson, 1984, received 1985

Cigoli 1559–1613, *Study of Head and Bust of Youth, Looking to Lower Left*, bought from the Gow Fund with a contribution from the National Arts Collection Fund, 1983

Cima da Conegliano, Giovanni Battista c.1459–1517, *St Lanfranc Enthroned between St John the Baptist and St Liberius*, bequeathed by Charles Brinsley Marlay, 1912

Cina, Colin b.1943, *A Young Person's Guide to Suprematism*, given by East England Arts, 2002

Civerchio, Vincenzo (attributed to) c.1470–c.1544, *St Roch with the Angel of the Annunciation Above (left panel), St Sebastian with the Virgin Annunciate Above (right panel)*, bequeathed by Charles Brinsley Marlay, 1912

Claesz., Anthony the younger c.1607/1608–1649, *A Vase of Flowers*, bequeathed by Major the Hon. Henry Rogers Broughton, Second Lord Fairhaven, 1973

Claesz., Pieter 1597/1598–1660, *Still Life*, bequeathed by Daniel Mesman, 1834

Clausen, George 1852–1944, *Self Portrait*, given by George Clausen, 1918, © Clausen estate

Clausen, George 1852–1944, *Henry Festing Jones*, given by Henry Festing Jones, 1923, © Clausen estate

Cleve, Cornelis van (attributed to) 1520–1567, *Virgin and Child*, bequeathed by Charles Brinsley Marlay, 1912

Cleve, Joos van c.1464–c.1540, *Virgin and Child*, bequeathed by the Reverend Richard Edward Kerrich, 1873

Cleve, Joos van (school of) c.1464–c.1540, *Adoration of the Kings*, bequeathed by Arthur William Young, 1936

Clough, Prunella 1919–1999, *Bolted Fence*, bequeathed by Dr Alastair Hunter, 1984, © the estate of Prunella Clough 2006. All rights reserved, DACS

Clough, Prunella 1919–1999, *In the Yard*, bequeathed by Bryan Charles Francis Robertson, 2003, © the estate of Prunella Clough 2006. All rights reserved, DACS

Coghill, Egerton Bush 1851–1921, *The Mall from Malmaison, Castletownshend*, given by Katherine A. Johnstone, 1981

Cohen, Harold b.1928, *Random*, given by Richard Wollheim, 1998, © the artist

Coignet, Jules 1798–1860, *The Coast of the Bay of Naples near Posillipo*, given by the Friends of the Fitzwilliam Museum, 1979

Coleman, James William active c.1830–1882, *Thomas, Ninth Viscount Fitzwilliam of Merrion*, given by the Reverend Hereford Brooke George, 1895

Collier, John 1708–1786, *Trompe l'Oeil Painting*, bequeathed by Spencer George Perceval, 1922

Collins, Cecil 1908–1989, *Night*, bequeathed by Elizabeth Collins, through the National Art Collections Fund, 2001

Collins, Charles Allston 1828–1873, *Wilkie Collins*, given by Charles Fairfax Murray, 1909

Colquhoun, Robert 1914–1962, *Dancers Rehearsing*, given by Dr Alastair Hunter, 1982, © courtesy of the artist's estate/ www. bridgeman.co.uk

Comolera, Melanie de active 1816–1854, *Vase of Flowers*, given by Major the Hon. Henry Rogers Broughton, 1966

Conca, Sebastiano (attributed to) 1680–1764, *The Virgin and Child in Glory and the Four Latin Fathers of the Church*, bequeathed by Warren Pollock, 1986, received 1992

Conder, Charles 1868–1909, *Mrs Amy Halford*, bequeathed by Georgina de Paszt, 1968

Constable, John 1776–1837, *East Bergholt*, bequeathed by Sidney Ernest Prestige, 1965, with a life-interest to his widow who died in 1968, when the picture was received

Constable, John 1776–1837, *Archdeacon John Fisher*, bought from the G. F. Webb bequest, with a contribution from the Victoria & Albert Museum Grant-in-Aid, 1972

Constable, John 1776–1837, *Mrs Mary Fisher*, bought from the G. F. Webb bequest, with a contribution from the Victoria & Albert Museum Grant-in-Aid, 1972

Constable, John 1776–1837, *Hampstead Heath*, bought from the Marlay Fund with a contribution from the National Art Collections Fund, 1948

Constable, John 1776–1837, *Sky Study with a Shaft of Sunlight*, bequeathed by John Eric Bullard, 1961

Constable, John 1776–1837, *Parham's Mill, Gillingham, Dorset*, bequeathed by Reverend Osmond Fisher, 1914, with a life-interest to his son, the Reverend O. P. Fisher, received 1937

Constable, John 1776–1837, *Shoreham Bay, near Brighton*, given by Gertrude Caton-Thompson, 1969

Constable, John 1776–1837,

Constable, John 1776–1837, *Hove Beach*, bequeathed by Sidney Ernest Prestige, 1965, with a life-interest to his widow who died in 1968, when the picture was received

Constable, John (attributed to) 1776–1837, *Sky Study, Sunset*, bought from the Fairhaven Fund, 1951

Constable, John (attributed to) 1776–1837, *Sky Study with Mauve Clouds*, bought from the Fairhaven Fund, 1951

Constable, John (attributed to) 1776–1837, *At Hampstead, Looking towards Harrow*, bought from the Fairhaven Fund, 1959

Conte, Jacopino del (attributed to) 1510–1598, *F. De Pisia, a Papal Notary*, given by Joseph, First Lord Duveen, 1933

Conte, Jacopino del (attributed to) 1510–1598, *The Virgin and Child with St Elizabeth and the Infant Baptist*, given by Charles Fairfax Murray, 1908

Cooper, Thomas Sidney 1803–1902, *Cattle by a River*, given by Mrs Richard Ellison, 1862

Cooper, Thomas Sidney 1803–1902, *Cattle Reposing*, given by Mrs Richard Ellison, 1862

Coorte, Adriaen c.1660–after 1707, *A Bundle of Asparagus*, given by Sir Frank Brangwyn, 1943

Cornelisz. van Haarlem, Cornelis 1562–1638, *Female Head*, bequeathed by Daniel Mesman, 1834

Cornelisz. van Haarlem, Cornelis (studio of) 1562–1638, *Dirck Volckertsz. Coornhert*, given by T. Brooks Bumpstead, 1898, lent back to donor for his lifetime; received on his death, 1917

Corot, Jean-Baptiste-Camille 1796–1875, *View of the Convent of Sant'Onofrio on the Janiculum, Rome*, given by Captain Stanley William Sykes, OBE, MC, 1960

Corot, Jean-Baptiste-Camille 1796–1875, *The Chestnut Grove*, bequeathed by Frank Hindley Smith, 1939

Corot, Jean-Baptiste-Camille 1796–1875, *Landscape in Holland*, bequeathed by Frank Hindley Smith, 1939

Corot, Jean-Baptiste-Camille 1796–1875, *Auvers-sur-Oise, Daubigny's Pond*, bequeathed by John Tillotson, 1984, received 1985

Corot, Jean-Baptiste-Camille 1796–1875, *The Dyke*, given by Charles Fairfax Murray, 1916

Cortona, Pietro da 1596–1669, *The Calling of St Peter and St Andrew*, given by the Friends of the Fitzwilliam Museum with contributions from the Victoria & Albert Museum Grant-in-Aid and the funds of Miss I. M. E. Hitchcock's bequest, 1965

Cotman, John Sell 1782–1842, *Boats at Anchor on Breydon Water*, bought from the Fairhaven and L. D. Cunliffe Funds with a contribution from the National Heritage Memorial Fund, 1988

Courbet, Gustave 1819–1877, *The Rock at Bayard, Dinant*, bequeathed by Frank Hindley Smith, 1939

Courbet, Gustave 1819–1877, *The Charente at Port-Berteau*, given by Mme Barrère, 1999

Courbet, Gustave 1819–1877, *Beneath the Trees at Port-Berteau: Children Dancing*, given by the Very Reverend Eric Milner-White, CBE, DSO, Dean of York, in memory of his father, Henry Milner-White, Kt, LLD, MA, of Pembroke College, Cambridge, 1951

Couture, Thomas 1815–1879, *A Girl's Head*, given by Percy Moore Turner, 1943

Couture, Thomas 1815–1879, *Still Life with a Cornemuse*, lent by the Provost and Fellows of King's College, Cambridge (Keynes Collection)

Cox, David the elder 1783–1859, *Coast Scene near Hastings*, bequeathed by J. R. Holliday, 1927

Cox, David the elder 1783–1859, *The Vale of Clwyd*, bequeathed by Arthur W. Young, 1936

Cox, David the elder 1783–1859, *Landscape with Cattle by a Pool*, bequeathed by Thomas Henry Riches, 1935, with a life-interest to his widow, who died 1950, when received

Cox, David the elder 1783–1859, *Fisherman Riding on the Sands*, given by Michael C. Jaye in memory of Mrs Angela Crookenden, 2004

Coypel, Antoine (copy after) 1661–1722, *Zephyr and Flora*, bequeathed by Richard, Seventh Viscount Fitzwilliam, 1816

Crayer, Gaspar de (attributed to) 1584–1669, *Portrait of a Young Man*, bequeathed by Richard, Seventh Viscount Fitzwilliam, 1816

Crespi, Giuseppe Maria 1665–1747, *Girl with a Cat*, bequeathed by Daniel Mesman, 1834

Creswick, Thomas 1811–1869, *Crossing the Stream*, given by Mrs Richard Ellison, 1862

Creti, Donato 1671–1749, *The Mystic Marriage of St Catherine of Alexandria*, bought from the Gow Fund with a contribution from the MLA/ Victoria & Albert Purchase Grant Fund, 2005

Crivelli, Vittore c.1444–1501 or later, *Virgin and Child Enthroned: St Bonaventura (left); St Louis of Toulouse (right) St Agatha and St Augustine, an Unidentified Female Franciscan St and St Clare of Assisi, Four Male Franciscan Saints (below)*, 26.6 x 37.4; 26.6 x 37.1; 26 x 36.5; 26 x 36.8, bequeathed by G. G. Milner-Gibson-Cullum, 1921

Crome, John 1768–1821, *High Tor, Matlock*, bought from the Fairhaven Fund, 1949

Crome, John 1768–1821, *A Sandy Hollow*, bequeathed by Guy John Fenton Knowles in 1959 with a life-interest to Lady Vera Murray Morrison, who died in 1966, when received

Croos, Anthonie Jansz. van der c.1606–1662/1663, *Landscape with Figures*, given by H. J. Pfungst, 1904

Croos, Anthonie Jansz. van der c.1606–1662/1663, *Landscape with Figures*, given by H. J. Pfungst, 1904

Crowe, Eyre 1824–1910, *Capo le case, Rome*, given by Michael C. Jaye, through Cambridge in America, in memory of Mrs Angela Crookenden, 2004

Crowe, Eyre 1824–1910, *Horses in a Field with Gypsies and a Caravan*, given by Michael C. Jaye, through Cambridge in America, in memory of Mrs Angela Crookenden, 2004

Cruz-Diez, Carlos b.1923, *Physichromie No.1.288*, given by His Excellency Ignacio Arcaya, Venezuelan Ambassador to the Court of St James on behalf of the Venezuelan Government, 1993, © ADAGP, Paris and DACS, London 2006

Cuylenborch, Abraham van c.1610–1658, *Grotto with Figures*, bequeathed by Daniel Mesman, 1834

Cuyp, Aelbert 1620–1691, *Sunset after Rain*, bought from the Hitchcock, L. D. Cunliffe, Perceval and University Purchase Funds with contributions from the Friends of the Fitzwilliam Museum, the National Art Collections Fund and the Victoria & Albert Museum Grant-in-Aid, 1975

Cuyp, Jacob Gerritsz. 1594–1651/1652, *Portrait of a Woman*, bequeathed by Charles Brinsley Marlay, 1912

Cuyp, Jacob Gerritsz. 1594–1651/1652, *Portrait of a Young Girl*, given by Francis Atkinson, 1907

Dael, Jan Frans van 1764–1840, *A Vase of Flowers on a Ledge*, bequeathed by Major the Hon. Henry Rogers Broughton, Second Lord Fairhaven, 1973, with a life-interest to his widow, Joyce, Lady Fairhaven, relinquished, 1987

Dahl, Johan Christian Clausen 1788–1857, *The Neapolitan Coast with Vesuvius in Eruption*, bought from the Gow Fund, 1986

Dalby, John 1810–1865, *Jumping the Brook*, given by the executors of Sir Paul Mellon's estate, 2000

Dalby, John 1810–1865, *The End of the Day*, given by the executors of Sir Paul Mellon's estate, 2000

Dall, Nicholas Thomas d.1776/1777, *Ashby Lodge, Northamptonshire*, bequeathed by the Reverend James William Arnold, 1873

Danby, Francis 1793–1861, *View of a Norwegian Lake before the Sun Has Dissipated the Early Morning Mist*, bought from the Bartlett, Fairhaven, Holmes, Jones and University Purchase Funds, with contributions from the National Art Collections Fund, and the Regional Fund administered by the Victoria & Albert Museum on behalf of the Museums and Galleries Commission, 1990

Dandridge, Bartholomew 1691–c.1754, *Portrait of a Painter*, given by Charles Fairfax Murray, 1908

Dandridge, Bartholomew (after) 1691–c.1754, *George Frederick Handel*, bequeathed by Felix Thornley Cobbold, 1909

Daniell, William 1769–1837, *Coast Scene, Madeira?*, bequeathed by Joseph Prior, 1919

Daubigny, Charles-François 1817–1878, *Village on a River, Sunset*, given by Arthur W. Young, 1936

Daubigny, Charles-François 1817–1878, *Villerville, Normandy*, given by Charles Fairfax Murray, 1911

Daubigny, Charles-François 1817–1878, *Beach at Villerville, Normandy*, bequeathed by John Tillotson, 1984, received 1985

Daubigny, Charles-François 1817–1878, *On the River Oise*, given by Charles Fairfax Murray, 1910

Daubigny, Charles-François 1817–1878, *The Painter's Family in the Country*, bequeathed by John Tillotson, 1984, received 1985

Daubigny, Charles-François 1817–1878, *The Wood*, given by Charles Fairfax Murray, 1910

Davie, Alan b.1920, *Entry of the Fetish*, bought from the Gulbenkian and University Purchase Funds, 1973, © the artist

Davie, Alan b.1920, *Prophet in a Tree, 1963*, given by Dr Alastair Hunter, 1981, © the artist

De Karlowska, Stanislawa 1876–1952, *Lock on the Canal*, given by Mrs E. H. Baty and R. A. P. Bevan, CBE, the artist's children, 1968

de Longpré, Paul 1855–1911, *Iris, Fuchsia and Other Flowering Plants*, bequeathed by Major the Hon. Henry Rogers Broughton, Second Lord Fairhaven, 1973

de Longpré, Paul 1855–1911, *Lily of the Valley, Camellia, Pansy and Laburnum*, bequeathed by Major the Hon. Henry Rogers Broughton, Second Lord Fairhaven, 1973

de Longpré, Paul 1855–1911, *Three Flower and Shrub Plants*, bequeathed by Major the Hon. Henry Rogers Broughton, Second Lord Fairhaven, 1973

de Longpré, Paul 1855–1911, *Wild Roses and Various Other Flowers and Shrubs*, bequeathed by Major the Hon. Henry Rogers Broughton, Second Lord Fairhaven, 1973

De Wint, Peter 1784–1849, *Dunster, Somerset?*, bought from the Fairhaven Fund, 1977

De Wint, Peter 1784–1849, *Landscape Study*, bought from the Fairhaven Fund, 1975

Decamps, Alexandre-Gabriel 1803–1860, *Scene in the Near East*, given by Lady Courtney of Penwith, 1930

Decan, Eugène 1829–after 1894, *Corot at His Easel, Crécy-en-Brie*, bequeathed by John Tillotson, 1984, received 1985

Degas, Edgar 1834–1917, *Ceremony of Ordination in the Cathedral of Lyons*, bequeathed by A. S. F. Gow, through the National Art Collections Fund, 1978

Degas, Edgar 1834–1917, *The Finding of Moses (copy after Paolo Veronese)*, bequeathed by A. S. F. Gow, through the National Art Collections Fund, 1978

Degas, Edgar 1834–1917, *The Castel Sant Elmo from the Capodimonte, Naples*, bought from the Gow, L. D. Cunliffe and Perceval Funds, with contributions from the National Art Collections Fund and the Museums and Galleries Commission/Victoria & Albert Purchase Grant Fund, 2000

Degas, Edgar 1834–1917, *David and Goliath*, bequeathed by Captain Stanley William Sykes, OBE, MC, 1966

Degas, Edgar 1834–1917, *At the Café*, bequeathed by Frank Hindley Smith, 1939

Delacroix, Eugène 1798–1863, *Odalisque Reclining on a Divan*, bequeathed by Percy Moore Turner, 1957

Delacroix, Eugène 1798–1863, *Study for Part of the 'Justice' Frieze, Palais Bourbon, Paris*, bequeathed by Charles Haslewood Shannon, 1937

Delacroix, Eugène 1798–1863, *The Muse of Orpheus*, bequeathed by Charles Haslewood Shannon, 1937

Delacroix, Eugène 1798–1863, *The Lion and the Snake*, lent by the Provost and Fellows of King's College, Cambridge (Keynes Collection)

Delacroix, Eugène 1798–1863, *Ceres*, bequeathed by Charles Haslewood Shannon, 1937

Delacroix, Eugène 1798–1863, *Horse in a Landscape*, lent by the Provost and Fellows of King's College, Cambridge (Keynes Collection)

Delacroix, Eugène 1798–1863, *The Bride of Abydos*, lent by the Provost and Fellows of King's College, Cambridge (Keynes Collection)

Delen, Dirck van 1604/1605–1671, *Interior of a Church*, bequeathed by Richard, Seventh Viscount Fitzwilliam, 1816

Denies, Isaac (attributed to) 1647–1690, *Glass Vase of Flowers*, given by Major the Hon. Henry Rogers Broughton, 1966

Derain, André 1880–1954, *Madame Van Leer*, bequeathed by Frank Hindley Smith, 1939, © ADAGP, Paris and DACS, London 2006

Derain, André 1880–1954, *Still Life*, lent by the Provost and Fellows of King's College, Cambridge (Keynes Collection), © ADAGP, Paris and DACS, London 2006

Desgoffe, Alexandre 1805–1882, *Château de la Bâtiaz, Sion, Martigny*, bought from the L. D. Cunliffe Fund, 1998

Desportes, Alexandre-François 1661–1743, *Sketches of a Kitten*, given by the Friends of the Fitzwilliam Museum, 1951

Deverell, Walter Howell 1827–1854, *Self Portrait*, given by Charles Fairfax Murray, 1915

Devis, Arthur 1712–1787, *Sir John van Hatten*, bequeathed by Dr D. M. McDonald, 1991, received 1992

Devis, Arthur 1712–1787, *Lady Milner (née Miss Mordaunt)*, bequeathed by Dr D. M. McDonald, 1991, with a life-interest to his widow, relinquished 1996, received 1997

Diaz de la Peña, Narcisse Virgile 1808–1876, *Wooded Landscape*, bequeathed by John Tillotson, 1984, received 1985

Diaz de la Peña, Narcisse Virgile 1808–1876, *Storm in the Forest of Fontainbleau*, given by Percy Moore Turner, 1936

Diaz de la Peña, Narcisse Virgile 1808–1876, *Landscape*, given by F. Matthiesen, 1953

Diaz de la Peña, Narcisse Virgile 1808–1876, *Nymphs and Satyrs*, bequeathed by John Tillotson, 1984, received 1985

Diepenbeeck, Abraham Jansz. van 1596–1675, *The Crucifixion*, bought from the University Purchase Fund, 1972

Diepenbeeck, Abraham Jansz. van (attributed to) 1596–1675, *The Last Communion of St Francis of Assisi (after Peter Paul Rubens)*, given by Edward Speelman, 1984

Dolci, Carlo 1616–1686, *The Penitent Magdalene*, bought from the funds of Miss I. M. E. Hitchcock's bequest, 1966

Dolci, Carlo 1616–1686, *Sir John Finch FRS, FRCP (1626–1682)*, given by the National Art Collections Fund, 1972

Dolci, Carlo 1616–1686, *Sir Thomas Baines FRS, FRCP (1622–1681)*, given by the National Art Collections Fund, 1972

Dolci, Carlo (copy after) 1616–1686, *Mater Dolorosa*, bequeathed by Richard, Seventh Viscount Fitzwilliam, 1816

Domenichino 1581–1641, *Landscape with St John Baptising*, bought from the S. G. Perceval fund, with a contribution from Sir Thomas D. Barlow, CBE, 1946

Domenico Veneziano active 1438–1461, *A Miracle of St Zenobius*, bequeathed by Professor Frederick Fuller, 1909, received 1923

Domenico Veneziano active 1438–1461, *The Annunciation*, bequeathed by Professor Frederick Fuller, 1909, received 1923

Donzello, Pietro del 1452–1509, *St Julian the Hospitaller*, bequeathed by Charles Brinsley Marlay, 1912

Dou, Gerrit 1613–1675, *The Schoolmaster*, bequeathed by Richard, Seventh Viscount Fitzwilliam, 1816

Dou, Gerrit 1613–1675, *Woman at a Window with a Copper Bowl of Apples and a Cock Pheasant*, bequeathed by Richard, Seventh Viscount Fitzwilliam, 1816

Dou, Gerrit 1613–1675, *Portrait of a Young Man*, bequeathed by Daniel Mesman, 1834

Dou, Gerrit (copy after) 1613–1675, *Self Portrait*, bequeathed by Richard, Seventh Viscount Fitzwilliam, 1816

Drechsler, Johann Baptist 1756–1811, *A Basket of Flowers with Fruit*, bequeathed by Major the Hon. Henry Rogers Broughton, Second Lord Fairhaven, 1973, received 1975

Drouais, François Hubert 1727–1775, *Child with a Tambourine*, bequeathed by Dr D. M. McDonald, 1991, with a life-interest to his widow, relinquished 1996, received 1997

Duck, Jacob c.1600–1667, *Soldier with a Girl*, bequeathed by Daniel Mesman, 1834

Dufy, Raoul 1877–1953, *The Basket of Bread*, given by Keith Stuart Baynes, 1974, © ADAGP, Paris and DACS, London 2006

Dufy, Raoul 1877–1953, *The Painter's Studio*, given by Keith Stuart Baynes, 1974, © ADAGP, Paris and DACS, London 2006

Dughet, Gaspard 1615–1675, *Landscape near Rome*, bequeathed by Charles Brinsley Marlay, 1912

Dughet, Gaspard 1615–1675, *Landscape with Figures*, bequeathed by Richard, Seventh Viscount Fitzwilliam, 1816

Dughet, Gaspard 1615–1675 & Miel, Jan 1599–1663, *Landscape with Figures*, bought from the L. D. Cunliffe Fund and University Purchase Fund, with the aid of funds from the Victoria & Albert Museum Grant-in-Aid, and National Art Collections Fund, 1969

Dujardin, Karel 1626–1678, *Italians with a Dog*, bequeathed by Daniel Mesman, 1834

Dujardin, Karel 1626–1678, *Italian Landscape*, bequeathed by Samuel Sandars, 1923

Dujardin, Karel 1626–1678, *Travellers Resting*, given by H. J. Pfungst, 1906

Dulac, Edmund 1882–1953, *Charles Ricketts and Charles Shannon as Medieval Saints*, bequeathed by Dr Eric George Millar, DLitt, 1966

Dunoyer de Segonzac, André 1884–1974, *Landscape with Red Roofs*, bequeathed by Frank Hindley Smith, 1939, © ADAGP, Paris and DACS, London 2006

Dunoyer de Segonzac, André 1884–1974, *Still Life*, bequeathed by Frank Hindley Smith, 1939, ©

ADAGP, Paris and DACS, London 2006

Dunthorne, John IV 1798–1832, *Salisbury Cathedral*, bequeathed by Dr D. M. McDonald, 1991, with a life-interest to his widow, relinquished 1996, received 1997

Dupré, Jules 1811–1889, *Shipping in a Breeze*, bequeathed by Henry Scipio Reitlinger, 1950, received from the Reitlinger Trust, 1991, accessioned 2005

Dutch School late 15th C, *Deposition from the Cross*, given by Aymer Vallance, 1929

Dutch School *Adoration of the Kings*, bequeathed by Charles Brinsley Marlay, 1912

Dutch School *A Man and His Wife*, given by T. Brooks Bumpstead, 1898, and lent back to him for his lifetime; received on his death, 1917

Dutch School *A Young Man*, bequeathed by Charles Brinsley Marlay, 1912

Dutch School *A Young Woman*, bequeathed by Charles Brinsley Marlay, 1912

Dutch School *A Lady*, bequeathed by Charles Brinsley Marlay, 1912

Dutch School *A Gentleman*, bequeathed by Charles Brinsley Marlay, 1912

Dutch School *A Young Gentleman*, bequeathed by Richard, Seventh Viscount Fitzwilliam, 1816

Dutch School *Portrait of a Child with a Toy Goat*, bequeathed by Richard, Seventh Viscount Fitzwilliam, 1816

Dutch School 17th C, *Portrait of a Female Artist*, bequeathed by Richard, Seventh Viscount Fitzwilliam, 1816

Dutch School 17th C, *Portrait of a Woman in a White Cap and Ruff*, bequeathed by Daniel Mesman, 1834

Dutch School 17th C, *Sea Piece*, given by H. J. Pfungst, 1904

Dutch School 17th C, *St Peter Healing St Agatha (after Alessandro Turchi)*, bequeathed by Richard, Seventh Viscount Fitzwilliam, 1816

Dutch School 17th C, *Vase of Flowers*, given by Major the Hon. Henry Rogers Broughton, 1966

Dutch School 17th C, *Winter Scene*, bequeathed by Professor Frederick Fuller, 1909, received 1923

Dutch School 19th C, *Assorted Flowers in an Urn on a Brown Ledge*, bequeathed by Major the Hon. Major the Hon. Henry Rogers Broughton, Second Lord Fairhaven, 1973, received 1975

Dyck, Anthony van 1599–1641, *An Old Woman*, bought from the L. D. Cunliffe Fund, 1961

Dyck, Anthony van 1599–1641, *The Virgin and Child*, bought from the Abbott, L. D. Cunliffe, Leverton Harris, Marlay, Perceval University Purchase and the Duplicate Objects Funds, after a public appeal through the Friends of

the Fitzwilliam, (which raised an anonymous donation of £100,000) and with contributions from the National Art Collections Fund, the Pilgrims Trust, the Radcliffe Trust, the Raye Foundation, the Monument Trust, various Cambridge Colleges and the Victoria & Albert Grant-in-Aid, 1976

Dyck, Anthony van 1599–1641, *Portrait of a Man*, bequeathed by the executors of the Misses Alexander, through the National Art Collections Fund, 1972

Dyck, Anthony van 1599–1641, *Archbishop Laud*, bequeathed by Charles Haslewood Shannon, 1937

Dyck, Anthony van 1599–1641, *Rachel de Ruvigny, Countess of Southampton, as Fortune*, accepted in lieu of inheritance tax by HM Government and allocated to the Fitzwilliam Museum, 1978

Eastlake, Charles Lock 1793–1865, *A Panoramic View near Rome*, bought from the Fairhaven Fund, 1998

Edwards, Edwin 1823–1879, *High Street, Whitechapel*, given by Philip Henry Gosse, MD, 1942

Edwards, John Uzzell b.1937, *Green Spread*, bequeathed by Diana A. M. Hunter, 1985, © John Edwards 2006. All rights reserved, DACS

Egg, Augustus Leopold 1816–c.1863, *The Farmyard*, bought from the Fairhaven Fund, 1980

Elmore, Alfred 1815–1881, *On the Brink*, given by the Friends of the Fitzwilliam Museum in memory of Dr A. N. L. Munby, with a contribution from the Victoria & Albert Museum Grant-in-Aid, 1975

Elsheimer, Adam 1578–1610, *Minerva as Patroness of Arts and Sciences*, bequeathed by Daniel Mesman, 1834

Elsheimer, Adam 1578–1610, *Venus and Cupid*, bequeathed by Daniel Mesman, 1834

Ensor, James 1860–1949, *Porcelaines et masques*, bought from the Bartlett, L. D. Cunliffe and American Friends of Cambridge University Funds, 1989, © DACS 2006

Etchells, Frederick 1886–1973, *The Dead Mole*, lent by the Provost and Fellows of King's College, Cambridge (Keynes Collection)

Etty, William 1787–1849, *Two Male Nude Studies*, bequeathed by Charles Haslewood Shannon, 1937

Etty, William 1787–1849, *Dr John Camidge*, bequeathed by Mrs Hustwick, 1907

Etty, William (attributed to) 1787–1849, *Taking of Christ (copy of Guercino)*, given by Jack Baer, 1990

Evans, Merlyn Oliver 1910–1973, *Discrimination*, bequeathed by Diana A. M. Hunter, 1985, received 1986

Everdingen, Allart van 1621–1675,

Norwegian Landscape, bequeathed by Daniel Mesman, 1834

Everdingen, Allart van (attributed to) 1621–1675, *Rocky Landscape*, bequeathed by Henry Scipio Reitlinger, 1950, transferred from the Reitlinger Trust, 1991, accessioned 2005

Eworth, Hans c.1525–after 1578, *Female Portrait (possibly Queen Mary I)* bequeathed by Sir Bruce Stirling Ingram, OBE, 1963

Fabre, François-Xavier 1766–1837, *Allen Smith Contemplating across the Arno, Florence*, given by the Friends of the Fitzwilliam Museum, in celebration of their 75th anniversary, with the aid of a special gift from the Directors of Hazlitt, Gooden & Fox and contributions from the National Art Collections Fund, the L. D. Cunliffe, Perceval and University Purchase Funds, 1984

Fabris, Pietro active 1768–1801, *Ferry over the Volturno, near Caiazzo*, bequeathed by Daniel Mesman, 1834

Fabritius, Barent 1624–1673, *Portrait of a Child*, bequeathed by Richard, Seventh Viscount Fitzwilliam, 1816

Faes, Peter 1750–1814, *A Vase of Flowers*, bequeathed by Major the Hon. Henry Rogers Broughton, Second Lord Fairhaven, 1973

Fantin-Latour, Henri 1836–1904, *White Cup and Saucer*, given by Sir (Henry Francis) Herbert Thompson, Bt, 1920

Fantin-Latour, Henri 1836–1904, *Head of a Young Girl*, given by Sir (Henry Francis) Herbert Thompson, Bt, 1929

Fantin-Latour, Henri 1836–1904, *White Candlestick*, given by Sir (Henry Francis) Herbert Thompson, Bt, 1920

Fantin-Latour, Henri 1836–1904, *The Entombment (after Titian)*, bequeathed by Charles Brinsley Marlay, 1912

Fantin-Latour, Henri (attributed to) 1836–1904, *Venus and Cupid*, bequeathed by Bryan Charles Francis Robertson, 2003

Fearnley, Thomas 1802–1842, *Sunrise in the Wengeralp*, bought from the Gow Fund with a contribution from the National Art Collections Fund, 1998

Ferneley, John E. 1782–1860, *Longford Lass and the Jew*, bequeathed by Dr D. M. McDonald, 1991, received 1992

Ferri, Ciro 1634–1689, *The Adoration of the Shepherds*, lent by Sir Denis Mahon

Fielding, Anthony V. C. 1787–1855, *A Heath near the Coast*, bequeathed by Arthur William Young, 1936

Flegel, Georg 1566–1638, *Still Life with Flowers*, bought from the Gow and Perceval Funds, 1996

Flemish School *The Emperor Charles V*, bequeathed by Leonard Daneham Cunliffe, 1937

Flemish School early 16th C, *St Catherine of Alexandria (left wing of triptych)*, bequeathed by Leonard Daneham Cunliffe, 1937

Flemish School early 16th C, *St Barbara (right wing of triptych)*, bequeathed by Leonard Daneham Cunliffe, 1937

Flemish School *Portrait of a Man*, bequeathed by Richard, Seventh Viscount Fitzwilliam, 1816

Flemish School *Portrait of a Woman*, bequeathed by Richard, Seventh Viscount Fitzwilliam, 1816

Flemish School *Dives and Lazarus (after Heinrich Aldegrever)*, bequeathed by Daniel Mesman, 1834

Flemish School *Nonsuch Palace*, bequeathed by Richard, Seventh Viscount Fitzwilliam, 1816

Flemish School *The Thames at Richmond with the Old Royal Palace*, bequeathed by Richard, Seventh Viscount Fitzwilliam, 1816

Flemish School *Girl Gathering Flowers*, bequeathed by Daniel Mesman, 1834

Flemish School late 17th C, *Virgin and Child with a Female Saint*, bought from the L. D. Cunliffe Fund, 1969

Flemish School *Portraits of a Man and His Wife*, bequeathed by Richard, Seventh Viscount Fitzwilliam, 1816

Floris, Frans the elder c.1517–1570, *Couple Embracing*, unknown provenance

Forain, Jean Louis 1852–1931, *Bust of a Small Boy in a Red Coat*, bequeathed by A. S. F. Gow, through the National Art Collections Fund, 1978

Fouquier, Jacques 1590/1591–1659, *Winter Scene*, bequeathed by Charles Brinsley Marlay, 1912

Fragonard, Jean-Honoré, 1732–1806 **& Gérard, Marguerite** 1761–1837, *The Reader*, bequeathed by Charles Brinsley Marlay, 1912

Franceschini, Marc Antonio (attributed to) 1648–1729, *The Virgin Reading*, bequeathed by Daniel Mesman, 1834

Francesco di Antonio di Bartolomeo active 1393–1433, *The Virgin and Child Enthroned, between St Lawrence (left) and St John Gualbert (right)*, bequeathed by Charles Brinsley Marlay, 1912

Franchi, Rossello di Jacopo c.1376–1456, *Virgin and Child with St John the Baptist, St James, St Andrew and Possibly St Anthony Abbot*, given by Bernard Berenson, 1924

Francken, Ambrosius I 1544–1618, *The Judgement of Zaleucus*, given by the Friends of the Fitzwilliam Museum, 1916

Francken, Frans II 1581–1642, *The Worship of the Golden Calf*, given by Augustus Arthur VanSittart, 1864

Fredricks, Jan Hendrick *Basket of Fruit*, given by Major the Hon.

Henry Rogers Broughton, 1966

Freedman, Barnett 1901–1958, *The Barn at Fingest, Buckinghamshire*, given anonymously by friends of the artist, 1953

Frélaut, Jean 1879–1954, *The Brigantine*, bequeathed by Frank Hindley Smith, 1939, © ADAGP, Paris and DACS, London 2006

French School late 15th C–early 16th C, *The Deposition (centre), the Presentation of the Virgin (left), the Marriage of the Virgin (right)*, bequeathed by Charles Brinsley Marlay, 1912

French School late 17th C, *River Scene by Moonlight*, bequeathed by Richard, Seventh Viscount Fitzwilliam, 1816

French School late 17th C–early 18th C, *River Scene*, bequeathed by Daniel Mesman, 1834

French School *Study of a Mulatto Woman*, bought from the Marlay Paintings and Duplicates Fund with a contribution from the National Art Collections Fund, 1954

French School *Charles Brinsley Marlay*, bequeathed by Charles Brinsley Marlay, 1912

French School *Provencal Landscape*, bequeathed by John Tillotson, 1984, received 1985

French School mid-19th C, *A French Revolutionary*, bought from the Spencer George Perceval Fund, 1931

Frith, William Powell 1819–1909, *Othello and Desdemona*, given by Mrs Richard Ellison, 1862

Fromantiou, Hendrik de c.1633–c.1700, *Vase of Flowers*, given by Major the Hon. Henry Rogers Broughton, 1966

Frost, Terry 1915–2003, *Orange and Yellow Verticals*, given by the Lord Croft, 1979, © the artist's estate

Frost, Terry 1915–2003, *Red, White and Blue*, bequeathed by Warren Pollock, 1986, received 1992, © the artist's estate

Fry, Roger Eliot 1866–1934, *The Cloister*, bequeathed by Frank Hindley Smith, 1939

Fry, Roger Eliot 1866–1934, *The Port of Cassis*, bequeathed by Mrs M. E. L. Brownlow, 1972

Fry, Roger Eliot 1866–1934, *Still Life of Fish*, given by Sarah Margery Fry, in accordance with the artist's wishes, 1935

Fry, Roger Eliot 1866–1934, *The Church of St Etienne, Toulouse*, bequeathed by Mrs M. E. L. Brownlow, 1972

Fry, Roger Eliot 1866–1934, *A Study of Ilexes*, bequeathed by Warren Pollock, 1986, received 1992

Fussell, Michael 1927–1974, *Instant, 1*, bequeathed by Warren Pollock, 1986, received 1992

Fussell, Michael 1927–1974, *Storm Centre*, given by the Lord Croft, 1979

Fyt, Jan 1611–1661, *Flowers and Game*, bequeathed by Charles Brinsley Marlay, 1912

Fyt, Jan (copy after) 1611–1661, *Dead Birds*, bequeathed by Daniel Mesman, 1834

Gainsborough, Thomas 1727–1788, *Landscape with a Pool*, bequeathed by Percy Moore Turner, 1950, with a life-interest to his widow, relinquished 1966

Gainsborough, Thomas 1727–1788, *John Kirby*, given by Charles Fairfax Murray, 1908

Gainsborough, Thomas 1727–1788, *Mrs John Kirby*, given by Charles Fairfax Murray, 1908

Gainsborough, Thomas 1727–1788, *A Forest Road*, given by the Friends of the Fitzwilliam Museum, 1933

Gainsborough, Thomas 1727–1788, *Heneage Lloyd and His Sister, Lucy*, given by Charles Fairfax Murray, 1911

Gainsborough, Thomas 1727–1788, *Joshua Kirby*, given by Charles Fairfax Murray, 1911

Gainsborough, Thomas 1727–1788, *Philip Dupont*, given by Charles Fairfax Murray, 1918

Gainsborough, Thomas 1727–1788, *Landscape with Herdsman and Cows Crossing a Bridge*, bought from the Fairhaven Fund with a contribution from the National Art Collections Fund, 2000

Gainsborough, Thomas 1727–1788, *The Hon. William Fitzwilliam*, bequeathed by Richard, Seventh Viscount Fitzwilliam, 1816

Gallego, Fernando (school of) active 1468–1507, *The Mass of St Gregory*, given by the Friends of the Fitzwilliam Museum, 1910

Gauguin, Paul 1848–1903, *Landscape*, given by the Very Reverend Eric Milner-White, CBE, DSO, Dean of York, in devoted memory of his mother, Annie Booth Milner-White, 1952

Gaulli, Giovanni Battista 1639–1709, *The Three Marys at the Sepulchre*, bought from the L. D. Cunliffe Fund with contributions from the National Art Collections Fund and the Regional Fund administered by the Victoria & Albert Museum on behalf of the Museums and Galleries Commission, 1987

Gelder, Aert de 1645–1727, *Baptism of Christ*, given by the Right Reverend Lord Alwyne Frederick Compton, Bishop of Ely, 1905

Gelton, Toussaint c.1630–1680, *Boors Playing Cards*, bequeathed by Richard, Seventh Viscount Fitzwilliam, 1816

Gérard, Louis-Auguste 1782–1862, *Landscape with a Bridge*, given by the Friends of the Fitzwilliam Museum, 1973

Géricault, Théodore 1791–1824, *Wounded Soldiers in a Cart*, bequeathed by Arnold John Hugh

Smith, through the National Art Collections Fund, 1964

Gerini, Niccolò di Pietro active 1368–1415, *Virgin and Child*, bequeathed by Charles Haslewood Shannon, 1937

German (Saxon) School late 15th C, *Albert the Bold, Duke of Saxony*, bequeathed by Daniel Mesman, 1834

German (Saxon) School *An Historical Scene*, bequeathed by Leonard Daneham Cunliffe, 1937

German School late 15th C, *The Mass of St Gregory*, bequeathed by Charles Brinsley Marlay, 1912, transferred from the library, 1982

German School *Johannes Theodorus Streuffius*, bequeathed by Charles Brinsley Marlay, 1912

German School *Stream in a Dell, with Flowers and Reptiles*, given by Major the Hon. Henry Rogers Broughton, 1966

Gerrard, Kaff 1894–1970, *Chalk Pit*, given by Professor A. H. Gerrard, 1992

Gerrard, Kaff 1894–1970, *Fungi and Woodland*, given by Professor A. H. Gerrard, 1992

Gerrard, Kaff 1894–1970, *Small Fungus Painting*, given by Professor A. H. Gerrard, 1992

Gerrard, Kaff 1894–1970, *Twisted Metal in Crater*, given by Professor A. H. Gerrard, 1992

Gertler, Mark 1892–1939, *Seashells*, given by J. Howard Bliss, 1945, © the artist's estate

Gertler, Mark 1892–1939, *The Pigeon House*, bequeathed by Thomas Balston, OBE, MC, through the National Art Collections Fund, 1968, © the artist's estate

Gertler, Mark 1892–1939, *Violin and Bust*, bequeathed by Thomas Balston, OBE, MC, through the National Art Collections Fund, 1968, © the artist's estate

Ghezzi, Pier Leone (attributed to) 1674–1755, *St Dominic Receiving the Rosary from the Virgin Mary*, bequeathed by Daniel Mesman, 1834

Ghirlandaio, Davide 1452–1525, *Virgin and Child Enthroned between St Ursula and St Catherine*, bequeathed by Charles Brinsley Marlay, 1912

Ghirlandaio, Domenico 1449–1494, *The Nativity*, bequeathed by Charles Brinsley Marlay, 1912

Ghirlandaio, Ridolfo (attributed to) 1483–1561, *Portrait of a Young Man*, bequeathed by Professor Frederick Fuller, 1909, received 1923

Ghislandi, Giuseppe 1655–1743, *Boy in Red*, given by F. D. Lycett Green, through the Magnasco Society, 1931

Gill, William active 1826–1869, *Leap Frog*, given by Mrs Richard Ellison, 1862

Gilman, Harold 1876–1919, *Still Life*, given by Captain Stanley William Sykes, OBE, MC, 1948

Gilman, Harold 1876–1919, *Nude on a Bed*, given by Benjamin Fairfax Hall, in memory of Edward Le Bas, 1967

Gilpin, Sawrey 1733–1807, *A Grey Arab*, bought from the Coppinger Prichard Fund, with a contribution from the Friends of the Fitzwilliam Museum, 1945

Ginner, Charles 1878–1952, *The Church of All Souls, Langham Place, London*, bequeathed by Mrs M. E. L. Brownlow, in memory of Goldsworthy Lowes Dickinson and his family, 1972

Ginner, Charles 1878–1952, *Dahlias and Cornflowers*, bequeathed by Thomas Balston, OBE, MC, through the National Art Collections Fund, 1968

Ginner, Charles 1878–1952, *The Punt in the Mill Stream*, given by Francis Wormald, CBE, 1948

Giolfino, Niccolò the younger 1476–1555, *Atalanta's Race*, bequeathed by Daniel Mesman, 1834

Giolfino, Niccolò the younger 1476–1555, *Classical Subject*, bequeathed by Daniel Mesman, 1834

Giovanni da Asola d.1531, *Lamentation over the Dead Christ*, given by the Butler family, in memory of their late father, William John Butler, DD, Dean of Lincoln, 1894

Giovanni dal Ponte 1385–c.1437, *Virgin and Child with Angels*, bought, 1893

Giovanni dal Ponte 1385–c.1437, *St Jerome and St Francis (recto, panel 1)*, bought, 1893

Giovanni dal Ponte 1385–c.1437, *Pietà (verso, panel 1)*, bought, 1893

Giovanni dal Ponte 1385–c.1437, *St John the Baptist and St Anthony Abbot (recto, panel 2)*, bought, 1893

Giovanni dal Ponte 1385–c.1437, *Mary Magdalene Embracing the Cross (verso, panel 2)*, bought, 1893

Giovanni di Paolo 1403–1482, *St Bartholomew*, given by Francis Neilson, through the National Art Collections Fund, 1935

Giovanni di Paolo 1403–1482, *The Entombment of the Virgin with St Bartholomew (left) and a Female Saint (right)*, bought from the S. G. Perceval Fund, 1938

Giroux, André 1801–1879, *A View of Rome*, given by the Friends of the Fitzwilliam Museum, 1978

Glimes, P. de active 1750–1800, *Portrait of a Young Man*, bequeathed by Daniel Mesman, 1834

Goetze, Sigismund Christian Hubert 1866–1939, *Tamarisk Tree, Lake Como*, given by Mrs Sigismund Goetze, 1943

Goetze, Sigismund Christian Hubert 1866–1939, *Old Bridge, Glen Moriston*, given by Mrs Sigismund Goetze, 1943

Goetze, Sigismund Christian Hubert 1866–1939, *Return of the Sardine Boats, Dournenez, Brittany*,

given by Mrs Sigismund Goetze, 1943

Goetze, Sigismund Christian Hubert 1866–1939, *The Feast Day of St George, Portofino*, given by Mrs Sigismund Goetze, 1943

Goetze, Sigismund Christian Hubert 1866–1939, *Vannes, Brittany*, given by Mrs Sigismund Goetze, 1943

Gogh, Vincent van 1853–1890, *The Alley of Trees in Autumn*, bought with a special allocation to the University Purchase Fund with a contribution from the Gow Fund and the Victoria & Albert Museum Grant-in-Aid, 1980

Golding, John b.1929, *DII*, bought from the University and Gulbenkian purchase funds, through the Rowan Gallery, London, 1975

Goltzius, Hendrick 1558–1617, *Vertumnus and Pomona*, bequeathed by Henry Scipio Reitlinger, 1950, transferred from the Reitlinger Trust, 1991

Goodall, Frederick 1822–1904, *Cottage Interior*, given by Mrs Richard Ellison, 1862

Goodall, Frederick 1822–1904, *The Heath Cart*, given by Mrs Richard Ellison, 1862

Gore, Spencer 1878–1914, *The Green Dress*, bequeathed by James William Freshfield, 1955

Gore, Spencer 1878–1914, *A View from the Window at 6 Cambrian Road, Richmond*, bought from the Gow Fund with a contribution from the Victoria & Albert Museum Grant-in-Aid, 1983

Gore, Spencer 1878–1914, *Nearing Euston Station*, lent by the Provost and Fellows of King's College, Cambridge (Keynes Collection)

Gore, Spencer 1878–1914, *The Toilet*, lent by the Provost and Fellows of King's College, Cambridge (Keynes Collection)

Gosse, Laura Sylvia 1881–1968, *Still Life with Eggs and Carrots*, bequeathed by Henry Scipio Reitlinger, 1950, transferred from the Reitlinger Trust, 1991, © courtesy of the artist's estate/ www.bridgeman.co.uk

Gower, George (follower of) c.1540–1596, *Unknown Lady*, bequeathed by Charles Brinsley Marlay, 1912

Gowing, Lawrence 1918–1991, *Hester Chapman*, given by Dr G. H. W. Rylands, 1976, © estate of Sir Lawrence Gowing

Goyen, Jan van 1596–1656, *Landscape with Figures*, bequeathed by Daniel Mesman, 1834

Goyen, Jan van 1596–1656, *An Estuary*, bequeathed by Daniel Mesman, 1834

Goyen, Jan van 1596–1656, *A Watergate by an Estuary*, anonymous gift, 1970

Goyen, Jan van 1596–1656, *Near Dordrecht*, bequeathed by Daniel Mesman, 1834

Goyen, Jan van 1596–1656, *River*

Landscape with Boats, bequeathed by Dr R. B. Meyer, 1975

Granet, François-Marius 1775–1849, *Hermit Reading*, bought from the Gow Fund, 1997

Grant, Duncan 1885–1978, *Miss Mary Coss*, bequeathed by Frank Hindley Smith, 1939, © 1978 estate of Duncan Grant

Grant, Duncan 1885–1978, *The Chinese Plate*, bequeathed by Warren Pollock, 1986, received 1992, © 1978 estate of Duncan Grant

Grant, Duncan 1885–1978, *Design for Needlework*, given by Keith Stuart Baynes, 1974, © 1978 estate of Duncan Grant

Grant, Keith b.1930, *Volcano and White Bird, Iceland (4 panels)*, given by Keith Grant in memory of his son, Paul (1974–1995), 1995

Grant, Keith b.1930, *Eruption Column at 20,000 Feet, Heimæy, Iceland*, given by Keith Grant, 2001

Grassi, Nicola (attributed to) 1682–1748, *Christ Falling under the Cross*, bequeathed by Warren Pollock, 1986, received 1992

Grassi, Nicola (attributed to) 1682–1748, *The Woman Taken in Adultery*, bequeathed by Warren Pollock, 1986, received 1992

Gray, Maurice 1889–1918, *Langdale Pikes from near Crinkle Crags*, given by Mrs Alan Gray, the artist's mother, 1943

Greuze, Jean-Baptiste 1725–1805, *George Augustus Herbert, Eleventh Earl of Pembroke (1759–1827)*, bought from the McDonald Fund with a contribution from the National Art Collections Fund, 2000

Griffier, Jan I c.1645–1718, *View on the Rhine*, bequeathed by Richard, Seventh Viscount Fitzwilliam, 1816

Gryef, Adriaen de 1670–1715, *Spaniel and Dead Game in a Landscape*, bequeathed by Daniel Mesman, 1834

Guardi, Antonio 1699–1760, *The Sala Grande of the Ridotto, Palazzo Dandolo, San Moise*, bought from the Gow Fund, 1980

Guardi, Antonio 1699–1760, *Pharaoh's Daughter (after Jacopo Palma il giovane)*, given by the Friends of the Fitzwilliam Museum, 1952

Guardi, Francesco 1712–1793, *Forte San Andrea del Lido, Venice*, bequeathed by the Reverend C. Lesingham Smith, 1878

Guardi, Francesco 1712–1793, *The Island of Anconetta, Venice*, bequeathed by Daniel Mesman, 1834

Guardi, Francesco 1712–1793, *View near Venice*, bequeathed by Daniel Mesman, 1834

Guardi, Francesco 1712–1793, *View towards Murano from the Fondamente Nuove, Venice*, bequeathed by the Reverend C. Lesingham Smith, 1878

Guardi, Giacomo 1764–1835,

Handel, given by the Reverend Arthur Robert Ward, 1870

Hudson, Thomas (school of) 1701–1779, *Mrs Susannah Hope*, bequeathed by Lady Hope, given in accordance with the wishes of her husband Sir William H. St John Hope, 1952

Huet, Jean-Baptiste I 1745–1811, *A Pastoral*, bequeathed by the Reverend C. Lesingham Smith, 1878

Huet, Jean-Baptiste I 1745–1811, *A Pastoral*, bequeathed by the Reverend C. Lesingham Smith, 1878

Hughes, Arthur 1832–1915, *Edward Robert Hughes as a Child*, bequeathed by Mrs Edward Robert Hughes, 1925

Hughes, Arthur 1832–1915, *The King's Orchard*, bequeathed by Lady Courtney of Penwith, 1929

Hulsman, Johann d. before 1652, *Latona Transforming the Peasants into Frogs*, bequeathed by Daniel Mesman, 1834

Hunt, William Holman 1827–1910, *The Thames at Chelsea, Evening*, given by Charles Fairfax Murray, 1917

Hunt, William Holman 1827–1910, *Cyril Benoni Holman Hunt*, bequeathed by Cyril Benoni Holman Hunt, 1934

Huxley, Paul b.1938, *Untitled*, bequeathed by Bryan Charles Francis Robertson, 2003

Huxley, Paul b.1938, *Untitled No.17*, bequeathed by Dr Alastair Hunter, 1984

Huysmans, Cornelis 1648–1727, *Landscape with Figures*, bequeathed by Daniel Mesman, 1834

Huysum, Jacob van 1686–1740, *A Vase of Flowers with Fruit*, bequeathed by Major the Hon. Henry Rogers Broughton, Second Lord Fairhaven, 1973

Huysum, Jacob van 1686–1740, *Twelve Months of Flowers: January*, bequeathed by Major the Hon. Henry Rogers Broughton, Second Lord Fairhaven, 1973

Huysum, Jacob van 1686–1740, *Twelve Months of Flowers: February*, bequeathed by Major the Hon. Henry Rogers Broughton, Second Lord Fairhaven, 1973

Huysum, Jacob van 1686–1740, *Twelve Months of Flowers: March*, bequeathed by Major the Hon. Henry Rogers Broughton, Second Lord Fairhaven, 1973

Huysum, Jacob van 1686–1740, *Twelve Months of Flowers: April*, bequeathed by Major the Hon. Henry Rogers Broughton, Second Lord Fairhaven, 1973

Huysum, Jacob van 1686–1740, *Twelve Months of Flowers: May*, bequeathed by Major the Hon. Henry Rogers Broughton, Second Lord Fairhaven, 1973

Huysum, Jacob van 1686–1740, *Twelve Months of Flowers: June*, bequeathed by Major the Hon. Henry Rogers Broughton, Second

Lord Fairhaven, 1973

Huysum, Jacob van 1686–1740, *Twelve Months of Flowers: July*, bequeathed by Major the Hon. Henry Rogers Broughton, Second Lord Fairhaven, 1973

Huysum, Jacob van 1686–1740, *Twelve Months of Flowers: August*, bequeathed by Major the Hon. Henry Rogers Broughton, Second Lord Fairhaven, 1973

Huysum, Jacob van 1686–1740, *Twelve Months of Flowers: September*, bequeathed by Major the Hon. Henry Rogers Broughton, Second Lord Fairhaven, 1973

Huysum, Jacob van 1686–1740, *Twelve Months of Flowers: October*, bequeathed by Major the Hon. Henry Rogers Broughton, Second Lord Fairhaven, 1973

Huysum, Jacob van 1686–1740, *Twelve Months of Flowers: November*, bequeathed by Major the Hon. Henry Rogers Broughton, Second Lord Fairhaven, 1973

Huysum, Jacob van 1686–1740, *Twelve Months of Flowers: December*, bequeathed by Major the Hon. Henry Rogers Broughton, Second Lord Fairhaven, 1973

Huysum, Jan van 1682–1749, *A Vase of Flowers*, bequeathed by Major the Hon. Henry Rogers Broughton, Second Lord Fairhaven, 1973, received 1975

Huysum, Jan van (after) 1682–1749, *Fruit and Flowers*, bequeathed by Charles Brinsley Marlay, 1912

Huysum, Jan van (attributed to) 1682–1749, *A Vase of Flowers*, bequeathed by Major the Hon. Henry Rogers Broughton, Second Lord Fairhaven, 1973

Huysum, Justus van 1659–1716, *A Vase of Flowers*, bequeathed by Major the Hon. Henry Rogers Broughton, Second Lord Fairhaven, 1973, received 1975

Huysum, Justus van 1659–1716, *A Vase of Flowers*, bequeathed by Major the Hon. Henry Rogers Broughton, Second Lord Fairhaven, 1973, received 1975

Huysum, Justus van 1659–1716, *Group of Flowers*, bought, 1905

Huysum, Michiel van 1703–1777, *A Dish of Fruit*, bequeathed by Major the Hon. Henry Rogers Broughton, Second Lord Fairhaven, 1973, received 1975

Huysum, Michiel van 1703–1777, *A Vase of Flowers*, bequeathed by Major the Hon. Henry Rogers Broughton, Second Lord Fairhaven, 1973, received 1975

Ibbetson, Julius Caesar 1759–1817, *Ullswater from the Foot of Gowbarrow Fell*, bequeathed by Charles Brinsley Marlay, 1912

Inchbold, John William 1830–1888, *Anstey's Cove, Devon*, bought from the Fairhaven Fund, 1951

Inlander, Henry 1925–1983, *Mirror Landscape, Self Portrait*, bequeathed by Warren Pollock, 1986, received 1992, © the artist's

estate

Innes, James Dickson 1887–1914, *Arenig Fawr, North Wales*, bequeathed by Edward Maurice Berkeley Ingram, CMG, OBE, 1941, received 1946

Isabey, Eugène 1803–1886, *Washerwomen on the Shore*, bequeathed by A. S. F. Gow, through the National Art Collections Fund, 1978

Isenbrandt, Adriaen c.1500–before 1551, *A Male Donor*, bequeathed by Thomas Henry Riches, 1935, received on the death of his widow, 1950

Isenbrandt, Adriaen c.1500–before 1551, *St Jerome*, bequeathed by Thomas Henry Riches, 1935, received on the death of his widow, 1950

Israëls, Jozef 1824–1911, *A Young Girl Sewing, Seated at a Window*, given by the executors of Mrs Alice Chapp, 1987

Italian (Bolognese) School 17th C, *A Prophet Set in a Spandrel*, bequeathed by Warren Pollock, 1986, received 1992

Italian (Bolognese) School 17th C, *The Triumph of Galatea*, bequeathed by Richard, Seventh Viscount Fitzwilliam, 1816

Italian (Florentine) School early 15th C, *Virgin and Child*, bequeathed by Charles Haslewood Shannon, 1937

Italian (Neopolitan) School *Virgin and Child between St John the Baptist and St Onuphrius*, given by Harold, First Viscount Rothermere, 1927

Italian (Roman) School *Fight of Sea Deities and Sea Monsters*, bequeathed by Warren Pollock, 1986, received 1992

Italian (Roman) School *Fight of Sea Deities and Sea Monsters*, bequeathed by Warren Pollock, 1986, received 1992

Italian (Sienese) School late 13th C, *Crucifixion*, bought, 1893

Italian (Sienese) School late 15th C, *Joseph Sold by His Brethren*, given by the executors of Robert Ross (d.1918), 1926

Italian (Sienese) School late 15th C, *Joseph and Potiphar's Wife*, given by the executors of Robert Ross (d.1918), 1926

Italian (Sienese) School late 15th C, *Joseph before Pharaoh*, given by the executors of Robert Ross (d.1918), 1926

Italian (Sienese) School late 15th C, *Trajan and the Widow (a desco da parto or salver to celebrate the birth of a child)*, bequeathed by Charles Brinsley Marlay, 1912

Italian (Umbrian) School *Head of Christ*, bought, 1892

Italian (Venetian) School 14th/15th C, *St Augustine, St Jerome and St Benedict*, given by the Friends of the Fitzwilliam Museum, 1931

Italian (Venetian) School mid-16th C, *The Presentation in the Temple*, given by Mrs J. C. Hare

in accordance with the wishes of her husband, the Ven. J. C. Hare, Archdeacon of Lewes, 1855

Italian (Venetian) School late 16th C, *Venus and Cupid*, bequeathed by Richard, Seventh Viscount Fitzwilliam, 1816

Italian (Venetian) School *Rebecca and Eliezer at the Well*, given by Charles Edward Sayle, 1900

Italian (Veronese) School *Unknown Man*, given by the Trustees of Dr Ludwig Mond (1839–1909), 1926

Italian School late 15th C, *Ecce homo*, bequeathed by Charles Brinsley Marlay, 1912

Italian School *Apollo and Poseidon Come to Assist Laomedon*, bequeathed by Charles Brinsley Marlay, 1912

Italian School *Laomedon Refuses Apollo and Poseidon Their Reward*, bequeathed by Charles Brinsley Marlay, 1912

Italian School late 16th C, *Portrait of a Young Man*, given by Henry Roe, 1837

Jackson, John 1778–1831, *Thomas Stothard, RA*, given by Charles Fairfax Murray, 1908

Jacque, Charles Émile 1813–1894, *The Distant Storm*, bequeathed by John Tillotson, 1984, received 1985

Janson, Johannes 1729–1784, *Cattle Piece*, bequeathed by Daniel Mesman, 1834

Janson, Johannes 1729–1784, *Cattle Piece*, bequeathed by Daniel Mesman, 1834

Janson, Johannes 1729–1784, *Cattle Piece*, bequeathed by Daniel Mesman, 1834

Janssens van Ceulen, Cornelis 1593–1661, *Unknown Lady*, given by the Garrison Officer Cadet Battalion Association as a memorial to No.22 (Garrison) Officer Cadet Battalion, Cambridge (1916–1919), 1958

Jeaurat, Etienne (attributed to) 1699–1789, *Beggar Boy*, bequeathed by Richard, Seventh Viscount Fitzwilliam, 1816

Jeaurat, Etienne (attributed to) 1699–1789, *Beggar Girl*, bequeathed by Richard, Seventh Viscount Fitzwilliam, 1816

Jervas, Charles (after) c.1675–1739, *Martha and Teresa Blount*, given by Charles Fairfax Murray, 1908

John, Augustus Edwin 1878–1961, *Dorelia with a Feathered Hat*, bequeathed by Major Peter Harris (1898–1976), with a life-interest to his widow, relinquished 1976, © bridgeman.co.uk

John, Augustus Edwin 1878–1961, *David and Dorelia in Normandy*, bequeathed by Edward Maurice Berkeley Ingram, CMG, OBE, 1941 received 1945, © courtesy of the artist's estate/ www.bridgeman.co.uk

John, Augustus Edwin 1878–1961, *Sir William Nicholson*, given by

Miss Sydney Renée Courtauld, 1933, © courtesy of the artist's estate/ www.bridgeman.co.uk

John, Augustus Edwin 1878–1961, *Caspar*, bequeathed by Major Peter Harris (1898–1976), with a life-interest to his widow, relinquished 1976, © courtesy of the artist's estate/ www.bridgeman.co.uk

John, Augustus Edwin 1878–1961, *Dorelia and the Children at Martigues*, bequeathed by Major Peter Harris (1898–1976) with a life-interest to his widow, relinquished 1976, © courtesy of the artist's estate/ www.bridgeman.co.uk

John, Augustus Edwin 1878–1961, *Girl Leaning on a Stick*, bequeathed by Louis Colville Gray Clarke, 1960, received 1961, © courtesy of the artist's estate/ www.bridgeman.co.uk

John, Augustus Edwin 1878–1961, *The Blue Pool*, bequeathed by Major Peter Harris (1898–1976), with a life-interest to his widow, relinquished 1976, © courtesy of the artist's estate/ www.bridgeman.co.uk

John, Augustus Edwin 1878–1961, *Woman with a Daffodil*, given by Sir (Henry Francis) Herbert Thompson, Bt, 1920, © courtesy of the artist's estate/ www.bridgeman.co.uk

John, Augustus Edwin 1878–1961, *Dorelia by the Caravan*, bequeathed by Louis Colville Gray Clarke, 1960, received 1961, © courtesy of the artist's estate/ www.bridgeman.co.uk

John, Augustus Edwin 1878–1961, *David and Caspar*, bequeathed by Major Peter Harris (1898–1976), with a life-interest to his widow, relinquished 1976, © courtesy of the artist's estate/ www.bridgeman.co.uk

John, Augustus Edwin 1878–1961, *Dorelia Seated and Holding Flowers*, bequeathed by Major Peter Harris (1898–1976), with a life-interest to his widow, relinquished 1976, © courtesy of the artist's estate/ www.bridgeman.co.uk

John, Augustus Edwin 1878–1961, *Dorelia Wearing a Turban*, bequeathed by Major Peter Harris (1898–1976), with a life-interest to his widow, relinquished 1976, © courtesy of the artist's estate/ www.bridgeman.co.uk

John, Augustus Edwin 1878–1961, *The Yellow Dress*, bequeathed by Major Peter Harris (1898–1976), with a life-interest to his widow, relinquished 1976, © courtesy of the artist's estate/ www.bridgeman.co.uk

John, Augustus Edwin 1878–1961, *The Woman of Ower*, given by the Friends of the Fitzwilliam Museum, 1917, © courtesy of the artist's estate/ www.bridgeman.co.uk

John, Augustus Edwin 1878–1961, *The Mumper's Daughter*,

bequeathed by Major Peter Harris (1898–1976), with a life-interest to his widow, relinquished 1976, © courtesy of the artist's estate/ www.bridgeman.co.uk

John, Augustus Edwin 1878–1961, *George Bernard Shaw*, given by George Bernard Shaw, 1922, © courtesy of the artist's estate/ www.bridgeman.co.uk

John, Augustus Edwin 1878–1961, *Olives in Spain*, bequeathed by Louis Colville Gray Clarke, 1960, received 1961, © courtesy of the artist's estate/ www.bridgeman.co.uk

John, Augustus Edwin 1878–1961, *Thomas Hardy*, given by Thomas Henry Riches, 1923, © courtesy of the artist's estate/ www.bridgeman.co.uk

John, Augustus Edwin 1878–1961, *Study in Provence*, bequeathed by Louis Colville Gray Clarke, 1960, received 1961, © courtesy of the artist's estate/ www.bridgeman.co.uk

John, Augustus Edwin 1878–1961, *Edwin John*, bequeathed by Major Peter Harris (1898–1976), with a life-interest to his widow, relinquished 1976, © courtesy of the artist's estate/ www.bridgeman.co.uk

John, Gwen 1876–1939, *The Convalescent*, given by the Very Reverend Eric Milner-White, CBE, DSO, Dean of York, 1951, © estate of Gwen John 2006. All rights reserved, DACS

Joli, Antonio c.1700–1777, *Capriccio: Elegant Figures outside and within a Classical Palace*, bequeathed by Dr D. M. McDonald, 1991, with a life-interest to his widow, relinquished December 1996, received 1997

Jones, Thomas 1742–1803, *Scene near Naples*, bought from the Paintings Duplicates Fund, 1954

Jordaens, Jacob 1593–1678, *Two Studies of a Male Head*, given by F. Thackeray, 1841

Kauffmann, Angelica 1741–1807, *Louisa Hammond*, bequeathed by G. E. Beddington, 1958, received on the death of his widow, Mrs C. H. Beddington, who had a life-interest, 1995

Kerr-Lawson, James 1864–1939, *Paul Verlaine*, bought from the Coppinger Prichard Fund, 1943

Kessel, Jan van (attributed to) 1641–1680, *Swags of Fruit and Flowers Surrounding a Cartouche with a Sulphur-Crested Cockatoo*, bequeathed by Dr D. M. McDonald, 1991, received 1992

Kessel, Jan van II 1626–1679, *Butterflies and Other Insects*, bequeathed by Daniel Mesman, 1834

Kessel, Jan van II 1626–1679, *Butterflies and other Insects*, bequeathed by Daniel Mesman, 1834

Kessel, Jan van II 1626–1679, *A Vase of Flowers*, bequeathed by Major the Hon. Henry Rogers Broughton, Second Lord Fairhaven, 1973, received 1975

Kessel, Jan van II 1626–1679, *A Vase of Flowers*, bequeathed by Major the Hon. Henry Rogers Broughton, Second Lord Fairhaven, 1975

Kessel, Jan van II 1626–1679, *Insects*, bequeathed by Daniel Mesman, 1834

Kessel, Jan van II 1626–1679, *Insects*, bequeathed by Daniel Mesman, 1834

Kessel, Jan van II 1626–1679, *Insects*, bequeathed by Daniel Mesman, 1834

Kessel, Jan van II 1626–1679, *Insects*, bequeathed by Daniel Mesman, 1834, stolen in 1992

Kessel, Jan van II 1626–1679, *Insects*, bequeathed by Daniel Mesman, 1834

Kingsford, Florence Kate 1872–1949, *Joan Kingsford Reading*, given by Wilfred R. Wood, 1975

Klinghoffer, Clara 1900–1970, *Mrs Jimmy H. Ede*, bequeathed by Miss E. M. J. Pleister, 1982, placed on permanent deposit at Kettle's Yard, 1983

Klomp, Albert Jansz. c.1618–1688/1689, *Cattle in a Landscape*, bequeathed by Daniel Mesman, 1834

Klomp, Albert Jansz. c.1618–1688/1689, *Cattle Piece*, bequeathed by Daniel Mesman, 1834

Klomp, Albert Jansz. c.1618–1688/1689, *Sheep and Goats with a Shepherd*, bequeathed by Daniel Mesman, 1834

Knapton, George 1698–1778, *Edward Morrison*, bequeathed by the Reverend James William Arnold, 1865, with a life-interest to his widow, Lady Mary Arnold, relinquished, 1873

Knewstub, Walter John 1831–1906, *O If I Were Grandma*, given by Charles Fairfax Murray, 1909

König, Johann 1586–1642, *Adam and Eve in Paradise*, given by Miss O. Ault, in memory of her father, Norman Ault, 1974

Kustodiyev, Boris 1878–1927, *Peter Kapitza*, given by Mrs Peter Kapitza, 1935

Lachtropius, Nicolaes active c.1656–1700, *Vase of Flowers*, given by Major the Hon. Henry Rogers Broughton, 1966

Lamb, Henry 1883–1960, *Lytton Strachey*, given by Justin Edward Vulliamy, 1945

Lamb, Henry 1883–1960, *The River Ebble, Wiltshire*, bought from the Fairhaven Fund, 1961

Lambinet, Emile Charles 1815–1877, *The Mill*, given by the National Art Collections Fund (Mrs Rose Dallas Bequest), 2003

Lance, George 1802–1864, *Fruit Piece*, given by Mrs Richard Ellison, 1862

Lancret, Nicolas 1690–1743, *'In this pleasant solitude...'*, bequeathed by Richard, Seventh Viscount Fitzwilliam, 1816

Lancret, Nicolas 1690–1743, *Music Party in a Landscape*, bequeathed by Daniel Mesman, 1834

Lancret, Nicolas 1690–1743, *'With a tender little song…'*, bequeathed by Richard, Seventh Viscount Fitzwilliam, 1816

Landseer, Edwin Henry 1802–1873, *The Pot of Gartness, Drymen, Stirlingshire*, bought from the Fairhaven Fund, 1984

Lanyon, Peter 1918–1964, *Shy Deep*, bequeathed by Dr Alastair Hunter, 1984, © Sheila Lanyon

László, Philip Alexius de 1869–1937, *Sir Charles Walston*, given by Patrick Browne, 1986, © courtesy of the artist's estate/ www.bridgeman.co.uk

Laurent, François Nicholas c.1775–1828, *A Bowl of Flowers*, bequeathed by Major the Hon. Henry Rogers Broughton, Second Lord Fairhaven, 1973, received 1975

Lauri, Filippo 1623–1694, *The Agony in the Garden*, bequeathed by Richard, Seventh Viscount Fitzwilliam, 1816

Lavery, John 1856–1941, *Studies Made in the House of Lords*, given by the Friends of the Fitzwilliam Museum, 1922, © the artist's estate

Lavieille, Eugène Antoine Samuel 1820–1889, *On the Banks of the Seine at Lévy*, 1884, given by Philip McClean, 1996

Lawrence, Thomas 1769–1830, *Samuel Woodburn*, given by Miss Woodburn, 1865

Le Brun, Charles 1619–1690, *The Holy Family*, bequeathed by the Reverend Charles Mesman, 1842

Le Sidaner, Henri Eugène 1862–1939, *The Pond Garden, Hampton Court*, given by the Friends of the Fitzwilliam Museum, 1962, © ADAGP, Paris and DACS, London 2006

Le Sidaner, Henri Eugène 1862–1939, *Trafalgar Square*, given by Mrs Frederick Leverton Harris, 1931, © ADAGP, Paris and DACS, London 2006

Lear, Edward 1812–1888, *The Temple of Apollo at Bassae*, given by the Subscribers, 1860

Leeb, Nat b.1906, *The Tortoise*, given by Nat Leeb, 1981, © ADAGP, Paris and DACS, London 2006

Leen, Willem van 1753–1825, *Bowl of Flowers*, given by Major the Hon. Henry Rogers Broughton, 1966

Lees, Derwent 1885–1931, *Lyndra in Wales*, bequeathed by Edward Maurice Berkeley Ingram, CMG, OBE, 1941

Leeuwen, Gerrit Johan van 1756–1825, *Flowers in an Urn, with Fruit*, given by Major the Hon. Henry Rogers Broughton, 1966

Léger, Fernand 1881–1955, *Young Girl Holding a Flower*, given by Dr Alastair Hunter, 1974, © ADAGP, Paris and DACS, London 2006

Legros, Alphonse 1837–1911, *The*

Legros, Alphonse 1837–1911, *The Reverend Robert Burn*, given by Alphonse Legros, 1880

Legueult, Raymond Jean 1898–1971, *MOUTHIER: Abstract Landscape with Trees*, bequeathed by the Very Reverend Eric Milner-White, CBE, DSO, Dean of York, 1970 © ADAGP, Paris and DACS, London 2006

Leighton, Frederic, 1st Baron Leighton of Stretton 1830–1896, *Miss Laing*, given by Carolin Nias, 1928

Leighton, Frederic, 1st Baron Leighton of Stretton 1830–1896, *On the Nile*, bought from the Fairhaven Fund, 1979

Leighton, Frederic, 1st Baron Leighton of Stretton 1830–1896, *Clytie*, bequeathed by Charles Brinsley Marlay, 1912

Lely, Peter 1618–1680, *Portrait of a Lady, Probably Mary Parsons, Later Mrs Draper*, given by the Friends of the Fitzwilliam Museum, 1941

Lemonnier, Anicet Charles Gabriel 1743–1824, *Vesuvius in Eruption*, bought from the Gow Fund, 1997

Lengele, Maerten d.1668, *A Company of the Hague Arquebusiers*, bequeathed by Charles Brinsley Marlay, 1912

Lépine, Stanislas 1835–1892, *The Coast of Normandy*, given by Charles Fairfax Murray, 1911

Lewis, John Frederick 1805–1876, *A Syrian Sheik, Egypt*, given by Mrs Richard Ellison, 1862

Lewis, Neville 1895–1972, *H. S. Reitlinger*, bequeathed by Henry Scipio Reitlinger, 1950, transferred from the Reitlinger Trust, 1991, accessioned 2005

Liberale da Verona c.1445–c.1526, *Simon Magus Offering St Peter Money for the Power of Conferring the Holy Spirit*, given by Louis Colville Gray Clarke, 1949, received 1961

Liberale da Verona c.1445–c.1526, *The Dead Christ Supported by Mourning Angels*, accepted by HM Government in lieu of inheritance tax and allocated to the Fitzwilliam Museum, 2003

Licinio, Bernadino (attributed to) c.1489–c.1565, *An Unknown Youth*, bequeathed by Arthur W. Young, 1936

Lievens, Jan Andrea c.1640/1644–before 1708, *Dirck Decker of Amsterdam*, bequeathed by Richard, Seventh Viscount Fitzwilliam, 1816

Lin, Richard b.1933, *Friday*, bought from the Gulbenkian Fund, 1974

Lingelbach, Johannes 1622–1674, *A Port Scene*, given by Mrs M. Joan Wyburn-Mason, in memory of her husband, Professor R. Wyburn-Mason, 1983

Linnell, John 1792–1882, *The River Kennet, near Newbury*, bought from the Fairhaven Fund, 1958

Linnell, John 1792–1882, *Steep Hill, Isle of Wight*, given by the

executors of Sir Geoffrey Keynes, 1985

Linnell, John 1792–1882, *Sunset over a Moorland Landscape*, bought from the Fairhaven Fund, 1950

Linnell, John 1792–1882, *Autumn Woods*, bequeathed by Wilfrid Ariel Evill, 1963

Linnell, John 1792–1882, *Christ and the Woman of Samaria at Jacob's Well*, bought from the Fairhaven Fund, 1981

Linnell, John 1792–1882, *Shoreham Vale*, bequeathed by Geoffrey Keynes, allocated by HM Treasury from the estate of Sir Geoffrey Keynes, through the Minister of the Arts, accepted in lieu of capital taxes, 1985

Linnell, John 1792–1882 **& Palmer, Hannah Emma** 1818–1893, *Job Offering a Sacrifice on His Return to Prosperity*, given by Mr and Mrs Robert Tear, 1988

Linnell, William 1826–1906, *View near Redhill*, bought from the Fairhaven Fund, 1971

Lint, Hendrik Frans van 1684–1763, *The Villa Madama, Rome*, bequeathed by Daniel Mesman, 1834

Lint, Hendrik Frans van 1684–1763, *Coast Scene*, bequeathed by Daniel Mesman, 1834

Lint, Hendrik Frans van 1684–1763, *Landscape with Figures and Cattle*, bequeathed by Daniel Mesman, 1834

Linthorst, Jacobus 1745–1815, *Vase of Flowers*, given by Major the Hon. Henry Rogers Broughton, 1966

Linthorst, Jacobus 1745–1815, *Vase of Flowers*, given by Major the Hon. Henry Rogers Broughton, 1966

Linton, William 1791–1876, *Mistra*, given by Mrs Richard Ellison, 1862

Liot, A. active 19th C, *A Bowl of Flowers*, bequeathed by Major the Hon. Henry Rogers Broughton, Second Lord Fairhaven, 1973, received 1975

Liotard, Jean-Étienne 1702–1789, *Louise Elizabeth, Madame Infanta*, bought from the Gow Fund, 2005

Lippi, Filippo c.1406–1469, *Virgin and Child (centre), St John the Baptist (left) St George or St Ansanus (right)*, bought, 1893

Liss, Johann 1597–1631, *A Bacchanalian Feast*, bought from the L. D. Cunliffe Fund with contributions from the National Art Collections Fund and the Victoria & Albert Museum Grant-in-Aid, 1978

Lisse, Dirck van der 1586–1669, *Landscape with Diana and Actaeon*, bequeathed by Richard, Seventh Viscount Fitzwilliam, 1816

Lizars, William Home (attributed to) 1788–1859, *John Cowper, an Edinburgh Beggar*, given by Kenneth Clark, 1935

Loir, Nicolas Pierre (attributed to) 1624–1679, *Christ and the*

Woman of Samaria, bequeathed by Richard, Seventh Viscount Fitzwilliam, 1816

Loiseau, Gustave 1865–1935, *The Iron Bridge, St Ouen*, given by Mrs Frederick Leverton Harris, 1928, © ADAGP, Paris and DACS, London 2006

Lonsdale, James 1777–1839, *Dr Samuel Parr*, bequeathed by the Right Reverend Edward Maltby, Bishop of Durham, 1859

Lopez, Gasparo d.c.1732, *Flowers in a Landscape*, bequeathed by Major the Hon. Henry Rogers Broughton, Second Lord Fairhaven, 1973, received 1975

Lopez, Gasparo d.c.1732, *Flowers in a Landscape with Overturned Urn*, bequeathed by Major the Hon. Henry Rogers Broughton, Second Lord Fairhaven, 1973, received 1975

Lopez, Gasparo d.c.1732, *Vase of Flowers*, given by the Hon. Major Henry Rogers Broughton, 1966

Lorenzo Monaco c.1370–1425, *Virgin and Child Enthroned with Two Attendant Angels*, bought, 1893

Lorrain, Claude 1604–1682, *Pastoral Landscape with Lake Albano and Castel Gandolfo*, bought from funds bequeathed by Miss I. M. E. Hitchcock, and L. D. Cunliffe, with grants from the National Art Collections Fund and the Victoria & Albert Museum, 1963

L'Ortolano 1485–c.1527, *St John the Baptist*, given by Mrs J. C. Hare, 1855

Loutherbourg, Philip James de 1740–1812, *The River Wye at Tintern Abbey*, bought from the Fairhaven Fund, 1958

Lowry, Laurence Stephen 1887–1976, *After the Wedding*, given by Mrs F. J. Collard, 2002 © the Lowry Estate

Luca di Tommè active 1355–1389, *Virgin and Child Enthroned*, bought, 1893

Luini, Bernadino (attributed to) c.1480–c.1532, *Child Angel Playing a Flute*, given by the Right Reverend Lord Alwyne Frederick Compton, Bishop of Ely, 1905

Lust, Antoni de (attributed to) active 1650, *Flower Piece*, bequeathed by Daniel Mesman, 1834

Lust, Antoni de (attributed to) active 1650, *Glass Vase of Flowers*, given by Major the Hon. Henry Rogers Broughton, 1966

MacColl, Dugald Sutherland 1859–1948, *Blue Glass and Pippin*, given by Sir Ivor and Lady Batchelor, 1994

Mackley, George 1900–1983, *Brackie's Burn, Northumberland*, bequeathed by Mrs G. M. Sanderson, 1982

Maes, Dirk 1659–1717, *A Riding School*, bequeathed by Richard, Seventh Viscount Fitzwilliam, 1816

Maes, Dirk 1659–1717, *A Riding School*, bequeathed by Richard, Seventh Viscount Fitzwilliam, 1816

Maes, Dirk 1659–1717, *Stag Hunt*, bequeathed by Daniel Mesman, 1834

Magnasco, Alessandro 1667–1749, *Landscape with Camaldolite Monks Praying at a Roadside Shrine*, bequeathed by the Hon. Sir Steven Runciman, CH, 2000

Maineri, Gian Francesco de active 1489–1506, *The Virgin and Child Enthroned with Saints Cosmas and Damian, St Eustace and St George in the Background*, bequeathed by the Hon. Sir Steven Runciman, CH, 2000

Maitland, Paul Fordyce 1863–1909, *In Kensington Gardens*, given by Sir Denis Proctor, 1979

Manzuoli, Tommaso 1531–1571, *The Visitation*, given by Henry Thomas Hope, 1859, on long-term loan to Trinity Hall Chapel

Maratti, Carlo 1625–1713, *Cardinal Jacopo Rospigliosi*, bought from the L. D. Cunliffe Fund, 1962

Maratti, Carlo (copy after) 1625–1713, *The Virgin Teaching the Infant Christ to Read*, bequeathed by the Reverend Charles Mesman, 1842

Marchand, Jean Hippolyte 1883–1940, *Still Life*, given by Keith Stuart Baynes, 1974

Marellus, Jacob 1614–1678, *Vase of Flowers*, given by Major the Hon. Henry Rogers Broughton, 1966

Marieschi, Michele Giovanni 1710–1743, *The Grand Canal, Venice, above the Rialto Bridge*, given by Augustus Arthur VanSittart, 1876

Marieschi, Michele Giovanni (copy after) 1710–1743, *The Grand Canal with San Simeone, Venice*, given by Augustus Arthur VanSittart, 1876

Marion, Antoine Fortune 1846–1900, *The Village Church*, given by Captain Stanley William Sykes, OBE, MC, 1956

Mariotto di Nardo active 1394–1424, *The Coronation of the Virgin*, bequeathed by Charles Brinsley Marlay, 1912

Marlow, William 1740–1813, *View near Naples*, bought from the Fairhaven Fund, 1952

Marquet, Albert 1875–1947, *River Scene*, bequeathed by Henry Scipio Reitlinger, 1950, transferred from the Reitlinger Trust, 1991, © ADAGP, Paris and DACS, London 2006

Martin, John 1789–1854, *Landscape: View in Richmond Park*, bought from the Fairhaven Fund with a donation by the Charles Z. Offin Art Fund Inc., 1977

Martin, John 1789–1854, *Twilight in the Woodlands*, given by Lancelot Hugh Smith, 1928

Martini, Simone c.1284–1344, *St Geminianus, St Michael and St Augustine, Each with an Angel above*, bought, 1893

Martino di Bartolomeo d.1434/1435, *The Annunciation*, bought, 1893

Mason, George Heming 1818–1872, *Landscape*, given by Sir (Henry Francis) Herbert Thompson, Bt, 1920

Master of the Castello Nativity active second half of 15th C, *Virgin Adoring the Child*, bequeathed by Charles Brinsley Marlay, 1912

Master of the Female Half-Lengths active c.1525–1550, *Virgin and Child*, bequeathed by Charles Brinsley Marlay, 1912

Master of the Magdalen Legend c.1483–c.1530, *Two Donors from a Wing of an Altarpiece*, given by Mrs Sigismund Goetze, 1943

Master of the Munich Adoration active c.1520, *The Adoration of the Kings*, bequeathed by Charles Brinsley Marlay, 1912

Master of the Pala Sforzesca active c.1490–c.1500, *Salvator mundi*, bequeathed by the Reverend Philip Sidney, 1955

Master of the Saint Ursula Legend (circle of) active c.1485–1515, *The Entombment*, given by Sir (Henry Francis) Herbert Thompson, Bt, 1929

Master of the Saint Ursula Legend (circle of) active c.1485–1515, *The Virgin of the Annunciation*, given by Sir (Henry Francis) Herbert Thompson, Bt, 1929

Master of the Statthalterin Maria active 1530–1540, *Portrait of a Man*, bequeathed by Daniel Mesman, 1834

Master of Verucchio c.1320–c.1350, *Crucifixion*, bequeathed by the Reverend Philip Sidney, 1955

Matisse, Henri 1869–1954, *The Studio under the Eaves*, bequeathed by Arnold John Hugh Smith, through the National Art Collections Fund, 1964, © succession H. Matisse/ DACS 2006

Matisse, Henri 1869–1954, *Woman Seated in an Armchair*, lent by the Provost and Fellows of King's College, Cambridge (Keynes Collection), © succession H. Matisse/ DACS 2006

Matisse, Henri 1869–1954, *Boats on the Beach, Etrétat*, bequeathed by Captain Stanley William Sykes, OBE, MC, 1966, © succession H. Matisse/ DACS 2006

Matisse, Henri 1869–1954, *The Bulgarian Blouse*, bequeathed by Frank Hindley Smith, 1939, © succession H. Matisse/ DACS 2006

Matisse, Henri 1869–1954, *Women on the Beach, Etrétat*, bequeathed by Arnold John Hugh Smith through the National Art Collections Fund, 1964, © succession H. Matisse/ DACS 2006

Mazzolino, Lodovico c.1480–c.1530, *Christ before Pilate*, bequeathed by Charles Brinsley Marlay, 1912

McEvoy, Ambrose 1878–1927, *Professor James Ward*, given by the Subscribers, 1914

Meulen, Adam Frans van der (studio of) 1631/1632–1690, *Siege of Besançon by Condé in 1674*, bequeathed by Richard, Seventh Viscount Fitzwilliam, 1816

Meyer, Henry Hoppner 1782–1847, *George Dyer with His Dog Daphne*, bequeathed by Miss Sarah Travers to the University of Cambridge, and placed in the Fitzwilliam Museum, 1897

Meyer, Jan van c.1681–after 1741, *The Daughters of Sir Matthew Decker, Bt*, bequeathed by Richard, Seventh Viscount Fitzwilliam, 1816

Meyer, Jeremiah 1735–1789, *Adoration of the Kings (after Theodor van Loon)*, bequeathed by Richard, Seventh Viscount Fitzwilliam, 1816

Michallon, Achille Etna 1796–1822, *The Oak and the Reed*, bought from the Gow Fund with contributions from the Museum and Galleries Commission/Victoria & Albert Museum Purchase Grant Fund and the National Art Collections Fund, 1991

Michau, Theobald 1676–1765, *Wooded Landscape with Stream and Figures*, bequeathed by Daniel Mesman, 1834

Michel, Georges 1763–1843, *Landscape with a Windmill*, bequeathed by Leonard Daneham Cunliffe, 1937

Michetti, Francesco Paolo 1851–1929, *Study for 'The Return from the Campagna'*, given by Jak Katalan, through the American Friends of Cambridge University, 2000

Middleton, John 1827–1856, *A Path through a Wooded Landscape*, bought from the Fairhaven Fund, 1985

Miel, Jan 1599–1663, *The Veneration of St Lambert*, bought with contributions from the Victoria & Albert Museum Grant-in-Aid, the National Art Collections Fund and the University Purchase Fund, 1974

Miereveld, Michiel Jansz. van 1567–1641, *Portrait of a Lady*, bequeathed by Leonard Daneham Cunliffe, 1937

Miereveld, Michiel Jansz. van 1567–1641, *Aeltje van der Graft*, bequeathed by Charles Brinsley Marlay, 1912

Miereveld, Michiel Jansz. van 1567–1641, *Heyndrik Damensz. van der Graft*, bequeathed by Charles Brinsley Marlay, 1912

Mieris, Frans van the elder 1635–1681, *Dutch Courtship*, bequeathed by Richard, Seventh Viscount Fitzwilliam, 1816

Mieris, Frans van the younger 1689–1763, *Man with a Tankard*, bequeathed by Daniel Mesman, 1834

Mieris, Willem van 1662–1747, *Landscape with Ruins, Nymphs Bathing*, bequeathed by Richard, Seventh Viscount Fitzwilliam, 1816

Mieris, Willem van 1662–1747, *The Market Stall*, bequeathed by Richard, Seventh Viscount Fitzwilliam, 1816

Mignon, Abraham 1640–c.1679, *Flower Piece*, bequeathed by Daniel Mesman, 1834

Mignon, Abraham 1640–c.1679, *Still Life: Fruit and Nuts on a Stone Ledge*, bequeathed by Dr D. M. McDonald, 1991, received 1992

Millais, John Everett 1829–1896, *Mrs Coventry Patmore*, given by the Friends of the Fitzwilliam Museum, 1920

Millais, John Everett 1829–1896, *The Bridesmaid*, given by Thomas Richards Harding, 1889

Millais, John Everett 1829–1896, *The Twins, Kate and Grace Hoare*, accepted by HM Government in lieu of inheritance tax from the estate of Mrs Jean Wynne and allocated to the Fitzwilliam Museum, 2005

Millar, James active 1763–1805, *Young Man in Red*, bequeathed by Roger Francis Lambe, 1951

Modigliani, Amedeo 1884–1920, *Portrait of a Young Woman, Seated*, accepted in lieu of inheritance tax by HM Government and allocated to the Fitzwilliam Museum, 1998

Mola, Pier Francesco 1612–1666, *Landscape with Mythological Figures*, bequeathed by Richard, Seventh Viscount Fitzwilliam, 1816

Molenaer, Klaes d.1676, *Landscape with Sportsmen*, bequeathed by Daniel Mesman, 1834

Molenaer, Klaes d.1676, *Outside the Town Wall*, given by the Reverend G. A. S. Schneider, 1907

Molyn, Pieter 1595–1661, *Landscape with Figures*, bequeathed by the Reverend C. Lesingham Smith, 1878

Molyn, Pieter 1595–1661, *Landscape with Figures*, bequeathed by Daniel Mesman, 1834

Momper, Frans de 1603–1660, *A Village in Winter*, bequeathed by Charles Brinsley Marlay, 1912

Monet, Claude 1840–1926, *The Rock Needle and Porte d'Aval, Etrétat*, accepted in lieu of inheritance tax by HM Government and allocated to the Fitzwilliam Museum, 1998

Monet, Claude 1840–1926, *Rocks at Port Coton, the Lion Rock*, accepted in lieu of inheritance tax by HM Government and allocated to the Fitzwilliam Museum, 1998

Monet, Claude 1840–1926, *Springtime*, bought with the aid of the National Art Collections Fund, 1953

Monet, Claude 1840–1926, *Poplars*, bequeathed by Captain Stanley William Sykes, OBE, MC, 1966

Moni, Louis de 1698–1771, *The Fishmonger*, bequeathed by Daniel Mesman, 1834

Moni, Louis de 1698–1771, *The Fishwife*, bequeathed by Daniel Mesman, 1834

Monnoyer, Jean-Baptiste 1636–1699, *An Urn with Flowers*, bequeathed by Major the Hon. Henry Rogers Broughton, Second

Lord Fairhaven, 1973, received 1974

Monnoyer, Jean-Baptiste 1636–1699, *Still Life of Mixed Flowers in a Vase on a Ledge*, bequeathed by Dr D. M. McDonald, 1991, received 1992

Monnoyer, Jean-Baptiste 1636–1699 & **Monnoyer, Antoine** 1677–1745, *A Floral Composition*, bequeathed by Major the Hon. Henry Rogers Broughton, Second Lord Fairhaven, 1973, received 1975

Monti, Francesco 1685–1768, *The Apotheosis of St Martin*, bequeathed by Warren Pollock, 1986, received 1992

Moore, Albert Joseph 1841–1893, *The Umpire*, given by Louis Colville Gray Clarke, 1943

Mor, Antonis (after) 1512–1516–c.1576, *Elisabeth of Valois*, bequeathed by Charles Brinsley Marlay, 1912

Mor, Antonis (after) 1512–1516–c.1576, *Portrait of a Man as St Sebastian*, given by Percy Moore Turner, 1943

Mor, Antonis (studio of) 1512–1516–c.1576, *Philip II of Spain*, bequeathed by Charles Brinsley Marlay, 1912

More, Jacob 1740–1793, *Bonnington Linn on the River Clyde*, bequeathed by the Reverend Charles Lesingham Smith, 1878

Moreelse, Paulus 1571–1638, *A Girl with a Mirror, an Allegory of Profane Love*, bought from the Duplicate Paintings Fund, with a contribution from the Friends of the Fitzwilliam, 1968

Morland, George 1763–1804, *Visit to the Child at Nurse*, bequeathed by Dr D. M. McDonald, 1991, received 1992

Morland, George 1763–1804, *Donkey and Pigs*, bequeathed by Daniel Mesman, 1834

Morland, George 1763–1804, *Landscape with Figures*, bequeathed by Daniel Mesman, 1834

Morland, George 1763–1804, *Watering Horses*, bequeathed by Joseph Roe, 1931

Morland, George 1763–1804, *Morning (The Benevolent Sportsman)*, bequeathed by Arthur William Young, 1936

Morland, George 1763–1804, *The Smugglers*, bequeathed by Dr D. M. McDonald, 1991, received 1992

Morland, George 1763–1804, *A Windy Day*, bequeathed by Dr D. M. McDonald, 1991, received 1992

Morland, George 1763–1804, *Buying Fish*, bequeathed by Dr D. M. McDonald, 1991, with a life-interest to his widow, relinquished December 1996, received 1997

Morland, George 1763–1804, *Calf and Sheep*, bequeathed by Daniel Mesman, 1834

Morland, George 1763–1804, *Coast Scene*, bequeathed by Mrs Richard Ellison, 1862

Morland, George 1763–1804,

Encampment of Gypsies, given by Mrs Richard Ellison, 1862

Morland, George (after) 1763–1804, *The Farmyard*, bequeathed by Joseph Roe, 1931

Moroni, Giovanni Battista c.1525–1578, *The Transfiguration*, given by Sir (Henry Francis) Herbert Thompson, Bt, 1920

Moser, Mary 1744–1819, *Vase of Flowers*, given by Major the Hon. Henry Rogers Broughton, 1966

Mostaert, Jan c.1475–1555/1556, *Ecce homo*, given by Sir Frank Brangwyn, 1943

Motesiczky, Marie Louise von 1906–1996, *At the Dressmaker's*, given by Marie Louise von Motesiczky, 1993 © Marie Louise von Motesiczky Trust

Motesiczky, Marie Louise von 1906–1996, *Baron Philippe de Rothschild*, given by Marie Louise von Motesiczky, 1993 © Marie Louise von Motesiczky Trust

Moynihan, Rodrigo 1910–1990, *Self Portrait in a Mirror*, given by C. N. Peter Powell, through the Friends of the Fitzwilliam Museum, 1986, © the artist's estate

Müller, William James 1812–1845, *River Landscape with an Angler*, given by the Friends of the Fitzwilliam Museum, 1974

Müller, William James 1812–1845, *Millpond with Children Fishing*, bequeathed by Samuel Sandars, 1894, with a life-interest to his wife, received 1923

Müller, William James 1812–1845, *Landscape with a Cottage*, given by Martin Young, in memory of Michael Jaffé, 1997

Mulready, William 1786–1863, *The Farrier's Shop*, bequeathed by Joseph Prior, 1918, received 1919

Mundy, Henry b.1919, *Composition*, bequeathed by Warren Pollock, 1986, received 1992, © the artist

Mura, Francesco de 1696–1782, *Count James Joseph O'Mahoney, Lieutenant-General in the Neapolitan Service, Knight of St Januarius*, given by the Friends of the Fitzwilliam Museum, with contributions from the Victoria & Albert Museum Grant-in-Aid and the National Art Collections Fund, 1984

Mura, Francesco de 1696–1782, *Liberality*, bequeathed by Warren Pollock, 1986, received 1992

Mura, Francesco de 1696–1782, *Wisdom or Nobility*, bequeathed by Warren Pollock, 1986, received 1992

Murant, Emanuel 1622–1700, *Landscape with a Bridge*, bequeathed by Daniel Mesman, 1834

Murillo, Bartolomé Esteban 1618–1682, *The Vision of Fray Lauterio*, given by Joseph Prior, 1879

Murillo, Bartolomé Esteban 1618–1682, *St John the Baptist with the Scribes and Pharisees*, bought from the University Purchase

Fund, 1869

Murray, Charles Fairfax 1849–1919, *The Flaming Heart (after Dante Gabriel Rossetti)*, bequeathed by Charles Haslewood Shannon, 1937

Nash, John Northcote 1893–1977, *The Edge of the Plain*, bequeathed by Henry Scipio Reitlinger, 1950, transferred from the Reitlinger Trust, 1991, © courtesy of the artist's estate/ www.bridgeman.co.uk

Nash, Paul 1889–1946, *Coronilla (recto)*, given by the children of the late Dr Moyne, in accordance with his wishes, 1997, © Tate, London 2006

Nash, Paul 1889–1946, *Landscape (verso)*, given by the children of the late Dr Moyne, in accordance with his wishes, 1997, © Tate, London 2006

Nash, Paul 1889–1946, *November Moon*, given by the Contemporary Art Society, 1955, © Tate, London 2006

Nasmyth, Alexander 1758–1840, *Loch Doon, Ayrshire*, bought from the Fairhaven Fund, 1974

Nasmyth, Patrick 1787–1831, *A View of the Douglas Bridge near Inverary, Argyllshire*, bequeathed by Dr D. M. McDonald, 1991, with a life-interest to his widow, relinquished 1996, received 1997

Nasmyth, Patrick 1787–1831, *View near Norwood*, bequeathed by Arthur William Young, 1936

Nasmyth, Patrick 1787–1831, *View in Leigh Woods*, bought from the Fairhaven Fund, 1956

Nason, Pieter c.1612–c.1690, *Man in Armour with Yellow, Flowing Hair*, bequeathed by Henry Scipio Reitlinger, 1950, transferred from the Reitlinger Trust, 1991, accessioned 2005

Neeffs, Peeter the younger 1620–1675, *Interior of a Gothic Church*, bequeathed by Richard, Seventh Viscount Fitzwilliam, 1816

Neer, Aert van der 1603–1677, *An Estuary by Moonlight*, bought from the Gow Fund, with contributions from the Grant-in-Aid for the Regions administered by the Victoria & Albert Museum, and the National Art Collections Fund (The Eugene Cremetti Fund), 1985

Neroccio de' Landi (studio of) 1447–1500, *Virgin and Child with St Bernardino and St Catherine of Siena*, bought, 1893

Netscher, Theodorus 1661–1732, *Pineapple Grown in Sir Matthew Decker's Garden at Richmond, Surrey*, bequeathed by Richard, Seventh Viscount Fitzwilliam, 1816

Netscher, Theodorus 1661–1732, *Sir Matthew Decker, Bt*, bequeathed by Richard, Seventh Viscount Fitzwilliam, 1816

Newton, Herbert H. 1881–1959, *The Valley of the Palud, towards Sunset*, given by Herbert H. Newton, 1929

Neyn, Pieter de 1597–1639, *Halt

at an Inn*, bequeathed by Charles Brinsley Marlay, 1912

Nicholson, Ben 1894–1982, *White Relief, 1936, Second Version*, given by Ben Nicholson, 1977, © Angela Verren Taunt 2006. All rights reserved, DACS

Nicholson, Ben 1894–1982, *Ivory*, allocated by HM Treasury, in lieu of estate duty, 1986, © Angela Verren Taunt 2006. All rights reserved, DACS

Nicholson, Kate b.1929, *Jug Leaf*, bequeathed by Warren Pollock, 1986, received 1992

Nicholson, William 1872–1949, *The Girl with a Tattered Glove*, given by Mr and Mrs Edward Owen Vulliamy, 1917, © Elizabeth Banks

Nicholson, William 1872–1949, *Armistice Night*, given by Mrs Frederick Leverton Harris, 1928, © Elizabeth Banks

Nicholson, William 1872–1949, *Field Marshall J. C. Smuts*, given by Almeric, Lord Queensborough, 1924, © Elizabeth Banks

Nicholson, William 1872–1949, *A. C. Benson*, given by Arthur Christopher Benson, CVO, 1924, © Elizabeth Banks

Nicholson, William 1872–1949, *The Gate of Honour under Snow*, given by Sir William Nicholson, 1924, © Elizabeth Banks

Nicholson, William 1872–1949, *Still Life, Fruit on a Dish*, given by the Friends of the Fitzwilliam Museum, 1929, © Elizabeth Banks

Nicholson, William 1872–1949, *Matadero, Segovia*, given by Emanuel Vincent Harris, in memory of his wife Edith, 1967, © Elizabeth Banks

Nickele, Isaak van active 1660–1703, *St Bavo, Haarlem*, given by Augustus Arthur VanSittart, 1864

Nickele, Jan van (attributed to) 1656–1721, *Architecture with Figures*, given by Augustus Arthur VanSittart, 1876

Noland, Kenneth b.1924, *Saturday Morning*, bequeathed by Dr Alastair Hunter, 1983, received 1984, © Kenneth Noland/ VAGA, New York/ DACS, London 2006

Nomé, François de c.1593–after 1644, *King Asa of Judah Destroying the Idols*, bequeathed by Francis Falconer Madan, 1962

Northcote, James 1746–1831, *Joseph Nollekens*, given by the Reverend Richard Edward Kerrich, 1861

Olis, Jan c.1610–1676, *Gentlemen Playing Backgammon*, bequeathed by Daniel Mesman, 1834

Olivuccio di Cicarello da Camerino c.1365–1439, *St Peter and St Paul with Angels*, bequeathed by G. G. Milner-Gibson-Cullum, 1921

Olivuccio di Cicarello da Camerino c.1365–1439, *St James and Possibly St Andrew with Angels*, bequeathed by G. G. Milner-Gibson-Cullum, 1921

Oost, Jacob van the elder (attributed to) 1603–1671, *Portrait of a Man Holding a Statuette*, bequeathed by Richard, Seventh Viscount Fitzwilliam, 1816

Oosterwyck, Maria van 1630–1693, *A Vase of Flowers*, bequeathed by Major the Hon. Henry Rogers Broughton, Second Lord Fairhaven, 1973, received 1975

Orioli, Pietro di Francesco degli 1458–1496, *The Baptism of Christ*, bequeathed by Mrs Irene Mann, 1963

Orioli, Pietro di Francesco degli 1458–1496, *The Resurrection*, bequeathed by Mrs Irene Mann, 1963

Orley, Bernaert van (attributed to) c.1492–1541, *The Annunciation*, bequeathed by Richard, Seventh Viscount Fitzwilliam, 1816

Orpen, William 1878–1931, *The Right Honourable Sir Clifford Allbutt*, bequeathed by the Rt Hon. Professor Sir Thomas Clifford Allbutt, 1925

Orpen, William 1878–1931, *Self Portrait*, given by Sir William Newenham Montague Orpen, 1928

Os, Georgius Jacobus Johannes van 1782–1861, *A Vase of Flowers*, bequeathed by Major the Hon. Henry Rogers Broughton, Second Lord Fairhaven, 1973

Os, Jan van 1744–1808, *A Vase of Flowers*, bequeathed by Major the Hon. Henry Rogers Broughton, Second Lord Fairhaven, 1973

Os, Jan van 1744–1808, *Flowers and Fruit*, bequeathed by Major the Hon. Henry Rogers Broughton, Second Lord Fairhaven, 1973

Os, Jan van 1744–1808, *Fruit Piece*, bequeathed by Daniel Mesman, 1834

Os, Jan van 1744–1808, *Fruits and Flowers*, bequeathed by Major the Hon. Henry Rogers Broughton, Second Lord Fairhaven, 1973

Os, Jan van 1744–1808, *Still Life with Fruit, Flowers and Fish*, bequeathed by Major the Hon. Henry Rogers Broughton, Second Lord Fairhaven, 1973, received 1975

Os, Jan van 1744–1808, *Vase of Flowers and Fruit*, bequeathed by Charles Brinsley Marlay, 1912

Ostade, Adriaen van 1610–1685, *Fiddler at the Door of a House*, bequeathed by Richard, Seventh Viscount Fitzwilliam, 1816

Ostade, Adriaen van 1610–1685, *Peasants Smoking*, bequeathed by Augustus Arthur VanSittart, 1876

Oudry, Jean-Baptiste 1686–1755, *Huntsman with a Tufter on a Leash*, bought from the Abbott, L. D. Cunliffe, Gow, Leverton Harris, Marlay, Perceval, University Purchase and Zoë Hadwen Funds with contributions from the Regional Fund administered by the Victoria & Albert Museum on behalf of the Museums and Galleries Commission, the Pilgrims

Trust, the American Friends of Cambridge University and Miss Helen Smailes, 1988

Ouless, Walter William 1848–1933, *Professor Sir George Murray Humphrey*, given to the University by the Subscribers, and placed in the Fitzwilliam Museum, 1887

Palma, Jacopo il giovane 1544/1548–1628, *Christ Calling Zacchaeus*, bequeathed by Richard, Seventh Viscount Fitzwilliam, 1816

Palma, Jacopo il giovane 1544/1548–1628, *Elijah and the Angel*, bequeathed by Richard, Seventh Viscount Fitzwilliam, 1816

Palma, Jacopo il vecchio c.1479–1528, *Venus and Cupid*, bequeathed by Richard, Seventh Viscount Fitzwilliam, 1816

Palmer, Samuel 1805–1881, *View of Lee, North Devon*, bought from the Fairhaven Fund with contributions from the National Art Collections Fund and the National Lottery through the Heritage Lottery Fund, 2003

Panini, Giovanni Paolo c.1692–1765, *Ruins with Figures*, bequeathed by Richard, Seventh Viscount Fitzwilliam, 1816

Panini, Giovanni Paolo c.1692–1765, *Ruins with Figures*, bequeathed by Richard, Seventh Viscount Fitzwilliam, 1816

Panini, Giovanni Paolo c.1692–1765, *Capriccio of Roman Ruins with the Colosseum*, bequeathed by Dr D. M. McDonald, 1991, received 1992

Panini, Giovanni Paolo c.1692–1765, *Capriccio of Roman Ruins with the Pantheon*, bequeathed by Dr D. M. McDonald, 1991, received 1992

Panini, Giovanni Paolo c.1692–1765, *Marcus Curtius Leaping into the Gulf*, bequeathed by Richard, Seventh Viscount Fitzwilliam, 1816

Paolo Schiavo 1397–1478, *Tabernacle: The Virgin of Humility, with a Complete Cycle of Sin and Redemption (made for a flagellant company)* bought, 1893

Pasinelli, Lorenzo 1629–1700, *A Sibyl*, bequeathed by Daniel Mesman, 1834

Passeri, Giuseppe 1654–1714, *Vision of St Philip Neri*, bequeathed by Richard, Seventh Viscount Fitzwilliam, 1816

Patch, Thomas 1725–1782, *Interior of an Italian Coffee House*, bequeathed by Daniel Mesman, 1834

Patel, Pierre I c.1605–1676, *Landscape with Classical Ruins*, given by Augustus Arthur VanSittart, 1864

Pater, Jean-Baptiste 1695–1736, *Elegant Company in a Park*, bequeathed by Dr D. M. McDonald, 1991, received 1992

Pater, Jean-Baptiste 1695–1736, *The Fortune Teller*, bequeathed by Dr D. M. McDonald, 1991, received 1992

Pater, Jean-Baptiste 1695–1736,

The Swing, bought from the Perceval Fund with contributions from the National Art Collections Fund and the Victoria & Albert Museum Grant-in-Aid, 1977

Peeters, Bonaventura I 1614–1652, *River Scene*, bequeathed by Daniel Mesman, 1834

Peeters, Bonaventura I 1614–1652, *Sea Coast with a Storm*, bequeathed by Daniel Mesman, 1834

Peeters, Bonaventura I 1614–1652, *Sea Piece with Figures*, bequeathed by Daniel Mesman, 1834

Pellegrini, Giovanni Antonio (attributed to) 1675–1741, *St Catherine of Siena before Pope Gregory XI*, bequeathed by Warren Pollock, 1986, received 1992

Peploe, Samuel John 1871–1935, *Still Life*, given by Mr and Mrs Edward Owen Vulliamy, 1910, © courtesy of the artist's estate/ www.bridgeman.co.uk

Pérez, Bartolomé 1634–1693, *Flowers in a Sculpted Vase*, bequeathed by Sir Robert Hyde Greg, 1953, received 1954

Perryman, Margot b.1938, *Untitled*, bequeathed by Bryan Charles Francis Robertson, 2003

Perugino (studio of) c.1450–1523, *Virgin and Child*, given by Mrs J. C. Hare, 1855, received 1864

Petersen, Vilhelm 1812–1880, *View towards Hesbjerg from the Hornbaek Estate*, bequeathed by Miss Barbara Doreen Tallerman, 2002

Petter, Franz Xaver 1791–1866, *Jug of Flowers*, given by Major the Hon. Henry Rogers Broughton, 1966

Pettie, John 1839–1893, *Mrs Bossom, the Artist's Mother*, bequeathed by Charles Haslewood Shannon, 1937

Phillip, John 1817–1867, *Spanish Carnival*, given by Sir (Henry Francis) Herbert Thompson, Bt, 1920

Phillips, Thomas 1770–1845, *Hugh Percy, Third Duke of Northumberland*, given by George Crauford Heath, 1850

Philpot, Glyn Warren 1884–1937, *The Dog-Rose (La zarzarosa)*, bequeathed by Mrs Emile Mond, in memory of her sons Captain Francis Mond and Alfred William Mond, 1942, © the artist's estate

Philpot, Glyn Warren 1884–1937, *Siegfried Sassoon*, given by Siegfried Sassoon, 1924, © the artist's estate

Piazzetta, Giovanni Battista 1682–1754, *The Death of Darius*, given by the Rt Hon. F. Leverton Harris, 1923

Picart, Jean Michel 1600–1682, *A Vase of Flowers*, bequeathed by Major the Hon. Henry Rogers Broughton, Second Lord Fairhaven, 1973, received 1975

Picart, Jean Michel 1600–1682, *A Vase of Flowers*, bequeathed by Major the Hon. Henry Rogers Broughton, Second Lord Fairhaven, 1975

Picasso, Pablo 1881–1973, *Cubist Head (Portrait of Fernande)*, given by Dr Alastair Hunter, 1974, © succession Picasso/ DACS 2006

Picasso, Pablo 1881–1973, *Still Life: Green Apple and Glass*, lent by the Provost and Fellows of King's College, Cambridge (Keynes Collection), © succession Picasso/ DACS 2006

Picasso, Pablo 1881–1973, *Still Life: Bowl and Apples*, lent by the Provost and Fellows of King's College, Cambridge (Keynes Collection), © succession Picasso/ DACS 2006

Picolet, Cornelis 1626–1679, *Boy Drinking*, bequeathed by Daniel Mesman, 1834

Picot, François Eduard 1786–1868, *Adélaïde-Sophie Cléret, Mme Tiolier*, bought from the Gow Fund with a contribution from the Victoria & Albert Museum Grant-in-Aid, 1978

Picot, François Eduard 1786–1868, *Nicolas-Pierre Tiolier*, bought from the Gow Fund, with a contribution from the Victoria & Albert Museum Grant-in-Aid, 1978

Pietersz., Gertrude active c.1718, *Still Life of Flowers*, bequeathed by Richard, Seventh Viscount Fitzwilliam, 1816

Pietro di Niccolò da Orvieto 1430–1484, *Virgin and Child*, given by Francis Neilson through the National Art Collections Fund, 1935

Pignoni, Simone 1611–1698, *A Poet, Presented to Jupiter by Hercules is Crowned by Glory, below Venus, Cupid and the Poet*, bequeathed by Warren Pollock, 1986, received 1992

Pils, Isidore Alexandre Augustin 1813/1815–1875, *Study for the Head of a Young Arab*, given by John Lishawa, in memory of his wife, Kate, 1998

Pino, Paolo (attributed to) active 1534–1565, *Man in a Fur Coat*, bequeathed by Charles Brinsley Marlay, 1912

Pinturicchio, Bernardino c.1454–1513, *Virgin and Child with St John the Baptist*, given by Samuel Sandars, 1880

Pissarro, Camille 1830–1903, *Road to Port-Marly*, given by the Very Reverend Eric Milner-White, CBE, DSO, Dean of York, 1958

Pissarro, Camille 1830–1903, *Study for 'The Banks of the Marne'*, bought from the C. C. Mason Fund, 1964

Pissarro, Camille 1830–1903, *Haymaking*, bequeathed by Arnold John Hugh Smith, through the National Art Collections Fund, 1964

Pissarro, Camille 1830–1903, *Piette's House at Montfoucault: Snow Effect*, bequeathed by Captain Stanley William Sykes, OBE, MC, 1966

Pissarro, Camille 1830–1903, *In*

the Garden at Pontoise: A Young Woman Washing Dishes, bought from the Spencer George Perceval Fund with a contribution from the National Art Collections Fund, 1947

Pissarro, Camille 1830–1903, *Snowy Landscape at Eragny with an Apple Tree*, bequeathed by the Very Reverend Eric Milner-White, CBE, DSO, Dean of York, 1963

Pissarro, Lucien 1863–1944, *Le Ragas, near Toulon*, given by Mme Esther Pissarro, 1948, © the artist's estate

Pitati, Bonifazio de' 1487–1553, *The Trial of Moses*, bequeathed by Warren Pollock, 1986, received 1992

Pittoni, Giovanni Battista the younger 1687–1767, **Valeriani, Domenico** d.1771 **& Valeriani, Giuseppe** d.1761, *An Allegorical Monument to Sir Isaac Newton*, bought from the L. D. Cunliffe, Perceval and Jones Funds, with contributions from the Victoria & Albert Museum Grant, the National Art Collections Fund, Trinity and King's College Cambridge, the faculty of Physics, Cambridge University, and an anonymous benefaction, 1973

Poelenburgh, Cornelis van 1594/1595–1667, *Adoration of the Kings*, bequeathed by Richard, Seventh Viscount Fitzwilliam, 1816

Poelenburgh, Cornelis van 1594/1595–1667, *Jan Both*, bequeathed by Daniel Mesman, 1834

Poelenburgh, Cornelis van 1594/1595–1667, *Landscape with Abraham and Isaac*, bequeathed by Richard, Seventh Viscount Fitzwilliam, 1816

Poelenburgh, Cornelis van 1594/1595–1667, *Landscape with the Finding of Moses*, bequeathed by Daniel Mesman, 1834

Poelenburgh, Cornelis van (style of) 1594/1595–1667, *Landscape with Herdsman and Flocks*, bequeathed by Daniel Mesman, 1834

Polidoro da Lanciano c.1515–1565, *Holy Family with the Infant St John Baptist and St Catherine*, given by Mrs J. C. Hare, 1855

Polidoro da Lanciano c.1515–1565, *Virgin and Child with St Catherine, Mary Magdalene and St Barbara*, given by Mrs J. C. Hare, 1855

Pond, Arthur c.1705–1758, *Richard Snow*, given by the Friends of the Fitzwilliam Museum, 1935

Pond, Arthur (attributed to) c.1705–1758, *Thomas Gray*, given by Henry Hazard, 1858

Porter, Frederick James 1883–1944, *Tulips*, bequeathed by Frank Hindley Smith, 1939

Pot, Hendrik Gerritsz. c.1585–1657, *Portrait of a Man*, bequeathed by Daniel Mesman, 1834

Poussin, Nicolas 1594–1665,

Rebecca and Eliezer at the Well, bought from the Gow Fund and the University Purchase Fund with contributions from the National Art Collections Fund, the Pilgrims Trust, the Esmée Fairbairn Trust, the American Friends of Cambridge University, the Goldsmith's Company, the Grocer's Company, Ciba-Geigy Plastics and a number of private donations, encouraged by the Fitzwilliam Museum, 1984

Poussin, Nicolas (after) 1594–1665, *Rebecca and Eliezer at the Well*, bequeathed by Richard, Seventh Viscount Fitzwilliam, 1816

Procktor, Patrick 1936–2003, *Two Figures and a Head Hand*, anonymous gift, 2002

Prud'hon, Pierre-Paul (after) 1758–1823, *Study for 'Minerva Leading the Genius of the Arts into Immortality'*, bought from the L. D. Cunliffe Fund, with a contribution from the Victoria & Albert Museum, Grant-in-Aid, 1982

Pynacker, Adam c.1620–1673, *Italian Landscape with a Monastery*, bought from the Marlay Fund, 1958

Pynas, Jacob Symonsz. c.1590–c.1648, *Jupiter and Io*, given by the Friends of the Fitzwilliam Museum, 1977

Quizet, Alphonse 1885–1955, *The Boulevard Sérurier*, given by the Friends of the Fitzwilliam Museum, 1953, © ADAGP, Paris and DACS, London 2006

Raeburn, Henry 1756–1823, *William Glendonwyn*, bought, 1892

Ramenghi, Bartolomeo (attributed to) 1484–1542, *The Virgin and Child with St Catherine*, given by the Right Reverend Lord Alwyne Frederick Compton, Bishop of Ely, 1905

Ramsay, Allan 1713–1784, *James Haughton Langston*, given by Professor James Meade, 1979

Raphael, Sarah 1960–2001, *Desert Painting I*, given by Sarah Raphael, 1995, © estate of Sarah Raphael

Raphael, Sarah 1960–2001, *Desert Painting II*, given by Sarah Raphael, 1995, © estate of Sarah Raphael

Raverat, Gwendolen 1885–1957, *Mountain Scenery*, given by Sophie Gurney, 1994 © estate of Gwen Raverrat 2006. All rights reserved, DACS

Raverat, Gwendolen 1885–1957, *Punting*, given by Sophie Gurney, 1994, © estate of Gwen Raverat 2006. All rights reserved, DACS

Ravier, Auguste François 1814–1895, *Landscape at Sunset*, bequeathed by John Tillotson, 1984, received 1985

Redon, Odilon 1840–1916, *The Chariot of Apollo*, given by Captain Stanley William Sykes, OBE, MC, 1964

Reichelt, Augusta Wilhelmine 1840–1907, *Flowers under a Lion Mask Fountain*, given by Major the Hon. Henry Rogers Broughton,

1966

Reinagle, Philip 1749–1833, *Cupid Inspiring the Plants with Love*, bequeathed by Major the Hon. Henry Rogers Broughton, Second Lord Fairhaven, 1973, received 1974

Reinagle, Philip 1749–1833, *Lilium Superbum*, bequeathed by Major the Hon. Henry Rogers Broughton, Second Lord Fairhaven, 1973

Reinagle, Philip (attributed to) 1749–1833, *Landscape with Figures*, bequeathed by Daniel Mesman, 1834

Reinagle, Ramsay Richard 1775–1862, *Landscape near Tivoli, with Part of the Claudian Aqueduct*, bequeathed by Richard, Seventh Viscount Fitzwilliam, 1816

Rembrandt van Rijn (attributed to) 1606–1669, *Portrait of a Man in Military Costume*, given by Richard Seventh Viscount Fitzwilliam, 1816

Rémond, Jean Charles Joseph 1795–1875, *Italian Landscape with a View of a Harbour*, given by the Friends of the Fitzwilliam Museum, 1976

Reni, Guido 1575–1642, *Christ Appearing to the Virgin*, bequeathed by Richard, Seventh Viscount Fitzwilliam, 1816

Reni, Guido 1575–1642, *Joseph and Potiphar's Wife*, accepted in lieu of inheritance tax by HM Government from Holkham Hall and allocated through the Museums and Galleries Commission to the Fitzwilliam Museum to be kept in situ at Holkham Hall, 1993

Reni, Guido 1575–1642, *The Man of Sorrows*, given by Mrs Sigismund Goetze, 1943

Renoir, Pierre-Auguste 1841–1919, *Apples and Walnuts*, bequeathed by Arnold John Hugh Smith, through the National Art Collections Fund, 1964

Renoir, Pierre-Auguste 1841–1919, *The Gust of Wind*, bequeathed by Frank Hindley Smith, 1939

Renoir, Pierre-Auguste 1841–1919, *Place Clichy*, bought from the Abbott, L. D. Cunliffe, Robin Hambro Works of Art, Leverton Harris, Marlay, Perceval and University Purchase Funds and the Bartlett Bequest, with the aid of very generous grants from the National Heritage Memorial Fund, the National Art Collections Fund, the Esmée Fairbairn Charitable Trust, the Pilgrim Trust, the Seven Pillars of Wisdom Trust, the American Friends of Cambridge University, the Friends of the Fitzwilliam Museum and a number of Cambridge Colleges (Trinity, King's, Cains, St John's, Emmanuel, Peterhouse, Sidney Sussex, Clare, Corpus Christi and Churchill) together with contributions from numerous friends and individuals, 1986

Renoir, Pierre-Auguste 1841–1919, *Léon Goujon in Sailor-Suit*,

lent by the Provost and Fellows of King's College, Cambridge (Keynes Collection)

Renoir, Pierre-Auguste 1841–1919, *The Return from the Fields*, given by Captain Stanley William Sykes, OBE, MC, 1964

Renoir, Pierre-Auguste 1841–1919, *Dance*, bequeathed by Arnold John Hugh Smith, through the National Art Collections Fund, 1964

Renoir, Pierre-Auguste 1841–1919, *Music*, bequeathed by Arnold John Hugh Smith, through the National Art Collections Fund, 1964

Renoir, Pierre-Auguste 1841–1919, *Apples and Teacup*, bequeathed by Arnold John Hugh Smith, through the National Art Collections Fund, 1964

Renoir, Pierre-Auguste 1841–1919, *Landscape*, bequeathed by Keith Stuart Baynes, 1977

Renoir, Pierre-Auguste 1841–1919, *Study of Flowers*, bequeathed by Keith Stuart Baynes, 1977

Renoir, Pierre-Auguste 1841–1919, *Olive Trees, Cagnes*, lent by the Provost and Fellows of King's College, Cambridge (Keynes Collection)

Renoir, Pierre-Auguste 1841–1919, *Study of a Girl*, bequeathed by Frank Hindley Smith, 1939

Renoir, Pierre-Auguste 1841–1919, *Landscape with Figures*, given by Mme Barrere, 1999

Reynolds, Alan b.1926, *Dusk, the Outbuildings*, given by the Friends of the Fitzwilliam Museum, 1958, © the artist

Reynolds, Joshua 1723–1792, *Henry Vansittart*, bought from the Spencer George Perceval Fund, 1926

Reynolds, Joshua 1723–1792, *Mrs Angelo*, bought from the Spencer George Perceval Fund, 1936

Reynolds, Joshua 1723–1792, *Lord Rockingham and Edmund Burke*, given by Charles Fairfax Murray, 1908

Reynolds, Joshua 1723–1792, *The Braddyll Family*, given by the National Art Collections Fund, from the Ernest Edward Cook collection, 1955

Ribot, Augustin Théodule 1823–1891, *Jules Luquet*, bequeathed by Miss Amy Sarah Halford, 1964

Ribot, Augustin Théodule 1823–1891, *The Cooks*, given by Mrs Frederick Leverton Harris, 1928

Ricci, Sebastiano 1659–1734, *Bacchus and Ceres*, bequeathed by Daniel Mesman, 1834

Richards, Ceri Geraldus 1903–1971, *Pastorale*, given by Alice Zeitlyn in memory of her husband, Dr B. B. Zeitlyn, 2001, © estate of Ceri Richards 2006. All rights reserved, DACS

Richardson, Jonathan the younger 1694–1771, *Alexander Pope*, bequeathed by Daniel Mesman, 1834

Richardson, Jonathan the younger

(follower of) 1694–1771, *Henry, Lord Herbert, Later Tenth Earl of Pembroke*, bequeathed by Richard, Seventh Viscount Fitzwilliam, 1816

Richmond, George 1809–1896, *Self Portrait*, accepted by the Treasury in lieu of death duties, and distributed by the Standing Commission of Museums from the estate of the late Kerrison Preston, 1975

Richmond, George 1809–1896, *Mrs William Fothergill Robinson*, given by the Reverend W. Fothergill Robinson, 1927

Richmond, George 1809–1896, *Ploughing: Study for 'The Mantle of Elijah'*, accepted by HM Treasury from the estate of Sir Geoffrey Keynes and allocated to the Fitzwilliam Museum through the Minister of Arts, in lieu of capital taxes, 1985

Rigden, Geoff b.1943, *Riposte*, given by East England Arts, 2002

Riley, Bridget b.1931, *Shadow Play*, given by the Contemporary Art Society, 1996, © the artist

Rivers, Larry 1923–2002, *Camels*, bought from the L. D. Cunliffe Fund with Grant-in-Aid from the Victoria & Albert Museum, 1979, © Larry Rivers/ VAGA, New York/ DACS, London 2006

Robert, Hubert 1733–1808, *Wooded River Landscape with a Traveller, a Barking Dog, a Horseman, and Women Washing at an Islet*, bequeathed by Dr D. M. McDonald, 1991, received 1992

Roberts, David 1796–1864, *The Doge's Palace, Venice, from the Bacino di San Marco*, bequeathed by Dr D. M. McDonald, 1991, with a life-interest to his widow, relinquished 1996, received 1997

Roedig, Johannes Christianus 1751–1802, *Still Life with Fruit and Flowers*, given by Major the Hon. Henry Rogers Broughton, 1966

Roedig, Johannes Christianus 1751–1802, *Vase of Flowers*, given by Major the Hon. Henry Rogers Broughton, 1966

Roedig, Johannes Christianus 1751–1802, *Basket of Flowers with Fruit*, given by Major the Hon. Henry Rogers Broughton, 1966

Rogers, Claude 1907–1979, *Big Red Still Life*, given by Lady Proctor, in memory of her husband, Sir Denis Proctor, 1987

Rogers, Claude 1907–1979, *Clover Field, Somerton, Suffolk*, bought from the D. M. McQuaid Fund, 1960

Rogers, Claude 1907–1979, *Athens*, given by Keith Stuart Baynes, 1974

Romanelli, Giovanni Francesco 1610–1662, *St John and St Peter at the Empty Tomb of Christ*, given by the Friends of the Fitzwilliam Museum, with the aid of the Regional Fund administered by the Victoria & Albert Museum on behalf of the Museums and Galleries Commission, 1985

Romney, George 1734–1802, *Mrs Beal Bonnell*, bought from

the Perceval and L. D. Cunliffe Funds with contributions from the Victoria & Albert Museum/Museum and Galleries Commission Regional Fund and the Charlotte Bonham Carter Charitable Trust, 1992

Romney, George 1734–1802, *Possibly William Thomas Meyer*, given by Charles Fairfax Murray, 1908

Rosa, Salvator 1615–1673, *Human Frailty*, bought from the L. D. Cunliffe Fund, 1958

Rosselli, Cosimo 1439–1507, *Virgin and Child with St John the Baptist, St Andrew, St Bartholomew and St Zenobius*, bought, 1893

Rossetti, Dante Gabriel 1828–1882, *Girl at a Lattice*, given by Charles Fairfax Murray, 1911

Rossetti, Dante Gabriel 1828–1882, *Joan of Arc*, given by Charles Fairfax Murray, 1909

Rossi, Mariano (attributed to) 1731–1807, *The Dove of the Holy Ghost Surrounded by Cherubim*, bequeathed by Warren Pollock, 1986, received 1992

Rouault, Georges 1871–1958, *Landscape with St George and the Dragon*, given by Dr Alastair Hunter, 1974, © ADAGP, Paris and DACS, London 2006

Rousseau, Théodore 1812–1867, *Panoramic Landscape*, bought from the Anne Pertz and Charles Brinsley Marlay Funds, 1956

Rousseau, Théodore 1812–1867, *The Plain of Chailly*, bequeathed by John Tillotson, 1984, received 1985

Rousseau, Théodore 1812–1867, *The Marsh in the Souterraine*, bequeathed by John Tillotson, 1984, received 1985

Royen, Wilhelm Frederik van 1645–1723, *A Vase of Flowers*, bequeathed by Major the Hon. Henry Rogers Broughton, Second Lord Fairhaven, 1973

Rubens, Peter Paul 1577–1640, *Death of Hippolytus*, accepted by HM Treasury in lieu of estate duty and allocated to the Fitzwilliam Museum, 1979

Rubens, Peter Paul 1577–1640, *Teresa of Avila's Vision of the Dove*, accepted in lieu of inheritance tax by HM Government and allocated to the Fitzwilliam Museum, 1999

Rubens, Peter Paul 1577–1640, *Head Study of a Bearded Man*, bought from the Gow and Perceval Funds with contributions from the National Art Collections Fund and the Victoria & Albert Museum Grant-in-Aid, 1980

Rubens, Peter Paul 1577–1640, *The Discovery of Achilles among the Daughters of Lykomedes*, bequeathed by Arnold John Hugh Smith, through the National Art Collections Fund, 1964

Rubens, Peter Paul 1577–1640, *The Union of Earth and Water*, given by Charles Finch, before 1853

Rubens, Peter Paul 1577–1640, *Christ as Redeemer of the World*,

given by Dr M. Henry Roland, 1975

Rubens, Peter Paul 1577–1640, *The Four Evangelists (panel 1 of 7)*, bequeathed by the Reverend Richard Edward Kerrich, 1873

Rubens, Peter Paul 1577–1640, *The Victory of the Eucharist over Heresy (panel 2 of 7)*, bequeathed by the Reverend Richard Edward Kerrich, 1873

Rubens, Peter Paul 1577–1640, *The Triumph of Divine Love (panel 3 of 7)*, bequeathed by the Reverend Richard Edward Kerrich, 1873

Rubens, Peter Paul 1577–1640, *The Triumph of the Eucharist over Ignorance and Blindness (panel 4 of 7)*, bequeathed by the Reverend Richard Edward Kerrich, 1873

Rubens, Peter Paul 1577–1640, *The Defenders of the Eucharist (panel 5 of 7)*, bequeathed by the Reverend Richard Edward Kerrich, 1873

Rubens, Peter Paul 1577–1640, *The Triumph of the Eucharist over Philosophy and Science (panel 6 of 7)*, bequeathed by the Reverend Richard Edward Kerrich, 1873

Rubens, Peter Paul 1577–1640, *The Meeting of Abraham and Melchisedek (panel 7 of 7)*, bequeathed by the Reverend Richard Edward Kerrich, 1873

Rubens, Peter Paul 1577–1640, *Design for the Title Page of the Pompa Introitus … Ferdinandi*, bequeathed by the Reverend Richard Edward Kerrich, 1873

Ruisdael, Jacob van 1628/1629–1682, *Landscape with a Blasted Tree near a House*, given by Augustus Arthur VanSittart, 1864

Ruisdael, Jacob van 1628/1629–1682, *Landscape with River and Pines*, bequeathed by Richard, Seventh Viscount Fitzwilliam, 1816

Ruisdael, Jacob van 1628/1629–1682, *Landscape with Waterfall*, given by Augustus Arthur VanSittart, 1876

Ruisdael, Jacob van 1628/1629–1682, *View on the Amstel Looking towards Amsterdam*, given by Augustus Arthur VanSittart, 1864

Ruisdael, Jacob van (imitator of) 1628/1629–1682, *Landscape with a Brook and Farmhouse among Trees*, given by Augustus Arthur VanSittart, 1876

Russell, John 1745–1806, *Captain and Mrs Hardcastle*, bequeathed by Dr D. M. McDonald, 1991, with a life-interest to his widow, relinquished 1996, received 1997

Rustin, Jean b.1928, *Portrait of a Young Man*, given by the Rustin Foundation, through Edward Lucie-Smith, 1992, © ADAGP, Paris and DACS, London 2006

Ruysch, Anna Elisabeth d.1741, *Vase of Flowers*, given by Major the Hon. Henry Rogers Broughton, 1966

Ruysch, Rachel 1664–1750, *A Vase of Flowers*, bequeathed by Major the Hon. Henry Rogers Broughton,

Second Lord Fairhaven, 1973
Ruysch, Rachel 1664–1750, *A Vase of Flowers*, bequeathed by Major the Hon. Henry Rogers Broughton, Second Lord Fairhaven, 1973
Ruysch, Rachel 1664–1750, *A Spray of Flowers*, bequeathed by Major the Hon. Henry Rogers Broughton, Second Lord Fairhaven, 1973, received 1975
Ruysch, Rachel 1664–1750, *A Still Life with Flowers, Butterflies and a Lizard in a Dell*, bequeathed by Major the Hon. Henry Rogers Broughton, Second Lord Fairhaven, 1973
Ruysch, Rachel 1664–1750, *Still Life with Fruit and a Vase of Flowers*, bequeathed by Major the Hon. Henry Rogers Broughton, Second Lord Fairhaven, 1973
Ruysdael, Salomon van c.1602–1670, *Farm Buildings in a Landscape*, given by Mrs Laurence Humphrey, 1921
Ryckaert, Marten 1587–1631, *Landscape with Pan and Syrinx (after Paul Bril)*, given by Augustus Arthur VanSittart, 1876
Sacchi, Andrea 1599–1661, *The Baptism of Christ*, lent by Sir Denis Mahon
Saftleven, Cornelis 1607–1681, *Boy with Goats*, bequeathed by Daniel Mesman, 1834
Saftleven, Cornelis 1607–1681, *Interior of a Stable*, bequeathed by Richard, Seventh Viscount Fitzwilliam, 1816
Saftleven, Herman the younger 1609–1685, *View on the Rhine*, bequeathed by Daniel Mesman, 1834
Sagrestani, Giovanni Camillo 1660–1731, *The Virgin with St John*, bequeathed by Warren Pollock, 1986, received 1992
Salazar, Francisco b.1937, *Immaterial Space, No.783*, given by His Excellency, Signor Alfredo Toro-Hardy, the Venezuelan Ambassador to the Court of St James's, 2001
Salviati, Francesco (attributed to) 1510–1563, *Portraits of Five Artists: Giotto, Donatello, Michelangelo, Raphael and Brunelleschi*, given by the Trustees of Dr Ludwig Mond, 1926
Sánchez, Juan active c.1500 & **Sánchez, Diego** active late 15th C, *The Road to Calvary*, bought from the Marlay Fund, 1925
Sands, Ethel 1873–1962, *Still Life with a View over a Cemetery*, bequeathed by Henry Scipio Reitlinger, 1950, transferred from the Reitlinger Trust, 1991
Sandys, Frederick 1829–1904, *Mrs Sandys, the Artist's Mother*, given by Charles Fairfax Murray, 1917
Sandys, Frederick 1829–1904, *Mrs Sandys, the Artist's Mother*, given by Charles Fairfax Murray, 1917
Sandys, Frederick 1829–1904, *Portrait of a Young Man (copy after Rogier van der Weyden)*, given by Charles Fairfax Murray, 1917
Sandys, Frederick 1829–1904,

Emma Sandys, the Artist's Sister, given by Charles Fairfax Murray, 1911
Santvoort, Dirck Dircksz. 1610/1611–1680, *Portrait of a Man*, bequeathed by Guy John Fenton Knowles, 1959
Sargent, John Singer 1856–1925, *Dorothy Barnard*, bequeathed by Miss Dorothy Barnard, 1949
Sargent, John Singer 1856–1925, *Santa Maria della Salute, Venice*, given by Harold, First Viscount of Rothermere, 1926
Sargent, John Singer 1856–1925, *Near the Mount of Olives, Jerusalem*, given by Miss Sargent and Mrs Ormond, 1929
Sargent, John Singer 1856–1925, *Study of a Sicilian Peasant*, given by John Singer Sargent, 1914
Sargent, John Singer 1856–1925, *Olives in Corfu*, given by the Friends of the Fitzwilliam Museum, 1922
Sassoferrato 1609–1685, *The Holy Family*, bequeathed by Charles Brinsley Marlay, 1912
Savery, Roelandt 1576–1639, *The Creation of Birds*, bequeathed by Daniel Mesman, 1834
Savery, Roelandt 1576–1639, *Orpheus with Beasts and Birds*, bequeathed by Daniel Mesman, 1834
Savery, Roelandt 1576–1639, *Still Life with Flowers in a Glass Berkemeyer with a Lizard, Frog and Dragonfly on a Ledge*, accepted by HM Government, in lieu of inheritance tax, and allocated to the Fitzwilliam Museum, 2002
Say, Frederick Richard c.1827–1860, *Albert Francis Charles Augustus Emmanuel of Saxe-Coburg-Gotha, Prince Consort of England*, given by Prince Albert, 1849
Scarsellino 1551–1620, *Landscape with Abraham and Isaac*, bequeathed by Edward Fitzgerald, 1883
Scarsellino (school of) 1551–1620, *The Annunciation*, given by Mrs Sigismund Goetze, 1943
Schalcken, Godfried 1643–1706, *A Lady Holding a Plate*, bequeathed by Richard, Seventh Viscount Fitzwilliam, 1816
Schalcken, Godfried 1643–1706, *Self Portrait*, bequeathed by Richard, Seventh Viscount Fitzwilliam, 1816
Schedoni, Bartolomeo 1578–1615, *The Coronation of the Virgin*, lent by Sir Denis Mahon
Schoevaerdts, Mathys active 1682–1694, *Landscape with a Hunting Party*, bequeathed by Daniel Mesman, 1834
Schoevaerdts, Mathys active 1682–1694, *Landscape with a Pleasure Party*, bequeathed by Daniel Mesman, 1834
Schooten, Floris Gerritsz. van c.1585–after 1655, *Kitchen Utensils, Meat and Vegetables*, given by Professor C. Hague, 1820
Schrieck, Otto Marseus van

1619/1620–1678, *Flowers, Insects and Reptiles*, bequeathed by Daniel Mesman, 1834
Schrieck, Otto Marseus van 1619/1620–1678, *Still Life with Flowers*, bequeathed by Major the Hon. Henry Rogers Broughton, Second Lord Fairhaven, 1973, received 1975
Schrieck, Otto Marseus van (attributed to) 1619/1620–1678, *Silver Birch Trunk and Branch with Rose, Lizards, a Snake, Toadstools, Butterflies and a Snail*, bequeathed by Major the Hon. Henry Rogers Broughton, Second Lord Fairhaven, 1973, received 1975
Schwarz, Christoph c.1548–1592, *The Rape of Proserpine*, given by Harold, First Viscount of Rothermere, 1936
Scott, William George 1913–1989, *Full House*, bequeathed by Warren Pollock, 1986, received 1992
Scott, William George 1913–1989, *Message obscure II*, bequeathed by Warren Pollock, 1986, received 1992
Scott, William George 1913–1989, *Kippers on a Blue Plate*, bequeathed by Warren Pollock, 1986, received 1992
Scott, William George 1913–1989, *Pears and Grapes*, bequeathed by Warren Pollock, 1986, received 1992
Scully, Sean b.1945, *Painting 20/7/74, No.3/3*, bought from the Gulbenkian and University Purchase Funds, 1975
Sebastiano del Piombo c.1485–1547, *Adoration of the Shepherds*, bequeathed by Richard, Seventh Viscount Fitzwilliam, 1816
Sebastiano del Piombo c.1485–1547, *Madonna and Child*, bought with grants from the National Lottery through the Heritage Lottery Fund and the National Art Collections Fund with contributions from the Friends of the Fitzwilliam Museum, the Gow, Perceval and University Purchase Funds and the Perrins Bequest, 1997
Seghers, Daniel 1590–1661, *A Vase of Flowers*, bequeathed by Major the Hon. Henry Rogers Broughton, Second Lord Fairhaven, 1973, received 1975
Seghers, Daniel (attributed to) 1590–1661, *Festoon of Flowers*, bequeathed by Daniel Mesman, 1834
Seghers, Daniel (attributed to) 1590–1661, *Festoon of Flowers*, bequeathed by Daniel Mesman, 1834
Seghers, Gerard (attributed to) 1591–1651, *Faith, Hope and Charity*, bequeathed by Samuel Sandars, 1923
Sellaio, Jacopo del c.1441–1493, *Virgin Adoring the Child*, bequeathed by Charles Haslewood Shannon, 1937
Sellaio, Jacopo del c.1441–1493, *The Story of Cupid and Psyche*, bequeathed by Charles Brinsley

Marlay, 1912
Serres, Dominic 1722–1793, *British Men-of-War at Anchor in Blackwell Reach*, bequeathed by Dr D. M. McDonald, 1991, received 1992
Seurat, Georges 1859–1891, *The Rue St Vincent, Paris in Spring*, given by Captain Stanley William Sykes, OBE, MC, 1948
Seurat, Georges 1859–1891, *Study for 'A Sunday on the Island of La Grand Jatte': Couple Walking*, lent by the Provost and Fellows of King's College, Cambridge (Keynes Collection)
Seymour, James 1702–1752, *Horse and Groom*, bequeathed by Daniel Mesman, 1834
Shannon, Charles Haslewood 1863–1937, *Self Portrait*, bequeathed by Charles Haslewood Shannon, 1937
Shannon, Charles Haslewood 1863–1937, *Jacopo Nazzaro (copy of Titian)*, given by Charles W. Stewart, 1991
Shayer, William 1788–1879, *The Prawn Fishers*, bequeathed by Samuel Sandars, 1894 with a life-interest to his widow, received 1923
Sickert, Walter Richard 1860–1942, *The Old Bedford Music Hall*, bequeathed by Edward Maurice Berkeley Ingram, CMG, OBE, 1941, © estate of Walter R. Sickert 2006. All rights reserved, DACS
Sickert, Walter Richard 1860–1942, *The Lion of St Mark*, bequeathed by Guy John Fenton Knowles, 1959, © estate of Walter R. Sickert 2006. All rights reserved, DACS
Sickert, Walter Richard 1860–1942, *Church of St Jacques, Dieppe*, bequeathed by the Very Reverend Eric Milner-White, CBE, DSO, Dean of York, 1963, received 1970, © estate of Walter R. Sickert 2006. All rights reserved, DACS
Sickert, Walter Richard 1860–1942, *St Mark's, Venice*, bequeathed by Dr Alastair Hunter, 1983, received 1984, © estate of Walter R. Sickert 2006. All rights reserved, DACS
Sickert, Walter Richard 1860–1942, *Mrs Swinton*, bequeathed by James William Freshfield, 1955, © estate of Walter R. Sickert 2006. All rights reserved, DACS
Sickert, Walter Richard 1860–1942, *The Montmartre Theatre*, lent by the Provost and Fellows of King's College, Cambridge (Keynes Collection), © estate of Walter R. Sickert 2006. All rights reserved, DACS
Sickert, Walter Richard 1860–1942, *Girl at a Looking Glass, Little Rachel*, given by Keith Stuart Baynes, 1974, © estate of Walter R. Sickert 2006. All rights reserved, DACS
Sickert, Walter Richard 1860–1942, *Mornington Crescent Nude*, given by Mrs Maurice Hill, 1990, © estate of Walter R. Sickert 2006. All rights reserved, DACS

Sickert, Walter Richard 1860–1942, *The Glance*, given by J. Howard Bliss, 1945, © estate of Walter R. Sickert 2006. All rights reserved, DACS
Sickert, Walter Richard 1860–1942, *Woman with Ringlets*, bequeathed by Frank Hindley Smith, 1939, © estate of Walter R. Sickert 2006. All rights reserved, DACS
Sickert, Walter Richard 1860–1942, *Rushford Mill*, bought from the Fairhaven Fund, 1953, © estate of Walter R. Sickert 2006. All rights reserved, DACS
Sickert, Walter Richard 1860–1942, *The Trapeze*, bequeathed by Frank Hindley Smith, 1939, © estate of Walter R. Sickert 2006. All rights reserved, DACS
Sickert, Walter Richard 1860–1942, *The Bar Parlour*, lent by the Provost and Fellows of King's College, Cambridge (Keynes Collection), © estate of Walter R. Sickert 2006. All rights reserved, DACS
Sickert, Walter Richard 1860–1942, *Chez Vernet*, given by Keith Stuart Baynes, 1974, © estate of Walter R. Sickert 2006. All rights reserved, DACS
Sickert, Walter Richard 1860–1942, *Lainey's Garden (The Garden of Love)*, given by J. Howard Bliss, 1945, © estate of Walter R. Sickert 2006. All rights reserved, DACS
Sickert, Walter Richard 1860–1942, *Sir Hugh Walpole*, bequeathed by Hugh Walpole, 1941, received 1943, © estate of Walter R. Sickert 2006. All rights reserved, DACS
Signac, Paul 1863–1935, *The Entry to the Port, Portrieux*, given by the Very Reverend Eric Milner-White, CBE, DSO, Dean of York, 1959
Sims, Charles 1873–1928, *The Little Faun*, given by Mrs Sigismund Goetze, 1943
Sims, Charles 1873–1928, *Study of a Dead Rail*, given by the Friends of the Fitzwilliam Museum, 1928
Sisley, Alfred 1839–1899, *A Street, Possibly in Port-Marly*, bequeathed by Frank Hindley Smith, 1939
Sisley, Alfred 1839–1899, *The Flood at Port-Marly*, given by Captain Stanley William Sykes, OBE, MC, 1958
Sleigh, Bernard 1872–1954, *Aslaug*, bequeathed by M. A. B. Bulkley, 1996
Smibert, John (attributed to) 1688–1751, *Unknown Man*, given by Charles Fairfax Murray, 1908
Smith, Jack b.1928, *Four Movements 'Relief'*, bequeathed by Warren Pollock, 1986, received 1992, © the artist
Smith, Jack b.1928, *Above and Below*, bequeathed by Warren Pollock, 1986, received 1992, © the artist
Smith, Jack b.1928, *Abstract Painting*, bequeathed by Bryan Charles Francis Robertson, 2003, © the artist

Smith, Matthew Arnold Bracy 1879–1959, *Still Life with Pomegranates and Pears*, bequeathed by Claude William Guillebaud, with a life-interest to his widow, who relinquished it in 1971, © the artist's estate

Smith, Matthew Arnold Bracy 1879–1959, *Landscape at Aix-en-Provence*, bequeathed by Edward Maurice Berkeley Ingram, CMG, OBE, 1941, © the artist's estate

Smith, Ralph Maynard 1892–1962, *Circles and Moon*, given by the Friends of the Fitzwilliam Museum, 2003

Snyders, Frans 1579–1657, *The Larder*, bequeathed by Richard, Seventh Viscount Fitzwilliam, 1816

Snyders, Frans (studio of) 1579–1657, *The Fowl Market*, given by C. Maud, 1856

Snyers, Peeter 1681–1752, *A Dead Hare*, given by Mrs M. Joan Wyburn-Mason, in memory of her husband, Professor R. Wyburn-Mason, 1983

Soest, Gerard c.1600–1681, *Unknown Man*, given by Claude Dickason Rotch, 1939

Sole, Giovan Gioseffo dal 1654–1719, *Salome with the Head of St John the Baptist*, bequeathed by Richard, Seventh Viscount Fitzwilliam, 1816

Solimena, Francesco 1657–1747, *The Virgin and Child, with a Boy Presented by His Guardian Angel, and San Francesco di Paola*, bought from the L. D. Cunliffe Fund, 1962

Solimena, Francesco (attributed to) 1657–1747, *The Rest on the Flight into Egypt*, lent by Sir Denis Mahon

Solimena, Francesco (studio of) 1657–1747, *Virgin and Child*, bequeathed by Daniel Mesman, 1834

Somer, Paulus van I 1576–1621, *Elizabeth, Countess of Kent*, given by Claude Dickason Rotch, 1942

Somer, Paulus van I 1576–1621, *Catherine Vaux, Lady Abergavenny*, bequeathed by Richard, Seventh Viscount Fitzwilliam, 1816

Son, Joris van 1623–1667, *Still Life with a Lobster*, bequeathed by Charles Brinsley Marlay, 1912

Sonnabend, Yolanda b.1935, *Gaby*, given by Yolanda Sonnabend, 1999, © the artist

Sørensen, Carl Frederik 1818–1879, *Rough Sea beside a Jetty*, bought from the Bartlett Fund, 1994

Sorgh, Hendrik Martensz. 1609/1611–1670, *A Kitchen*, bequeathed by Daniel Mesman, 1834

Sorgh, Hendrik Martensz. 1609/1611–1670, *Peasant in an Outhouse*, bequeathed by Daniel Mesman, 1834

Soulages, Pierre b.1919, *Untitled*, bequeathed by Dr Alastair Hunter, 1983, received 1984, © ADAGP, Paris and DACS, London 2006

Spaendonck, Cornelis van 1756–1840, *Open wicker basket of mixed flowers, including iris, roses, poppies, hollyhock, marigold, larkspur and convolvulus on a marble ledge with an open pomegranate and a goldfinch with its nest*, bequeathed by Major the Hon. Henry Rogers Broughton, Second Lord Fairhaven, 1973

Spaendonck, Cornelis van 1756–1840, *Open wicker basket of mixed flowers, including tulip, roses, harebell, hollyhock, poppy, larkspur and auricula on a marble ledge*, bequeathed by Major the Hon. Henry Rogers Broughton, Second Lord Fairhaven, 1973

Spaendonck, Cornelis van 1756–1840, *A Basket of Flowers*, bequeathed by Major the Hon. Henry Rogers Broughton, Second Lord Fairhaven, 1973, received 1975

Spaendonck, Cornelis van 1756–1840, *Vase of Flowers*, given by Major the Hon. Henry Rogers Broughton, 1966

Spaendonck, Gerard van 1746–1822, *A Vase of Flowers*, bequeathed by Major the Hon. Henry Rogers Broughton, Second Lord Fairhaven, 1973

Speeckaert, Michel Joseph 1748–1838, *A Glass of Flowers*, bequeathed by Major the Hon. Henry Rogers Broughton, Second Lord Fairhaven, 1973, received 1974

Spencer, Gilbert 1893–1979, *Dorset Downs*, given by Florence Image, the artist's sister, 1956, © courtesy of the artist's estate/ www.bridgeman.co.uk

Spencer, Stanley 1891–1959, *Study for 'The Centurian's Servant'*, bought from the L. D. Cunliffe Fund with a contribution from the National Art Collections Fund, 2003, © estate of Stanley Spencer 2006. All rights reserved, DACS

Spencer, Stanley 1891–1959, *Sarajevo, Bosnia*, given by Mrs Frederick Leverton Harris, 1928, © estate of Stanley Spencer 2006. All rights reserved, DACS

Spencer, Stanley 1891–1959, *Cottages at Burghclere*, given by the Friends of the Fitzwilliam Museum, 1930, © estate of Stanley Spencer 2006. All rights reserved, DACS

Spencer, Stanley 1891–1959, *Love among the Nations*, bequeathed by Wilfrid Ariel Evill, 1963, © estate of Stanley Spencer 2006. All rights reserved, DACS

Spencer, Stanley 1891–1959, *Self Portrait with Patricia Preece*, bequeathed by Wilfrid Ariel Evill, 1963, © estate of Stanley Spencer 2006. All rights reserved, DACS

Spencer, Stanley 1891–1959, *Landscape in North Wales*, bequeathed by Edward Maurice Berkeley Ingram, CMG, OBE, 1941, © estate of Stanley Spencer 2006. All rights reserved, DACS

Spencer, Stanley 1891–1959, *Self Portrait*, given by the Friends of the Fitzwilliam Museum, 1942, © estate of Stanley Spencer 2006. All rights reserved, DACS

Spencer, Stanley 1891–1959, *Love on the Moor*, bequeathed by Wilfrid Ariel Evill, 1963, © estate of Stanley Spencer 2006. All rights reserved, DACS

Spinello Aretino 1350/1352–1410, *Annunciation*, bought from Charles Butler, 1893

Stanfield, Clarkson 1793–1867, *Coast Scene near Genoa*, given by Mrs Richard Ellison, 1862

Stannard, Joseph 1797–1830, *Boats on the Yare near Bramerton, Norfolk*, bought from the Fairhaven Fund, 1948

Stark, James 1794–1859, *Near Norwich*, bought from the Fairhaven Fund, 1954

Steele, Jeffrey b.1931, *Sg III 103*, bought from the Bartlett Fund, 1994

Steen, Jan 1626–1679, *Village Festival*, bequeathed by Richard, Seventh Viscount Fitzwilliam, 1816

Steen, Jan 1626–1679, *Interior with Figures*, bequeathed by Richard, Seventh Viscount Fitzwilliam, 1816

Steen, Jan 1626–1679, *Interior with a Painter and His Family*, bequeathed by Richard, Seventh Viscount Fitzwilliam, 1816

Steenwijck, Hendrick van the younger c.1580–1649, *The Liberation of St Peter*, bequeathed by the Reverend Richard Edward Kerrich, 1873

Steenwijck, Hendrick van the younger c.1580–1649, *The Liberation of St Peter*, bequeathed by Daniel Mesman, 1834

Steer, Philip Wilson 1860–1942, *Surf*, bequeathed by Frank Hindley Smith, 1939, © Tate, London 2006

Steer, Philip Wilson 1860–1942, *The Blue Dress*, bequeathed by Mrs G. John Scaramanga, 1975, © Tate, London 2006

Steer, Philip Wilson 1860–1942, *The Thames from Richmond Hill*, bequeathed by Frank Hindley Smith, 1939, © Tate, London 2006

Steer, Philip Wilson 1860–1942, *Walberswick, Children Paddling*, given by Lady Daniel, in memory of her husband, Sir Augustus Moore Daniel (1866–1950), 1951, © Tate, London 2006

Steer, Philip Wilson 1860–1942, *Children Playing, Ludlow Walks*, bequeathed by Mrs G. John Scaramanga, 1975, © Tate, London 2006

Steer, Philip Wilson 1860–1942, *Hydrangeas*, bequeathed by Mrs G. John Scaramanga, 1975, © Tate, London 2006

Steer, Philip Wilson 1860–1942, *Richmond, Yorkshire*, bequeathed by Edward Maurice Berkeley Ingram, CMG, OBE, 1941, © Tate, London 2006

Steer, Philip Wilson 1860–1942, *Montreuil from the Ramparts*, bequeathed by Edward Maurice Berkeley Ingram, CMG, OBE, 1941, received 1946, © Tate, London 2006

Steer, Philip Wilson 1860–1942, *Summer Evening*, bequeathed by Henry Blackwell Harris, 1929, © Tate, London 2006

Steer, Philip Wilson 1860–1942, *Self Portrait*, given by Philip Wilson Steer, 1920, © Tate, London 2006

Stella, Jacques 1596–1657, *The Martyrdom of St Stephen*, given by the Friends of the Fitzwilliam Museum, with contributions from the L. D. Cunliffe Fund and the MGC/ Victoria & Albert Purchase Grant Fund, 1995

Stephenson, Ian 1934–2000, *Reddi Painting*, given by Sir Alan Bowness, 2000

Stevens, Alfred 1817–1875, *The Ascension of Christ*, bequeathed by Charles Haslewood Shannon, 1937

Stevens, Alfred 1817–1875, *The Return of Odysseus to His Hearth*, given by the Friends of the Fitzwilliam Museum, 1912

Stevens, Alfred 1817–1875, *Leonard W. Collmann*, bequeathed by Charles Haslewood Shannon, 1937

Stevens, Alfred Emile Léopold Joseph Victor 1823–1906, *The Reader*, bought from the Spencer George Perceval Fund, 1930

Stöcklin, Christian (attributed to) 1741–1795, *Interior of a Church*, bequeathed by Daniel Mesman, 1834

Stone, Henry (attributed to) 1616–1653, *Unknown Man*, bequeathed by Leonard Daneham Cunliffe, 1937

Storck, Abraham 1644–1708, *A Marine Sham Fight on the Y before Amsterdam*, bequeathed by Professor Frederick Fuller, 1909, received 1923

Storck, Abraham 1644–1708, *Sea Piece with a Dutch Man-of-War*, bequeathed by Richard, Seventh Viscount Fitzwilliam, 1816

Storck, Abraham 1644–1708, *The Four Days' Battle, 1–4 June 1666*, given by the Reverend Thomas Halford, 1855

Stralen, Antoni van c.1594–1641, *Winter Scene*, given by Sir Charles Sherrington OM, FRS, and his son, C. E. R. Sherrington, 1943

Strang, William 1859–1921, *Self Portrait*, given by William Strang, 1919

Stuart, Gilbert 1755–1828, *Unknown Man*, given by Mrs George Frederic Watts, 1916

Stuart, Gilbert (copy after) 1755–1828, *George Washington*, given by Mrs T. T. Greg, 1925

Stubbs, George 1724–1806, *Joseph Smyth Esquire, Lieutenant of Whittlebury Forest, Northamptonshire, on a Dapple Grey Horse*, bequeathed by Dr D. M. McDonald, 1991, received 1992

Stubbs, George 1724–1806, *Gimcrack with John Pratt up on Newmarket Heath*, bought from the Abbott, Fairhaven, Gow, Jones, Perceval, Webb and University Purchase Funds after a public appeal through the Friends of the Fitzwilliam with subscriptions led by their Majesties the Queen and Queen Elizabeth, the Queen Mother and contributions from the National Heritage Memorial Fund, the Victoria & Albert Museums Grant-in-Aid, the National Art Collections Fund, the Pilgrims Trust and the British Sporting Art Trust, 1982

Stubbs, George 1724–1806, *Isabella Salstonstall as Una in Spenser's 'Faerie Queene'*, bought from the Paintings and Duplicates, the Perceval and the L. D. Cunliffe Funds, 1971

Subleyras, Pierre Hubert 1699–1749, *The Holy Family with Saints Elisabeth and Zaccharias and the Infant Saint John*, lent by Sir Denis Mahon

Susenier, Abraham (attributed to) c.1620–1668, *A Storm at Sea*, given by Mrs M. Joan Wyburn-Mason, in memory of her husband Professor R. Wyburn-Mason, 1983

Sutherland, Graham Vivian 1903–1980, *The Deposition*, bequeathed by Wilfrid Ariel Evill, 1963, © estate of Graham Sutherland

Sutherland, Graham Vivian 1903–1980, *Tree, Red Ground*, given by Mrs Charles Cunningham-Reid, in memory of her husband Sir Robert Adeane, Patron of the Friends of the Fitzwilliam Museum (1975–1979), 1984, © estate of Graham Sutherland

Swanevelt, Herman van c.1600–1665, *The Campo Vaccino, Rome*, bequeathed by Richard, Seventh Viscount Fitzwilliam, 1816

Swanevelt, Herman van c.1600–1665, *Landscape with Joseph and His Brethren*, bequeathed by Richard, Seventh Viscount Fitzwilliam, 1816

Swanevelt, Herman van c.1600–1665, *Landscape with the Sale of Joseph*, bequeathed by Richard, Seventh Viscount Fitzwilliam, 1816

Sweerts, Michael 1618–1664, *An Old Woman Spinning*, bought from the Gow Fund with contributions from the National Art Collections Fund and the Museum and Galleries Commission/Victoria & Albert Purchase Grant Fund, 1994

Taylor, Edward Ingram 1855–1923, *Lambert Castle*, bequeathed by Geoffrey Taylor, 1975, received 1985

Tempel, Abraham Lambertsz. van den 1622/1623–1672, *Portrait of a Man*, bought from the Spencer Perceval Fund, 1952

Teniers, David II 1610–1690, *Interior, with an Old Woman Peeling Apples*, bequeathed by Richard, Seventh Viscount Fitzwilliam, 1816

Teniers, David II (copy after) 1610–1690, *The Temptation of St Anthony*, bequeathed by Richard, Seventh Viscount Fitzwilliam, 1816

Thielen, Jan Philip van (attributed to) 1618–1667, *Flowers with a Sculptured Vase*, bequeathed by Major the Hon. Henry

Rogers Broughton, Second Lord Fairhaven, 1973, received 1975

Thielen, Jan Philip van (attributed to) 1618–1667, *A Vase of Flowers*, bequeathed by Major the Hon. Henry Rogers Broughton, Second Lord Fairhaven, 1973, received 1975

Thielen, Jan Philip van (attributed to) 1618–1667, *A Vase of Flowers*, bequeathed by Major the Hon. Henry Rogers Broughton, Second Lord Fairhaven, 1973, received 1975

Thielen, Jan Philip van (attributed to) 1618–1667, *A Vase of Flowers*, bequeathed by Major the Hon. Henry Rogers Broughton, Second Lord Fairhaven, 1973, received 1975

Tillemans, Peter 1684–1734, *View of a Town*, bequeathed by Richard, Seventh Viscount Fitzwilliam, 1816

Tintoretto, Jacopo 1519–1594, *The Adoration of the Shepherds*, bought from a fund given by Miss S. R. Courtauld, 1932

Tintoretto, Jacopo (studio of) 1519–1594, *Young Man in a Fur Cloak*, bequeathed by Charles Brinsley Marlay, 1912

Titian c.1488–1576, *Venus and Cupid with a Lute Player*, bequeathed by Richard, Seventh Viscount Fitzwilliam, 1816

Titian c.1488–1576, *Tarquin and Lucretia*, given by Charles Fairfax Murray, 1918

Titian (after) c.1488–1576, *Sleeping Venus*, bequeathed by Richard, Seventh Viscount Fitzwilliam, 1816

Titian (copy after) c.1488–1576, *Death of St Peter Martyr*, given by J. W. Clark, 1891

Tommaso active late 15th C–early 16th C, *Martyrdom of St Sebastian*, given by David Forbes, 1885

Torbido, Francesco c.1482–c.1562, *Portrait of a Man*, bequeathed by Professor Frederick Fuller, 1909, received 1923

Tott, Sophie de (copy after) active 1801–1804, *Charles X of France*, given by William Key, before 1833

Toulouse-Lautrec, Henri de 1864–1901, *Study of a Female Nude*, given by the Friends of the Fitzwilliam Museum, 2005

Tovey, Samuel Griffiths 1808–1873, *William Beard*, bequeathed by Spencer George Perceval, 1922

Towne, Charles 1739–1816, *Hilly Landscape*, given by Captain Stanley William Sykes, OBE, MC, 1932

Trevisani, Francesco 1656–1746, *Study for 'The Massacre of the Innocents'*, bought from the Gow Fund, supported by the National Lottery through the Heritage Lottery Fund, 1996

Trevisani, Francesco (attributed to) 1656–1746, *The Agony in the Garden*, bequeathed by Richard, Seventh Viscount Fitzwilliam, 1816

Tristán de Escamilla, Luis 1585–1624, *The Adoration of the Shepherds*, bequeathed by Charles

Brinsley Marlay, 1912

Troy, Jean François de 1679–1752, *Duck Shooting in a Wood*, bequeathed by Arnold John Hugh Smith, through the National Art Collections Fund, 1964

Troyon, Constant 1810–1865, *Shepherd and His Flock*, bequeathed by John Tillotson, 1984, received 1985

Troyon, Constant 1810–1865, *Four Sketches of Cows*, bequeathed by John Tillotson, 1984, received 1985

Tucker, James Justus 1795/1796–1842, *The Angel Proclaiming the End of Time*, bequeathed by the Reverend James Justus Tucker, 1842

Tunnard, John 1900–1971, *Untitled*, given by the family and friends of Sarah Adeane, in her memory, through the National Art Collections Fund, 1991

Tura, Cosmè c.1430–1495, *The Crucifixion*, given by the Friends of the Fitzwilliam Museum, 1947

Turchi, Alessandro 1578–1649, *The Adoration of the Shepherds*, given by the National Art Collections Fund (the Vera and Aileen Woodroffe Bequest), 1986

Turner, Joseph Mallord William 1775–1851, *Welsh Mountain Landscape*, bought from the Marlay Fund, 1925

Turner, Joseph Mallord William 1775–1851, *A Beech Wood with Gypsies round a Campfire*, bought from the Fairhaven Fund with contributions from the Victoria & Albert Museum Grant-in-Aid, the Chase Charity, the Leche Trust, the Pilgrim Trust and the National Heritage Memorial Fund, 1981

Turner, Joseph Mallord William 1775–1851, *A Beech Wood with Gypsies Seated in the Distance*, bought from the Fairhaven Fund, with contributions from the Victoria & Albert Museum Grant-in-Aid, the Chase Charity, the Leche Trust, the Pilgrim Trust and the National Heritage Memorial Fund, 1981

Uden, Lucas van 1595–1672, *The Escorial from a Foothill of the Guadarrama Mountains (after Peter Paul Rubens)*, bequeathed by the Reverend Richard Edward Kerrich, 1872

unknown artist late 17th C, *The Annunciation*, bequeathed by Mrs M. M. Hasluck, 1949

unknown artist late 17th C, *The Elevation of the Cross with St George and St Demetrius*, bequeathed by Mrs M. M. Hasluck, 1949

unknown artist 18th C, *St Anastasius*, bequeathed by Mrs M. M. Hasluck, 1949

unknown artist late 18th C, *The Altmaria*, bequeathed by Mrs M. M. Hasluck, 1949

unknown artist *Deisis*, bequeathed by Mrs M. M. Hasluck, 1949

unknown artist *Head of a Virgin*, bequeathed by Mrs M. M. Hasluck, 1949

unknown artist *Head of Christ*, bequeathed by Mrs M. M. Hasluck, 1949

unknown artist *The Baptism in Jordan*, bequeathed by Mrs M. M. Hasluck, 1949

unknown artist *The Entry into Jerusalem*, bequeathed by Mrs M. M. Hasluck, 1949

unknown artist *The Forty Martyrs of Taki Sebaste*, bequeathed by Charles Haslewood Shannon, 1937

unknown artist *Virgin and Child with St George*, bequeathed by Mrs M. M. Hasluck, 1949

Vallayer-Coster, Anne 1744–1818, *A Vase of Flowers*, bequeathed by Major the Hon. Henry Rogers Broughton, Second Lord Fairhaven, 1973, received 1975

Van Utrecht, Jacob Claesz. (attributed to) c.1480–1530, *Marriage of the Virgin (polyptych)*, bequeathed by Charles Brinsley Marlay, 1912

Van Utrecht, Jacob Claesz. (attributed to) c.1480–1530, *The Annunciation (polyptych)*, bequeathed by Charles Brinsley Marlay, 1912

Van Utrecht, Jacob Claesz. (attributed to) c.1480–1530, *Adoration of the Child (polyptych)*, bequeathed by Charles Brinsley Marlay, 1912

Van Utrecht, Jacob Claesz. (attributed to) c.1480–1530, *Adoration of the Kings (polyptych)*, bequeathed by Charles Brinsley Marlay, 1912

Vanni, Andrea c.1332–c.1414, *Virgin and Child*, bought, 1893

Vasarely, Victor 1908–1997, *Kontosh*, bequeathed by Diana A. M. Hunter, 1984, received 1985, © ADAGP, Paris and DACS, London 2006

Vaughan, John Keith 1912–1977, *Road through a Village*, given by the Lord Croft, 1979, © the estate of Keith Vaughan 2006. All rights reserved, DACS

Vaughan, John Keith 1912–1977, *Standing Figure*, bought from the D. M. McQuaid Fund, 1960, © the estate of Keith Vaughan 2006. All rights reserved, DACS

Vaughan, John Keith 1912–1977, *Cattle Shed*, bequeathed by Diana A. M. Hunter, 1984, received 1985, © the estate of Keith Vaughan 2006. All rights reserved, DACS

Veen, Otto van 1556–1629, *On the Disposal of Wealth: Illustration to Horace, Carmina III, xxiv, 40–45*, given by the Friends of the Fitzwilliam Museum, 1980

Velde, Adriaen van de 1636–1672, *Landscape with Cattle and Figures*, given by Augustus Arthur VanSittart, 1864

Velde, Esaias van de I 1587–1630, *Winter Landscape*, bequeathed by Charles Brinsley Marlay, 1912

Velde, Jan van de II c.1593–1641, *Landscape*, bequeathed by Daniel Mesman, 1834

Velde, Willem van de II (school of) 1633–1707, *Dutch Men O'War*

and Other Shipping in Choppy Seas, bequeathed by Mrs Margaret Hawkins in memory of her husband, George, 1993

Velde, Willem van de II (school of) 1633–1707, *Storm at Sea*, bequeathed by Richard, Seventh Viscount Fitzwilliam, 1816

Vellacott, Elisabeth 1905–2002, *Garden Painting*, bequeathed by Bryan Charles Francis Robertson, 2003

Venne, Adriaen van de 1589–1662, *Christ and the Woman of Samaria at the Well*, bequeathed by Henry Scipio Reitlinger, 1950, transferred from the Reitlinger Trust, 1991

Verbeeck, Pieter Cornelisz. c.1610–1654, *Horse Drinking*, given by Augustus Arthur VanSittart, 1864

Verbeeck, Pieter Cornelisz. (attributed to) c.1610–1654, *Sea Piece with Shipping*, bequeathed by Daniel Mesman, 1834

Verbruggen, Gaspar Peeter de II 1664–1730, *A Vase of Flowers with Fruit in a Landscape*, bequeathed by Major the Hon. Henry Rogers Broughton, Second Lord Fairhaven, 1973

Verelst, Cornelis 1667–1734, *A Vase of Flowers*, given by Major the Hon. Henry Rogers Broughton, 1966

Verelst, Simon Pietersz. 1644–probably 1721, *A Vase of Flowers*, bequeathed by Major the Hon. Henry Rogers Broughton, Second Lord Fairhaven, 1973, received 1975

Verelst, Simon Pietersz. 1644–probably 1721, *A Vase of Flowers*, given by Major the Hon. Henry Rogers Broughton, 1966

Verelst, Simon Pietersz. 1644–probably 1721, *A Vase of Flowers*, bequeathed by Major the Hon. Henry Rogers Broughton, Second Lord Fairhaven, 1973

Verelst, Simon Pietersz. 1644–probably 1721, *A Vase of Flowers*, bequeathed by Major the Hon. Henry Rogers Broughton, Second Lord Fairhaven, 1973, received 1975

Verelst, Simon Pietersz. 1644–probably 1721, *Glass Vase of Mixed Flowers on a Marble Ledge*, bequeathed by Richard, Seventh Viscount Fitzwilliam, 1816

Verelst, Simon Pietersz. 1644–probably 1721, *Group of Flowers*, bequeathed by Daniel Mesman, 1834

Verendael, Nicolaes van 1640–1691, *A Vase of Flowers*, bequeathed by Major the Hon. Henry Rogers Broughton, Second Lord Fairhaven, 1973

Verendael, Nicolaes van 1640–1691, *A Vase of Flowers*, bequeathed by Major the Hon. Henry Rogers Broughton, Second Lord Fairhaven, 1973, received 1975

Vermeulen, Cornelis c.1732–1813, *Landscape with Figures*, bequeathed by Daniel Mesman, 1834

Vermeulen, Cornelis c.1732–1813, *River Scene by Moonlight*, bequeathed by Daniel Mesman, 1834

Vernet, Claude-Joseph 1714–1789, *View on the Arno*, bequeathed by Daniel Mesman, 1834

Vernet, Claude-Joseph 1714–1789, *Sunrise*, bequeathed by Dr D. M. McDonald, 1991, with a life-interest to his widow, relinquished 1996, received 1997

Vernet, Claude-Joseph 1714–1789, *Noon*, bequeathed by Dr D. M. McDonald, 1991, with a life-interest to his widow, relinquished 1996, received 1997

Vernet, Claude-Joseph 1714–1789, *Sunset*, bequeathed by Dr D. M. McDonald, 1991, with a life-interest to his widow, relinquished 1996, received 1997

Vernet, Claude-Joseph 1714–1789, *A Coastal Mediterranean Landscape with a Dutch Merchantman in a Bay*, bequeathed by Dr D. M. McDonald, 1991, with a life-interest to his widow relinquished, 1996, received 1997

Veronese, Paolo 1528–1588, *Hermes, Herse and Aglauros*, bequeathed by Richard, Seventh Viscount Fitzwilliam, 1816

Veronese, Paolo (copy after) 1528–1588, *The Martyrdom of St George*, given by Archdeacon G. O. Cambridge, 1835

Vidal, L. c.1754–1804, *Vase of Flowers*, given by Major the Hon. Henry Rogers Broughton, 1966

Ville, Nick de b.1945, *Still Life with Stools and Books*, given by the Contemporary Art Society, 1979

Vincent, George 1796–1831, *Loch Etive, Argyllshire*, bought from the Fairhaven Fund, 1954

Vincent, George 1796–1831, *View in the Highlands*, bought from the Fairhaven Fund, 1949

Vinckeboons, David 1576–1632, *Wooded Landscape*, bequeathed by Richard, Seventh Viscount Fitzwilliam, 1816

Vleughels, Nicolas 1668–1737, *Telemachus on Calypso's Island*, bequeathed by Alan Milburn, 1995

Vlieger, Simon de 1601–1653, *Storm with a Wreck*, bequeathed by Daniel Mesman, 1834

Vlieger, Simon de 1601–1653, *Sea Piece, a Breeze near a Dutch Port*, bequeathed by Richard, Seventh Viscount Fitzwilliam, 1816

Vlieger, Simon de 1601–1653, *Shipping before Dordrecht*, bequeathed by Richard, Seventh Viscount Fitzwilliam, 1816

Vlieger, Simon de 1601–1653, *Sea Piece, a Calm*, bequeathed by Richard, Seventh Viscount Fitzwilliam, 1816

Vliet, Hendrick Cornelisz. van c.1611–1675, *The Old Church at Delft*, bequeathed by the Reverend Richard Edward Kerrich, 1872

Vollon, Antoine 1833–1900, *A River Scene*, given by Charles Fairfax Murray, 1916

Vonck, Jacobus active 1717–1773,

A Sculpted Stone Vase with Roses, Auricula, Poppies, Convolvulus, with a Jay on a Ledge, bequeathed by Major the Hon. Henry Rogers Broughton, Second Lord Fairhaven, 1973, received 1975

Vonck, Jacobus active 1717–1773, *A Sculpted Stone Vase with Roses, Poppies, Convolvulus, Ivy, a Wicker Basket and Grapes with a Hobby on a Ledge,* bequeathed by Major the Hon. Henry Rogers Broughton, Second Lord Fairhaven, 1973, received 1975

Vos, Paul de 1591–1592 or 1595–1678, *Stag Hunt,* bequeathed by Richard, Seventh Viscount Fitzwilliam, 1869

Vos, Simon de (attributed to) 1603–1676, *Portrait of a Man (perhaps Jan de Wael),* bequeathed by Richard, Seventh Viscount Fitzwilliam, 1816

Vouet, Simon 1590–1649, *The Entombment,* bought from the Marlay Fund, 1959

Vries, Guilliam de 1624/1629–1675/1678, *Still Life of Fruit with the Supper at Emmaus,* bequeathed by the Reverend Osmond Fisher, 1914, subject to the life-interest of his son, the Reverend O. P. Fisher, received 1937

Vries, Roelof van c.1631–after 1681, *A Tower beside a River,* bequeathed by Daniel Mesman, 1834

Vroom, Cornelis the younger (circle of) c.1591–1661, *River Scene,* bequeathed by Daniel Mesman, 1834

Vuillard, Jean Edouard 1868–1940, *The Artist's Sister with a Cup of Coffee,* accepted in lieu of tax by HM Government and allocated to the Fitzwilliam Museum, 1994, © ADAGP, Paris and DACS, London 2006

Vuillard, Jean Edouard 1868–1940, *Seated Woman, Reading,* bequeathed by Captain Stanley William Sykes, OBE, MC, 1966, © ADAGP, Paris and DACS, London 2006

Vuillard, Jean Edouard 1868–1940, *Woman Reading in the Reeds, Saint-Jacut-de-la-mer,* given by E. Vincent Harris, OBE, RA, in memory of his wife Edith, 1967, © ADAGP, Paris and DACS, London 2006

Vuillard, Jean Edouard 1868–1940, *Marguerite Chapin in Her Apartment with Her Dog,* bequeathed by Edward Maurice Berkeley Ingram, CMG, OBE, 1941, © ADAGP, Paris and DACS, London 2006

Vuillard, Jean Edouard 1868–1940, *Stoneware Vase and Flowers,* bequeathed by Frank Hindley

Smith, 1939, © ADAGP, Paris and DACS, London 2006

Walker, Ethel 1861–1951, *Girl's Head,* bequeathed by Miss Edith Bateson, 1938, © courtesy of the artist's estate/ www.bridgeman.co.uk

Walker, Frederick 1840–1875, *Mother with a Baby and a Nursemaid,* bequeathed by Henry Scipio Reitlinger, 1950, transferred from the Reitlinger Trust, 1991, accessioned 2005

Wallis, Alfred 1855–1942, *Two Masted Yawl,* bequeathed by Warren Pollock, 1986, received 1992

Wallis, George Augustus 1761–1847, *The Marble Falls, Terni,* bought from the Fairhaven Fund, 1997

Wallis, George Augustus 1761–1847, *Portrait of an Unknown Lady,* given by John Lishawa, in memory of Kate Lishawa, 2004

Wals, Goffredo c.1605–c.1638, *A Country Road by a House,* given by the Friends of the Fitzwilliam Museum, 1974

Walton, Edward Arthur 1860–1922, *Self Portrait,* given by Mrs Edward Arthur Walton, in accordance with the wishes of her husband, 1923

Walton, Elijah 1832–1880, *The Tombs of the Sultans near Cairo,* given by Elijah Walton, 1866

Ward, James 1769–1859, *Pigs,* given by Sir Frank Brangwyn, 1943

Ward, James 1769–1859, *Fight between a Lion and a Tiger,* given by Mrs Richard Ellison, 1862

Ward, James 1769–1859, *Two Studies of Children,* bequeathed by Charles Haslewood Shannon, 1937

Ward, James 1769–1859, *Sketch for 'The Family Compact',* given by Anthony Reed, 1993

Ward, James 1769–1859, *Sleeping Lioness,* unknown provenance

Ward, James 1769–1859, *The Descent of the Swan,* given by Anthony Reed, 1993

Waterlant, Simon Claesz. van d.1556, *Adoration of the Kings,* bequeathed by Charles Brinsley Marlay, 1912

Watts, George Frederick 1817–1904, *William Cavendish, Seventh Duke of Devonshire,* given to the University by a body of Subscribers, and accepted to be placed in the Fitzwilliam Museum, 1883

Watts, George Frederick 1817–1904, *Chaos,* given by the Friends of the Fitzwilliam Museum, 1916

Watts, George Frederick 1817–1904, *Three Heads,* bequeathed by the Rt Hon. Professor Sir Thomas Clifford Allbutt, 1925, received

1935

Webber, John 1750–1793, *A Native of Otaheite,* bequeathed by Daniel Mesman, 1834

Weenix, Jan 1642–1719, *Dead Game and Fruit,* bequeathed by Richard, Seventh Viscount Fitzwilliam, 1816

Weenix, Maria c.1679–1720 or later, *Flowers and Fruit,* bequeathed by Major the Hon. Henry Rogers Broughton, Second Lord Fairhaven, 1973, received 1975

Weenix, Maria c.1679–1720 or later, *A Group of Flowers,* bequeathed by Major the Hon. Henry Rogers Broughton, Second Lord Fairhaven, 1973, received 1975

Werff, Adriaen van der 1659–1722, *Tancred's Servant Presenting the Heart of Guiscard in a Golden Cup to Guismond,* bequeathed by Richard, Seventh Viscount Fitzwilliam, 1816

Werff, Pieter van der 1665–1722, *Bacchus and Ariadne,* bequeathed by Richard, Seventh Viscount Fitzwilliam, 1816

Weschke, Karl 1925–2005, *Cloud Study,* bequeathed by Warren Pollock, 1986, received 1992, © the estate of Karel Weschke 2006. All rights reserved, DACS

West, Benjamin 1738–1820, *The Continence of Scipio,* given by Charles Fairfax Murray, 1908

West, Benjamin 1738–1820, *Christ Healing the Sick in the Temple,* given by Charles Fairfax Murray, 1908

Weyerman, Jacob Campo 1677–1747, *A Vase of Flowers,* bequeathed by Major the Hon. Henry Rogers Broughton, Second Lord Fairhaven, 1973

Wheatley, Francis 1747–1801, *Benjamin Bond Hopkins,* given by Lt Col. B. E. Coke, in memory of Mrs Sarah Hopkins and the Reverend C. G. O. Bond, 1953

Whistler, James Abbott McNeill 1834–1903, *Portrait Study of a Man,* bequeathed by the Very Reverend Eric Milner-White, CBE, DSO, Dean of York, 1963, received 1970

Whistler, James Abbott McNeill (imitator of) 1834–1903, *Symphony in Grey and Brown: Lindsey Row, Chelsea,* given by the Very Reverend Eric Milner-White, CBE, DSO, Dean of York, 1948

Whistler, James Abbott McNeill (imitator of) 1834–1903, *Woman Sewing,* bequeathed by the Very Reverend Eric Milner-White, CBE, DSO, Dean of York, 1963

Wijnants, Jan c.1635–1684, *Landscape with Cattle,* given by Augustus Arthur VanSittart, 1876

Wijnants, Jan c.1635–1684, *Landscape with a Man and a Dog,* bequeathed by Daniel Mesman, 1834

Wijnants, Jan c.1635–1684, *Landscape with a Woman and a Dog,* given by Augustus Arthur VanSittart, 1876

Wijnants, Jan c.1635–1684, *Landscape with Coursing,* bequeathed by Richard, Seventh Viscount Fitzwilliam, 1816

Wijnants, Jan (copy after) c.1635–1684, *Landscape with Sheep,* bequeathed by Daniel Mesman, 1834

Wilkie, David 1785–1841, *The Burial of the Scottish Regalia,* given by the Friends of the Fitzwilliam Museum, 2000

Willaerts, Abraham c.1603–1669, *Family Group,* bequeathed by Daniel Mesman, 1834

Williams, Solomon 1757–1824, *Daniel Mesman,* bequeathed by Daniel Mesman, 1834

Wills, James active 1743–1777, *The Andrews Family,* given by Charles Fairfax Murray, 1908

Wilson, Frank Avray b.1914, *Miniature Configuration,* bequeathed by Warren Pollock, 1986, received 1992

Wilson, Richard 1713/1714–1782, *Apollo and the Seasons,* bought from the Fairhaven Fund, 1952

Wilson, Richard 1713/1714–1782, *Italian River Landscape with a Broken Bridge,* given by Frederick John Nettlefold, 1948

Wilson, Richard (after) 1713/1714–1782, *Bridge of Augustus at Rimini,* given by Charles Gerald Agnew, 1924

Wilson, Richard (attributed to) 1713/1714–1782, *Lake and Hills,* given by the Friends of the Fitzwilliam Museum, 1924

Woensel, Petronella van 1785–1839, *An Urn of Flowers,* bequeathed by Major the Hon. Henry Rogers Broughton, Second Lord Fairhaven, 1973, received 1975

Wood, Christopher 1901–1930, *La Ville-Close, Concarneau, Brittany,* bequeathed by Edward Maurice Berkeley Ingram, CMG, OBE, 1941

Wootton, John c.1682–1765, *A Race on the Round Course at Newmarket,* given by Paul Mellon KBE, 1979

Wootton, John c.1682–1765, *Classical Landscape,* given by Augustus Arthur VanSittart, 1876

Wouwerman, Philips 1619–1668, *Landscape with a Sporting Party,* bequeathed by Richard, Seventh Viscount Fitzwilliam, 1816

Wouwerman, Pieter 1623–1682, *Encampment beside an Ale House,*

bequeathed by Richard, Seventh Viscount Fitzwilliam, 1816

Wouwerman, Pieter 1623–1682, *The Stable,* bequeathed by Richard, Seventh Viscount Fitzwilliam, 1816

Wragg, Gary b.1946, *Painting No.1 C January 1974,* given by East England Arts, 2002, © the artist

Wragg, Gary b.1946, *Untitled,* bequeathed by Bryan Charles Francis Robertson, 2003, © the artist

Wragg, Gary b.1946, *Oval Works, Gaze Left,* given by the Friends of the Fitzwilliam Museum, 2002, © the artist

Wright, Joseph of Derby 1734–1797, *The Honourable Richard Fitzwilliam, Seventh Viscount Fitzwilliam of Merrion,* given by the Reverend Robert Fitzwilliam Halifax, 1819

Wright, Joseph of Derby 1734–1797, *Mrs John Ashton,* given by Charles Fairfax Murray, 1908

Wright, Joseph of Derby 1734–1797, *Matlock Tor,* bought from the Fairhaven Fund, 1948

Wtewael, Joachim Anthonisz. (after) 1566–1638, *The Judgement of Paris,* bequeathed Daniel Mesman, 1834

Wyck, Thomas 1616–1677, *The Alchemist,* bequeathed by Daniel Mesman, 1834

Zeeman, Reiner c.1623–c.1668, *Sea Piece,* bequeathed by Daniel Mesman, 1834

Ziem, Félix François Georges Philibert 1821–1911, *A View in Venice,* given by Philip McClean, 1996

Zocchi, Giuseppe 1711/1717–1767, *The Month of June,* bought from the Gow Fund with a contribution from the Victoria & Albert Museum Grant-in-Aid, 1983

Zuccarelli, Franco 1702–1788, *Refreshment during the Ride,* bequeathed by Richard, Seventh Viscount Fitzwilliam, 1816

Zuccarelli, Franco 1702–1788, *Italianate Wooded River Landscape with a Piping Shepherd, Two Women and a Child,* bequeathed by Dr D. M. McDonald, 1991, received 1992

Zuccarelli, Franco 1702–1788, *Stag Hunt,* bequeathed by Richard, Seventh Viscount Fitzwilliam, 1816

Zuccari, Taddeo 1529–1566, *Adoration of the Kings,* bequeathed by Charles Brinsley Marlay, 1912

Zugno, Francesco 1709–1787, *The Apotheosis of St Zeno,* bequeathed by Warren Pollock, 1986, received 1992

Zurbarán, Francisco de (school of) 1598–1664, *St Rufina,* bequeathed by Charles Brinsley Marlay, 1912

Collection Address

The Fitzwilliam Museum
Trumpington Street, Cambridge CB2 1RB
Telephone 01223 332900 Fax 01223 332923
Email fitzmuseum-admin@lists.cam.ac.uk
Website www.fitzmuseum.cam.ac.uk

Index of Artists

In this catalogue, artists' names and the spelling of their names follow the preferred presentation of the name in the Getty Union List of Artist Names (ULAN) as of February 2004, if the artist is listed in ULAN.

The page numbers next to each artist's name below direct readers to paintings that are by the artist; are attributed to the artist; or, in a few cases, are more loosely related to the artist being, for example, 'after', 'the circle of' or copies of a painting by the artist. The precise relationship between the artist and the painting is listed in the catalogue.

Preceding page: Gaulli, Giovanni Battista, 1639–1709, *The Three Marys at the Sepulchre* (detail), c.1684/1685, (p. 69)

Supporters of the Public Catalogue Foundation

Master Patrons

The Public Catalogue Foundation is greatly indebted to the following Master Patrons who have helped it in the past or are currently working with it to raise funds for the publication of their county catalogues. All of them have given freely of their time and have made an enormous contribution to the work of the Foundation.

Peter Andreae, High Sheriff for Hampshire *(Hampshire)*
Sir Nicholas Bacon, DL, High Sheriff for Norfolk *(Norfolk)*
Peter Bretherton *(West Yorkshire: Leeds)*
Richard Compton *(North Yorkshire)*
George Courtauld, Vice Lord Lieutenant for Essex *(Essex)*

The Marquess of Downshire *(North Yorkshire)*
Patricia Grayburn, MBE DL *(Surrey)*
Sir Michael Lickiss, DL *(Cornwall)*
Lord Marlesford, DL *(Suffolk)*
Phyllida Stewart-Roberts, OBE, Lord Lieutenant for East Sussex *(East Sussex)*
Leslie Weller, DL *(West Sussex)*

Financial Support

The Public Catalogue Foundation is particularly grateful to the following organisations and individuals who have given it generous financial support since the project started in 2003.

National Sponsor

Christie's

Benefactors (£10,000–£50,000)

The John S. Cohen Foundation
Christie's
Hampshire County Council
Peter Harrison Foundation
Hiscox plc
ICAP plc
Kent County Council
The Linbury Trust
The Manifold Trust
Robert Warren Miller

The Monument Trust
Stavros S. Niarchos Foundation
Norfolk County Council
Provident Financial
RAB Capital
Renaissance West Midlands
Saga Group Ltd
University College, London
University of Leeds
Garfield Weston Foundation

Series Patrons (Minimum donation of £2,500)

Harry Bott
Janey Buchan

Dr Peter Cannon-Brookes
Neil Honebon